THE WES ANDERSON

ANDERSON

COLLECTION

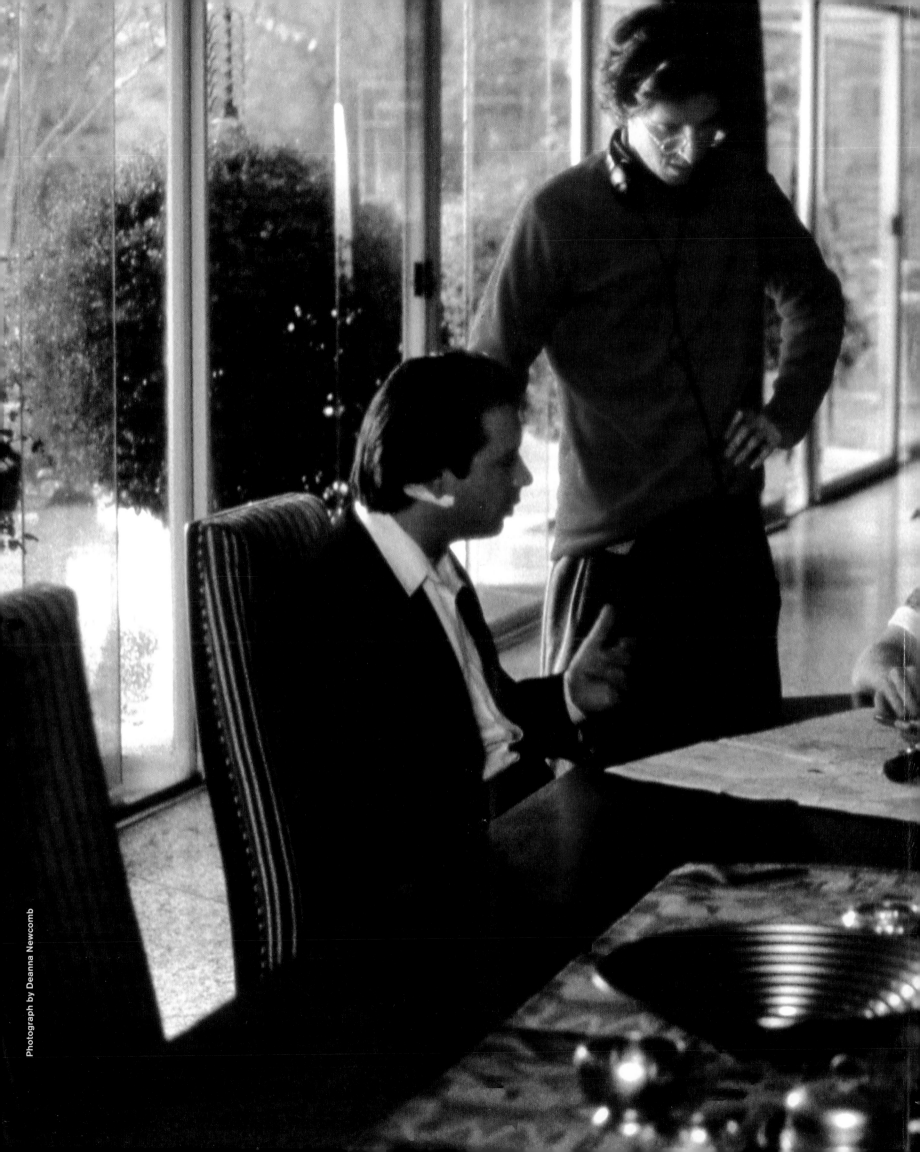

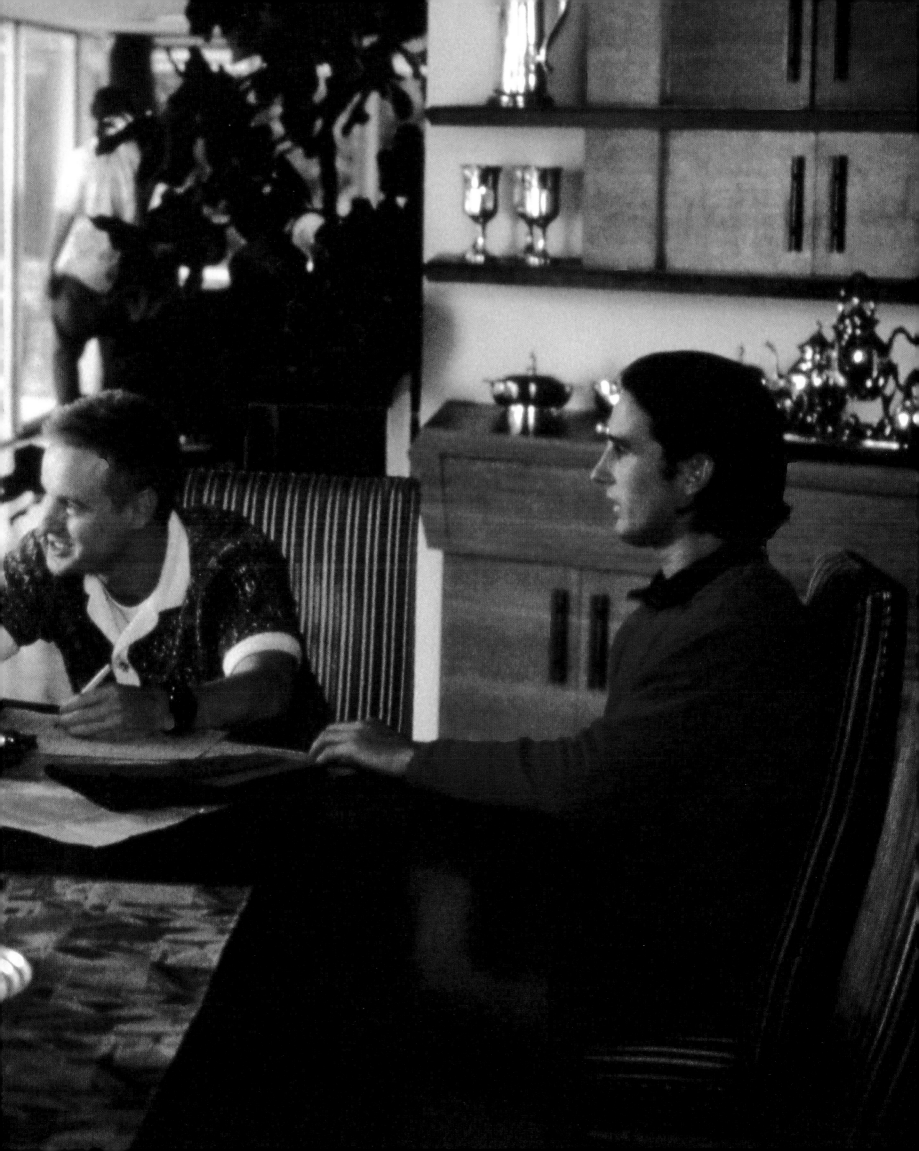

Photograph by Van Redin

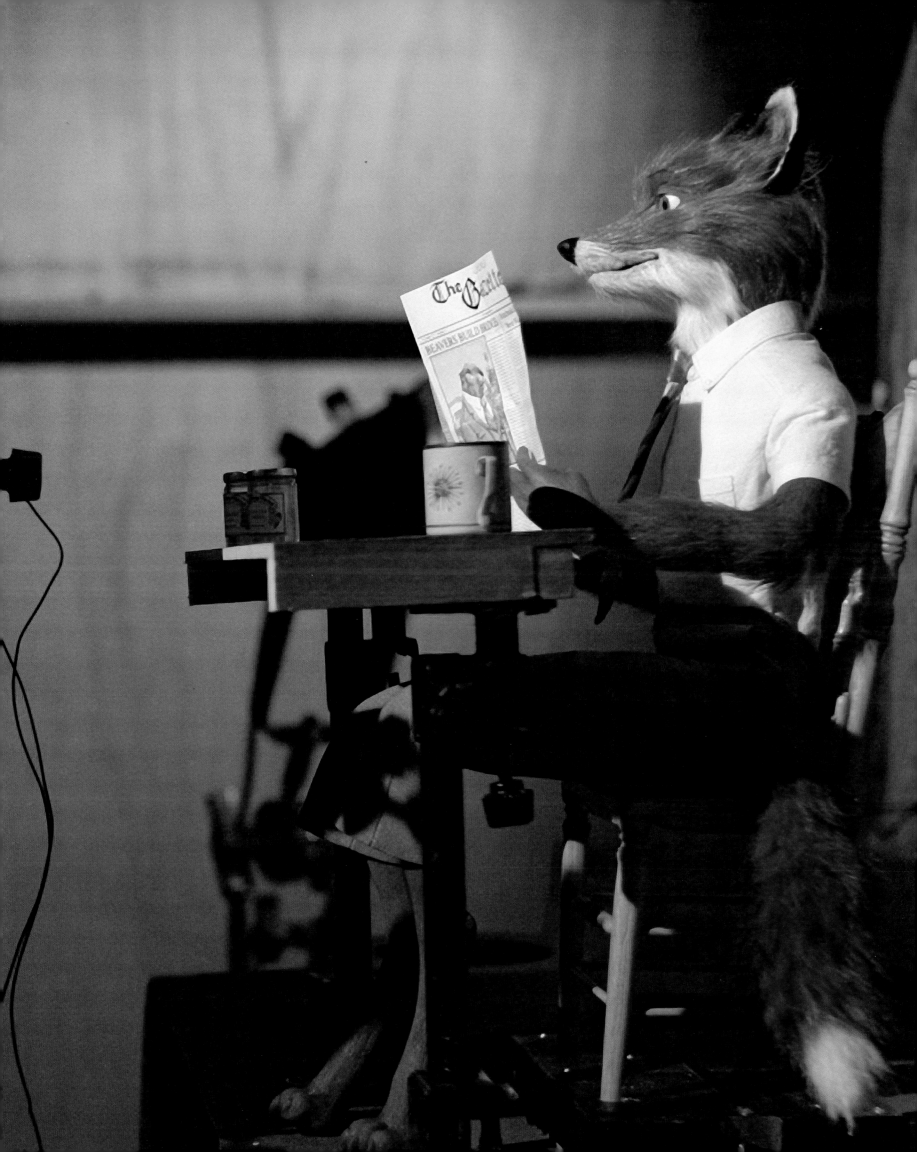

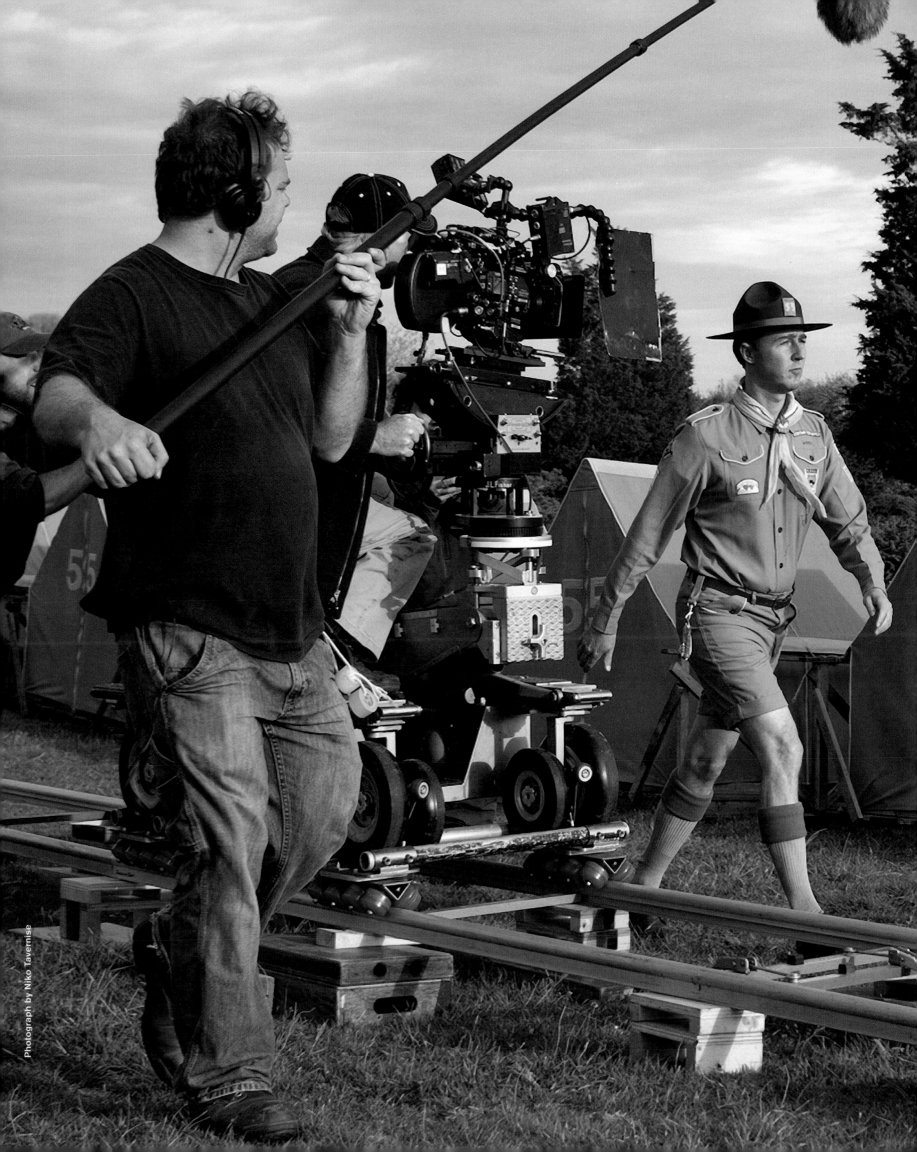

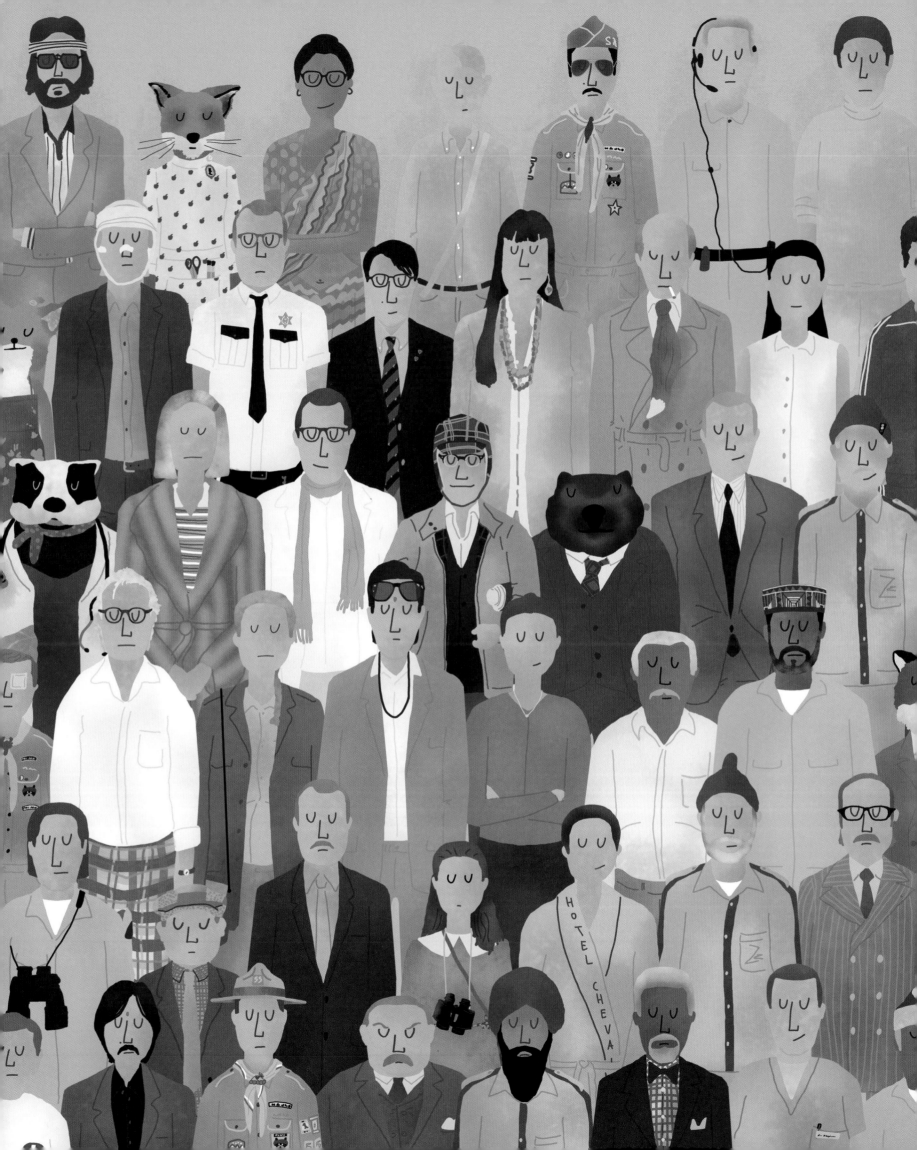

THE WES ANDERSON COLLECTION

by
MATT ZOLLER SEITZ
with an introduction by
MICHAEL CHABON

ABRAMS, NEW YORK

For

HANNAH & JAMES

CONTENTS

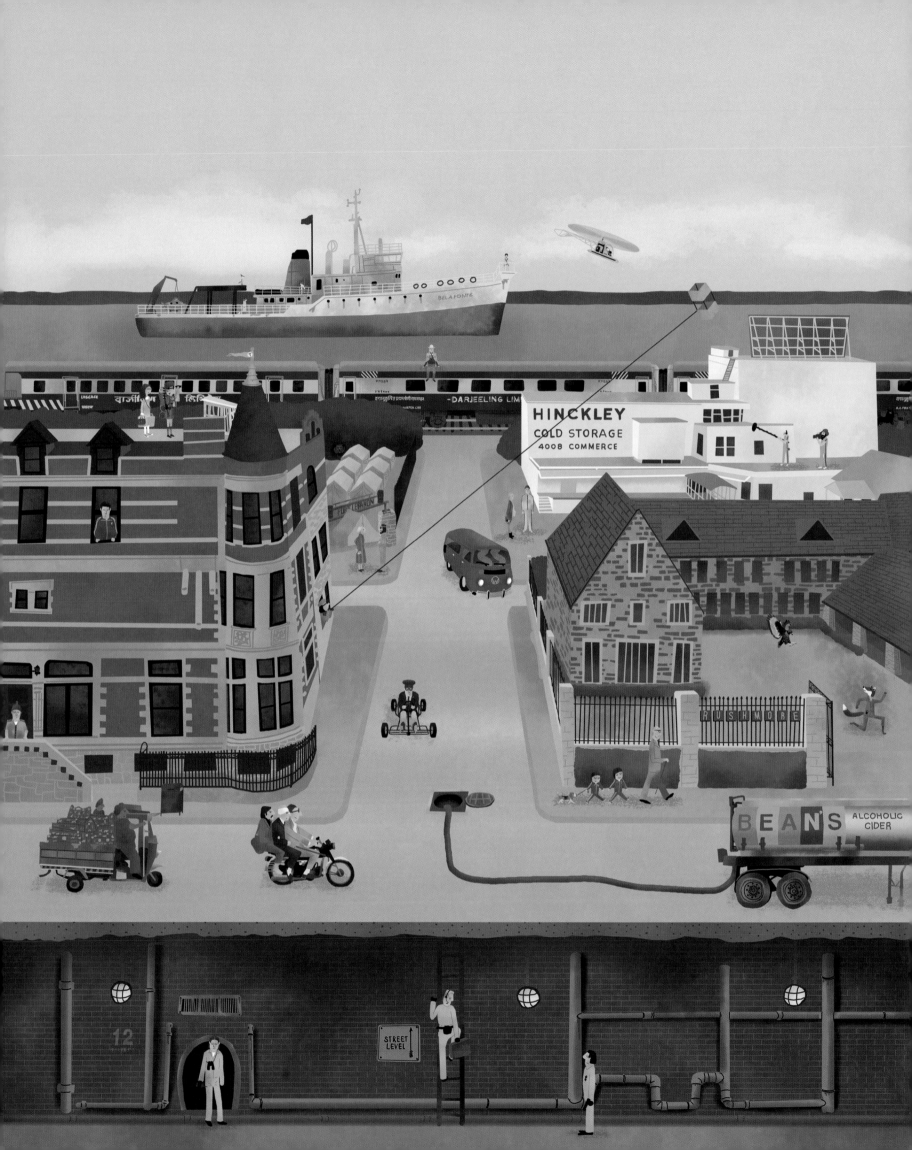

INTRODUCTION

T HE WORLD IS SO BIG, so complicated, so replete with marvels and surprises, that it takes years for most people to begin to notice that it is, also, irretrievably broken. We call this period of research "childhood."

There follows a program of renewed inquiry, often involuntary, into the nature and effects of mortality, entropy, heartbreak, violence, failure, cowardice, duplicity, cruelty, and grief; the researcher learns their histories, and their bitter lessons, by heart. Along the way, he or she discovers that the world has been broken for as long as anyone can remember, and struggles to reconcile this fact with the ache of cosmic nostalgia that arises, from time to time, in the researcher's heart: an intimation of vanished glory, of lost wholeness, a memory of the world unbroken. We call the moment at which this ache first arises "adolescence." The feeling haunts people all their lives.

Everyone, sooner or later, gets a thorough schooling in brokenness. The question becomes: What to do with the pieces? Some people hunker down atop the local pile of ruins and make do, Bedouins tending their goats in the shade of shattered giants. Others set about breaking what remains of the world into bits ever smaller and more jagged, kicking through the rubble like kids running through piles of leaves. And some people, passing among the scattered pieces of that great overturned jigsaw puzzle, start to pick up a piece here, a piece there, with a vague yet irresistible notion that perhaps something might be done about putting the thing back together again.

Two difficulties with this latter scheme at once present themselves. First of all, we have only ever glimpsed, as if through half-closed lids, the picture on the lid of the jigsaw puzzle box. Second, no matter how diligent we have been about picking up pieces along the way, we will never have anywhere near enough of them to finish the job. The most we can hope to accomplish with our handful of salvaged

by Michael Chabon

bits—the bittersweet harvest of observation and experience—is to build a little world of our own. A scale model of that mysterious original, unbroken, half-remembered. Of course the worlds we build out of our store of fragments can be only approximations, partial and inaccurate. As representations of the vanished whole that haunts us, they must be accounted failures. And yet in that very failure, in their gaps and inaccuracies, they may yet be faithful maps, accurate scale models, of this beautiful and broken world. We call these scale models "works of art."

In their set design and camerawork, their use of stop-motion, maps, and models, Wes Anderson's films readily, even eagerly, concede the "miniature" quality of the worlds he builds. And yet these worlds span continents and decades. They comprise crime, adultery, brutality, suicide, the death of a parent, the drowning of a child, moments of profound joy and transcendence. Vladimir Nabokov, his life cleaved by exile, created a miniature version of the homeland he would never see again and tucked it, with a jeweler's precision, into the housing of John Shade's miniature epic of family sorrow. Anderson—who has suggested that the break-up of his parents' marriage was a defining experience of his life—adopts a Nabokovian procedure with the families or quasi-families at the heart of all his films from *Rushmore* forward, creating a series of scale-model households that, like the Zemblas and Estotilands and other lost "kingdoms by the sea" in Nabokov, intensify our experience of brokenness and loss by compressing them. That is the paradoxical power of the scale model; a child holding a globe has a more direct, more intuitive grasp of the earth's scope and variety, of

its local vastness and its cosmic tininess, than a man who spends a year in circumnavigation. Grief, at full scale, is too big for us to take it in; it literally cannot be comprehended. Anderson, like Nabokov, understands that distance can increase our understanding of grief, allowing us to see it whole. But distance does not—ought not—necessarily imply a withdrawal. In order to gain sufficient perspective on the pain of exile and the murder of his father, Nabokov did not, in writing *Pale Fire,* step back from them. He reduced their scale, and let his patience, his precision, his mastery of detail—detail, the god of the model-maker—do the rest. With each of his films, Anderson's total command of detail—both the physical detail of his sets and costumes, and the emotional detail of the uniformly beautiful performances he elicits from his actors—has enabled him to increase the persuasiveness of his own family Zemblas, without sacrificing any of the paradoxical emotional power that distance affords.

Anderson's films have frequently been compared to the boxed assemblages of Joseph Cornell, and it's a useful comparison, as long as one bears in mind that the crucial element in a Cornell box is neither the imagery and objects it deploys, nor the Romantic narratives it incorporates and undermines, nor the playfulness and precision with which its objects and narratives have been arranged. The important thing in a Cornell box is the *box.*

Cornell always took pains to construct his boxes himself; indeed the box is the only part of a Cornell work literally "made" by the artist. The box, to Cornell, is a *gesture*—it draws a boundary around the things it contains, and forces them into a defined relationship, not merely with each other, but with everything on

the far side of the box. The box sets out the scale of a ratio; it mediates the halves of a metaphor. It makes explicit, in plain, hand-crafted wood and glass, the yearning of a model-maker to analogize the world, and at the same time it frankly emphasizes the limitations, the confines, of his or her ability to do so.

The things in Anderson's films that recall Cornell's boxes—the strict, steady, four-square construction of individual shots, by which the cinematic frame becomes a Cornellian gesture, a box drawn around the world of the film; the teeming, gridded, curio-cabinet sets at the heart of *Life Aquatic*, *Darjeeling*, and *Mr. Fox*—are often cited as evidence of his work's "artificiality," at times with the implication, simple-minded and profoundly mistaken, that a high degree of artifice is somehow inimical to seriousness, to honest emotion, to so-called authenticity. All movies, of course, are equally artificial; it's just that some are more honest about it than others. In this important sense, the hand-built, model-kit artifice on display behind the pane of an Anderson box is a *guarantor* of authenticity; indeed I would argue that artifice, openly expressed, is the only true "authenticity" an artist can lay claim to.

Anderson's films, like the boxes of Cornell or the novels of Nabokov, understand and demonstrate that the magic of art, which renders beauty out of brokenness, disappointment, failure, decay, even ugliness and violence, is authentic only to the degree that it attempts to conceal neither the bleak facts nor the tricks employed in pulling off the presto change-o. It is honest only to the degree that it builds its precise and inescapable box around its maker's scale version of the world.

"For my next trick," says Joseph Cornell, or Vladimir Nabokov, or Wes Anderson, "I have put the world into a box." And when he opens the box, you see something dark and glittering, an orderly mess of shards, refuse, bits of junk and feather and butterfly wing, tokens and totems of memory, maps of exile, documentation of loss. And you say, leaning in, "The world!"

Michael Chabon is the Pulitzer Prize–winning author of *The Mysteries of Pittsburgh, Wonder Boys, The Amazing Adventures of Kavalier & Clay, Summerland* (a novel for children), *The Final Solution, The Yiddish Policemen's Union, Gentlemen of the Road,* and *Telegraph Avenue,* as well as the short story collections *A Model World* and *Werewolves in Their Youth;* and the essay collections *Maps and Legends* and *Manhood for Amateurs.* He is the chairman of the board of the MacDowell Colony. He lives in Berkeley, California, with his wife, the novelist Ayelet Waldman, and their children.

The 896-Word
PREFACE

THIS BOOK WAS TWENTY years in the making. I don't mean that to sound momentous, or to imply I've been working on it continuously, but in terms of timeline, it's a fact.

I first encountered Wes Anderson's name in Dallas in 1994. I was a rookie film critic for my hometown weekly, the *Dallas Observer.* Anderson was an aspiring director whose first short film, *Bottle Rocket,* had been accepted into the local film festival. I wrote a positive capsule review of the short and found its style intriguing enough to write a couple of articles about Wes and his writing partner and leading man, Owen Wilson, as they struggled to turn it into a feature.

Since then, my life has intersected with Wes's in all sorts of ways: professional, personal, and, on occasion, weird. I had lunch with him a couple of times in the late '90s, when we were both living in New York, but didn't spend any serious time with him again until recently, when I talked to him for this book. Over the years I'd call him or Owen for a quote—always for articles I knew they'd want to be part of, such as a piece about the thirtieth anniversary of *A Charlie Brown Christmas* or Charles Schulz's retirement from cartooning. The weirdest path-crossing happened in 2000. Wes was shooting parts of *The Royal Tenenbaums* near downtown Brooklyn on State Street, where my wife and kids and I lived for many years. I saw film trucks parked outside an apartment building a couple blocks from the ground-floor brownstone apartment we were renting and asked a production assistant for the title of the movie. "*The Royal Tenenbaums,* directed by Wes Anderson," she said. Because I had to rush to work, I wrote Wes a note and asked the PA to hand it to him at lunch. He called later that day and left a message saying he was sorry he'd missed me. I thought, "Ah, well, bad timing," and figured that was the end of that anecdote.

Flash forward one year to the New York Film Festival critics' screening of *The Royal*

by Matt Zoller Seitz

Tenenbaums. Wes and I chatted briefly before the screening, then he introduced the film and the lights went down. Then came the "Me and Julio Down by the Schoolyard" montage. Gene Hackman and the boys chucked water balloons at a gypsy cab, and to my surprise, the cab screeched to a halt in front of my house on State Street. Any pretense of cool professionalism vanished, and I jabbed my finger at the screen like a straw-hatted yokel from an old movie and blurted, *"Hey! That's my house!"* My colleagues angrily shushed me; I am pretty sure one of them was Rex Reed.

Mortified, I fell silent for a moment, then muttered: "But that was my *house.*"

You should keep that anecdote in mind while perusing *The Wes Anderson Collection,* a book-length conversation interspersed with critical essays, photos, and artwork. Although I felt sure that Wes was a significant American filmmaker after *Rushmore,* I felt too close to the subject to officially review any of his features. Even my five-part series of video essays about Wes's movies, *The Substance of Style*—which was published in 2009 by the online magazine *Moving Image Source*—approached the work analytically, like a gastronome guessing what ingredients had fused to produce a unique flavor. A part of me was always rooting for Wes, a Texan about my age who shot parts of his first feature in neighborhoods I knew, and who shared many of my key influences, including the French New Wave, Orson Welles, and *Peanuts.*

This book is more personal, but it's still about the substance of Wes's style. I don't feel comfortable calling it a book-length "interview"; but it's more like a long talk between a filmmaker and journalist who know each other pretty well. It moves through Wes's career movie by movie, and although Wes shares personal anecdotes here and there—mostly in the *Bottle Rocket* and *Darjeeling Limited* chapters—the focus is always on the work. That's partly because Wes is an intensely private man, but it's mostly a by-product of how our minds operate. When we talk, we talk about movies, music, literature, art, the relationship between creativity and criticism, and other topics related to our jobs. Every now and then I'll try out one of my pet theories about his work to see what he says. If nothing else, the exercise gives the lie to the notion that every detail in a Wes Anderson picture is part of the grand design.

We spoke for two days in Tuscany in August 2010, and for one day in the *Moonrise Kingdom* editing suites in 2011, with a couple follow-up talks in 2012. The conversation went where it went, and eventually it ended up on paper, surrounded by visuals keyed into whatever topics happened to come up. Wes has always had a knack for showing how things describe and define individuals; this book was conceived in the same spirit. It's called *The Wes Anderson Collection* because the result reminded me of Margot's library in *The Royal Tenenbaums,* Steve Zissou's floating laboratory/film studio in *The Life Aquatic,* or Suzy Bishop's collection of stolen library books in *Moonrise Kingdom.* It's a tour of an artist's mind, with the artist as guide and amiable companion.

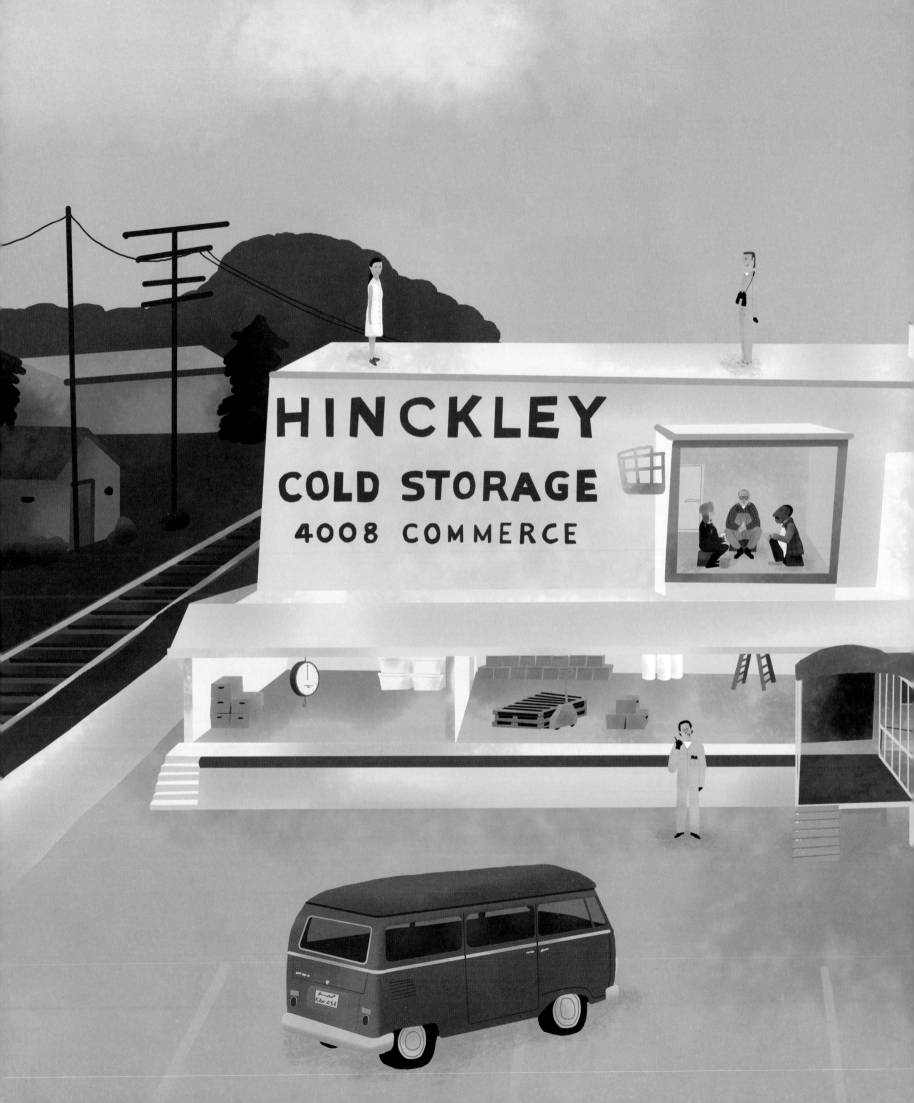

BOTTLE ROCKET

The 1,082–Word Essay

I WAS THE FIRST professional critic to review a Wes Anderson film. The adjective *professional* seems funny to me, though, because at that point I was in my early twenties, like Anderson. I'd been a working journalist for two years, and Anderson was just getting started himself. The film was *Bottle Rocket,* a twelve-minute, 16mm black-and-white short Anderson and the Wilson brothers made in Dallas not long after graduating from the University of Texas at Austin.

My review was published in 1994 in a piece about that year's Dallas-based USA Film Festival, which programmed *Bottle Rocket* in a block of shorts. By that point, the movie was already a success. It had played at the 1993 Sundance Film Festival and attracted the attention of industry veterans who would ultimately bring Anderson and his collaborators to Columbia Pictures, where they made a feature version with the same lead actors. The feature, a comedy about aimless rich kids who try to reinvent themselves as master thieves, launched Anderson's directing career and transformed Owen and Luke Wilson, who had charm but no formal acting training, into rising stars. It established Anderson and Owen Wilson as a screenwriting team and propelled them through two more projects, 1998's *Rushmore* and 2001's *The Royal Tenenbaums,* which got an Academy Award® nomination for Best Original Screenplay. It brought producer Polly Platt (*The Last Picture Show*) out of semi-retirement and gave supporting player James Caan, who had just finished a much-publicized stint in rehab, a plum supporting part as Mr. Henry, the heroes' hipster scalawag patron. And it was another creative feather in the cap of its executive producer James L. Brooks, who

by Matt Zoller Seitz

was known for his mentoring of new talent as well as for *The Mary Tyler Moore Show, Terms of Endearment, Broadcast News,* and other pop culture touchstones; his list of notable protégés includes Matt Groening (*The Simpsons*), Danny DeVito (*Throw Momma from the Train, The War of the Roses*), Steve Kloves (*The Fabulous Baker Boys*), and Cameron Crowe (*Say Anything*).

At the time, the very existence of Anderson's feature was astonishing. The post-1980s model for directorial success was defined by *Stranger Than Paradise, She's Gotta Have It,* and other no-budget, star-free indies. The established track required filmmakers to piece together a tiny budget from non-Hollywood sources, get the finished picture into Sundance, play art houses for a year or so, and gather sufficient acclaim and box office numbers to graduate to a glitzier follow-up, ideally at a major studio. The *Bottle Rocket* gang skipped to the studio part. Dallas's tight-knit film community congratulated them in public and grumbled in private: *How come these guys got to cut in line?*

If you'd seen the short, you were less likely to ask that. *Bottle Rocket* jumped out of my VHS screener stack because it didn't feel like anything else in the festival that year. In fact, it didn't feel like anything else, period. The black-and-white photography, stark credits, droll wit, and jazzy score (which included a bit from Vince Guaraldi's "Snowflakes," from the soundtrack to *A Charlie Brown Christmas*) bespoke an allegiance to 1960s and '70s film movements, particularly the French New Wave and the so-called American New Wave that followed it. It was clearly the work of people who knew film history but didn't treat the past as homework. The short was clever and

knowing, but wasn't a pastiche. It was somehow cool and warm at the same time, no small feat. Anderson didn't make references; he had influences. And there were already signs that he had a pretty good idea who he was as a director, and was comfortable in his own skin. "Bottle Rocket" didn't just signal the start of a career, but the birth of a voice.

Bottle Rocket the feature is a more problematic work—for me, at least. While I adore it, it's tough for me to just experience it as a movie because I chronicled its production over a period of months for a 1995 *Dallas Observer* cover story. During that period I was privy to creative disagreements between the young filmmakers and their mentors and bosses, and watched from afar as Columbia reacted to poor test screenings by abandoning its original plan to position *Bottle Rocket* as a youth-targeted sleeper, and opened it in limited release in early 1996. Given the unique circumstances of *Bottle Rocket*'s creation, there's just no way it could have been 100 percent Anderson and Wilson's picture; Anderson has obliquely acknowledged as much in DVD supplements, mainly in discussions of technical matters. Among other things, he had wanted to shoot the film in anamorphic (2:35:1 to 1) widescreen format, but ended up shooting it in 1.85:1 (or "flat") format because it was easier to light. There's at least one insert shot that Anderson was forced by higher-ups to replace because they didn't find it funny. And I know from talking to Anderson and Owen Wilson back in '95 that they struggled to make the love story between Anthony and ingenue Inez feel as natural as the slapstick, male bonding, and kinetic bursts of action and music. But judging from what's on-screen—the

converging lines and planes of the Hillsboro Motel, the lyrical images of Owen Wilson's Dignan shooting off firecrackers, Rocky giving Dignan the message "Tell Anthony I *love* him"—they got invested in that part, too. At the very least, they had fun with it.

Anderson has been circumspect about behind-the-scenes drama; it's his way. Almost two decades after the production of *Bottle Rocket,* he speaks of the film with great affection, as well he should. It's still his loosest, most relaxed feature. A friend of mine once said that it felt like the third or fourth picture from a director who'd had a couple of big successes and felt confident enough to put away the oil paints and doodle in a notebook. When you realize how much was at stake for the director and his friends—triumph or disgrace, the two most likely outcomes for first-timers bankrolled by major studios—the movie's no-fuss quality seems all the more remarkable. It's a special debut, audacious yet gentle, with a loping rhythm that reminds me of what it's like to stroll around Dallas in early summer at dusk, cicadas whirring. When I watch *Bottle Rocket* today, I see not just a notable 1990s comedy, but a stealth documentary that captures a certain time and place, and fixes the most important moment in an artist's career: the beginning.

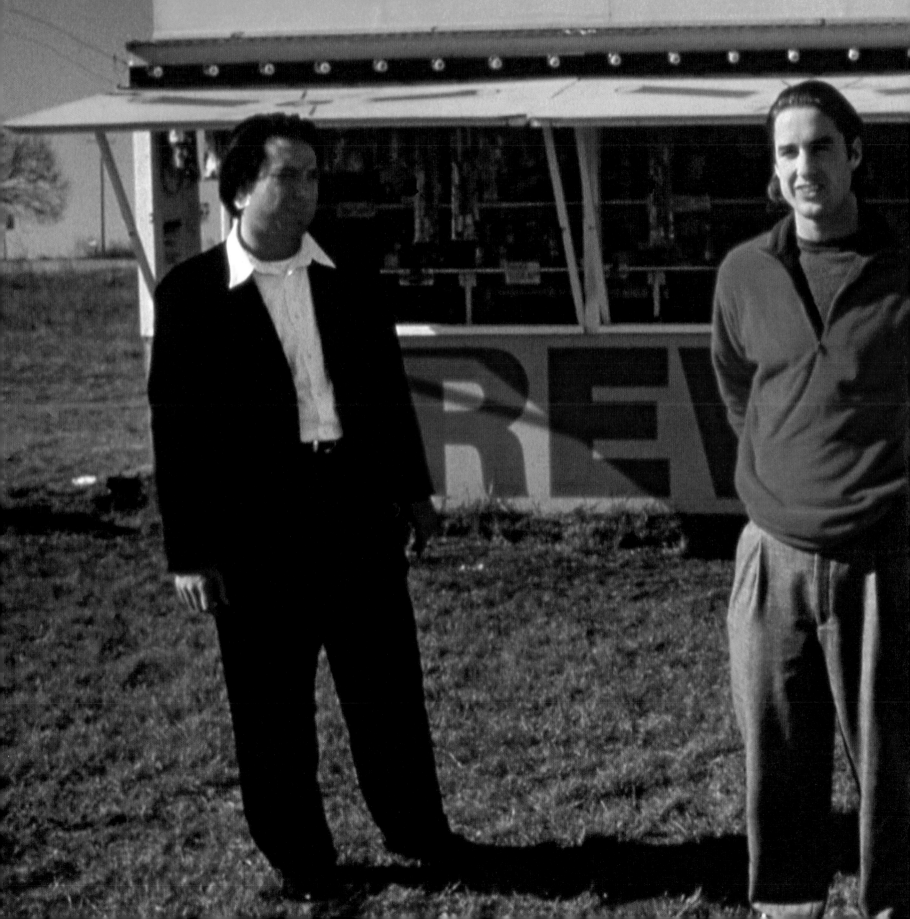

BOTTLE ROCKET

The 6,553-Word Interview

First they blew into town...then they BLEW IT UP!

Walt Disney Productions'
The APPLE
DUMPLING
GANG

It's a
24-Karat
caper
...and that's
NO
BULLion!

OPPOSITE: Wes Anderson on the set of the feature *Bottle Rocket* (1996) in Hillsboro, Texas.

ABOVE: A one-sheet for *The Apple Dumpling Gang* (1975).

RIGHT: A publicity still of Alfred Hitchcock from 1963's *The Birds*.

* *Rear Window* was shot when studios were trying out wider image shapes to distinguish their product from TV, which used the "Academy ratio" of 1.33 or 1.37:1. 35mm features post-TV continued to be shot in the Academy ratio, but were masked off (via a "hard matte" in-camera or a "soft matte" in the projector) or squeezed (using special lenses in cameras and projectors) to create a wider screen shape. *Rear Window* was composed for 1.66:1, but in such a way that it could be soft-matted in the projector and shown in an array of widths—from 1.37 to 1.85:1. The version of *Rear Window* that Anderson saw on Betamax used the full-frame, non-matted, 1.37:1 image.

MATT ZOLLER SEITZ: Do you remember the first movie you saw?

WES ANDERSON: I think it might have been a Pink Panther movie. I remember a lot of Disney movies. I know for a long period of time my favorite movie was the one where Kurt Russell was the strongest man in the world or something like that. Do you remember that?

Yeah.

That was a real favorite of mine. There was one called *The Apple Dumpling Gang* with Don Knotts which I think we liked.

Let me zero in a little bit. What was the first movie you remember seeing where you were fascinated by it for reasons other than the story, reasons that maybe sparked you to think, "what is a movie?"

I started watching Hitchcock movies. We had the Betamax, and we had these Hitchcock movies—*Rope* and *The Man Who Knew Too Much* and *Rear Window* and *The Trouble with Harry*. The man whose name was on the box was not in the movies. He was the director. Well, I didn't know

any other movies that quite fell into that category. The star was behind the camera. That made a big impression on me. Maybe I was eleven or twelve by the time I saw those.

Thinking of the films you mention, *Rear Window* really jumps out at me, because it's a movie that's so much about watching movies. The hero is sitting there, and his window is like a viewing screen. He's looking out across the courtyard, peering into other people's windows, looking at lives that reflect aspects of his own life, and they're these little dioramas.

I think maybe that's my favorite Hitchcock movie of all of them maybe. You know, the movie is 1.85* or something like that, but Jimmy Stewart's window is more like CinemaScope dimension, I think. He has those wide windows all across the back.

What is it about *Rear Window* that makes it your favorite?

Never leaving the apartment. Filming them only from across the way. Some of the other people who live there, you never see them close at all. *Most* of them you never see close at all—you just see them from across the way. You spend a lot of

time watching them, but only from across the way. But also mainly I think I just like the writing and the story, and the cast is the best. James Stewart and Grace Kelly. They're the best in it.

What was the first movie you *researched*—where you sought out material that discussed the making of the movie—rather than simply enjoying the movie?

I guess you'd have to say *Star Wars*. There was a lot available. There were a lot of supporting materials. There was every possible kind of information. Books. Weapons. Death Stars and X-wings and so on. And, you know, before much of anything was really out on tape, there were already bootlegs of *Star Wars*. The idea of a pirated *anything* was introduced to me by the fact that *Star Wars* was playing on the TV set in my doctor's office.

Your doctor had it?

Yep. Somehow he got hold of *Star Wars*. I think that would be frowned upon today.
I remember they had this one book that was just blueprints of the sets and vehicles and things.

The book with the production sketches?

That sounds right.

Ralph McQuarrie?

OK! I don't know. Was that the name of the guy who did the drawings? Was he the designer of the movie?

No. They had a name for him. It was visual consultant or production illustrator or something. Conceptual artist, I believe. He did conceptual illustrations. I remember that when I looked at his drawings as a kid, what struck me was that they were from a movie that was not the movie I had seen. There was a sketch of Darth Vader where it looked like he had a diving helmet on or something. Not at all close to the way he eventually turned out.**

I guess that was one of the ideas that evolved.

They were more classic cornball swashbuckling. They didn't have that hard edge that the *Star Wars* films had.

Well, they had a Landspeeder in there.

That's right. Did *Star Wars* and this material that surrounded it have an effect on your imagination?

BELOW: The closing sequence of Alfred Hitchcock's *Rear Window* (1954) gathers many future Anderson signatures into one filmic moment: It's a continuous shot that directs the viewer's attention through camera movement instead of cuts, and like so much of the movie, it adopts a somewhat voyeuristic perspective on action while treating life-size locations as if they're part of an enormous diorama.

OPPOSITE: Like a lot of the merchandising tied in to George Lucas's original 1977 space fantasy, the book *The Art of Star Wars* fed young film buffs' imaginations. It showed how much imagination, revision, and practical knowledge went into creating a detailed fictional world. But the drawings weren't all that different from what little kids might draw in school—just more technically sophisticated. If you were young in 1977, this was enormously reassuring.

** McQuarrie's actual title on *Star Wars* Episode IV: *A New Hope* was "production illustrator."

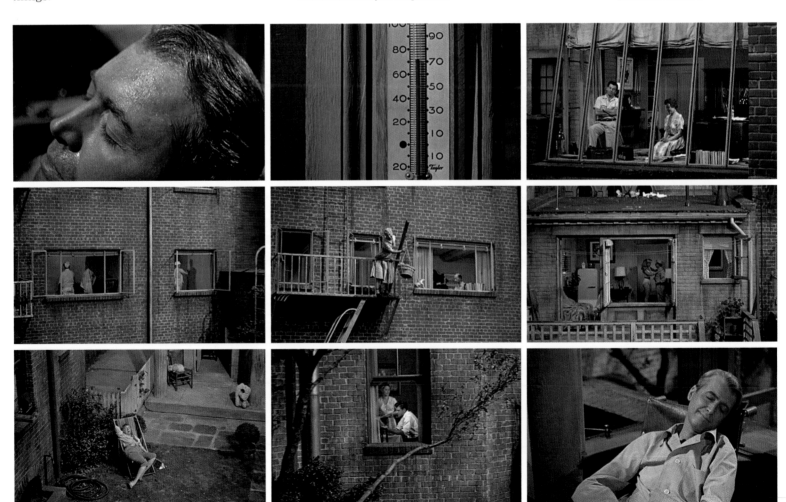

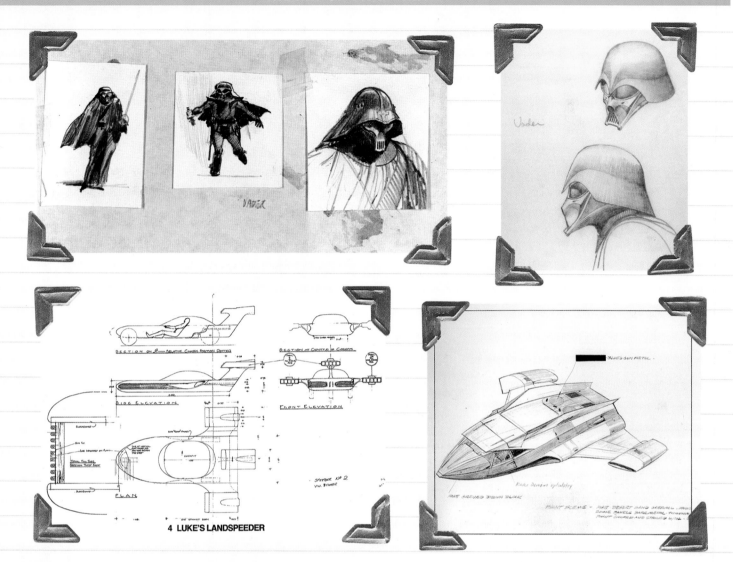

4 LUKE'S LANDSPEEDER

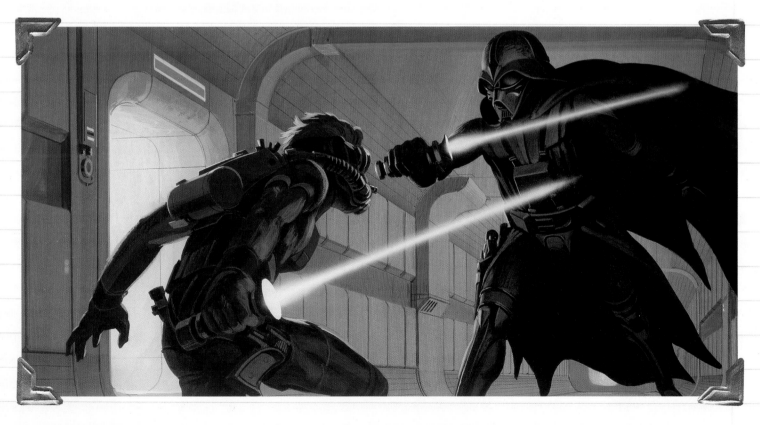

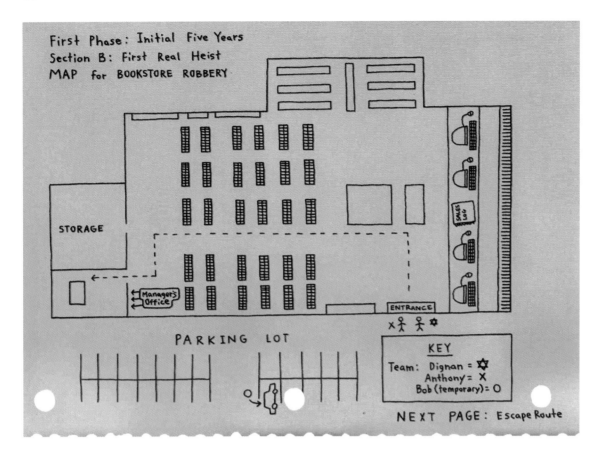

First Phase: Initial Five Years
Section B: First Real Heist
MAP for BOOKSTORE ROBBERY

STORAGE

Manager's Office

PARKING LOT

ENTRANCE

SALES

KEY
Team: Dignan = ✡
Anthony = X
Bob (temporary) = O

NEXT PAGE: Escape Route

They affected every human at that time. But there are many things like that which hit you at a certain age. You know, the way ninth graders can get so phenomenally focused on something like *Dune* or J. R. R. Tolkien. Those things where there's such a complicated world, a universe that you can kind of actually somewhat believe in. Scientology might even relate to that, where you can get so caught up in this invention that you make the choice to begin to embrace the reality of it.

At what point did you start to want to make movies yourself?

I wanted to make a movie about some skateboarding kids. That must have been in about 1978 or something. My father had a Super 8 camera that he gave me, but we had a contract, so it was actually more of a loan, but it ended up being a permanent loan.

Did you shoot the movie?

Yep. It was based on a library book. It was one reel, 180 seconds, I think. Cartridges.

Did it have a plot?

I doubt it. It had characters, but the characters were basically modeled on the people playing them, as I recall.

Beyond that, did you make more movies?

I did lots of them.

Can you describe them?

Most of them got stolen out of my car years ago. I think it's probably just as well. The camera got stolen out of the car, and I had all the reels in a bag along with it. I went to pawnshops around

Austin to see if I could locate them, but I never got them back.

That's tragic.

It was a bit of a drag. But the concepts weren't very well developed. I did a couple of Indiana Jones ones. For those, we made sets and sort of costumes, but you couldn't say they showed a lot of promise.

Did you draw as well?

Oh, yes. I like to draw.

What kind of drawing? Did you do just straight-up drawings, or comics?

I never really did comics. I remember I tried to do comics, and I remember some kids who could do drawings that looked like comics, kids whose style looked like some professional artist. I could never do that. I tended to do drawings that were a way to make me and my friends into fictional

LEFT: Dignan's schematic of the bookstore that the crew robs in *Bottle Rocket*.

BELOW: Director storyboards, in pencil. Note the near-CinemaScope dimensions of the frame—wishful thinking, in retrospect, since the movie ended up being shot in 1.85:1, or "flat," format.

OPPOSITE: A 1971 ad for a Vivitar Super 8 movie camera. Laura Mulvey could write a whole essay on this.

OVERLEAF: Anderson's storyboards for the scene in which Anthony and Dignan rob Anthony's mother's house.

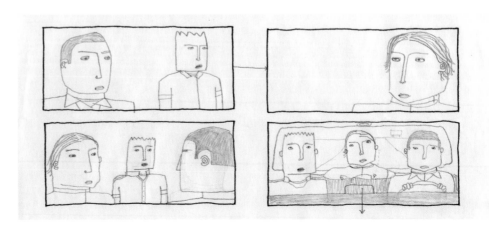

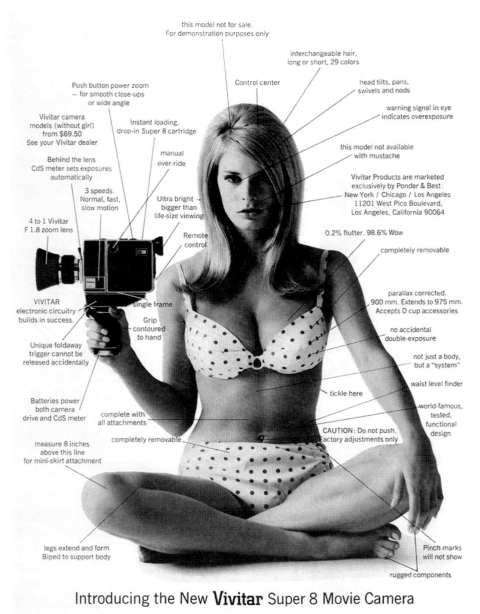

Introducing the New **Vivitar** Super 8 Movie Camera

characters and give us things to go around us. I used to do lots of drawings of trees with people living in them, giant trees with houses in them,*** and whole communities. For a long time I did those drawings of trees all the time. That's probably very strange.

Do you recall a moment where you made a conscious decision that you wanted to be a filmmaker?**

Well, I remember I always kind of felt that that was what I was working on. But then I decided to be a writer, and then when I went to college I sort of switched back.

What happened was, in the library at the University of Texas at Austin they had a very good collection of books about movies. And they also had several different libraries. There was the fine arts library, and then there were two other big libraries. Each had a movie-book section, and they also had movies you could watch there. I had much better access to books about movies than I did before. So I started reading books about filmmakers I was interested in, and then watching their movies, going back and forth.

What sort of books?

I feel like they built up the collection, and then it didn't keep growing. A lot of the books were about Fellini, Bergman, Truffaut, and people like that, and then there were books about Scorsese and Francis Coppola and some seventies movies. One of the biggest sections was European movies of the sixties. Plus, there were some books on John Ford and Raoul Walsh, but that seemed to be related to the French New Wave and to the Americans who followed. The library had Peter Bogdanovich's littler books about directors. They had Peter's John Ford book and his Allan Dwan book and I think a Howard Hawks? And they had a collection of his articles about movies—*Pieces of Time*, I think it's called.

Did discovering these directors in books spur you to seek out their movies?

Sure! And also Pauline Kael—they had all her books. It was quite a big collection of her books. And I was reading all her reviews in the *New Yorker* by then. One of the reviews I remember most was her piece on *Casualties of War* because she referred to *Grand Illusion* and *Shoeshine* and *The Chant of Jimmie Blacksmith*. And I went and saw them all—although *The Chant of Jimmie Blacksmith* didn't make as much of an impression on me as *Grand Illusion*. *The Chant of Jimmie Blacksmith*, do you know that movie?

Yes. I'm a big Fred Schepisi fan. He's one of the underrated directors, in fact. Especially his editing. It's very literary, the way he can jump back and forth in time very rapidly without making a big deal of it.

Six Degrees of Separation. I loved that one. It does that.

Yes, it does. So your interest in European art cinema from the fifties and sixties blossomed at the University of Texas?

Yep.

Were you making movies at that point, or were you not quite there?

I started doing some things. There was a public-access station in Houston, and I got to use their equipment. I made a documentary about my landlord Karl Hendler. I made it on commission from him in order to pay him some debts I owed him, but he didn't like it.

He didn't like the documentary?

No, but he was up-front about it. I don't think he was mad. He just didn't think it was going to be helpful to him.

Do you still have it?

I'm sure it's somewhere, but I don't currently have access to it.

*** In *The Royal Tenenbaums*, Margot writes a play titled *The Levinsons in the Trees*; the idea of characters living in trees is central to *Fantastic Mr. Fox*, and a treehouse figures in *Moonrise Kingdom*. In interviews, Anderson said he wasn't entirely sure where the treehouse obsession came from, but noted that he has long been fascinated by Johann David Wyss's 1812 novel *The Swiss Family Robinson*, about a family that gets wrecked in the East Indies and builds a number of structures, including a treehouse, to survive. The 1971 Walt Disney film version of the novel, which Anderson saw and loved as a boy, makes the treehouse a central location.

**** Anderson could not pinpoint the exact moment when he sat for this interview in August 2010, but during a 2012 interview for *Moonrise Kingdom*, he did (see page 312).

DIGNAN COMES IN FRAME—
HANDHELD moves backwards
in front of him.
CROSSES IN ON RIGHT,
CROSSES OUT ON RIGHT.

FOLLOW HIM UNTIL
HE DUCKS INTO THE STUDY.

JUMP TO:
BOOM IN HANDHELD AS
HE GETS BEHIND DESK.

CUBISM.

PULLS OPEN A
DRAWER— see it's
got pens, rubber bands,
SMALL ITEMS.

JUMP TO:
NEXT DRAWER, FLIPS,
PULLS OF JUNK: "COINS."
"SILVER QUARTERS,
1922 - 1951."

SILVER
QUARTERS
etc.

SETS ON DESK.

OPENS.

ANTHONY CROSSES IN.
follow him tight — don't
PAN like before — MOVE.
GRABS THIS. THAT. THAT.
CROSSES OUT. FOLLOW FAST
(MOVE TO HERE. GO HERE.
GO HERE. CROSS OUT.)

CROSS INTO FRAME
JUMP TO: (more consistent move.)
FOLLOWING HIM IN TIGHT.
FAST DOWN THE HALL. HE
LOOKS QUICK IN ONE ROOM.
(we look in.) DUCKS IN
ANOTHER ACROSS HALL.
(we go in.) KA-CASH.

RIFLING AMONG CLOTHES.
GRABBING OUT THE MONEY.
MOVES OUT PAST CAMERA.
(BAGGING MONEY.)

ONE BEAT.

COMES IN GRABS
DISCMAN. WATCH.
BAGS IT.
MOVE IN W/HIM TO
THIS:

as he grabs watch.

ONE BEAT.

DISCMAN & HEADPHONES
IN CU AS HE CUTS BACK
TOWARD CAMERA. FROM
PLACE WHERE WATCH WAS
AND GRABS.
(deep focus, low angle.)

ONE BEAT.

THESE SHOULD ACTUALLY
probably MATCH — make a pattern
OF JUMP CUTS — see ANTH plus
detail: ITEMS HE TAKES

FULL SHOT CATCHES
HIM AS HE DISAPPEARS
OUT THE DOOR.

one beat.

DIGNAN JUMPS COUCH,
GRABS OFF SHELF & COMES
TOWARD US,
CROSSES OUT.

CROSSES INTO
MASTER BEDROOM.
GRABS OFF TABLE
AS WE MOVE W/HIM—
WHIP PAN SHOWS
ROOM AS HE CROSSES
TO BOOKSHELF.

COMES TO SHELVES-SCANS.

(behind camera.)

SCAN SHELVES W/HAND.
MOVE DOWN ALSO.

SPINS AROUND (shelves
behind him) LOOKS AT
ROOM. LOOKS ANOTHER,
SEES. BOOM IN. CUT TO:
(staring at it.)

HAND OPENS JEWELRY
BOX.
(higher angle- clarity
of value of stuff.)
MOVE IN SLOWLY.
OPEN BOX SLOWLY.

HIGH-ANGLE. HEAD ON CENTERED.
Catch anthony crossing
into frame in hall, pull
into room (change in light—
he looks up, MOVING.)
coming out of darkness.

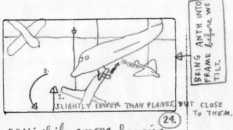

BRING ANTH INTO
FRAME before we
TILT.

SLIGHTLY LOWER THAN PLANES, BUT CLOSE
TO THEM.

POV: slide among hanging
well-painted model planes.

use low-
hanging crashing
plane to make
tilt

SMOOTH
TILT DOWN AS ANTH
~~moves deep in crosses into~~
~~CROSSES INTO~~ FRAME.

GRABS: (see grabbing in 24.)

SEE WHOLE ROOM WHEN WE TILT

GRABS ELECTRONIC FOOTBALL.

ANTH W/BACK TO CAMERA
TAKING FOOTBALL TURNS
& CROSSES. OUT.

comes in frame, grabs a trophy of
moves right.→ a runner.

his move from
here ... to the trophy
is one motion.

You met Owen Wilson at UT, right?

Yep.

Do you remember the first time you met him?

More or less. We were in a playwriting class together, but we didn't really meet in the class. I do remember when he came up to me one day in a corridor of a building in the English department. I think it's called Benedict. We were signing up for classes for the next semester, and he started asking me to help him figure out what he should do, as if we knew each other. As if we had ever spoken before or knew each other's names. I almost feel like he was taking it for granted that if we didn't know each other yet, soon we would. And we had a mutual friend who was Owen's roommate in military school and happened to be one of my friends from high school, which neither of us quite grasped yet. Owen and I met up again later that day, and he had already kind of put it together.

When did you get it into your head to make a movie?

I'd read Spike Lee's book about the making of *She's Gotta Have It*. I read that one, and I read one about Steven Soderbergh making *sex, lies, and videotape*, and there was something about the Coen brothers

going to dentists to raise funds, and something about a limited partnership and how that seemed to be the way you do it. Limited partnership, whatever that means. I was very intent on it. I started meeting people, several different people, who talked about investing. Who knew if any of these people actually had any money? There was one guy who did. He was a producer in Austin who had funded part of a movie, and I met with him. But I had a script that didn't make any sense, really.

Can you describe it?

It was one of those movies where you say, "It's about this guy . . ." There wasn't really a story. It was more of a portrait. I don't really even remember. The first script I really tried to do properly was *Bottle Rocket*, which Owen and I worked on together. There were various incarnations of that.

Did you write it as a short-film script first, or was it always a feature?

We wrote it as a feature.

What year was this?

1990, maybe? We started shooting in 1992, I want to say. When we made the short, we felt we were

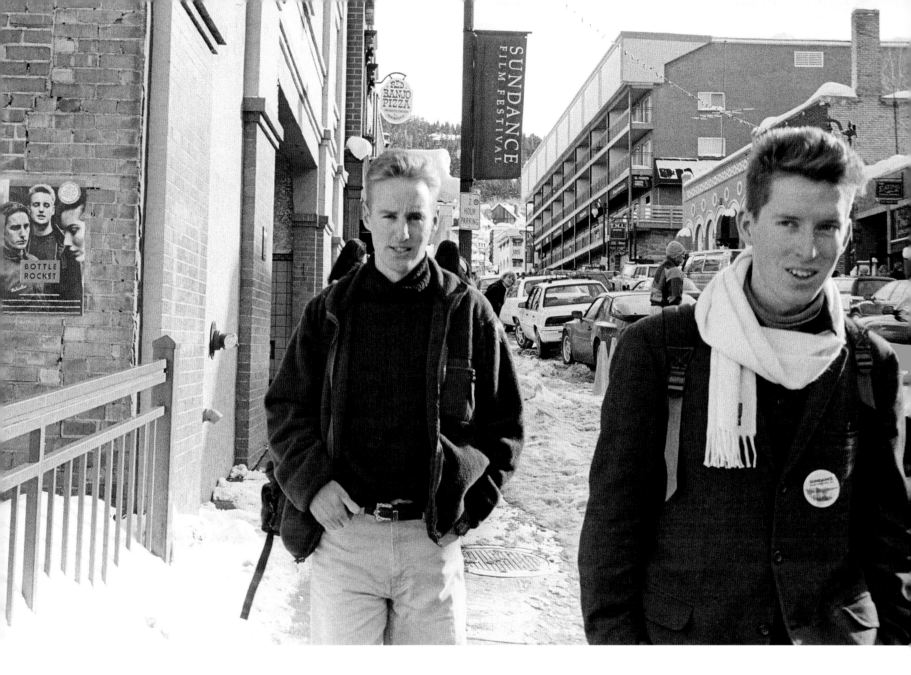

ABOVE AND OPPOSITE: Anderson and
Owen Wilson at Sundance in Provo, Utah,
1993. Photographs by Laura Wilson.

making installments of the feature. We only had
so much to work with at a time. We shot for two
and a half days, and then three days.

**Why did you shoot the first installment in Dallas as opposed to
Austin?**

In Austin we had started working on the script,
or part of the script. Then we finished school.
I graduated from there, and Owen sort of just
ended it for himself. And he said I should come
to Dallas and work for his brother Andrew, who
was going to be in charge of some aspects of his
father's business. And I became Andrew's helper.
Andrew introduced me to different guys. Andrew
was doing a lot of different documentary-type
sort of advertising stuff—I guess you would call
them industrials. He and I went to a lot of dif-
ferent places together, and Andrew and his col-
laborators ended up being the people who helped
us make the short. So Dallas was the place.
 Jim Brooks had a name for the place we were
all living in. A "flop." That was what he called it.
He'd say, "They live in a one-bedroom flop."

What neighborhood was it?

It was a street called Throckmorton. A terrible,
terrible place. At a certain point we had me,

Owen, Andrew, and Bob Musgrave—and
sometimes Luke—in this one apartment. There
were three rooms, but there was actually only one
official bedroom.

So it was like the stateroom sequence in *A Night at the Opera*.

Well, technically, there was enough room for
everybody, but it wasn't a well-kept quarters. It
was unhygienic. And nobody thinks back fondly
on those days. Not that we weren't happy, but it
was sort of a difficult time. Andrew was support-
ing everyone. He was the only one who really had
any money. We were all trying to get it figured out.
 We did auditions behind that apartment. Bob
auditioned in the parking lot. Owen wanted to put
him into the movie. So we had Bob audition, and
it didn't go well at all. And we had another friend
who happened to be there, and so we had him
audition, too, and he was a little bit better, and
we thought, "Well, maybe we'll just have the other
friend do this."
 But then Bob watched *that* audition—which
is actually quite cruel, having an actor audition
in front of somebody else who already auditioned
for that part, but we didn't have any sense of this,
that you don't have people audition in front of
each other—and Bob saw the other guy do it, and
he said, "Can I try again?" And Bob did it again

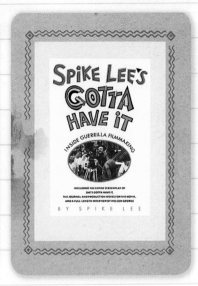

TOP ROW, FROM LEFT TO RIGHT: *David Holzman's Diary* (1967), directed by Jim McBride and written by and starring L. M. "Kit" Carson, who later helped produce *Bottle Rocket* the feature; *Pieces of Time*, a collection of film historian–raconteur turned director Peter Bogdanovich's writing about movies; *sex, lies, and videotape*, writer-director Steven Soderbergh's account of getting the 1989 film made; Spike Lee's making-of book on his 1986 debut feature, *She's Gotta Have It.*

MIDDLE ROW: *The Catcher in the Rye*, an influence on many early Anderson films; Frank Herbert's *Dune* (1965), a precursor to the world-building sci-fi fantasy *Star Wars.*

BOTTOM ROW: *The Art of Star Wars* (see pages 38–40); the cover of the August 21, 1989, issue of the *New Yorker*, which contained Pauline Kael's review of *Casualties of War*, a piece that had a profound impact on many young film buffs, including Wes Anderson and the book's author; the cover of the March 29, 1976, issue featured Saul Steinberg's vision of what the world looks like to a New Yorker—a mentality playfully endorsed by *The Royal Tenenbaums.*

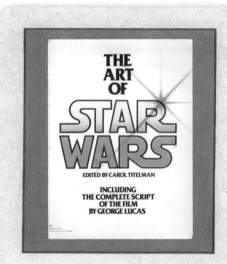
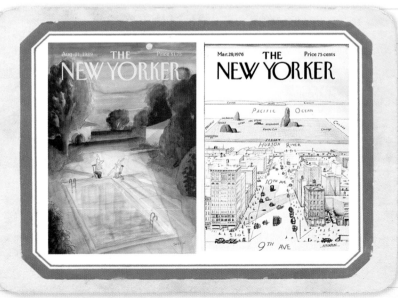

perfectly. And we said, "Oh! OK, Bob after all." That was the artistic process.

That's not the normal audition protocol.

No. But we were figuring everything out. We were in the process of figuring out that it was going to be a comedy. And even though it may seem like just a small part of the film, once we figured out that Kumar was going to be the safecracker, we said, "Ahh . . . so *that's* what the movie is. If that's the case, a lot of other things are going to be required. And a lot of other things are impossible."

Kumar Pallana being the proprietor of Cosmic Cup, the coffee shop you guys used to hang out in.

Yep.

So this is a classic first film, where somebody asks, "Who's in it?" and your answer is, "Everyone we know who is an actor of any kind."

Not very many actors, actually.

If they can behave anywhere close to naturally on camera, they're in the movie.

Yep. And you know, Kumar's son Dipak is in *Bottle Rocket*, and he's also in *Rushmore*, and he's in *The Royal Tenenbaums*. He has a scene with Gene Hackman. It wasn't so much, "Who do we know who's an actor?" It was, "Who do we know? Who do we know who's an interesting, memorable person we love—and is willing to do this?" It was more about geographical radius. Cosmic Cup was three blocks away from our apartment.

Did you get a break on coffee and pastries at least?

I'm sure we did. Although I don't think it was ever their habit to *give* it away.

Did you have a plan—and I guess I should put quotes around the word "plan"—for where all this was going? You shot the short, and it was what, twelve or thirteen minutes?

The first part was eight minutes. Then we shot more, and we cut out some of the eight minutes and rearranged it.

I don't remember any safecracking in the short I saw.

No, that came after. I don't think we cast Kumar, mentally, until after we'd done the short.

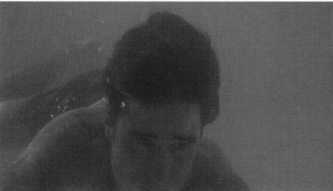

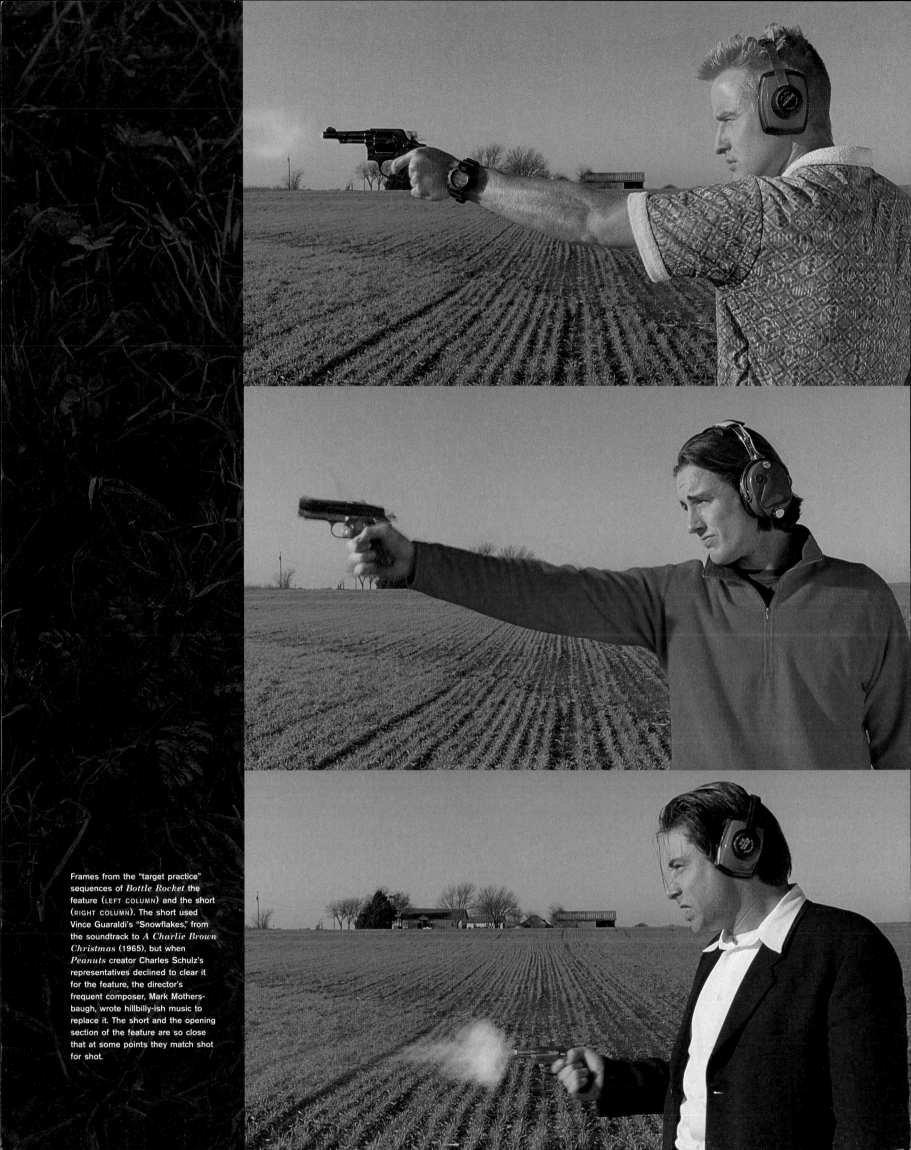

Frames from the "target practice" sequences of *Bottle Rocket* the feature (LEFT COLUMN) and the short (RIGHT COLUMN). The short used Vince Guaraldi's "Snowflakes," from the soundtrack to *A Charlie Brown Christmas* (1965), but when *Peanuts* creator Charles Schulz's representatives declined to clear it for the feature, the director's frequent composer, Mark Mothersbaugh, wrote hillbilly-ish music to replace it. The short and the opening section of the feature are so close that at some points they match shot for shot.

FROM TOP: Bob Musgrave, Lumi Cavazos.

You know, after we made the first section of *Bottle Rocket*, the short, we showed it to Kit Carson, who Owen's father, Bob, knew from public television—Mr. Wilson had been the president of the public television station in Dallas, maybe in the seventies—and then it became "What's Kit's plan?" Kit was the one who got it to this person and that person. He had a sense of what happens next.

Did you know who Kit Carson was as a filmmaker before you met him?

I'd sort of heard of him. I don't remember exactly what I knew about him, but I'd heard of him. I feel like maybe he'd done a Q&A in Austin or something that I'd just missed. But right after I met him, there was a screening of *David Holzman's Diary* at the Dallas Museum of Art, and I saw it and loved it. I thought, "This is really a good movie."

Did Kit have any effect on you as a budding filmmaker? Were there any useful pieces of advice he gave you, any suggestions for films you should see that might prove useful?

He gave us so much advice and so much input I couldn't even begin to know where to start. He was our guide. I don't know if I can think of

movies he turned me on to, exactly. Owen and I were both big movie watchers already. Owen was less interested in movies with subtitles. I showed him really old movies, and he showed me not quite as old movies.

Given your interest in the American films of the sixties and seventies—which in many ways were a continuation of the innovations of fifties and sixties European art cinema—it seems quite a lucky break that you ended up in the same sphere as Kit Carson, who was a pretty hard-core, real part of that scene. He was somebody you would say had indie cred before that was even a term.

Part of what Kit's always done instinctively is find somebody, somebody nobody has ever heard of, and bring them into some circle, introduce them to somebody they'll develop something with. And he was plugged in to Sundance. He'd been involved with Sundance from the beginning of it, and he probably knew Robert Redford before that. We had our short in Sundance, and Owen and I were in a writing lab at Sundance.

Were you in the lab together or separately?

We were there together. We did a writing lab, but it was at a time when they were really doing the directing lab. I feel like we didn't really get in, but somehow Kit convinced them to take us anyway. Everybody else was filming scenes, and we were just there to talk with the mentors.

So it was almost like you were auditing a class?

A bit. We did get the attention of these guys to help us talk about our project, but they didn't say, "OK, now you're ready to go film your scene." Everybody else filmed scenes. We just talked about our script. So somehow we must not have quite made the cut.

Once when you told me about your experience at Sundance, you told me you were in a directing lab. Did you guys do a directing lab at some later date, or—

Oh, it *was* a directing lab. But I probably didn't tell you at the time that we were in the thing. I probably did not choose to *accentuate* the fact that we were kind of second-class citizens. And that was not quite clear to me at first. When we arrived there, I was like, "Oh, so, uh . . . we're not *quite* doing the same thing?" No one explained that to us. We arrived there and it was like, "OK, now you two go over here and talk about your scene while everybody else is doing something a bit different."

What director was your teacher?

They had a bunch of different directors. Jeremy Kagan—do you know who he is?

Yes.

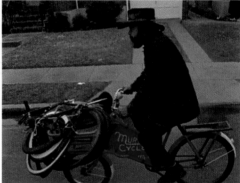

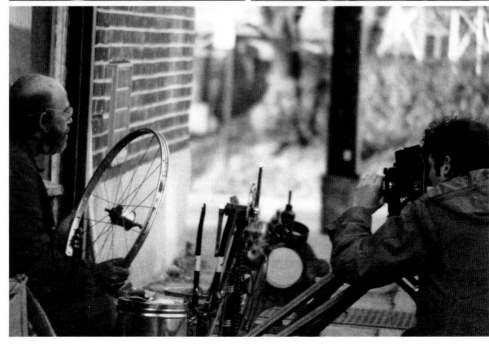

He had a Harvard ring on his finger. Michael Caton-Jones was one of them. He told us, "Your style is very assured, but it's glib. It's shallow." Which for some reason I didn't really resent because he said it in a way where you thought he felt there's room for improvement. Like we might actually improve ourselves. He was extremely nice to us. Frank Oz was there, too. He was very encouraging.

Was the thinking that this would be a standard kind of indie-movie trajectory? Which is: It's a short. It gets developed into a feature. You get the money to make it into a feature using the short as an example of what the feature might look like. You produce the feature independently, and then, at the end of the process, you try to find a distributor. Was that going to be the road?

No, ours was going to be more, "Let's just keep raising money and keep shooting." *Bottle Rocket* the short wasn't meant to be a short. We always meant to just keep shooting. We were never thinking, "Let's throw out what we've already done and start over from the beginning with more money." We'd already done some of it, and we thought we could just keep going.

So you were hoping to build on what you already had and keep adding sections until it was done?

Yep. We were shooting sections of a script.

You did part one, then maybe you'd do part two, part three, four, five, and then you'd join all the pieces together like Legos.

Yep. It was only when we had the first part at Sundance as a short—or maybe that wasn't it. Maybe we brought the short to the *lab* at Sundance. I'm trying to remember.
 You know, that actually didn't lead to anything, specifically. Sundance. A separate, simultaneous road was being taken. There were some people at Sundance who said, "We want to meet with you about this thing." We had a couple of tiny sparks of interest from somebody wanting to help us, but nothing happened out of Sundance.

At the same time, though, Kit had gone to other producers. Barbara Boyle and Michael Taylor. How it happened was, Kit knew Barbara Boyle, Barbara Boyle knew Polly Platt, and Polly Platt knew Jim Brooks. When that path was complete, the future of the film was decided. The one guy who was actually in a position to say, "Yes, this is going to happen"—well, that guy saw it and read it. And his name was Jim.

I want to take a little detour here and ask you about James L. Brooks because, of course, he's one of the big guys. And yet, when I look at films James L. Brooks has directed, and films he has produced for other filmmakers whom he has mentored, in every single case I can say, "Yes, of course, it makes perfect sense that he would be attracted to this filmmaker." Not so much in your case, though. Except for the gentleness and the dry humor. Visually, in terms of rhythm, the use of music, the camerawork, everything, your work is not Brooksian.

Hmm.

Did James L. Brooks ever tell you, "Wes, here is what I like about your work. Here is what I see in it"?

Well, I think Jim liked the writing. That was why he wanted us to do the movie. He liked the writing, and he liked the cast. "The boys." And he probably thought it would add up to something. I don't know if he *envisioned* the movie. I don't know that he ever pictured what the movie would be like. I think for him it was more, "We'll work on the script. These guys have their way, and it'll be a real movie. It'll be a movie people will go see, a real movie, which will entertain an audience of millions of people who go to a movie theatre and buy tickets." And I suppose it didn't really happen that way. For whatever reason, that just didn't occur. [WES LAUGHS.]

You didn't get into Sundance with *Bottle Rocket* the feature, the Columbia film executive-produced by James L. Brooks, did you?

We didn't get in. And it was kind of like the end of the world. We thought it was a bit of a tragedy for ourselves. I remember at some point Jim wrote

ABOVE: Anderson and Owen Wilson lunch at a restaurant in Provo, Utah, during Sundance, 1993. Photograph by Laura Wilson.

OPPOSITE ABOVE: Casting *Bottle Rocket* at a kitchen table in Dallas, Texas. Anderson and Owen Wilson cross-compare Polaroids with a Richard Avedon book. Photograph by Laura Wilson.

OPPOSITE BELOW: Owen and Luke Wilson and Wes Anderson in the kitchen in Dallas, Texas. Photograph by Laura Wilson.

OVERLEAF: Owen Wilson and Wes Anderson at Sundance, 1993. Photograph by Laura Wilson.

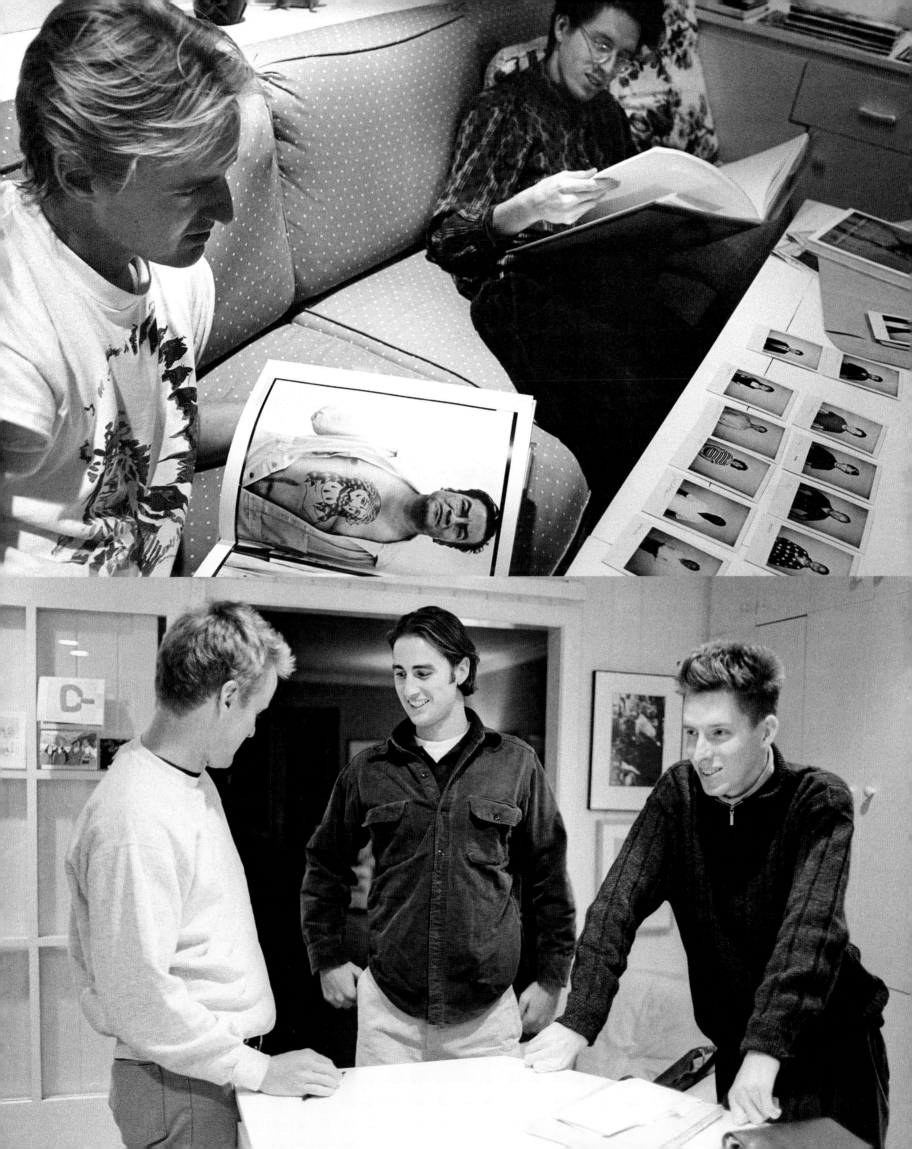

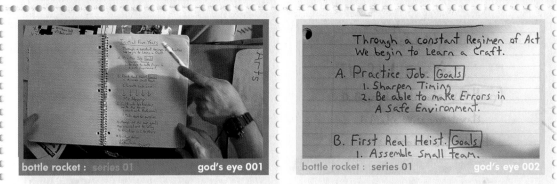

bottle rocket : series 01 god's eye 001

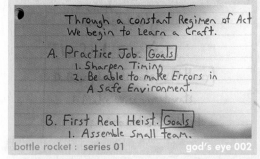

bottle rocket : series 01 god's eye 002

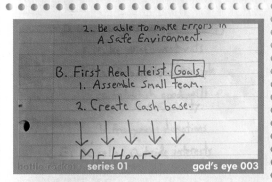

series 01 god's eye 003

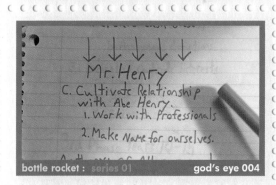

bottle rocket : series 01 god's eye 004

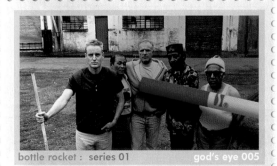

bottle rocket : series 01 god's eye 005

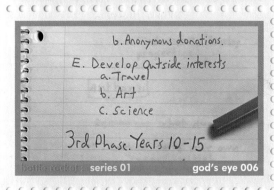

bottle rocket : series 01 god's eye 006

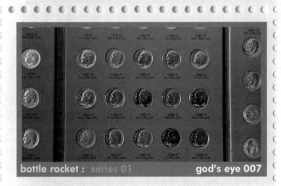

bottle rocket : series 01 god's eye 007

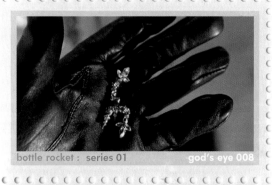

bottle rocket : series 01 god's eye 008

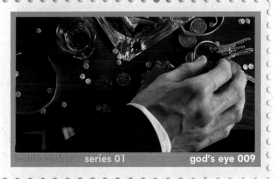

series 01 god's eye 009

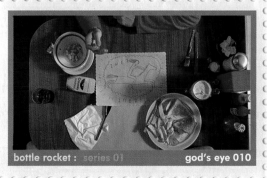

bottle rocket : series 01 god's eye 010

God's-eye-view shots are an Anderson signature dating back to *Bottle Rocket*. The perpendicular angles and tight framing recall similar inserts in Martin Scorsese's films, but the feeling is different; it's as if the scene has taken a brief time-out to let the viewer admire objects that define people. (1–6): Dignan explains his seventy-five-year plan to Anthony. (7–8): Inserts from the opening "heist" of Anthony's mother's house. (9): A close-up of Bob retrieving his car keys. Note the shot glass and pre-Watergate ashtray. (10): An overhead view of the diner table where Anthony and Dignan discuss how to handle Future Man's arrest.

OPPOSITE: Wes Anderson's soundtrack wish list for *Bottle Rocket*, the feature, with catalog information. Note that The Rolling Stones' "2000 Man"—parts of which did end up in *Bottle Rocket*—is crossed out.

ARTIE SHAW, "THE CHANT" from FREE FOR ALL. ← CBS RECORDS / PORTRAIT RECORDS RK 44090
previously EE 22023

SONNY ROLLINS, "OLD DEVIL MOON" a night at the village vanguard BLUE NOTE CDP 7 46517 2

CHET BAKER / ART PEPPER, "THE ROUTE" capitol / pacific jazz CDP 7 92931 2

VINCE GUARLDI TRIO, "SKATING"
"LINUS & LUCY"
"CHRISTMASTIME IS HERE"
"HARK THE HERALD ANGELS SING"
a charlie brown christmas
FANTASY
FCD 8431-2

HORACE SILVER TRIO / ART BLAKEY, "NOTHING BUT THE SOUL" blue note CDP 7 81520 2

MILES DAVIS, "SUR L'AUTOROUTE" soundtrack to L'ESCALIER POUR L'ECHAFAUD.

DJANGO REINHARDT / STEPHANE GRAPPELLY
w/ the quintet of the hot club of france
"UNDECIDED"
(vocalist: BERYL DAVIS.)
album: SOUVENIRS,
LONDON
820 591-2
DECCA RECORD CO.

MARIA BETHANIA / E GAL COSTA, "SONHU MEU" ←
album BELEZA TROPICAL
FLYISIRE RECORDS CO.
9/25805-2 warner bros

proclaimers.
CHRYSALIS
RECORDS
VK 41602
DIDX 4628

THE PROCLAIMERS, "OVER AND DONE WITH"
album:
THIS IS THE STORY

ALMIR GUINETO, "CAXAMBU" ←
BRAZIL CLASSICS 2 O SAMBA
LUAKA BOP / SIRE RECORDS
9 26019-2 W.BROS

DEXTER GORDON, "BROADWAY" ←
album OUR MAN IN PARIS.
BLUE NOTE 7/46394/2
CDP

VAN MORRISON, "BALLERINA" album ASTRAL WEEKS warner bros 1768-2
"DON'T LOOK BACK" best of van morrison 2

THE VELVET UNDERGROUND, "EUROPEAN SON"
& NICO
verve
polygram records
823 290-2

THE ROLLING STONES, "2000 MAN." album her majesty's satanic request.

mr. charlie's
motel w/ maids
bob's house - classical
mr henry's - classical
- swinging

mexican bar

→ ANTHONY death of swirly.
ULTRATIGHT CLOSEUPS:
→ ANTHONY W/ SOLDIERS.
→ DIGNAN: "YES, IT'S TRUE."
→ ANTHONY POST SLAP.
→ ANTHONY END OF JAIL.
→ ANTHONY first eye contact
w/ INEZ.

about Sundance and kind of took them to task for not seeing what it was. And I must say, that was something we appreciated. Frankly, we love Jim.

This is a perfect segue into what *Bottle Rocket* is. I remember Kit Carson and Polly Platt both telling me, independently, that they thought it was Salinger-esque. They both compared it to *The Catcher in the Rye*. I don't remember you ever framing it in quite those terms. But when the short, or the first section, or whatever we want to call it, was in the USA Film Festival lineup very early on, I remember being struck by it. It was just sitting there in a pile of screener tapes for the shorts program. It jumped out at me. And now I wonder, looking back, were you all just flying by the seat of your pants? Did you have a conscious design? To what extent was your aesthetic worked out? When I look at the black-and-white short, and for that matter the color feature, I don't think it's the "Wes Anderson style" quite yet, but there's a lot of it already in place.

Are you wondering if we knew in advance how we would do it?

Yes. Why does the movie look this way? Why are the performances in this tone? These are hard things to ask an artist to define.

The performances are those guys saying the lines. The tone comes mostly from the writing, I think. It's the writing and the casting. The

visuals? Well, I always have the same approach, which is, "Maybe it should be like this." [WES HOLDS HANDS IN FRONT OF FACE AND SHAPES FINGERS INTO A RECTANGLE.] It's not very conceptual. It's like, "I think maybe this is the lens? And this is the shot? And this is the angle? This is the feeling?"

I don't want to pull a James Lipton on you here, but I watched *Bottle Rocket* the feature with my daughter, who's in eighth grade. It was the only one of your movies she hadn't seen. She had an interesting reaction to it. She said, "I like it, but it doesn't quite feel like a Wes Anderson movie yet."

[WES SHRUGS.]

But at the same time, while watching the feature again for the first time in a while, I did notice a lot of Wes Anderson firsts—the appearances of certain moves or shots or touches that people would later think of as signatures. *Bottle Rocket* has the first Wes Anderson 90-degree whip pan. I believe it's in the scene where they're on the bus and you whip pan between them and the driver.

Hmm.

And your first emotionally expressive use of slow motion.

At the end of the movie.

Anderson at Sundance. Photograph by Laura Wilson.

OPPOSITE: Frames from the first Scorsese-style lateral whip pan in a Wes Anderson feature, from the bus sequence in *Bottle Rocket,* in which Dignan tells Anthony about his seventy-five-year plan.

BELOW, LEFT: Bob Musgrave in front of Hinckley Cold Storage, a real location that as of this writing is the Texas Ice House.

BELOW, TOP TO BOTTOM: Luke Wilson with Shea Fowler; the original insert in the bookstore robbery; the frame that Columbia made Anderson replace it with.

OPPOSITE: Luke Wilson and Wes Anderson with James Caan on set.

And you've got your silent montages with music, which of course is not a new or unheard-of way to do a montage, but I must say it's an awfully seventies way to do a montage. It's not the eighties way, where you hear the dialogue and sound effects in each shot, which has sort of become the default montage format.

Hmm.

And I believe the font Futura makes its first appearance in *Bottle Rocket* as well, doesn't it?

I believe you're right.
 We did have a montage we thought up after we finished shooting, which we should have gone back and gotten. We had an idea for a great montage about them training for their robbery, and we had stunts with them doing jumps. I can't remember what else was in it. I remember we had the Volkswagen van going over a ramp that was not very high, and doing a test-driving thing. We had several gags. It was potentially a very good montage. But we thought it up too late.

Every movie a filmmaker makes comes from a personal place, or at the very least it reminds them of where they were and who they were when they made the movie. What personal associations does *Bottle Rocket* call up?

Well, we had the Stoneleigh Hotel in Dallas, where we stayed during production, and the Stoneleigh P restaurant across the street from

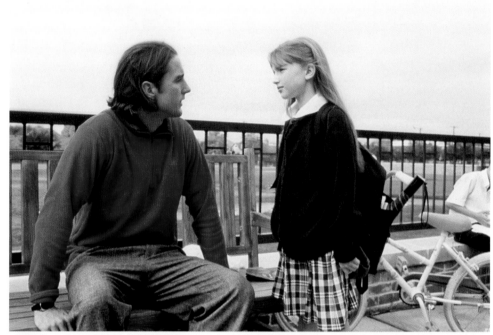

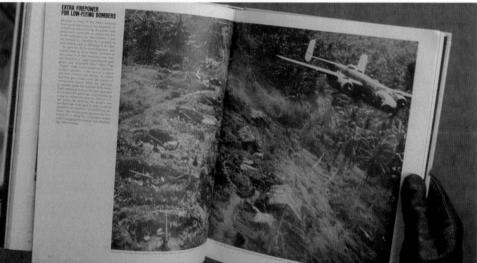

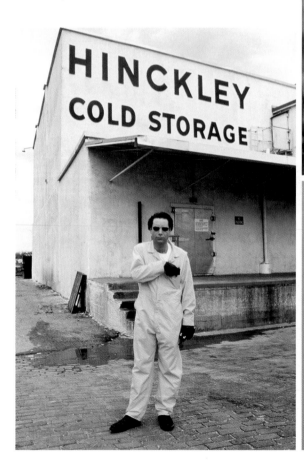

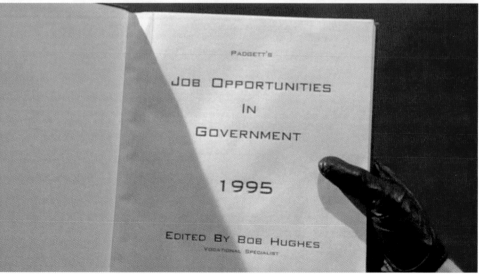

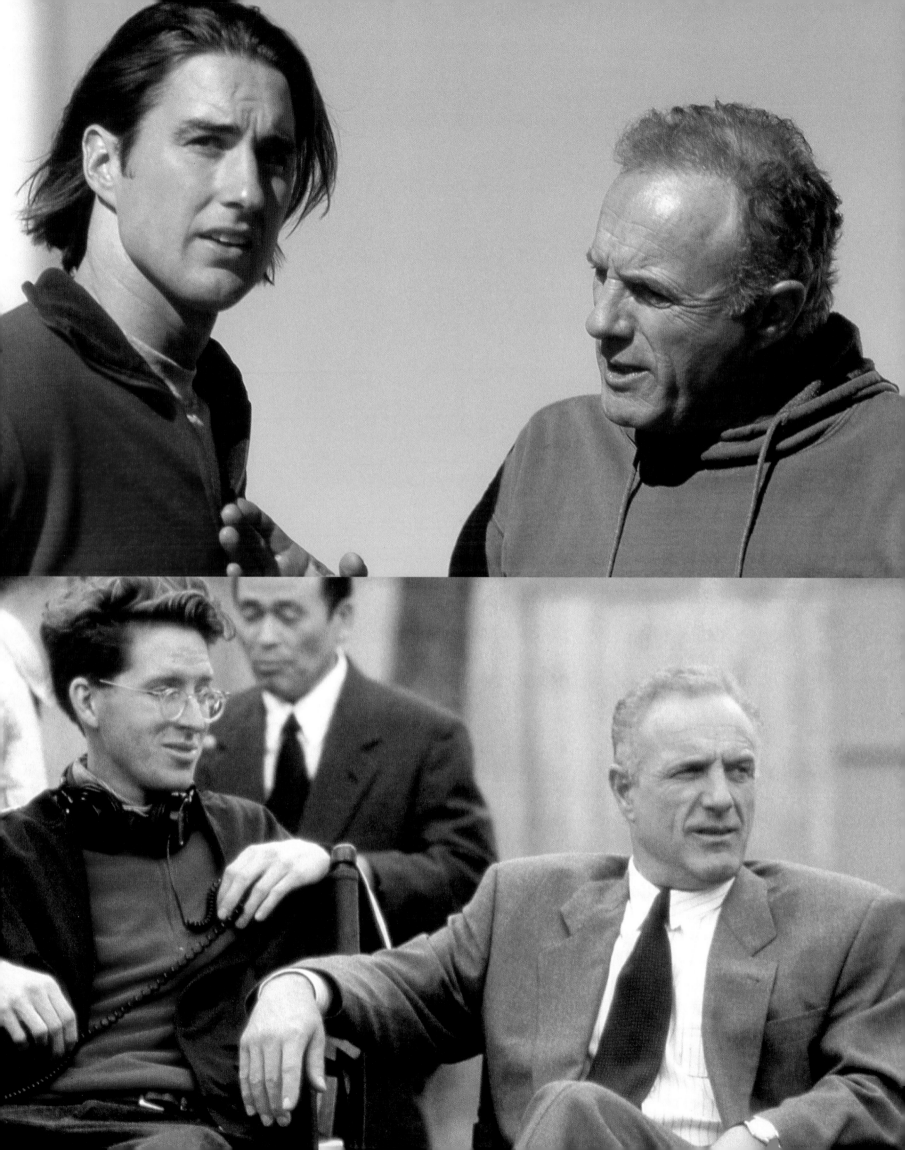

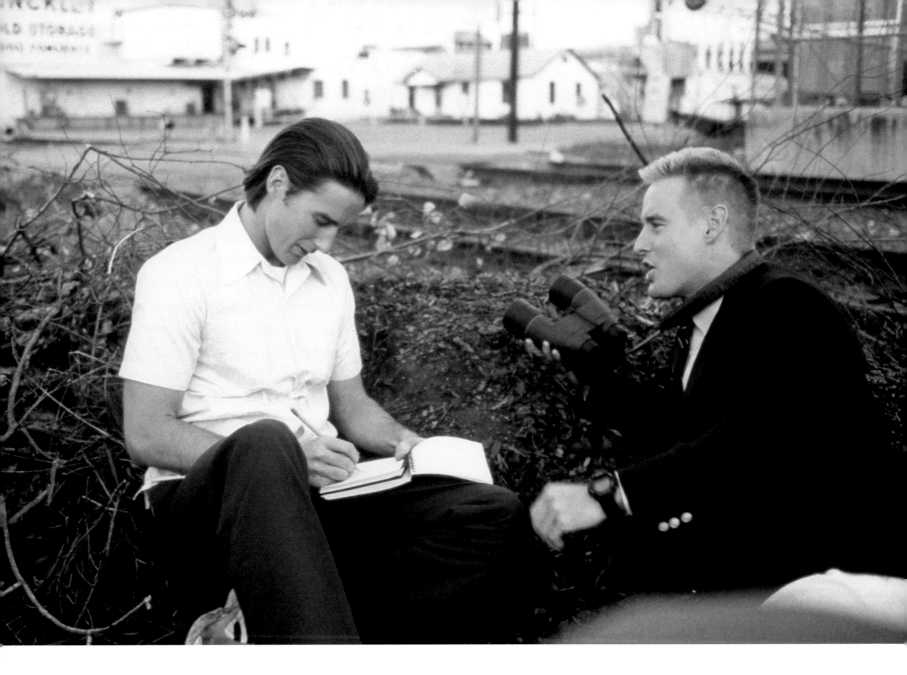

it. And then we had all these places where we shot the movie. We spent a lot of time in this motel in Hillsboro, Texas, an hour from Dallas. We lived there during that period. And then the postproduction was done in a not-very-exciting place in Brentwood or something.

I remember we had this one insert you liked. It was an insert, in the bookstore robbery sequence, of a book with a World War II airplane, where Luke flips open a book and it's like a Time-Life war book, and he's looking at it. It's about strafing or something. And I remember I showed you the movie, and you saw that image, and you laughed! And you reacted! And at that point it had already been determined that the shot was going to have to be changed because it didn't mean anything. We redid the shot so that the book he flips open is titled *Job Opportunities in Government*. That was not what we originally had in mind. We were going for something a bit more abstract.

The incongruity of the original was what amused me.

The book in the original insert shot was the kind of book that an eleven-year-old might love. It kind of connected to the character's childlike quality. I think for the Criterion Collection release we put the old shot back in.

The other thing about that *Job Opportunities in Government* book was, we really didn't make a proper prop. If you study it, you can see it's not a good prop. We printed it out on a laser printer.

But anyway, where were we?

Every movie is a documentary.

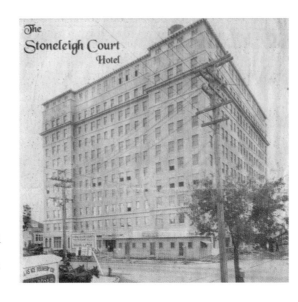

ABOVE: Dignan scopes out Hinckley Cold Storage while Anthony draws a flip book of a pole-vaulter.

BELOW: A promotional image for the Stoneleigh Court Hotel, where the cast and crew stayed during production.

OPPOSITE ABOVE: The Lawn Wranglers, a.k.a. Owen Wilson, Takayuki Kubota, James Caan, Jim Ponds, and Kumar Pallana. Photograph by Laura Wilson.

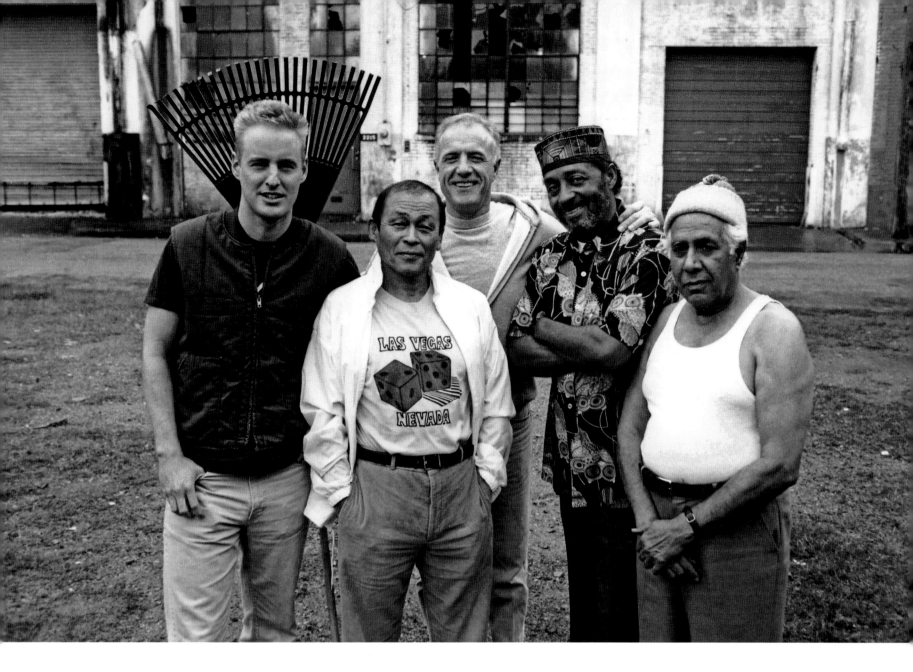

Like a Godard thing.*****

What is this movie a documentary of?

A lot of it was our attempt to capture what we felt we were experiencing right then. It's one of those films where the people in the movie were the same people it was semi-about right at that moment in time.

One can also see the film as a cautionary tale before the fact. If you look at the story, Mr. Henry equals Hollywood, and he robs these young guys blind.

Hmm.

And it's a story about some young guys who desperately need guidance, who need role models. And they pick the wrong guy. Yet at the same time, they kind of don't, because at the end of the story, in some way, they've all gotten what they needed from the experience.

Yep, it's definitely something like that. And it's also kind of like they're a little family doing their project together—even though, if you look at their project, it really doesn't make any sense.

You originally wanted to shoot _Bottle Rocket_ the feature in anamorphic widescreen, didn't you? And the test footage ended up on the DVD. Didn't you originally want to shoot it in black and white, as well?

Yep.

Why?

It seemed like a good idea at the time. The short is in black and white. We had color stock—we actually had some short ends in color, which we already owned in a refrigerator—but we decided to use most of our budget to buy the black-and-white stock. And I don't even know what, exactly, our reasoning was.

But in retrospect I think it was probably the right choice for the short, because in the feature we could do things with the colors, we could change things, we could paint things, we could _choose_ things. With the short, we had none of those privileges. It was, "OK, we're only allowed to be in this place for one hour, so let's go."

Black and white can be very helpful for a film to make it whatever the word _stylized_ means. A little less like reality. It's very helpful for that.

Are there moments where you watch the movie and think, "Geez, I wish I could have had one more day on that"? Or, "That was a bad idea. What were we thinking?"

***** Jean-Luc Godard's exact quote is, "Every film is a documentary of its actors." But a quote by another filmmaker, Jacques Rivette, applies here, too: "Every film is a documentary of its own making."

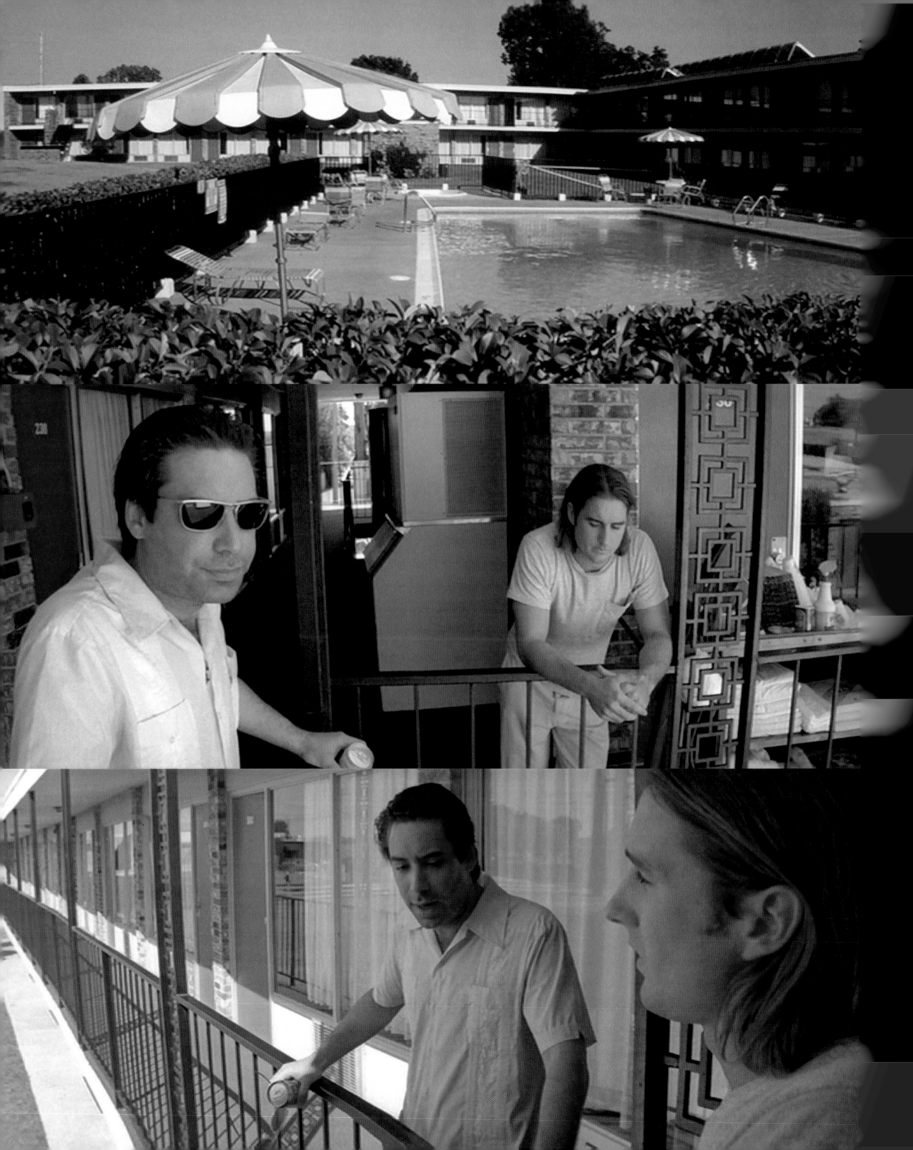

For every film I feel some of that. Places where we spent a lot of time trying to fix something that went wrong or never got right, something we couldn't use because it turned out so badly, and we had to figure out a way to make the movie work without it. I feel like every time you go into the editing room, you think it's going to come together, and you find it has to be forced.

Every time?

More or less.

I think of your movies as being carefully constructed. I'm sure the phenomenon you describe is something every filmmaker confronts to some degree, but "How the hell are we going to make a movie out of this?" is not a question I ever pictured you obsessing over, at least not to the same extent as filmmakers with a different working process, directors who shoot more wildly than you and who don't block as much or do as many long takes.

For me, it's more about putting together the individual pieces of a scene. There are many times when I go into the editing room to deal with a particular scene, and I already know, "The best takes for this scene were take seven of this angle, take three of this angle, and take two of this other angle." But the problem is, we only shot three angles for the whole scene. So you piece the best takes together however you piece them together, and you think, "Well, this seems to do it."

And then you put the whole movie together, and it's another matter. It's another issue. You start saying, "I do like walking him across here, and then bringing him over like that, but I think it's better if we just start the scene after we've already brought him over, and cut out all that other stuff."

Also, if I look at all the movies I've done, the thing I most often think is, "I probably could stand to let that shot breathe a bit. I might have erred on the side of cutting it too tight." But I'm sure a lot of people would disagree with that and say, "That was one of the most boring movies I've ever seen. I can't imagine you would want to lengthen it."

I remember a phone conversation we had sometime around 1998 or '99, after you made *Rushmore* but before *The Royal Tenenbaums*. We were talking about a notable movie that was out around that time and that was quite long, and you said, "Matt, if I ever make a movie where the running time doesn't have a nine in front of it, you'll know there's something wrong with me."

Well, I was probably right to say that. And then the next movie I did was a hundred!

What's the most gratifying reaction you got to *Bottle Rocket*, either from a critic or from another person?

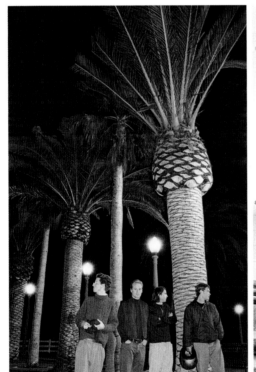

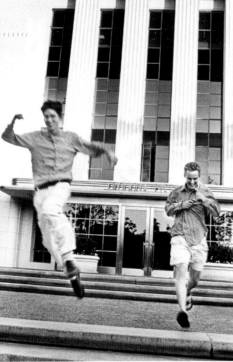

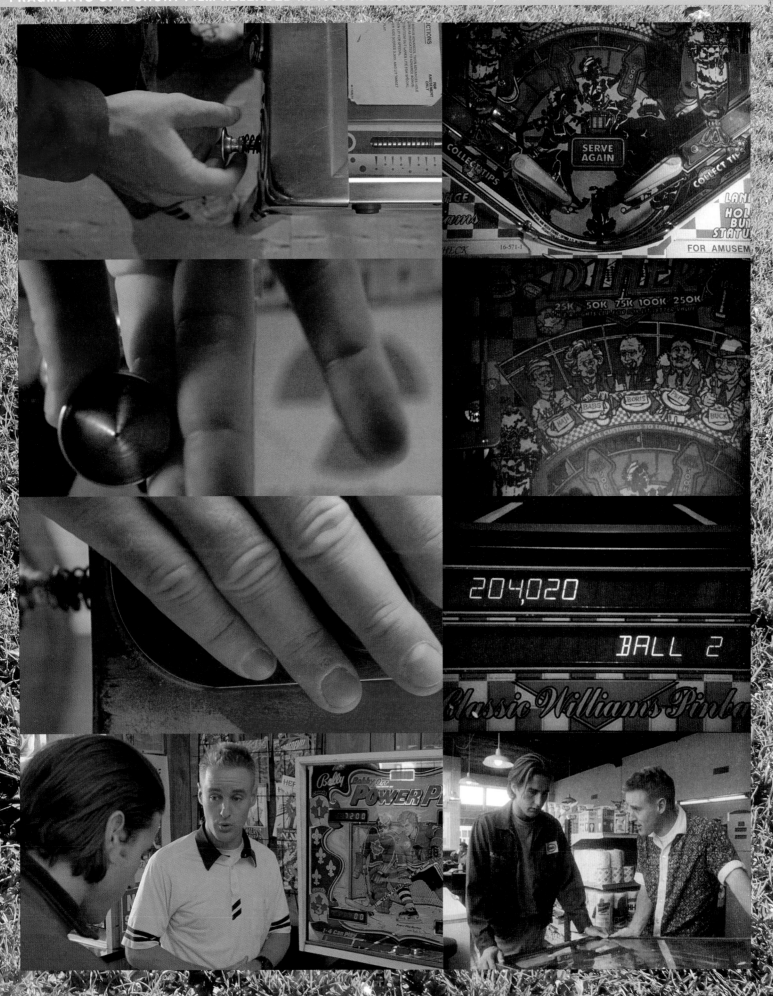

Los Angeles Times

23 inches; 792 words WEDNESDAY FEBRUARY 21, 1996, CALENDAR, PART F, PAGE 1 000015703
COPYRIGHT 1996 / LOS ANGELES TIMES FAX page #1

The Gang That Couldn't Shoot, or Think, Straight

■ Movie review: 'Bottle Rocket's' earnest characters would be shocked to find out how funny they are.

By KENNETH TURAN
TIMES FILM CRITIC

"Bottle Rocket" has just what its characters lack: an exact sense of itself. A confident, eccentric debut about a trio of shambling and guileless friends who become the Candides of crime, "Rocket" feels particularly refreshing because it never compromises on its delicate deadpan sensibility. Unlike most lost generation tales, this one never loses its way.

Inexplicably, almost criminally turned down by the Sundance Film Festival, "Bottle Rocket" is especially exciting because it was put together by a core group of under-30s all of whom are new to features. Director Wes Anderson co-wrote the script with his friend Owen C. Wilson, who, in very much of a family affair, co-stars with his brothers Luke and Andrew.

"Bottle Rocket" is likewise a story of the limits and strengths of friendship and other relationships. It generously invites us into the dim-bulb world of a gang that can't think straight, where daft self-delusion can always find a home and reality has only a limited appeal. A world whose always-in-earnest characters would be shocked to find out how funny they are.

Anthony (Luke Wilson) and Dignan (Owen C. Wilson) are best friends in their 20s who are searching for a handle on life, though searching may be too strenuous a word for how they go about things. Anthony, the quieter, more apologetic of the two, is a wistful romantic who's just been hospitalized for what is euphemistically called exhaustion. His younger sister is hardly fooled. "You haven't worked a day in your life," she points out. "How can you be exhausted?"

Nominally more directed but in truth just as clueless is Dignan, who has as much juice as the Energizer bunny but no real idea of what to do with it. A high-intensity motor-mouth given to writing out plans for the next 75 years of his life, Dignan is desperate to be the head of a crack criminal team.

The only trouble is, the only people he has to work with are himself and his equally goofball friends. Terribly sincere and insecure, always concerned about whose feelings have been hurt, these earnest misfits are not the most promising material for a life outside the law.

Anthony and Dignan hook up with the equally disaffected Bob (Robert Musgrave), a timid soul abandoned by his wealthy parents and terrorized by his older brother Futureman (Andrew Wilson). Bob gets to join the gang because he's the only one they know who has access to the essential getaway car.

The kind of team the word "misadventure" was invented for, the boys are to serious criminals what bottle rockets (a slang term for cheap, unimpressive fireworks) are to real explosives. After pulling a few desultory jobs, they flee to an isolated motel to "lie low until the heat cools down." There they meet one of the only people in the film to have a true sense of direction.

Her name is Inez ("Like Water for Chocolate's" Lumi Cavazos) and she's an immigrant from Paraguay who works as one of the motel's housekeepers. Though Inez speaks no English, Anthony instantly falls wholly in love ("It's just so unexpected," he marvels) to the point where he's helping Inez make beds while a threatened Dignan grouses about his friend's flabby commitment to a life of crime.

Also directed is the man Dignan idolizes, the enigmatic, all-knowing Mr. Henry (James Caan). Head of a grounds-keeping organization called the Lawn Wranglers by day, Mr. Henry runs an erratic crew of career criminals by night, and being accepted as one of his cohorts is Dignan's ultimate fantasy.

With these two versions of purposeful reality to choose from, the question is not only which one Anthony will select, but whether he can bring himself to choose anything. "You're like paper," Inez accurately tells him through the good offices of a dishwasher/translator, "flying here and there."

Though "Bottle Rocket" is wryly amusing from beginning to end, the hard edges of the real world are never too far from its surface. And it is the particular grace of the film that though all its characters end up with something like what they're looking for, its not exactly how they'd imagined it would be. And getting it doesn't prevent them from staying delusional to the end.

A cracked coming-of-age movie merged with a comic caper, the kind of flip side to "Heat" that the Italian "Big Deal on Madonna Street" was to "Rififi," "Bottle Rocket" at times seems reminiscent of any number of things, including Donald Westlake's wonderful Dortmunder mystery novels "Bank Shot" and "The Hot Rock."

But, not surprisingly, what is finally special about this film is its singularity, the ways it does not seem quite like anything else. Starting life as a short film that was accepted at Sundance, "Bottle Rocket" found a patron in executive producer James L. Brooks, who recognized in this gentle comedy of alienation and its cures a unique cinematic voice. Here's hoping there are others out there this fresh and this bright.

* MPAA rating: R, for language. Times guidelines: one armed robbery, but otherwise a gentle film.

(BEGIN TEXT OF INFOBOX / INFOGRAPHIC)
'Bottle Rocket'
 Luke Wilson: Anthony
 Owen C. Wilson: Dignan
 Robert Musgrave: Bob
 Andrew Wilson: Futureman

OPPOSITE: A comparison of frames from the pinball machine bit in *Bottle Rocket*, the feature and the short.

TOP: A *Los Angeles Times* review of the feature from Wes's archive.

BELOW: A scene from François Truffaut's *The 400 Blows* that inspired the images on the opposite page.

BOTTOM: Anderson directs Bob Musgrave and Owen Wilson in the prison scene.

It was from Jim Brooks.

I should preface this by saying that cutting the movie was complicated. We had very bad test screenings. And when the movie was finished, we didn't get into any festivals.

Any festivals? Really?

We didn't get into Sundance. We didn't get into Telluride. We didn't get into New York. I don't remember what other festivals we tried to enter it in, but those were the big ones, the ones we were really hoping for. And we didn't get in.

That must have knocked the wind out of you.

Well, the whole thing was a disaster.

Especially considering it had all been a bit of a Cinderella story up to that point.

By then, the Cinderella story was long over. Once we screened the movie for an audience and eighty-five people walked out, we knew the coach was about to turn back into a pumpkin, if that's the right legend for the metaphor. At that point, the studio decided there wasn't going to be a premiere, because they didn't want to waste any more money on it.

But then Jim arranged for us to have a little screening on the Columbia lot and invite people who had worked on the movie, and his friends and our friends, and just make the best of it. It was a very good screening. These people wanted to like it—and they sort of did. We had other screenings where the audience, perhaps, was not right for the movie. And in fairness, it was never a movie that could have played that broadly. It was odd, and it just didn't work for a lot of people. Well, Jim really liked it. When he watched it during that screening on the lot, he was no longer in the mode of "How can we fix this? How can we help it?" And I just remember his reaction that day. He told me, "It's well directed," which he never said something like that before. I'll remember that one. Anyway, the movie was done, and Jim was happy with the thing itself.

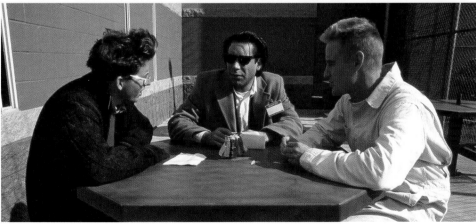

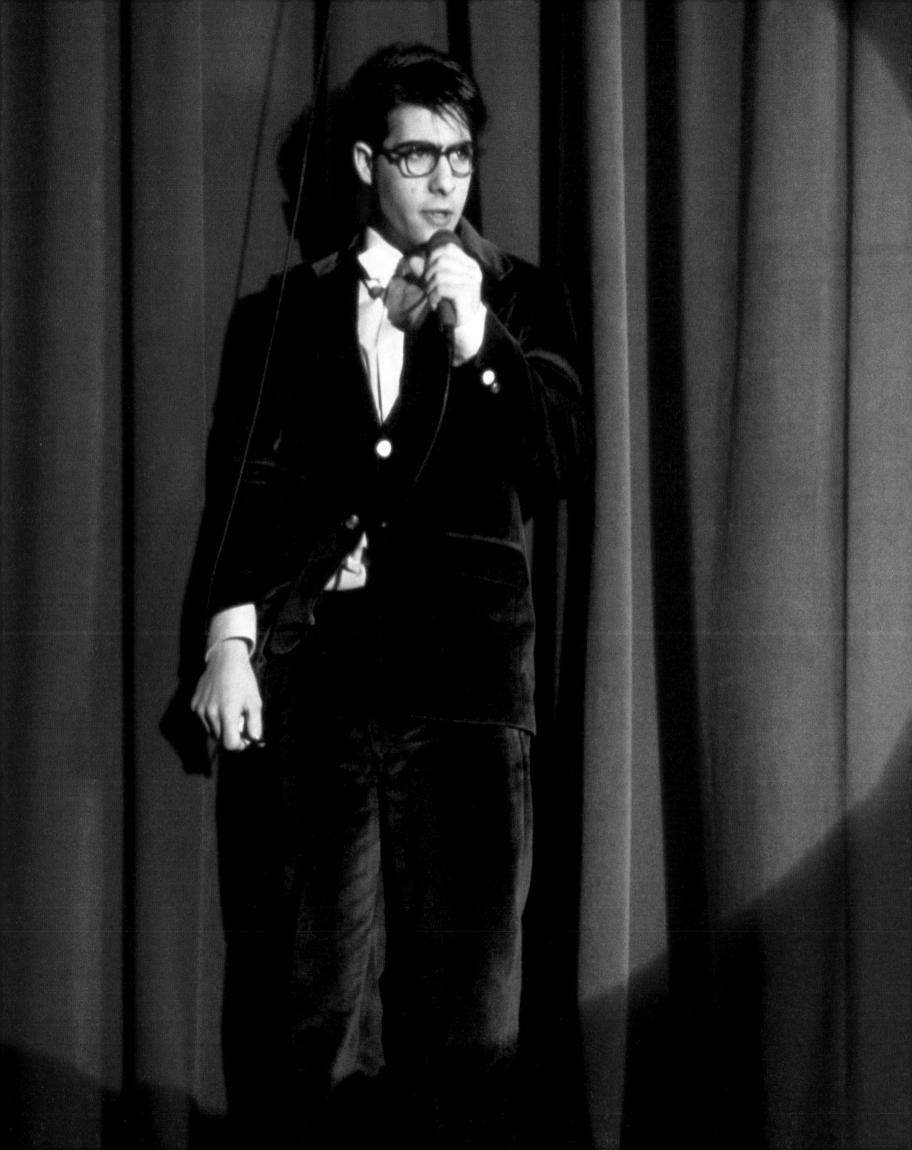

RUSHMORE

The 1,190–Word Essay

THERE ARE FEW perfect films; *Rushmore* is one of them. From the instant the Touchstone logo floats from screen right to screen left, backed by Mark Mothersbaugh's jaunty, plucked-violin score, the movie creates an aura of sly enchantment. Photographed by Robert Yeoman in anamorphic widescreen (the first Wes Anderson picture shot in that format), *Rushmore* is at once arch and earnest, knowing and innocent. From the playful on-screen captions in the yearbook sequence ("Debate Team Captain") to the chapter-heralding curtains that make it seem as though you're seeing a film by the movie's hero, self-styled high school theater impresario Max Fischer, it's jam-packed with artifice and foregrounds most of it; yet the sum feels singular and furiously alive.

Cowritten with Anderson's former University of Austin classmate and frequent leading man Owen Wilson, the movie stars newcomer Jason Schwartzman as Max, a high schooler whose brilliance, narcissism, creativity, and yearning are very Andersonian. Max is a working-class scholarship student at a private academy. He tells everyone that his widowed father (Seymour Cassel) is a neurosurgeon, but he's really a barber. (This is one of countless *Peanuts* references scattered throughout Anderson's filmography; both Charlie Brown's and his creator Charles Schulz's dads were barbers, and Cassel even has Schulz's crew cut and spectacles.) His grades are the worst in school, but he's the king of extracurricular activities and the boss of the drama crew,

by Matt Zoller Seitz

which mounts elaborately staged rehashes of Max's (and Wilson's and Anderson's) favorite movies. (At one point, Anderson shows us a bit of Max's adaptation of Sidney Lumet's 1973 cop corruption drama, *Serpico,* with Max and his pimply classmates posturing like seventies tough guys in a mock-up loft apartment with a tiny elevated train clattering through the background.) The character is a borderline parody of the supercompetent iconoclast jerk heroes who defined Hollywood in the Tom Cruise–Robin Williams–Bill Murray–dominated eighties and nineties, but Max's youthful gawkiness makes him more endearing than annoying. Nobody takes him as seriously as Max takes himself. He's so forceful and intense in telling everyone How Things Are Going to Be that each pipsqueak demand only confirms that his life is defined by powerlessness. When Rushmore Academy's headmaster (Brian Cox) informs Max that his grades are too poor for graduation, he replies, "If that means I have to stay on for a postgraduate year, then so be it." The headmaster's reply—that they don't offer one—barely fazes him. It's as if he believed that by proclaiming that something existed, he could make it so. And why wouldn't he believe it? He's Max Fischer.

Max's mother died when he was very young, and he writes all his plays on a typewriter that she gave him. It seems hilariously right when the movie reveals that Max's home is located next door to the cemetery where his mother is buried. His whole life is a state of extended mourning; he distracts himself from it by playing father and mother to his airless little world. His fake-mature posturing and mania for control make horribly perfect sense. Of course he'd birth plays, clubs, and an aquarium project, and order the Max Fischer Players around like unruly offspring who live to serve a visionary dad. And of course he'd court a young teacher, Rosemary Cross (Olivia Williams), who lost her husband, the heroic ocean explorer Edward Appleby.

Rosemary is not just a crush object for Max. She's a replacement for the mom who was taken from him. From the patient way she responds to Max's Joe Cool patter, it's clear that he fills a void in Rosemary as well. The hyperverbal geek with his five zillion projects is at once the dynamic young love that Rosemary lost (the Jacques Cousteau book that she donated to the library leads him straight to her, as if Edward Appleby's ghost were playing matchmaker) and the gifted son she never got to have.

Max and Rosemary's thwarted not-quite-love-story becomes a triangle when cuckolded steel magnate Herman Blume, whom Max ropes into funding an aquarium to impress Rosemary, falls for the teacher. The casting of Bill Murray (in the first of many Anderson collaborations) is a masterstroke, and not just because Murray's hangdog expressions complement Schwartzman's goofy intensity. Take away *Rushmore*'s intuitive belief that bravado is a cover for fear and depression, and Max becomes a half-pint version of the sorts of characters Murray played throughout his early film career. Herman's defeated moon-map face could be the secret self that previous Murray comic heroes hid from the world: the crying-on-the-inside kind of clown that the star sarcastically joked about in *Quick Change.*

Herman and Rosemary's affair drives Max into a feud with Herman that destroys the tycoon's wobbly marriage and lands Max

in jail. Its peak is a montage of vicious attacks scored to the Who's "A Quick One While He's Away"—one of many sixties and early seventies English rock songs on *Rushmore*'s soundtrack that infuse a mostly melancholy comedy with the buzz of hormones in turmoil. The tunes make Max's teenage impulsiveness, Rosemary's job-endangering recklessness, and Herman's middle-aged breakdown seem like different versions of the same internal chaos—the soundtrack for a collective lashing out against fate.

As in *Bottle Rocket* and their third writing collaboration, *The Royal Tenenbaums,* Anderson and Wilson avoid Hollywood deck stacking. They don't start out demanding that we adore Max simply because he's the main character, nor do they indulge in the usual feel-good Hollywood plot mechanics capped by an eleventh-hour conversion of Max into a boring saint. His evolution feels natural but not inevitable. We knew Max had potential for growth from the moment he tried to impress Rosemary by saving Rushmore's Latin program (Latin is a dead language; by bringing back Latin, Max is resurrecting the dead). Over time, Max excavates his own goodness without quite realizing he's doing it. His maturation is the result of an artist listening to his heart instead of his ego.

His generous impulses flower in the film's second half. Battered and humiliated, he mellows without softening, correcting and apologizing for his lies and using his art to reach out and heal rather than continuing to glorify his own cleverness. Staging the most ambitious play in his new school's history, a Vietnam epic, Max reaches out to a shy classmate and age-appropriate love interest,

Margaret Yang (Sara Tanaka); recruits his old Rushmore tormentor, Magnus Buchan (Stephen McCole), to play a plum supporting role ("I always wanted to be in one of your fuckin' plays," Magnus admits); and dedicates the production to both his late mother and Edward Appleby. Herman, a Vietnam veteran, is so moved he weeps. *Rushmore*'s postplay final shot—a dreamy, slow-motion tribute to the pre-pageant dance in *A Charlie Brown Christmas*—finds all of the film's significant characters paired off in unexpected configurations, dancing to the Faces' "Ooh La La." It's an embracing, humble, joyous end to a tale whose hero started out an alienated, selfish, angry person. It is as if Max had remembered his opening come-on to Rosemary Cross and thought about what it actually meant: "*Sic transit gloria.* Glory fades."

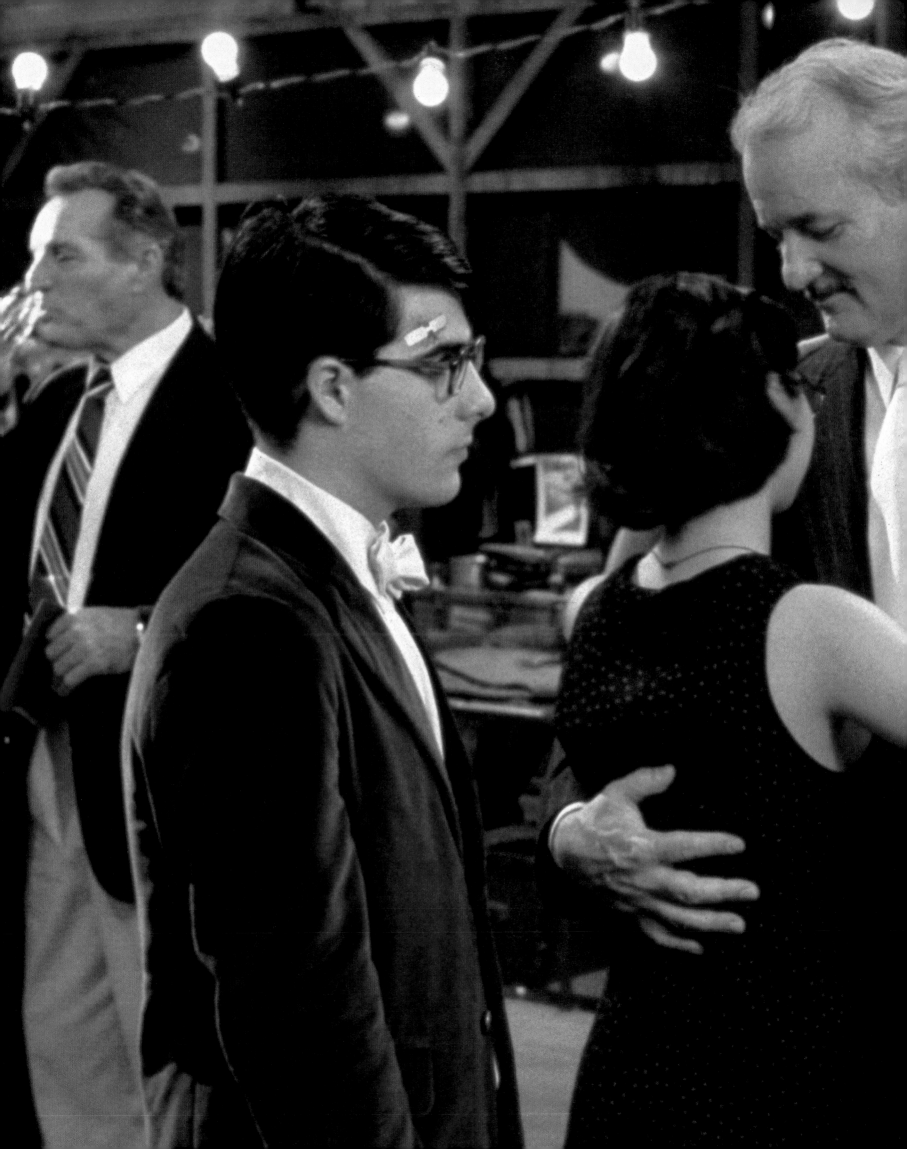

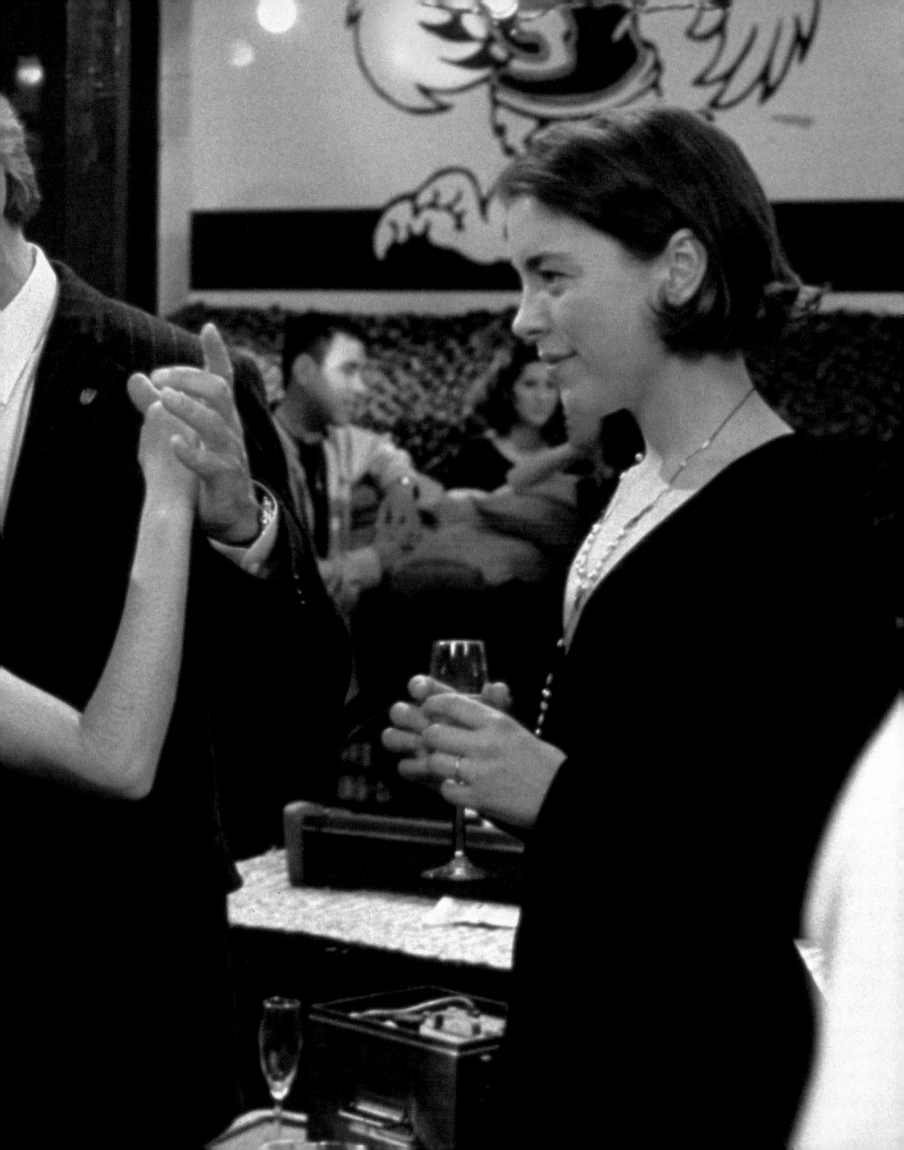

ST. JOHN'S SCHOOL

Wes Anderson attended this Houston private academy and later shot *Rushmore* there.

THE MONOPOLY GUY

Rich Uncle Pennybags, the "Monopoly guy," was not a direct inspiration for Herman Blume, but the character definitely has a 1920s industrialist vibe.

ST. MARK'S

Owen Wilson got kicked out of this Dallas private school and went to Thomas Jefferson, a public high school that became a model for the fictional Grover Cleveland.

LAMAR HIGH SCHOOL

Lamar doubled for *Rushmore*'s Grover Cleveland. As St. John's and Lamar are located directly across the street from each other, Anderson could have shown Max leaving his old school and crossing the street to enroll at his new one, if he'd wanted to.

HANS HOLBEIN THE ELDER

Hans Holbein the Elder was a Bavarian-born German who painted richly textured religious art in a style that transitioned between Gothic and Renaissance. His work influenced the look of Rushmore (1998). Shown here is *Presentation of Christ in the Temple*.

AGNOLO BRONZINO

The work of Agnolo Bronzino, an Italian Renaissance painter, was also a source of visual inspiration for *Rushmore*. Shown here is *Lodovico Capponi*.

RUSHMORE

The 9,446-Word Interview

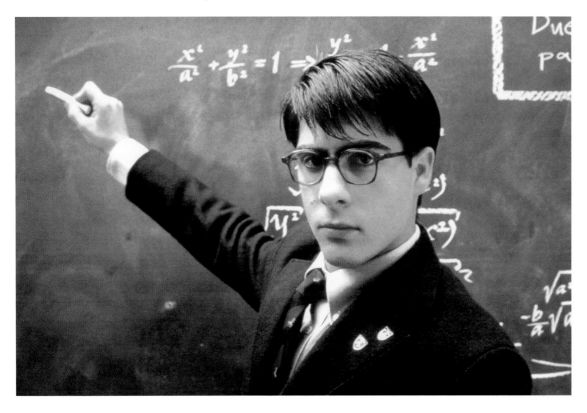

ABOVE: Max solves "The Hardest Geometry Problem in the World" . . . in his imagination.

BELOW: A frame from *Rushmore:* Max Fischer visiting Herman Blume in his office at the steel mill.

MATT ZOLLER SEITZ: I became aware of the movie that would later become *Rushmore* when I was having lunch with you in New York sometime after *Bottle Rocket* came out and I asked you what you were doing next. I think we were in a diner or something. And you said, "The next movie is going to be called The Tycoon. The Ty-*coon.*"

WES ANDERSON: [LAUGHS.] Oh, really? Interesting.

Yeah. Where does *The Tycoon* come from?

I have no recollection of that. I—was that referring to Bill Murray's character?

I don't know. I would say so, yeah.

And maybe a combination of him *and* Jason Schwartzman's character. Maybe it was a sort of way of these two—he's the tycoon of the school or something. Kind of a funny word, tycoon.

It seemed a very Monopoly kind of word. In fact, Bill Murray, in his own modern way in that movie, reminds me a little of the guy on the Monopoly box.

Well, he sells steel.

With his steel mill behind him, with the sparks flying.

It was originally supposed to be concrete. But in Houston we found this place that makes steel pipe that was our best option. It was a good location. It was this huge room where they made these giant steel pipes, and we built his office on stilts in it. That was the first set I ever had—the first time I had to build a set, it was Bill Murray's office.

When did this idea originate? Did you and Owen Wilson come up with it together?

Owen and I together came up with what the movie is. For years, I wanted to do what we always called "the school movie." I had wanted to do a school movie for a long time, because I remembered that in my applications for film school you had to send these treatments, and one of them was *Bottle Rocket*, which we had already been working on, and the other was for this thing. And I think I may have even had one of the next two—I can't remember. I did have a little thing that was a description of what became *The Life Aquatic,* which Owen had always encouraged me to do something with.

So *Rushmore* is an idea that predated *Bottle Rocket*. This is one of the movies you hoped to make one day.

It predated the making of *Bottle Rocket,* yep.

Were you a Max Fischer sort of student? Did you get good grades, or were you all about the—

No, I had good grades up to a certain point, and then I didn't have good grades later. The last couple of years of high school, I had pretty bad grades. I always felt like I was never a very good student. I was never a strong or a disciplined student. And I never had great grades. Even when I was doing my best, I never had great grades. But I did plays. The idea of Max putting on the plays was from my own experience. But his character is a combination of things from Owen's life and mine, though mostly it's from our imagination.

Owen got kicked out of a school at one point.

He got kicked out of St. Mark's.

There's so much in the movie that's about this guy who is not really of this milieu, of the prep school.

Yep.

He's trying not only to fit in but also to be the best example of the Rushmore spirit that ever walked on campus.

Yep. A Rushmore that may have once existed but certainly isn't there anymore.

And there's also a sense in which he seems to be playacting not just adulthood but almost a kind of movie-hero version of adulthood, the way that he carries himself.

Yep.

And the way that he talks to other people.

I could see that.

Were there any other projects you were trying to get made in addition to *Rushmore*? I mean, is this one of these cases where I ask, "Why did you make this next?" and the answer is, "Because we got the money for it"?

No, I only ever had one thing at a time anyway, so it was just the next one. Maybe we had a couple of flirtations, where somebody would say, "Do you want to do this thing or that thing?" But this was the one I wanted to do, the next movie I was going to direct, and that was what I was working on.

You had a lot of the people who worked on *Bottle Rocket* work on *Rushmore* as well. I have to assume you clicked as a unit.

Yep.

Can you tell me about some of the main people on the team?

Well, in terms of behind-the-camera people, there was Bob Yeoman, who was the cinematographer on *Bottle Rocket*. We had a very good time with him. I really like Bob, and I've worked with him ever since, really. For *Fantastic Mr. Fox* we used different technology—it's all miniatures—so I had different people on that, but I've worked with Bob ever since *Bottle Rocket*. When we were doing reshoots on *Bottle Rocket,* our soundman—his name is Pawel Wdowczak—worked with us, and he's worked on everything since. And we had David and Sandy Wasco, who I worked with for a number of years. And Karen Patch, the costume designer—we did three movies together. And, gosh, I don't know who else. I'm sure lots of people.

MAX
FISCHER

OPPOSITE: A frame from the *Rushmore* trailer. The annotations do not appear in the finished film.

BELOW TOP: A frame from Hal Ashby's 1971 comedy *Harold and Maude* in which Harold (future *Life Aquatic* cast member Bud Cort) talks to his psychiatrist. Note the blocking, similar to that of a scene from *Rushmore* (BOTTOM) in which the headmaster, Dr. Guggenheim (Brian Cox), talks to Max (Jason Schwartzman), but with the screen direction flipped.

How important is it to you that you get along with the people you work with?

You can get a group together on movies and have somebody who just doesn't *get* it. You don't want to have people who are more interested in how it's "normally done." It's just a bit of a drag. And if everybody's excited—they know each other, they're excited to work together, and they *like* it—that's a good atmosphere for me to have on the set. You want the best people, but at the same time I don't know that it adds a lot to the equation to have someone who's unhappy. With an actor, on the other hand, I'm sure it can add a lot. Or a director—you can have a director who's volatile, and that can bring something special to it.

Was there anything you told people when you were about to work on *Rushmore*, or while you were working on *Rushmore*, that would help them to visualize what sort of movie you were making? Even something as simple as a particular adjective or a particular image.

I had some postcards. There was this Bronzino painting that's at the Frick, and these paintings by Hans Holbein the Elder, and there's a color scheme in them.

With *Bottle Rocket* I had Hockneys, and I had photographs, and I had a whole collage all over the wall at the art department—they had all these pictures I had shown them. With *Rushmore* I don't really remember anything like that. You know, I knew the school. I'd gone to the school. So when we were working on the script, I was picturing, "This is in this corner, this is behind the air-conditioning unit, next to the thing here—" And we shot it next to the air-conditioning unit, so the sets were kind of what I already had in my mind. And they wear the uniform that they actually wear at that school: khaki trousers, blue shirt. What Max wears is something different—he has a blazer, he has a tie and those things. We made the insignia, but a lot of it was just there. And when he gets thrown out of the school, he goes to another school, a high school that is actually across the street, where my father went—I kind of knew that school already, too.

Which school was that?

It's called Lamar. We called it Grover Cleveland in the movie. My father went there for a semester or something. He went to a lot of schools.

You mentioned to me before that music had a big influence on the tone, the feeling of this movie. Music itself, and also musicians—particularly musicians.

Well, originally it was all going to be scored to the Kinks. They seemed like kind of a good model. They're in blazers but they're more like sort of lunatics, which is also our character. Eventually, it became more of a British Invasion idea. I had more or less all of the music before we shot it, so we were very close to the music during filming. We timed things to the music on the set and so on. But Mark Mothersbaugh also made music for the movie, and that's just as much a part of it as anything else. The music Mark made completed the movie. It was more than exactly what I was hoping for. It was something that was original to it. The tone of the movie was not there until his music was there.

I remember the first time I saw the movie, at an advance screening. When that Touchstone logo came up and I heard that music, I immediately got a little bit excited, because there was a sense of—I don't know how to describe it, exactly, but it was very childlike and innocent, and yet there was an edge to it, there was a kind of propulsive edge to that music. And there's a lot of that in his score, and particularly the section of the movie where things start to go magnificently wrong for our hero and he brings in those heavy drums.

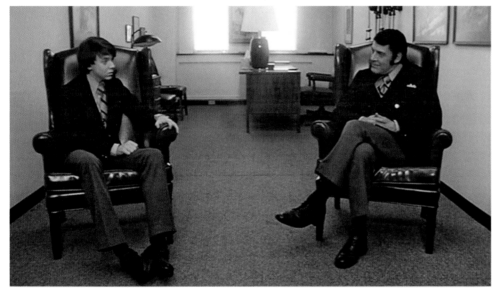

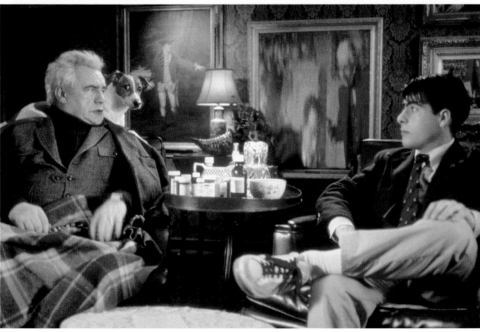

Big drums.

And it sounds like the Celtic army is coming or something.

We found some instruments that gave it a good feeling. There wasn't an orchestra, you know? It was a littler group. It was chamber music, really, and it was all done in his place. It was a very sort of contained operation, and it was a very good experience.

What was it like shooting this movie in your hometown?

The funny thing was, I didn't really see anybody who I knew there. I had a couple of friends who were in the movie, who make different appearances, but I stayed in a hotel. My mother came to the set, my father came to the set, but not very often. I was like part of a visiting movie company. We stayed in a hotel where you couldn't even open the window. It was a sealed thing.

I remember my ten-year high-school reunion happened during the shooting, and I didn't go. We were filming in my actual school itself during the reunion. We had a night shoot during the reunion. But it was nice being back at that school, and there were some teachers who I knew who were still there. The familiarity of the place was good. And my brother Eric was there. He did a making-of documentary.

Did you have any particular type of person in mind when you and Owen were writing Max Fischer? Any type of movie or type of actor or performer?

I always said we needed a fifteen-year-old Mick Jagger, and he was going to be kind of skinny. And also I loved the movie *Flirting*, and the lead actor in that, Noah Taylor, was kind of the model for Max. But who we ended up with was nothing like that, and I think when you're casting, especially when you're casting children or young people, you might as well just throw out what you picture, because you're going to have to pick from people who exist, and there's a lot that goes into that. You just want somebody special, and it's hard to find somebody who's going be the star of the movie—they've got to be sort of spectacular, in one way or another.

How did Jason Schwartzman come to be Max Fischer? And more importantly, what did he bring to this part that was not on the page and that maybe you didn't see coming?

We'd searched for a long, long time. I had a few people in mind, but nobody where I felt like, "Here!" Nobody where I left the room and said, "We got it!" There were a few where I said, "Well . . . maybe *this* one?"

But when Jason arrived, I did have that feeling, just seconds after we started talking. When he did the scene, I thought, "Nobody's done it like *this*." We were kind of friends, immediately. And the thing is, the movie, in the end—well, it's his face and it's his voice. And his personality is

very distinctive. So in the end it's our *words,* but it's *him,* that's what it is. And what you remember when you remember the movie is just as much how he moves when he walks across the room. We did this long search, and we discovered a special person who has every reason in the world to be in the movies.

The two people I occasionally thought of the first time I watched the movie were Dustin Hoffman, because Jason does, from certain angles, look like a teenage Dustin Hoffman, but maybe I'm just thinking that because *The Graduate* is such a presence in *Rushmore.* And also Tom Cruise.

Both of them are actors I thought of. When Jason auditioned, he did a thing where he had to hold an elevator open for somebody, and the way he did it really reminded me of Dustin Hoffman. The way he *moved* reminded me of Dustin Hoffman. And Tom Cruise, in his Vietnam play at the end—

He looks like him!

Yeah, he kind of looks like him. And all of a sudden, he's wearing sunglasses—he's got on his war paint. In the rest of the movie, Jason's wearing glasses and he's got his hair back. He doesn't look like Jason in real life. He's made into some other version of Jason. Thanks to that Vietnam play, we get to see both those versions of Jason.

And also, because the Tom Cruise character, up to a certain point—like, all the way through the eighties and well into the nineties—was the driven, master character, the guy who, even though you didn't have to like him, you had to admit he was *the best*.

Yep.

And I get that quality from Max, except that it's only in his head. There's a helplessness underneath it all. He's hapless. It's Tom Cruise without the mastery. I mean, Max has got the mastery of his craft, which is his saving grace. But the person that people see when they look at Max is not the person Max sees when he looks in the mirror.

I don't know who he sees in the mirror.

Which may be good for him, in the long run.

Yep, maybe. Certainly he would be comfortable playing in *Top Gun*. That character could take on the role. Even if he can't do any of the actual flying.

Was Bill Murray always somebody you wanted?

We wanted Bill. In fact, we had talked about Bill Murray for *Bottle Rocket*. But yeah, he was the guy for *Rushmore*. I had some other ideas for *Rushmore,* because I was resigned to the fact that we weren't going to get him. Everybody just said, "He's too hard. He won't read it. You can't get him." But then, at the last minute, we said, "Let's just try it." I don't know *why* he surfaced. But he did.

OPPOSITE: Frames from *Rushmore* of Max in his nihilistic phase.

THE PERFECT MAX

Rushmore's hero, Max Fischer (Jason Schwartzman, TOP, from his audition tape), and three inspirations for the character's look and attitude: Mick Jagger, Tom Cruise in the eighties (shown here in 1983's *Risky Business*), and Noah Taylor, hero of John Duigan's *Flirting* (1991).

VINYL GALLERY

KINKS 1964
The Kinks circa the mid-1960s influenced both the look and specific energy of *Rushmore*.

DEVO 1977
The new wave band Devo included lead singer Mark Mothersbaugh, later Wes Anderson's frequent composer, and the band's "Gut Feeling" ended up on the *Life Aquatic* soundtrack.

A CHARLIE BROWN CHRISTMAS 1965
Anderson tried to clear some of Vince Guaraldi's music for this TV special for *Bottle Rocket* (1996), and succeeded in *Rushmore* and *The Royal Tenenbaums* (2001).

THE FILMS OF BILL MURRAY
(THE CRYING-ON-THE-INSIDE KIND)

1984

THE RAZOR'S EDGE

1993

GROUNDHOG DAY

1994

ED WOOD

2005

BROKEN FLOWERS

I read an interview with him in *Esquire* recently, and he mentioned you guys—you and the Wilson gang. It was in context of why he chooses movies that would appear on the surface to be uncommercial. And I believe his quote was "I live to go down with those guys that have no fuckin' chance." That was what he said.

[WES LAUGHS.]

That's a pretty honored company to be in: people Bill Murray would go down with on the ship.

I suppose it's not wildly flattering to be thought of as someone who has no chance, but at least he doesn't mean to leave us alone in that.

He was a help during shooting, though, wasn't he?

He was stupendous. We didn't have so much money, and we probably proposed some deal, and I think he said, "Just give me my SAG day rate." So he ended up doing it for *not* $375,000 or something as the reduced price. He ended up doing it for like *nine* thousand dollars.

Jesus.

He did it for zip. He had a good profit participation, but he essentially said, "This is pro bono." And we scheduled him to not take up too much time. He said, "I'm doing it, I'll be there," and it was quick. And he made this deal with us, a deal that helped make the movie possible, and we clicked, you know? He wanted *me* to be happy. That made a big difference, because all of a sudden I've got this movie star, and I don't know him, but I do have some ideas, and it's really up to him whether he wants to hear those. And if he doesn't, if there isn't a good rapport, then it's not going to be that much fun for anybody. He had no reason to be particularly nice to us. He'd never seen *Bottle Rocket*. I don't think he's seen it still. He didn't have any reason to trust me. But he did trust me. I think he trusted me because he thought the script was very clear, and he trusted that. And then we enjoyed each other. I had a great time working with him.

Is the story about him helping you get that helicopter shot apocryphal?

No, that's true! We didn't get the helicopter shot from the studio. He gave me a check. I'm sure it's still in my archives. I didn't cash it yet. But he gave me a check, and he knew that if it was filled in and taken to the bank, that the amount was going to be in the range of twenty-five thousand dollars, which was almost three times what he was paid to do the film, so it was a pretty good contribution. He gave it to me before we finished the movie, which is funny because he gives Jason a check at some point in the story, too. In fact, he gives him twenty-five thousand dollars! No, no, no, he doesn't. Jason wants thirty-five thousand; Bill gives him twenty-five hundred. But he gave *me* twenty-five thousand.

Let's talk about Bill Murray. I know you're a connoisseur of Bill Murray the actor. What are some of the colorations you think he shows us in *Rushmore* that maybe he wasn't getting to show us in other films?

The performances that struck me were in *Mad Dog and Glory, Ed Wood, The Razor's Edge,* and *Groundhog Day.* I mean, I loved him in all the comedies. But there was something different happening in those other movies. He had played these dramatic roles, but in *Mad Dog and Glory,* he's funny, but he's also *scary* in it.

He is. And sad.

And sad.

You're a fan of *The Razor's Edge,* which is a movie very few people have even seen.

And he's great in that. And also that movie's not a comedy at all. That's a dramatic role, but he's funny in it, too, and the fact that he played it with this kind of lightness—you know, he's just very natural in that movie. So I thought, what could be better?

BELOW TOP: Frame of Tom Cruise in *Top Gun* (1986).

BELOW BOTTOM: Frame of Jason Schwartzman in *Rushmore.*

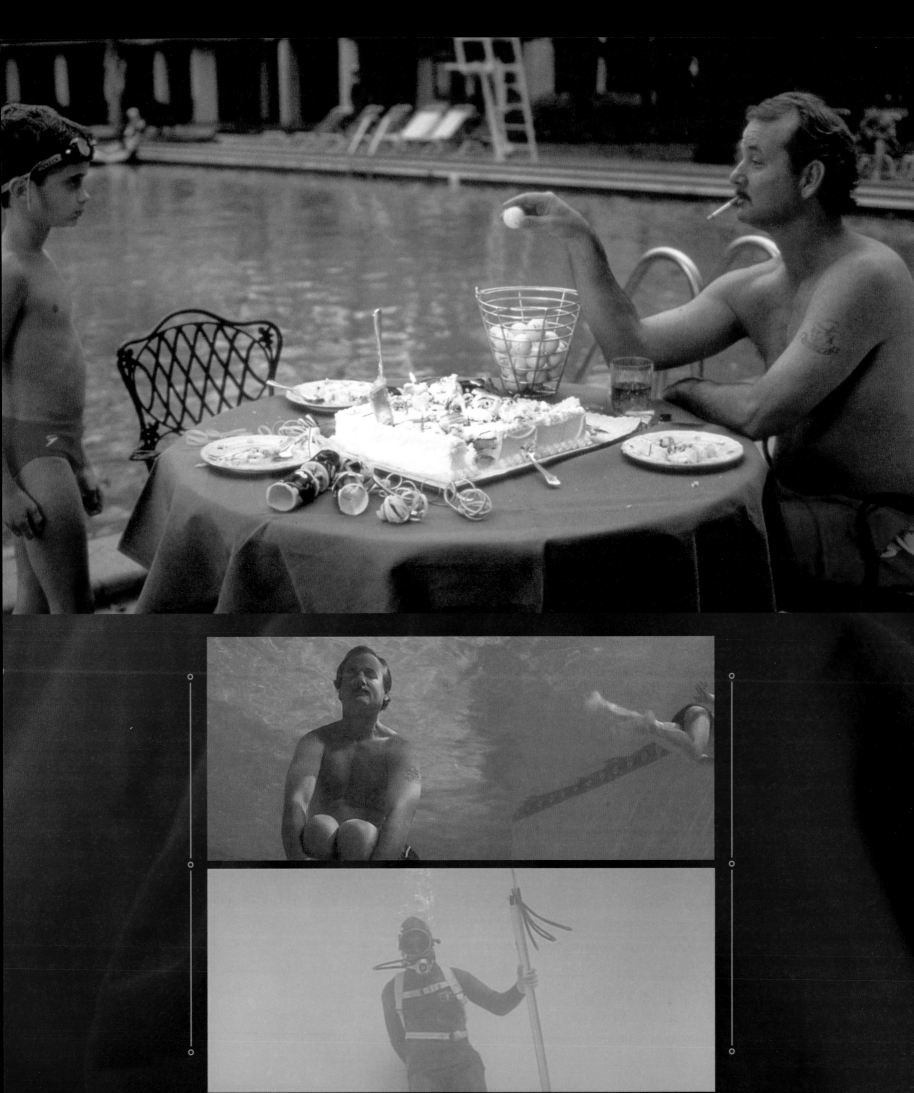

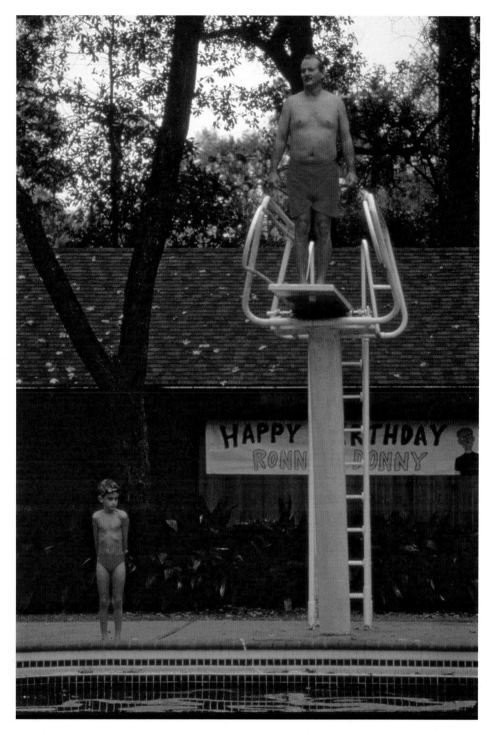

MR. BLUME WITH TWO CIGARETTES

BERT FISCHER

ABOVE AND OPPOSITE: You can detect the influence of Mike Nichols's *The Graduate* (1967) on Anderson's widescreen compositions, sense of humor, and use of pop music to stylize the characters' emotional states (depression, especially). The link is most clear in the *Rushmore* sequence set to the Kinks' "Nothing in This World Can Stop Me Worryin' 'Bout That Girl," which is partly a tribute to the "Sounds of Silence"/"April Come She Will" sequence in *The Graduate*. Intriguingly, there's a shot in the Kinks montage of Herman glaring at a young man that his wife is not so secretly sleeping with; this makes this sequence feel a bit like the *Graduate* sequence as told from the point of view of Mrs. Robinson's cuckolded husband.

This is a movie where you bust out the anamorphic widescreen. What does it do to the image that pleases you?

Well, I think the fact that it's anamorphic is a very subtle thing. The difference between a movie being shot with spherical lenses and cropped—

On Super 35, yeah.

On Super 35 or whatever. They used to do the spaghetti Westerns that way. They had names for cropping the frame to make it widescreen. Techniscope I think is one. Techniscope must've been very grainy, because the image is produced with a regular flat lens, and you're taking a squarish frame and just using a sliver of it. With the old-fashioned film stocks. But with an anamorphic lens, you use the whole negative, more than you use with 1.85. It's the sharpest, and it's also wide, and it does have this strange aspect where, when

you pan, when you move, there's this kind of distortion that happens. The optics are complicated.

It distorts the shape of light, as well.

I guess it does.

It makes the spherical light sources into ovoid shapes.

I think that's right! I think the grains look squeezed and stretched.

There's something that happens with the depth, too, isn't there?

Well, one thing certainly that happens is because you need more light with those lenses, you get less depth of focus—or you need more light to get the same depth of focus. But the wider the lens you use, the less that's an issue. We did those movies using these primo anamorphics in Panavision.

All the movies have the same primo anamor-
phics. There's one that's a forty-millimeter
close focus. They just made that lens right when
Rushmore was happening. It's a good one.

Did you use that lens for most of the movie?

Most of that movie, and all the ones after it,
except for *Mr. Fox* and *Moonrise Kingdom*.

Why the preference for the wide frame?

I guess I just always loved it when I went to movies
and it was bigger. I would rather do a scene
where we don't have to cut, and so maybe we
have three characters in it, and you can frame
it so you can be sort of close to everybody, and it

just encourages something I like. It's sort of an
extreme shape to work with, and it's nice. But I
also love the 1.33 frame.

I remember seeing *Rushmore* for the first time and being
struck by the fact that it was in anamorphic widescreen—and
especially as the film progressed, because *Rushmore* is
overwhelmingly a comedy, and anamorphic widescreen is
not normally used to shoot comedies. And also, the way you
framed the shots, the objects you put in the shots, the texture
of the things, the way they've been lit and photographed—it's
not just like a drama. It's almost more hyperreal, like a Douglas
Sirk or Peter Greenaway level of dreamy unreality. Where does
that fascination come from? Why that look?

Well, there are all these ideas that are precon-
ceived—we're going to have *this* in it, we're going

ABOVE: A CinemaScope-dimension frame (2.35:1) allows for more dramatic use of negative space.

to have *that* in it, and this scene will have *this* mood, and this scene will have *this* light—but I don't really know what it is until we start putting it together, you know? I couldn't describe it. For *The Life Aquatic,* I kind of thought, "Well, here are the colors—the whole movie's going to be these colors." And it sort of is, but I don't really know what that's going to be like in advance.

Is it that enveloping quality that you described earlier, that feeling that it's bigger, it's wider, it's more . . . overwhelming?

You mean why the widescreen?

Yeah. I'm dwelling on this because I think it's really important.

I think, for me, it's about having this big image,

but even when you watch it on an iPod, that shape is just a great shape for telling a story. What is it about it? I guess it's that this is kind of the ideal distance. If you want to be close to these characters, well, you can have three of them together like this [GESTURES WITH HAND, AS IF ARRANGING OBJECTS IN THE AIR], and if you're doing something with a landscape, landscapes are horizontal, so you can expand your landscape and you can put this thing here and this thing here.

So it's about the greater number of options visually?

Maybe so, but mainly it's just—I don't know if I have a very analytical answer. It's more like, "What a wonderful shape to make these pictures in."

I made a list of the first appearances of what I think of as distinctive Wes Anderson touches. The annotations first show up in *Rushmore*. Where does that come from, and what is that all about?

I have very little recollection of where that could have come from. We don't do anything like it in *Bottle Rocket*.

No, you don't.

It only happens in one scene in that movie, right? It's only in the first montage—and then one time later, he has a kite-flying club, and I put that in there, I think.

Yeah.

It's only for this one scene, and I think it was just that I had many different versions of how this information about him being in all these clubs was going to come across. As we were working on the script, I had these different ideas for how I was going to tell that, and then I had this music, and at a certain point, I needed to get a lot of things across—an image of him *doing* the activity, and each one of those was going to be kind of a joke, so we needed that, and the name of his organization, and his role in the organization, and I wanted to get fifteen of those across in sixty-two seconds or something.

So that's a lot of things, and how do you get all that information across? It must have been just in the process of that sort of thinking. You know: "I'll just *write it* up there." The guy I always thought of as the one who puts the words on the screen is Godard—those movies are just filled with words.

They are.

It's a Saul Bass–style way of treating the text. And I guess I've been influenced by those Eames films. There's probably something else, there's probably some key film that I can't remember, and when you bring it up, I'd say, "Yes, I stole it from them."

The close-ups. You use widescreen for close-ups in a very distinctive way a lot of the time. You're facing the characters. It's as if they're looking not quite exactly right at you, but pretty close to it.

It's just shy of a Jonathan Demme.

It is!

Well, I always loved Jonathan Demme—those Jonathan Demme close-ups are the greatest. Those are probably not even widescreen movies. You know, Jonathan Demme started doing this I guess before, or around the time of, *Silence of the Lambs*.

Before that, even. I caught a few of them in earlier films.

Something Wild?

Mm-hmm.

I loved those close-ups. I feel like somebody might say, "This takes me out of it," but I tend not to allow that to stop me. If somebody says, "It takes me out of it," I would tend to say, "Well, we're doing it."

In *Rushmore* we had these curtains with the months projected on them, and my agent (who I love) was like, "Yeah—you don't need that. That's just a show-off thing. It doesn't help, and it takes you out of the story and the reality of the movie, and I can tell there's a curtain on a movie set there, because it looks like a real thing." And I said, "It's *supposed* to look like a real thing." "I know, but I can *tell* there's a curtain where you're shooting it." "I know!" "Yeah, but there's not

MISS CROSS

DIRK CALLOWAY W/FLAMETHROWER

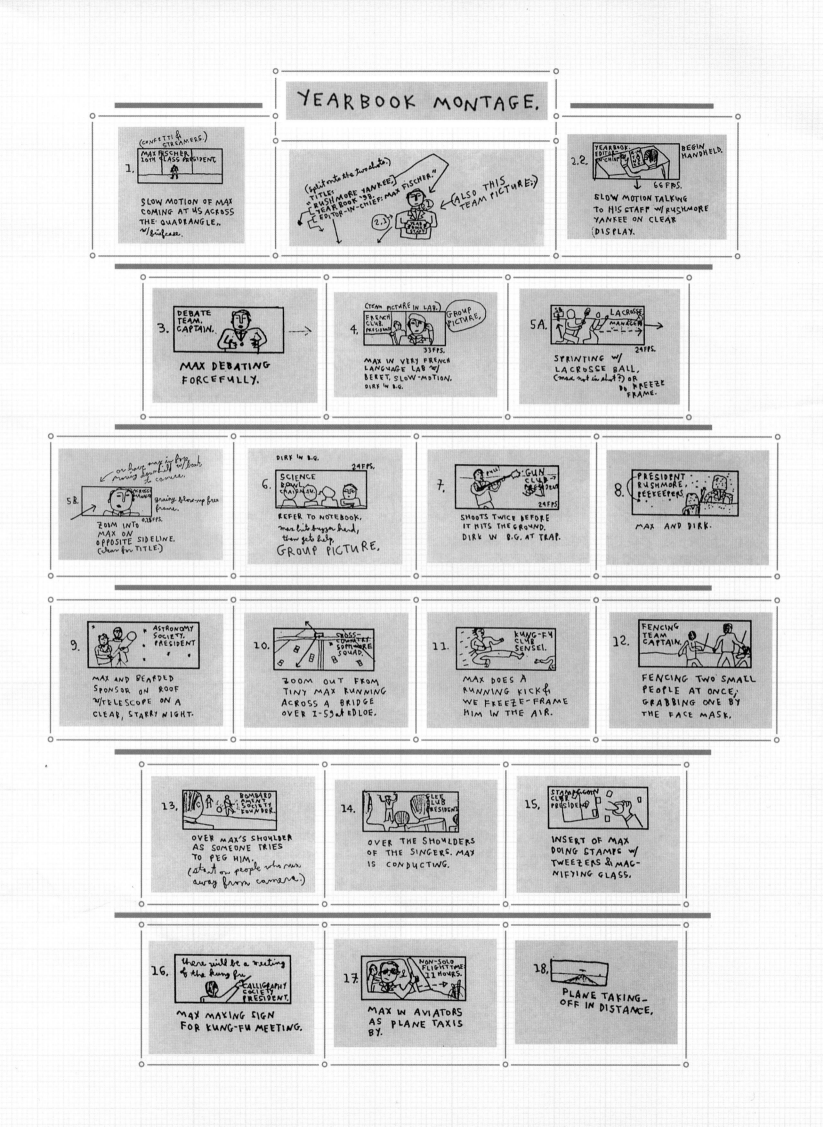

Max Fischer
EDITOR - IN - CHIEF

YANKEE STAFF

Features	David Connors / Greg Holloway
Classes	Duncan Wright / Murray Marshall
Clubs & Organizations	George McClennanan / Irving Vanderbilt
Advertising	Elliot Coll / Nicholas Appleby
Photographer	Shoeshine Benedict

YANKEE REVIEW
PUBLISHER

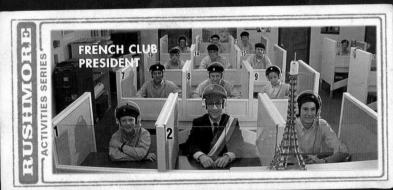

FRENCH CLUB
PRESIDENT

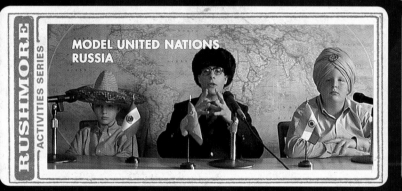

MODEL UNITED NATIONS
RUSSIA

STAMP & COIN CLUB
VICE-PRESIDENT

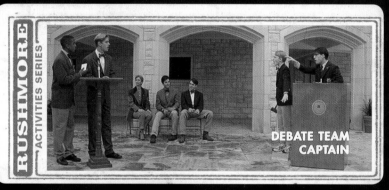

DEBATE TEAM
CAPTAIN

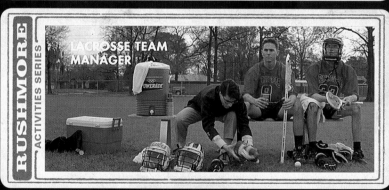

LACROSSE TEAM
MANAGER

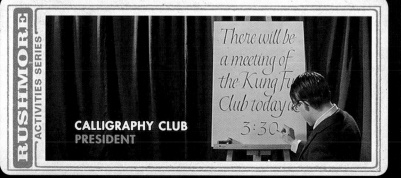

There will be
a meeting of
the Kung Fu
Club today at
3:30

CALLIGRAPHY CLUB
PRESIDENT

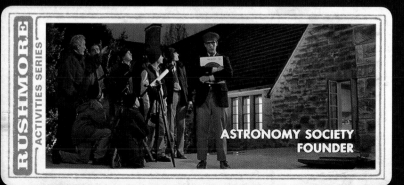

ASTRONOMY SOCIETY
FOUNDER

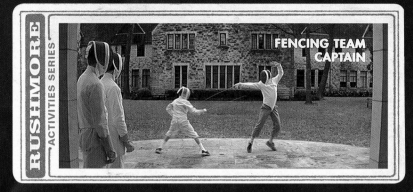

RUSHMORE ACTIVITIES SERIES

FENCING TEAM CAPTAIN

RUSHMORE ACTIVITIES SERIES

TRACK & FIELD J.V. DECATHLON

RUSHMORE ACTIVITIES SERIES

2ND CHORALE CHOIRMASTER

RUSHMORE ACTIVITIES SERIES

BOMBARDMENT SOCIETY FOUNDER

RUSHMORE ACTIVITIES SERIES

KUNG FU CLUB YELLOW BELT

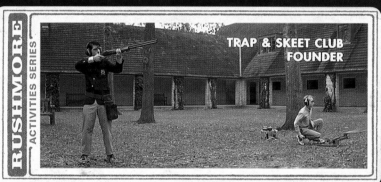

RUSHMORE ACTIVITIES SERIES

TRAP & SKEET CLUB FOUNDER

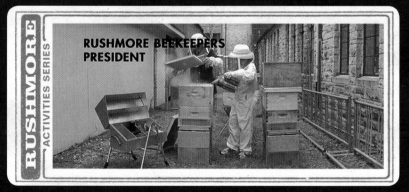

RUSHMORE ACTIVITIES SERIES

RUSHMORE BEEKEEPERS PRESIDENT

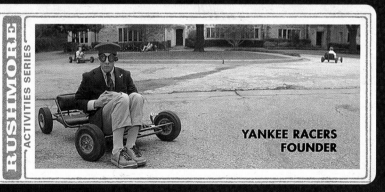

RUSHMORE ACTIVITIES SERIES

YANKEE RACERS FOUNDER

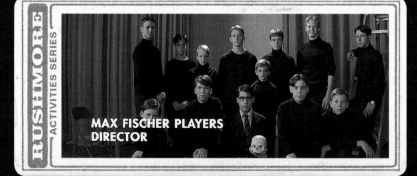

RUSHMORE ACTIVITIES SERIES

MAX FISCHER PLAYERS DIRECTOR

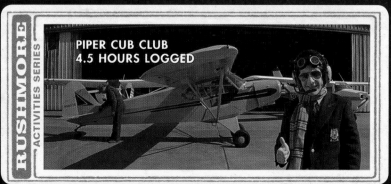

RUSHMORE ACTIVITIES SERIES

PIPER CUB CLUB 4.5 HOURS LOGGED

THE WES ANDERSON COLLECTION

supposed to be. It's supposed to be people, real
people." And I said, "Well, I know that, yes, but I
do want the curtain there." It's just, what are you
excited about when you see the movie? For me,
often what might take somebody else out of it is
what I think is just the most beautiful thing, and
I'd rather have that. I remember Mike Nichols
saying something like, "Whatever movies are
best at—well, they're not best at being reserved."
Or tasteful or something. He would object to that
horrible paraphrasing. Anyway, it was about
doing the bold thing. The most exciting movies
have always been the ones with people who attack
it. You know, Orson Welles is maybe one of the
greatest ever, even if the body of work doesn't
properly reflect that. He was the one who was just
not going to hold back. But at the same time, you
could also look at *Pather Panchali* as the other
extreme, and that works, too.

**Sure, absolutely. This leads us naturally into the notion of
artificiality, the whole idea of something being artificial or
taking you out of the movie, either because it's not something
that would actually happen or simply because it reminds you
too pointedly that there is a person behind the camera who's
making these decisions.**

**What really flowers fully in *Rushmore* for me is the ten-
sion between this extreme artificiality—the artifice, the thing
that the art is made of—and the authenticity of the emotions
these people are feeling. That tension continues all the way
through, and there's a touch of it in *Bottle Rocket*, but I feel
like it really comes out—it jumps out, puts its hands on its hips,
and says, "Here I am!"—in *Rushmore*.**

Michael Chapman* came to an early screening.
He liked it very much, and he said, "I don't see
how you can manage to do this. This is Disney.
How are you doing this?" I said, "Well, no, they
like it." "How can they like it? He cuts the man's
brakes! It's surreal. It's Godard." The truth

is, it's kind of hard to think, when he cuts his
brakes, of that as really quite being reality. Does
Max Fischer know how to ride his bicycle into a
factory, go underneath the car, and disconnect
the cable? I don't know. It's only in the world of the
movie that that's even possible.

**The same world in which the steel tycoon actually works in the
steel factory and has an office on stilts.**

Apparently.

It's almost like a little kid's idea of a tycoon.

Maybe so.

**"I go to work every day in my factory, where there are sparks
flying."**

Maybe he's a tycoon who, on his passport, it might
say that. It might say "tycoon."

For me, often the ideas that I liked the
most were the ones where I said to the guy I'm
working with, "This thing that happens here, with
lightning? What do you think of that? I mean, it
seems like Buñuel, right?" I don't know what to
say, but I want him to get it—I want this lightning.
I think that's the kind of thing that always turns
out to be what I like the most. Which meant,
simultaneously, when I read the script, I'd think,
"That's totally insane," and I just trusted it would
work out. It didn't make any sense to me at all.

I think what Steven Spielberg likes to do
happens to coincide with what vast numbers of
people like to do, and the thing I like to do is the
thing that my agent thinks is not necessarily
right. It really doesn't matter. It's all subjective,
and when I look back on putting curtains in the
movie, I like that, and I wouldn't take that away.
But I'm sure he's right, that a lot of people, if they

Jonathan Demme (1986's *Something
Wild;* 1991's *Silence of the Lambs,*
ABOVE LEFT) perfected a center-
frame, almost-first-person close-up that
Anderson has put to good use at
strategic points in his films. Another
important figure is Orson Welles (1941's
Citizen Kane, BELOW LEFT), whose
deep-focus images and Gothic sensibility
can be felt in *Rushmore* (BELOW
RIGHT) and *The Royal Tenenbaums*
(the Tenenbaums live in a house very
similar to the one in Welles's 1942 film
The Magnificent Ambersons).

OPPOSITE: Bill Murray between takes,
shooting the "Quick One While He's
Away" montage.

* Michael Chapman was director of
photography on *Jaws, Taxi Driver,
Raging Bull* and *The Fugitive,* among
other films.

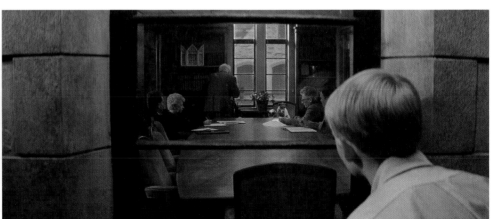

Bravo, Max!
Love, Mom.

ELOISE FISCHER
1942 — 1989

BELOVED WIFE OF BERT
AND MOTHER OF MAX.

THE PATHS OF GLORY LEAD
BUT TO THE GRAVE

saw a clip and it had the curtains in it, they'd say, "Not my kind of movie."

I have a grand unified theory I want to float here. I've seen *Rushmore* a number of times. The first few times I saw it, I fixated mainly on the comedy, the design aspects, the direction, and the film-as-film elements. But as I've watched it again, revisiting it after a number of years, and particularly as I've been watching your movies with my daughter, who is discovering all different kinds of films, what I really notice are the feelings. And now when I think about *Rushmore*, the image that immediately comes to mind is Max Fischer sitting by his mother's grave, in that scene with Bill Murray. And perhaps a close second would be Bill Murray's expression as he's watching the Vietnam play, which is this completely ludicrous spectacle with gasoline, explosions, and everything, and he's moved.

There are a lot of moments in the movie where that happens, where there is some very simple, very raw emotion coming through. It's a widescreen spectacular where there are forty-five things going on in every shot, and the cleverness of it is front and center, and it's unabashed about that—it's a fun movie—but I see a parallel between what happens to Max in the movie, and the movie itself. I feel like the movie is reflecting the interior journey of this character in the sense that he's a guy who is trying to control that which cannot be controlled.

This is one of my pet theories about your work, that it's about trying to control that which cannot be controlled. This is a kid who lost his mother at a very early age, and what is he doing? He's building world after world after world after world, which are completely of his own devising, and in which he controls every detail, no matter how small: who's in it, what the sets are constructed of, everything. The motherless child giving birth again and again.

Hmm.

And the scene where he's sitting by his mother's grave tells you where that comes from. And the change that comes over Max, the way in which he does grow a little, is that he's still this aggressive, controlling, big-visionary kind of kid, but he's using this play to bring two people together, and to give a gift to people who are really his mentors.

Hmm.

They're almost like his other parents, in a way.

I like that theory. And certainly, the only reason why it's a Vietnam play is because of Bill Murray's guy.

Right. Max is not just working out of his own head. He's taking things that are happening in his world and putting them in his art now.

His typewriter has a message from his mother on it: "Bravo, Max! Love, Mom." That's the only reference to the mother. That's the only time we have anything from the mother.

But she gave him that typewriter.

She gave him that typewriter. This is what she thinks he ought to do.

I guess what I was trying to get at was the danger of devising a style that is extremely designed and very front and center, where the personality of the filmmaker announces itself.

Hmm.

This goes back to *Pather Panchali* and films like that. There are two schools of thought on this: One is that you should avoid at all costs that which takes people out of the movie, that every time you do something that takes people out of the movie, it's a bad thing—it works against the drama, it works against the feelings. And the other is, "Who cares about all that? It's a spectacle, it's a show. It's about the rhythm. It's about the music, the images. That's cinema, too." Your movies are somewhere in the middle.

You know, if you look at Fellini's movies, there's this progression—the earliest Fellini movies are kind of neorealist. But then with each one that comes along, you've got more and more *Fellini*, and then you reach the point where it's *Roma*, which is—you know, I don't think there *is* a story in *Roma*. *Roma* is just, let's go through his city with him, and it's just entirely of his invention.

I'm interested in *writing* movies, and writing characters, and making stories, but as a viewer I've never felt any resistance to somebody inventing the whole thing. You know, I like Terry Gilliam.

You yourself have already offered me at least two examples of people in the industry who have expressed some trepidation about those sorts of touches, when they see them in your movies. "Are you sure that's such a good idea, Wes?" Or, "I can't believe you got away with that."

You don't have to pull up a lot of reviews to find people who absolutely hate what I do, for these reasons, or at least what they identify as these reasons. Maybe they would hate my movies even more if I took away the things they say they hate, but at a certain point, what am I going to do? I don't read minds, so I guess I'll just do what *I* want to do. And what I want to do has a lot to do with what I *enjoy* in movies.

Rushmore's also another first: the first movie of yours that is, start to finish, haunted by death. You've got Mr. Blume with his Vietnam experience, Miss Cross with her late husband, and Max with his mother. And that's, I think, the real source of the bond between these three people, even though they don't really talk about it. It's almost like somehow they found each other, like there was a similar energy between them.

Yep.

And for Max, I think there's a maternal attraction there as well, as opposed to Miss Cross just being the hot teacher.

Hmm.

And there's something about whatever it was that drove her late husband to be an undersea explorer that she probably sees a touch of in Max. I feel like it's all there. But the idea of death as the ultimate wrench in the machine, the kink in the plans, becomes increasingly important in the next three films.

MAGNUS
BUCHAN
←

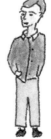

↖ BUCHAN'S
SIDEKICK

OPPOSITE: Three frames that emphasize how the threat of mortality hangs over many Anderson films, starting with *Rushmore*. The main character lost his mother, Eloise, at a young age and writes his plays on a typewriter that she gave him.

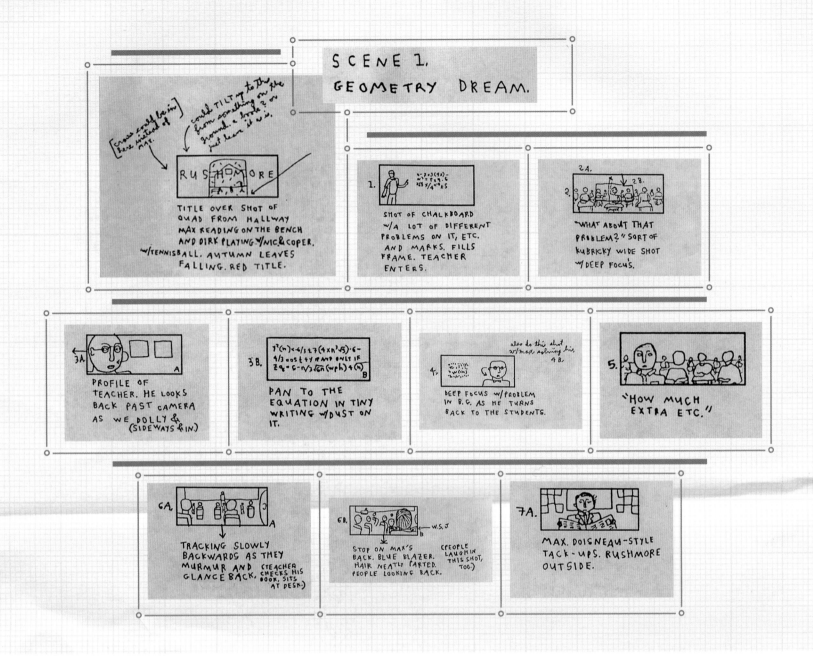

SCENE 1. GEOMETRY DREAM.

Well, I suppose it is.

If you dwell on death too much, it stops being a comedy, or so they say.

Hmm.

Or then it becomes a black comedy, which is a different animal. And yet I don't feel like those aspects of your films are comedic, ever.

Right.

You know, in a black comedy, you're laughing at death, but I don't feel like you're ever doing that.

Well, I don't ever recall being in the mood to. You know, I read some of Roald Dahl's notebooks and journals and things, and he would have a sentence that says, "Idea for a story where a husband's cheating," and it lays it out, and you see there's a whole story there. I've never had *any* of those. I don't have any gift for that. Every movie I've done is this accumulation of information about these characters and who they are and what their world is, and slowly figuring out what's going to happen to them.

So the plot comes second, or perhaps even later than that.

Or the plot doesn't come as a plot. The pieces of it are just all coming in together, and I just never do have a very good overview of it. And death, in *Rushmore,* just kind of crept in from three directions, until a certain point, when I first showed the movie to a friend—I had not tightened it up—and his reaction was, "It's too sad."

Really?

Yeah, and then we cut it down to the movie that it is, and he said, "It's too funny. It used to be so much sadder."

What was in there that's not in there anymore?

Nothing. The rhythm of it was different. It did make me realize that there's all this death around them all the time for the whole story, and his father is alone and he's just kind of shutting him out, and they're both dealing with the same problem. But it was interesting to see how much somebody's reaction can change, and he couldn't tell you what was cut out, except that it lasted about four and a half minutes.

ABOVE: Wes Anderson's storyboards for the "Geometry Dream" sequence that opens *Rushmore.* Intriguingly, this visualization of the scene includes reverse shots in which the students address the teacher. In the finished film, we don't see any of the students speaking to the teacher; they're unseen voices, sort of a reverse of the *Peanuts* cartoon technique of always keeping adults offscreen. We don't get a good look at any individual student's face until Max's introductory close-up.

OPPOSITE: Frame grabs exemplifying direct visual quotes from *The 400 Blows* (RIGHT COLUMN) in *Rushmore* (LEFT COLUMN). François Truffaut's childhood memoir is a touchstone for Anderson—his favorite film by one of his favorite directors, as he discusses in detail in the chapter on *Moonrise Kingdom.*

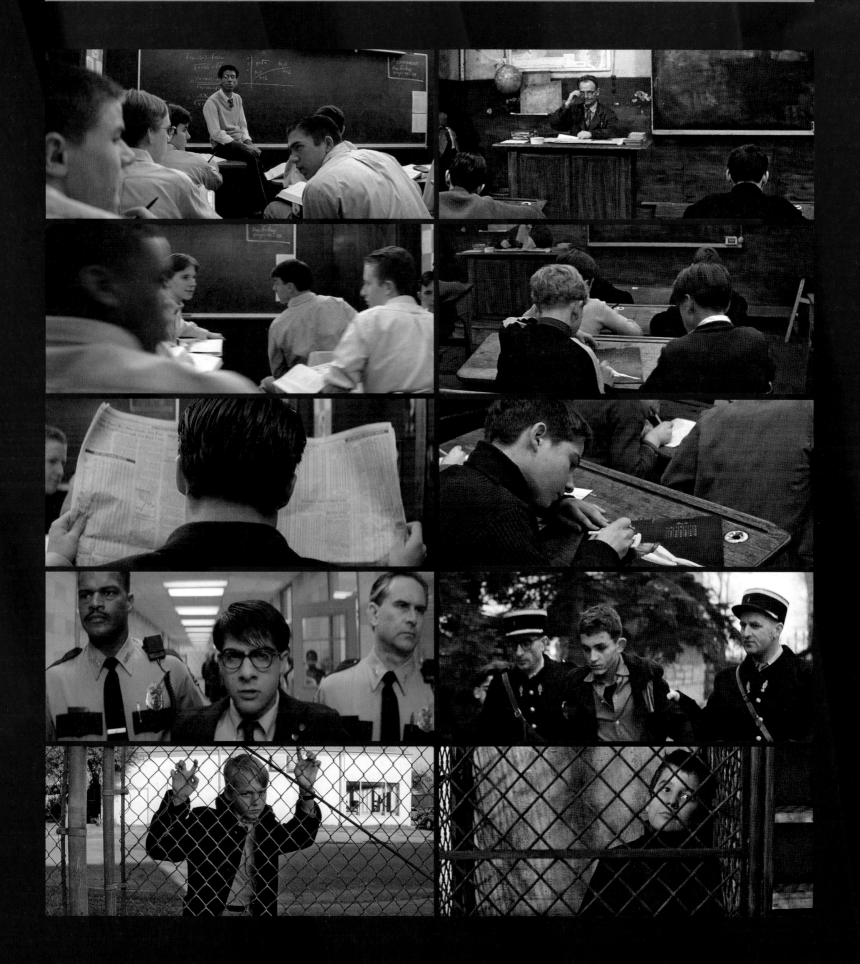

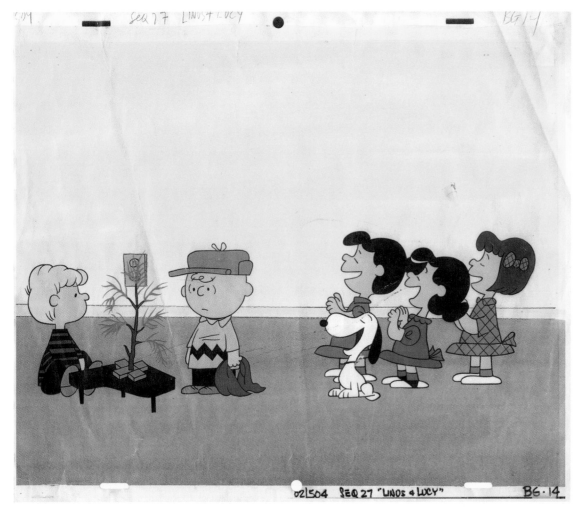

Let's turn to the lighter side and talk about *Peanuts*. *Peanuts* is a bit of a presence in *Bottle Rocket*, but I think that, in *Rushmore*, when you bust out the Charlie Brown hat with the earflaps, it becomes official. What have *Peanuts*, Charles Schulz, and Bill Melendez, who produced the *Peanuts* TV specials, meant to you as an artist?

I loved Indiana Jones and whatever we watched on TV, like *Magnum PI*, but *Peanuts* always affected me more. We had all the collections of the strips. And in those you could see the development of the drawings. Do you know how he changed Snoopy?

He became less doglike.

He became less doglike. He became this comic character.

He was like a guy in a dog suit, almost, as it went along.

Yes, you're right. Snoopy becomes a more important character as it goes along.

He does.

We loved *The Great Pumpkin,* but the Christmas special was the one that really got me. There's this wonderful thing that Charles Schulz invented, the look of these characters, and the spirit of it, and this main character—and nobody knows exactly how old they are, but this main guy is *depressed,* and that's really what his defining characteristic is. And this other character, Lucy, is just incredibly angry, and a bit mean. That whole invention is a great basis for something, but

then they have these voices, these real children's voices that are just the most wonderfully cast actors, and the way it's animated, and the script for it is a great script, the idea of it and the theme of the commercialization of Christmas and how depressing it is. It's very strange.

And restoring the spirituality to a religious holiday—that's not a theme you see every day in a cartoon special.

In a twenty-four-minute special that's supposed to play at six thirty on a Sunday night. It's very peculiar. And then you add to that the music, and what you end up with is a combination of all these talents and just tremendous good luck, and I think that's just a magical thing.

In your movies I also see a little bit of the Charles Schulz approach to characterization, in that everything about *Peanuts* is incongruous. It's about children, but the children don't talk like any children who have ever existed, and not only are they not into the sorts of things that you would expect little kids to be into, but you've got one kid who's into Beethoven and he's a great concert pianist, and you've got Linus, who apparently has memorized the entire Bible.

Doesn't Tolstoy creep in, often?

He does. *War and Peace* does, a lot, and you've got one little girl who's offering psychiatric advice, and all of that.

For a nickel.

I feel Charles Schulz coming through very strongly in *The Royal Tenenbaums,* especially in the sequences where they're kids. I remember, as a kid, being intrigued by how

ABOVE: A copy of a cel given to the author by Charles Schulz following a 1995 *Star-Ledger* profile.

OPPOSITE: Charlie Brown's dog, Snoopy, as seen in his early, doglike incarnation and in his anthropomorphized 1970s version.

SMASHED BIKE

depressed Charlie Brown was, and also how unpleasant the strip was at times, that there would be uncomfortable story lines. There was a lot of material that had to do with defeat and failure and thwarted wishes—Lucy pulling the football away from Charlie Brown again and again.

Charlie Brown. The best he gets, usually, is a glimmer of something *after* the total defeat.

You mentioned, in an interview I did with you in conjunction with the thirtieth anniversary of *A Charlie Brown Christmas*, that you conceived Max Fischer as a combination of Charlie Brown and Snoopy.

Hmm.

And Miss Cross as a mash-up of Miss Othmar and the little red-haired girl.

I don't remember Miss Othmar. I guess you could draw those connections.

Let's return to the idea of pacing—the energy in *Rushmore*. You talked, regarding *Bottle Rocket*, about the idea of looking at things again and saying, "Gee, I wish I'd let that shot breathe a little more." Do you have that feeling about *Rushmore*? Because the energy, the momentum is so important to that.

When I brought that up, I wasn't necessarily even referring to *Bottle Rocket*. I don't know which scenes I was referring to. I think my films probably all have moments where I made that error, and they probably also have moments where I should have cut something out. There's only one

tiny scene in *Rushmore* that was cut out. The only thing that was taken out of *Rushmore* was an image of him taking some books out of his locker after he's kicked out of the school. Nothing else was cut out of it.

So pretty much everything you shot ended up in the movie except for that.

Lines were cut out, and beats were cut out, but that was the only actual scene. The other ones, I think there were always at least a couple of scenes that ended up getting cut out.

If you look at the structure of a traditional narrative script, you've got act 1, act 2—which is often two pieces; it's like act 2A and 2B—and then act 3. One of the more distinctive things about the script for *Rushmore* is that act 2B, which is the part where everything turns to shit and everyone mopes for a while until they get their act together and rally for the big finish, is a montage.

The whole thing is truncated.

It's like you skipped ahead to the part where their spirits lift.

And then we spent a lot of time lifting the spirits.
I have a tendency to do a lot of beginnings. In most of my movies there are several different opening scenes, a lot of different kind of expositional, introductory scenes, and a lot of closings. *Rushmore* has several starts. There's a scene where Max is getting put on sudden-death academic probation. Well, that could easily be the first scene of the film, but in fact it comes after Bill Murray gives his speech.

And even before that, there's the chalkboard.

Oh yeah, there's the dream scene. There's the chalkboard, there's the dream, there's the scene with him and Max, there's the montage with the thing—

With his activities.

There are a lot of beginnings. And there are several endings, because there's not only the play, there's the party. I just don't like to leave out the party afterward, you know? I usually include that. I think the opening sequence of *The Life Aquatic* has several party scenes in a row.

It does. And you've got several endings in that one.

Several endings in that.

You could even say that for all intents and purposes, dramatically, *Rushmore* is over when they sit down to see Max's play and he's seated them together.

Right.

The triumvirate again.

Right.

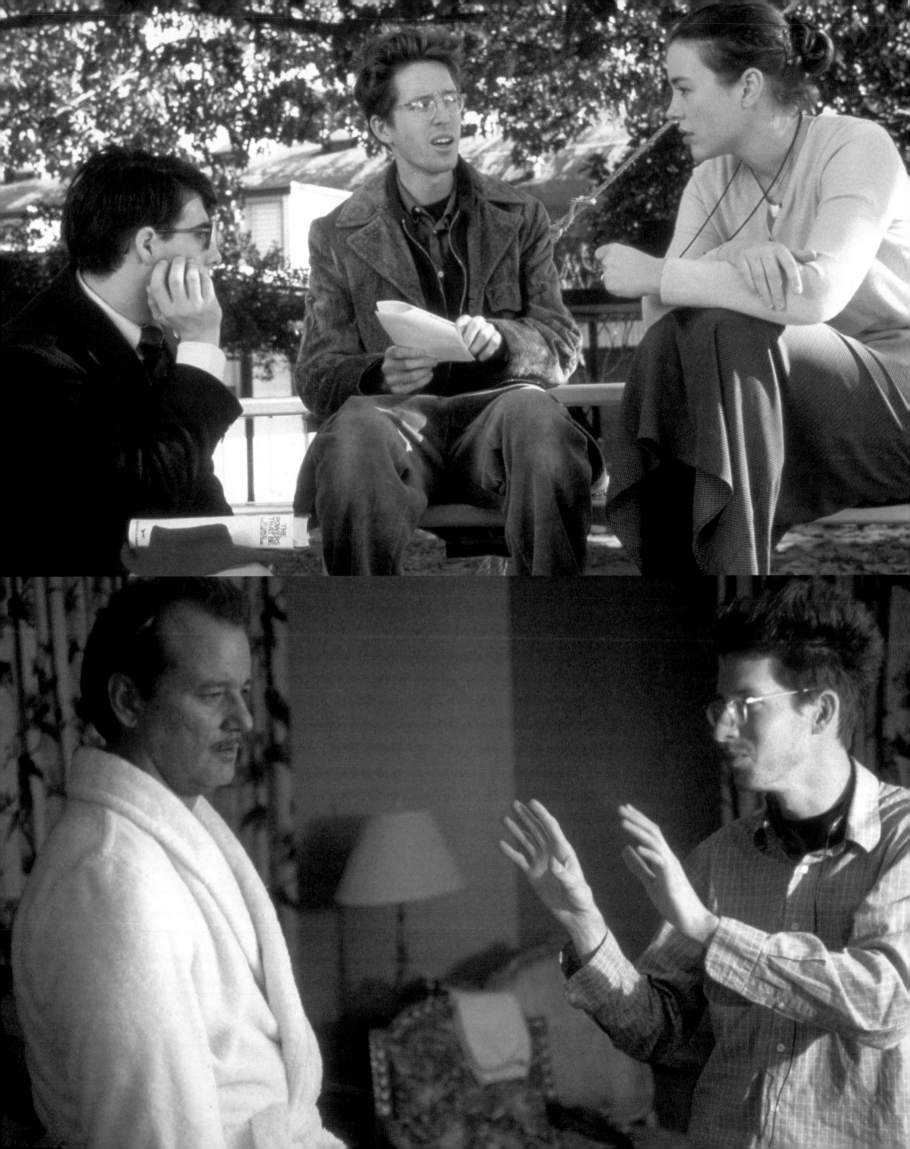

This kind of plays into your comment earlier about not being so much concerned with plot as with constructing the world and these people who happen to live in it.

I guess the climax of that movie must be in the play he's putting on, and maybe he's going to get shot by the girl—but no, she's not going to shoot him. And then the fireworks go off. I guess that's the climax of the movie. But how that makes any sense, dramatically, I have no idea. Sometimes that's just the way it works, I guess. I don't fully understand.

I was a little concerned when *Bottle Rocket* finally hit theaters. I remember that the release date had gotten changed, and the plans got changed, and the story I was writing about it got delayed because plans kept changing, and I think finally they just decided, "Fuck it, we're going to run it, and the movie will come out when it comes out." And the story came out months before the film. And I was worried, because I thought, "Well, is he going to get to make another movie? And if he makes another movie, is it going to work for him as the director, and is it going to work for audiences?" And I saw *Rushmore*, and I thought, "He's going to be fine."

It reminded me of one of my favorite quotes from James Agee, which is, "A work by master carpenters who drive every nail in cleanly, with one blow." It has that quality. It's a very efficient film, and it feels like you get exactly what you need—maybe a little more, but not much more. And it feels supersaturated. I looked at the running time, and I thought, "That must be a mistake." Because it felt longer, but not in a bad way. It felt like there was more information than—how long is it, ninety-eight minutes or something, or less?

Less, I think, when you take off the credits. I think it might be eighty-eight, plus the credits.

How important was it that this movie be exciting, propulsive, have that kind of relentless forward direction, which is sometimes what people are talking about when they say *Rushmore* is their favorite of your movies?

What is it exactly? It's not a direct story where this happens and as a result this happens and as a result this happens and as a result this happens. It's not one of those. Instead, it's where this happens, and here's another thing that's going on in his life, and now he's going to meet this person, and then, unrelated to that, we're going to start this other character's story up, and then bounce around among those, and they all start to intertwine eventually, but maybe they *don't* all intertwine, you know?

When you have him changing schools, that's something the viewer might think you shouldn't do. Midway through the movie, you put him in a completely different environment.

A totally different set of characters and everything. But there's something more accessible about it, I think. Certainly more people can directly relate to a movie set in an

OPPOSITE TOP: Wes Anderson confers with Jason Schwartzman and Olivia Williams while shooting takes of their first conversation.

OPPOSITE BELOW: Anderson with Bill Murray, shooting the scene in which Max's bees invade Herman's hotel room.

BELOW: Anderson couldn't deny the influence of Charles Schulz and animator Bill Melendez's *Peanuts* TV specials even if he wanted to, and he's never been shy about acknowledging their impact. Max Fischer's winter gear in *Rushmore* combines Charlie Brown's Christmas special getup with a zigzag pattern that evokes his famous shirt. And the finale of *Rushmore* feels like a live-action, widescreen shout-out to the dance sequence.

American school than probably a movie about an oceanographer. There's no real genre to refer to, and this is a ninety-minute movie that's a comedy, a romance, and that's sort of somewhat happy at the end. A movie like *The Life Aquatic* is longer, the guy is not as winning a person, and it's much more about his defeat in life, and how he's burned people and used them, and how he feels about that and how they feel about that, and is there really this shark, and what is real and what's not real. It's a more challenging thing for most audiences, and then if somebody likes it, well, that says as much about them as it does about the movie, probably.

So anyway, I don't know. I'm not really answering the question but just musing on what works for an audience. I guess over the years, you come up with some theories. Probably Warren Beatty after *Dick Tracy* said, "Americans don't want it to look fake. We should have just shot it on location." Better to just do what you want.

There's a lot of performance in *Rushmore:* the curtains being pulled back, Max being a playwright. You see the plays he's putting on within the movie. There are three of them, maybe four of them, right? *Serpico*—

I think three.

The unspecified *Blood In, Blood Out* thing and the Vietnam play.

I think that one could be called *Little Puppet*. I think that would be a good title for it.

Blood In, Blood Out—they changed the name of that, right?

No, that's what they changed it to, I think. It was originally called *Bound by Honor*.

I think originally originally it was called *Blood In, Blood Out*.**

I think that phrase is in *American Me*, actually. "Little puppet."

"Little puppet."

But back to the point: the artifice. Everyone has their own alternative theories about movies that have nothing to do with what the filmmaker intended. A friend of mine believes that the whole movie is in fact a Max Fischer production. Have you heard that before?

Well, that's what Owen said when he read some section I was working on of *The Royal Tenenbaums*. Somewhere along the way, that was one of his worries about *The Royal Tenenbaums*. He said, "The whole movie is like one of Max's plays."

Presentation—the artists presenting their art and the story being told perhaps in the style and spirit of a protagonist who happens to be an artist—is something that also pops up again and again for you.

Well, his theory about *Rushmore* is kind of like . . . Yeah, I'm not exactly sure what my comment is on that.

I think it goes back to what we were talking about earlier, the idea of calling attention to the story as it's being told, and to the act of storytelling.

Hmm.

That's not something you deal with glancingly. It's right there.

Maybe it's right there, but it's not like I do it on purpose. It's not like I want to announce to the audience, "We're going to do this in one long take, and we're going to move over here, and we're going to have smoke come through, and then we're going to pan over there, and then we're going to have a whatever-it-is, a 'this part will be in slow motion' thing." None of that is meant to be deliberately taking you out of the movie. It's supposed to make it better.

You don't have any sort of theoretical or aesthetic goal for doing that. You're just doing what feels right to you.

Well, usually it's that, in this part, I feel it will be more sad if it happens this way, or I feel that here

← MARGARET YANG

** Anderson is correct. The 1993 Taylor Hackford film about Mexican–American gangs in Los Angeles was originally titled *Blood in, Blood Out*, referring to the fact that one can only gain admittance to such a gang by killing a designated target, and one can only leave the gang through death. The film's releasing studio, Disney, retitled the movie *Bound by Honor* for its theatrical release, fearing the original title would spark violence in theaters. The movie regained its original title for home video.

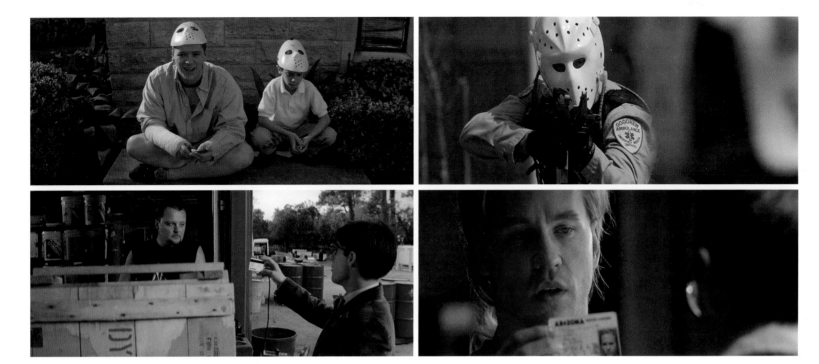

we'll get that information across, and here's a way that I think will affect people—not only will they know what month it is, but they'll know that October is against a blue curtain and here's the mood, and that this is meant to launch us into this moment, and now we can go through it and join the story. For me, it's just sort of abstract—I don't think I ever do anything to deliberately push the audience back, but I feel like that's what happens to some people anyway.

You have a lot of references to popular culture in the form of Max's obsessions, and you even have that direct shout-out to _Heat_.

A couple.

A couple? What are the two?

There's one where he's saying, "It keeps me sharp, on the edge."

"Where I need to be," yeah.

Which is actually a combination of a line from _On the Waterfront_ and a line from _Heat_. Karl Malden's saying, "You gotta promise me you're gonna follow this all the way, to the end of the line, so help me God." And he says, "You gotta follow this all the way, to the end [SNAPS] of the line [SNAPS]—where I gotta be." So it's a mixture. And then the other guy says, "So help me God." So it weaves together, which is a weird thing, I guess.

And then another place is when Max is ordering dynamite, and he just says what Val Kilmer says when he orders dynamite in _Heat_.

Speaking of _On the Waterfront_, the scene where Max reveals Mr. Blume's infidelity to Mrs. Blume is very much the scene where Terry Malloy reveals the truth of what happened to her brother to Edie Doyle.

We can't hear it.

You can't hear what they're saying, and you hear the steam whistles.

Right, and it's cold.

Yes, right, there's a lot of that. And yet, more than a decade on, I think we can safely say that this movie, which is so filled with affection for other iconic films, is an iconic movie. People quote the dialogue. And in fact, you've officially removed the phrase, "Yeah, I was in the shit," from the lexicon. It can't be used anymore. It's now property of _Rushmore_. It's almost become shorthand for someone overmelodramatizing their experience.

Hmm. I heard that one a lot. I think that must have been one of the scenes we had the actors audition with, because I feel like when I hear those lines, I don't just picture Jason saying it, I picture twenty different kids who all auditioned doing that bit. Jim Brooks said a thing to us about _Bottle Rocket_, maybe a year or so after it sort of came and went: "We made cult." That's not so bad. We made cult.

DR. GUGGENHEIM

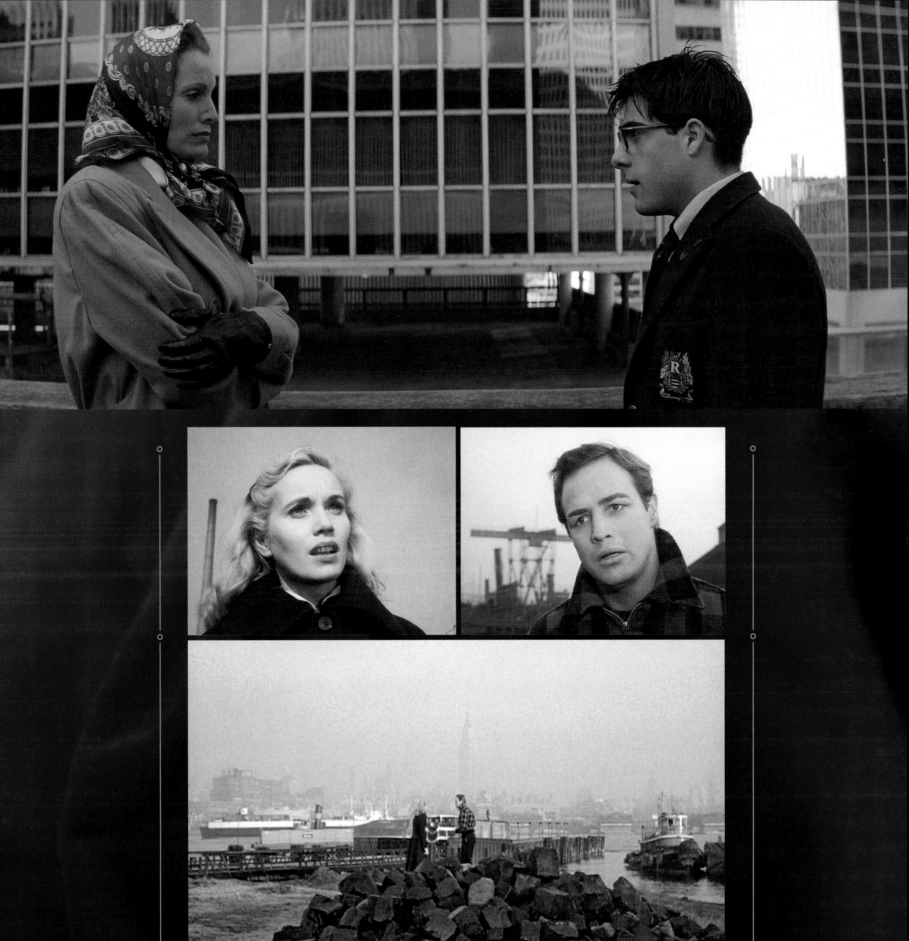

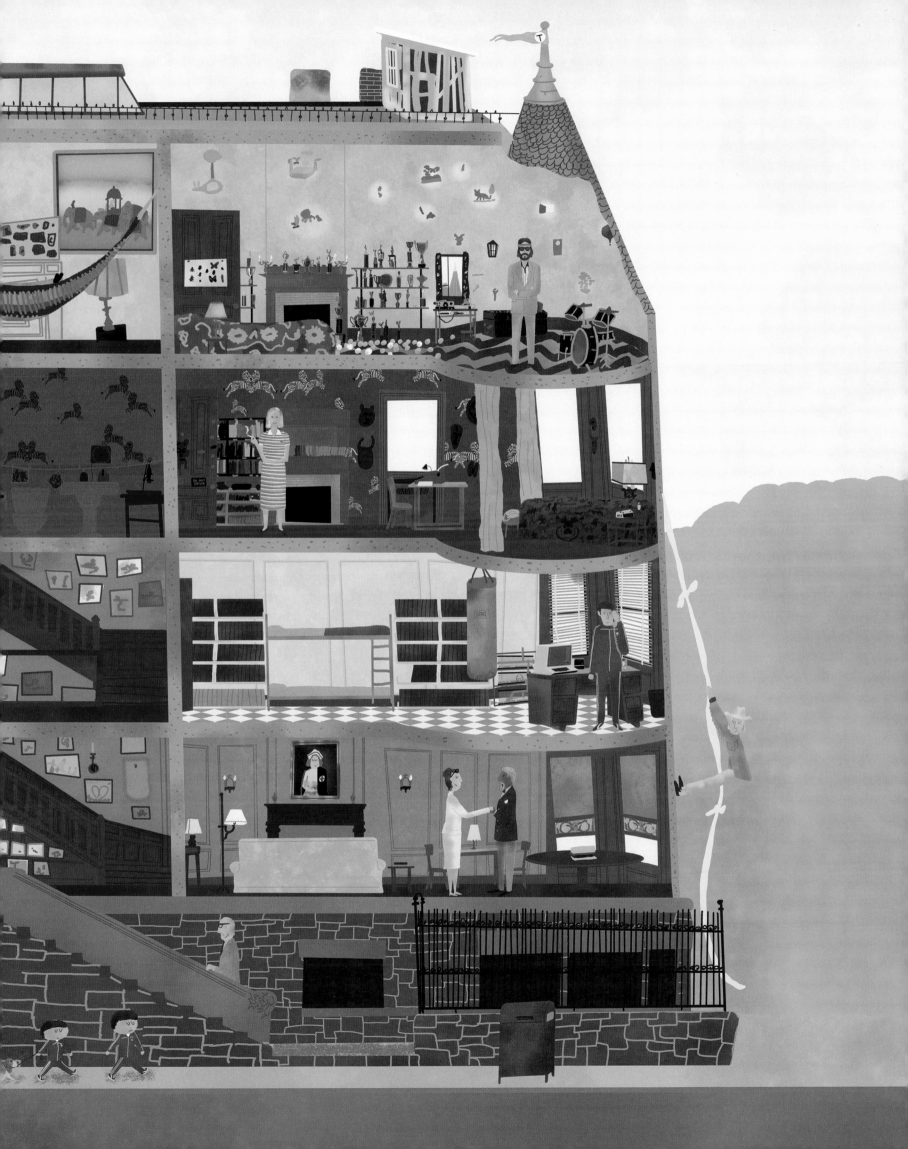

The ROYAL TENENBAUMS

The 1,113–Word Essay

*T**HE ROYAL TENENBAUMS*** starts with a bomb going off. The rest of the story takes place in the wreckage.

This description makes Wes Anderson's third feature sound unbearably dark, but if you're reading this book, you know that's not the case. Despite its emotional (and in one or two cases, physical) violence, it's a tenderhearted work, more comedic than dramatic, gliding deftly forward like Margot pirouetting in her room, packing each frame with so much detail that the film's very assemblage becomes a work of art: a mosaic built of tiles that are themselves mosaics. For all their fuming, sniping, lying, and self-dramatizing, Royal, Etheline, Richie, Margot, Chas, Ari, and Uzi Tenenbaum truly love one another; you can tell by how they look and speak to one another, always with affection even during the most awkward, even agonizing moments. Although it's the first Wes Anderson film to include gory violence, and to suddenly shift from comedy to full-on tragedy and back again, it never loses touch with its embracing heart. And even in the grimmest scenes, there are points where humor untainted by sadness suddenly wells up, brightening cinematographer Robert Yeoman's already radiant images.

Where are we, exactly? New York City? Maybe—the Big Apple as dreamed by a young person who has never been there and only knows it secondhand, through literary and cinematic and musical sources. And what a list of sources! *Midnight Cowboy, The French Connection*, J. D. Salinger, Simon and Garfunkel, E. L. Konigsburg's *From the Mixed-Up Files of Mrs. Basil E. Frankweiler*, the Andy Warhol Factory's musical wing, Robert Frank's street snapshots, *New Yorker* cartoons and covers: These references and others are nestled within the film's story and design, sometimes announcing themselves brazenly (Gene Hackman's Royal racing go-karts with his grandkids like Popeye Doyle), other times subtly (Eli Cash's wardrobe suggests *Midnight Cowboy*'s Joe Buck by way of Vegas-era Elvis).

by Matt Zoller Seitz

All the stylistic tics that Anderson developed in *Rushmore* bloom rather explosively here, like irradiated sci-fi flowers. Were it not for the director's characteristically circumspect style, it might feel like a detonation of too-muchness. More annotations, more musically varied soundtrack cues, more Easter Egg–style design touches (such as the Dalmatian mice that unexpectedly appear in the corners of already dense compositions). The movie feels physically, emotionally, and narratively bigger than his previous two movies because it just is. It has more characters, more plot, and, most important, more modes. How do we get from that opening conversation between Royal and his children, which suggests lines from the saddest Sunday strip Charles Schulz never wrote, to the overhead shot of Richie Tenenbaum's slashed wrists gushing blood into a sink? How is it possible that a major character's funeral could include heartfelt third-person narration, close-ups of shattered survivors' faces, a po-faced BB-gun salute, a close-up of a whopping lie inscribed on the deceased's tombstone, and music by Van Morrison, and yet somehow seem all of a piece?

The Royal Tenenbaums works because, as hilarious as it sometimes is, in its heart, it's a drama rather than a comedy, and it's not remotely kidding about the traumas it depicts. There is a specific darkness at the heart of the film: divorce. Anderson and Owen Wilson's script is keenly aware that divorce is a unique hurt, different from other types of loss because it doesn't strike from out of the blue. There is a deliberateness, or at least a creeping inevitability, to the splintering of families with children, and a sense, however ill founded, that everyone who endured the event was an active participant, even when they were collateral damage. Parents who've come to terms with the fact that things couldn't have gone any other way still beat themselves up for having gotten involved with their ex in the first place, or maybe for saying or doing things (or failing to say or do things) that lit the fuse. All children of divorce have at least some moments when they wonder if it's really their fault. If we've been through this particular hell, either as parents or kids, we may rationally know that a split-up is just one more disaster, different from a catastrophic death, illness, or injury only in that the wounds are mainly emotional.

I tell you all this by way of explaining why this introduction contains almost no analysis. Every time I tried to write about the film's structure or style or themes, my mind began wandering to my own parents' divorce. I grew up in a family of artists: jazz musicians, to be exact. My mom and dad split up when I was six and my younger brother was two. This, I now realize, explains why I was unable to fully embrace *The Royal Tenenbaums* until recently: It opened up scars and made them wounds again.

I was thirty-two when the film hit theaters, decades removed from the split, and I'd spent the previous few years getting to really know my father as a human being for the first time. By that point I was married and had a daughter of my own, and even though the marriage was profoundly happy, there were times when I wondered if it could happen to us, too. I didn't want to deal with this movie. When others asked me what I thought of *The Royal Tenenbaums,* I used to sidestep and bow out with something along the lines of "It's a

big artistic advancement over *Rushmore,* but maybe too ambitious for its own good, and parts of it felt too busy or too rushed," or something. To misquote the movie's narrator, even as I said these things, I realized they were untrue. The truth is, when I looked at Royal I saw my mother or my father, depending on what mood I was in and what miseries I'd decided to obsess over. When I looked at young Chas, Richie, and Margot, I saw myself and my brother. After all those years, the memories still hurt.

Anderson and I have talked about our respective experiences with divorce and agreed that the metaphor of a bomb detonating—"or maybe imploding," he suggested—was accurate.

I've talked to my parents about their divorce a few times over the years, awkwardly and never at length. After a certain point we didn't feel the need to have those conversations anymore, because the past is the past, and life is too short to keep living in it. You've doubtless had such talks with your own parents—if not about divorce, then about some other misfortune that befell your family and lodged in your self-image like the BB pellet buried in Chas's hand. We are all Tenenbaums.

The ROYAL TENENBAUMS

The 7,065-Word Interview

OPPOSITE: The Tenenbaum house on Archer Avenue, which is actually Convent Avenue at 144th Street in Harlem.

ABOVE: The one and only Gene Hackman. Photograph by Laura Wilson.

MATT ZOLLER SEITZ: The first thing I'd like to address with *The Royal Tenenbaums* is composition. Let's talk about composition and moving the camera. You do a lot of cutting in camera, and I think it reaches a peak with *The Royal Tenenbaums*. Do you prefer to cut with the camera whenever possible?

WES ANDERSON: You mean doing a take without cuts?

Well, yes—realigning the viewer's position within a take, but without actually physically cutting.

I do like that.

Take us there.

I asked you to clarify because sometimes when we were doing *Bottle Rocket*, I was often told, "Don't cut in the camera," which meant that—I think there's an old Hollywood way of cutting in the camera, which is where you shoot the close-up for just, say, two lines. A scene might be four pages long, but you shoot the close-up for just those two lines, and you shoot a wide shot for the rest of the scene, so that you're *only* getting those two shots for that scene. You're going to use the wide shot, and you're going to use the close-up for those two lines. So you've just got these two shots, but you haven't got "coverage."

That's the way Hitchcock used to shoot, deliberately, so they couldn't recut his movie.

Right. And I think John Ford. But anyway, I guess I do always like the longer takes. For me, there's suspense in it. I just find it thrilling. But I don't know—for most audiences, I guess it's probably not having that effect, because they don't notice it. But maybe it does affect them anyway. I mean, maybe they can feel that this is a real thing.

Well, I know I can, even though I didn't know what it meant until I was older and I had seen more movies. I wrote a column one time about the first movie I ever saw that made me realize that movies were directed, and it was *Raiders of the Lost Ark*. And one of the scenes I remember being quite struck by is the drinking contest scene, where Marion is drinking that guy under the table. It's all one take.

Ah.

That's another example of Spielberg, the silent master of the long take. No cuts in that thing.

Right.

Lateral pans down to the glass, up to the other person, down to the glass. And so on and so forth. It goes on for a couple of

minutes, and I think it's one of the reasons that scene is so tense.

Right. You're not only waiting to see who's going to get knocked out with the liquor, you're waiting to see who's going to screw up the take.

Even if you're not thinking of it that way as a viewer, it works on you subliminally.

Well, that's certainly the experience when you're watching a complicated take being played on the set, anyway. Everybody involved in it is just waiting to see "Are we going to get through this one?" Usually, something goes a little bit wrong. And also when you're shooting stuff like that—I mean, at least in my experience, anyway—it's always twelve takes before you have it, before it's good. If it's very complicated, it takes a long time of really doing it before everybody can get it timed out and fix the technical problems. It just takes so much practice. But obviously, it depends on how complicated it is.

One of the most exciting times I ever had at a movie was when I saw *Secrets and Lies* at the New York Film Festival. There are two long takes in that movie that are static. One is the first meeting between the mother and her daughter, who had been given up for adoption, at a backyard picnic, with the entire

extended family around one table. Both of the scenes play out for several minutes without a cut.

Hmm.

Both times, the audience applauded when there was finally a cut.

Really?

I'd never seen that before.

For just the performance of these moments?

Yeah.

Wow.

And, you know, when the audience is applauding the filmmaking, it's quite a different thing from when they're applauding the hero beating the bad guy.

Right.

It's a different thing, and I also experienced it with the mountaintop battle in *The Last of the Mohicans*. I saw that with a paying crowd on the opening weekend, and Magua fell into the frame—dead—and they broke into applause. And it wasn't about "the bad guy's dead," because he wasn't a traditional bad guy. It

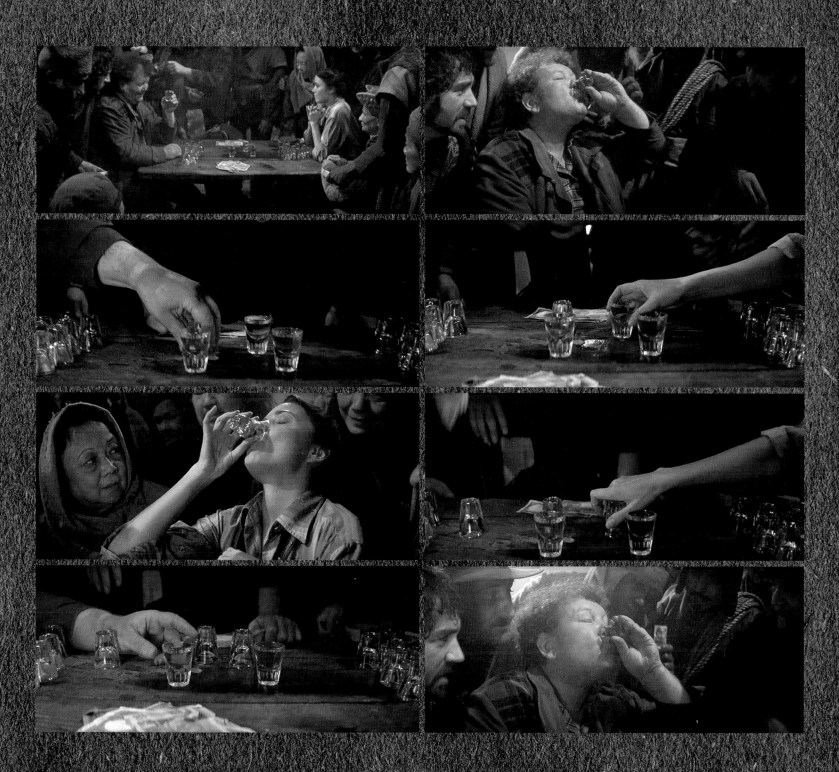

was more like when a great symphony has been concluded, you applaud that orchestra.

Wow. Pretty good.

There's a long take, cutting in camera, in *The Royal Tenenbaums*—Margot and Eli on a bridge.

It's a pedestrian bridge. I want to say it's on the edge of Harlem, but it's more like Spanish Harlem. Anyway, it's on the East River. Right, that's a peculiar one.

Are you able to see a whole movie in your head? How it ought to be? Cuts and everything? Some directors put it together in the editing room. I mean, everybody has to edit, but you don't strike me as somebody who has just—

No, I usually have a pretty good idea. I can definitely think up a way that a particular scene can be shot and cut in advance. Doing *Fantastic Mr. Fox* was a situation where I could think it up

and that's what we did, but shooting live action, especially on location, can complicate those ideas.

Usually, you may have an idea of how it ought to be done, but you may not know the location, so it just ends up having nothing to do with what you planned—actors do something unexpected, they surprise you, which changes the idea, or a question comes into the equation, or the space is just different from what you planned, and you're going to have to deal with it differently. Or there's something about the space that makes you change your plans. In *The Royal Tenenbaums*, I remember there was a scene where we had it figured out for ages, and on the day of shooting, these people would not, their window was reflecting—

What scene is this?

It's the scene where Gene Hackman gets swatted by Anjelica Huston. He's telling her, "I'm dying. I'm not dying. I'm dying." And anyway, this house they're supposed to talk in front of, they wouldn't

BELOW: Prepping for a crane shot of the Tenenbaum house during production in 2000. Photograph by Laura Wilson.

OPPOSITE TOP AND MIDDLE: Images from two longish takes: Margot's conversation with Eli Cash on the bridge, and Royal revealing his (nonexistent) illness to Etheline.

let us do anything to make it so the window wasn't going to reflect directly into the camera. They wanted to charge us a lot of money for that. And I ended up saying, "Do we control this part of the sidewalk here?" "Yes, we control that." "Can we lean a mattress against this tree, and we'll block that whole part there?" "Yes, we can do that." So then when we do the scene, Gene comes out, and he stops behind the mattress. You can't see him. I said, "Gene, can you—is there a way to do it so you're not hidden behind the mattress?" I feel the seething begin. He says, "Move the mattress." "Well, see, Gene, these people will not let us do the scene. If you can find a way, what I'm thinking is you can just kind of use this mattress as your entrance." I thought I was going to get socked in the face. He made it work, but the staging of it was completely dictated by the people with the window.

How often does that happen?

In different ways, it happens all the time. It doesn't happen on an animated film. But on an animated film, what happens is that you say, "I want him to walk up the hill, stop, and talk," and ten days later, you're saying, "Why can't we get him to walk up the hill? It looks ridiculous." You know, he takes three steps, and you say, "This looks too weird." Something that just seems simple is suddenly bizarrely impossible. There's no gravity.

Let's talk about the spaces in *The Royal Tenenbaums*. Let's talk about the house. Where is the house? Are the exterior and the interior the same house, or did you shoot those at different places?

No, it was a real house. At the time I was very adamant that this would be a real place and that we have to *make* it a real place. The movie's scheduled around the actors—it's a little jigsaw puzzle. We have Ben for these three weeks, and we have Gwyneth for only these ten days, and everything is built around that. I felt like they had to have this real place that exists that they can walk into and say, "This is my room. Here's my

room." And they did. It was also quite practical, I think. The roof was the real roof. It was all one place. The only cheat was with their kitchen, which was in the house next door, because this place had no windows—it was not going to work. But the rest of it's all there—it's near Convent Avenue and 144th Street in Harlem, just north of City College. The hotel where Gene Hackman is living at the beginning is the Waldorf.

Were there any places in the movie that were wholly invented, where you built a set? Did you build any sets?

Well, let's see . . . no. You know, we built the archaeological site, but they've had plenty of those in the city. Everything's kind of inspired by something, and everything's done in some converted place. For the 375th Street Y, the exterior was in one place on the Upper East Side, and for the interior we found a place in New Jersey. I can't remember where. I can't remember what it's called, but somewhere in Newark there was this big abandoned hospital, and we made our hospital in it. We also found a mansion in Yonkers that we used for many things—Gwyneth in Paris in one little corner, the bathroom of Gwyneth and Bill's apartment in another, and Gene's doctor's office in another. But anyway, the 375th Street Y—the place where they lived—that was in New Jersey.

Talk to me about Orson Welles and *The Magnificent Ambersons*. That house looks an awful lot like the Ambersons' house, and I'm assuming that's just a lucky accident.

Well, a lucky accident, but probably also because it was in my mind. *The Royal Tenenbaums* was really inspired by *The Magnificent Ambersons* more than anything, but it's the one film I haven't even thought to mention so far. But yes, I found the house with my friend George Drakoulias.* We were driving around, and one other person was with us, my assistant Will Sweeney. And George was on the phone, and we were walking around an area in New York called Hamilton Heights, and George said, "I think you might look up the street. There's a place up there." And I walked up there, and what I probably saw was a house that looked just like the one in *Ambersons,* and I thought, "That's the place." And I also saw a sign in the

window that said it had just been foreclosed on, so I thought, "Well, what state is this going to be in?" What happened was that a guy had just bought it after it was foreclosed on for the amount that we ended up paying him to use it. He got the house, ultimately, at no cost, because our fees for shooting there ended up being the equivalent of what he paid for it.

He had a very good year. The story of *The Magnificent Ambersons* is also—

It's faded glory.

It's the decline of a once-great family.

I guess that movie and the Glass family stories, and also *You Can't Take It with You.* And another: Kaufman and Ferber's *The Royal Family.* Maybe those are the other principal parts.

I haven't seen or read *The Royal Family*. What happens in that?

That one is modeled on the Barrymore family, a theatrical family. There's a movie, which is *The Royal Family of Broadway.* The mother is the boss, and there's this son who's a rogue young actor like John Barrymore. Frederic March. Anyway, that's the milieu.

Do you remember the first Orson Welles film that you saw?

I think it might have been *Touch of Evil* or *The Lady from Shanghai.* Even before I saw *Citizen Kane,* I think I might have seen those. He's always been one of my very favorite directors. I love *The Trial,* and I love Anthony Perkins in *The Trial.*

***The Trial* is fantastic, and very underrated. It's a part of Welles's European phase, when he was having trouble getting money together, and one of the things that's fascinating about it is that you can kind of see the production disintegrating as it goes along, as if the money is running out on-screen as you watch.**

I think originally they were going to shoot the entire thing on sets. And then they got the opportunity to shoot at the Gare d'Orsay, which was closed—before it became the museum.** But those exterior shots, the shots of the outskirts of

BOTTOM: The title card from *The Magnificent Ambersons,* Orson Welles's 1942 adaptation of Booth Tarkington's novel (LEFT). A photograph of the Ambersons' home (MIDDLE), actually a practical set that is believed to have been built on the RKO lot for use in the 1942 film *Syncopation.* It was modified and reused in 1946's *It's a Wonderful Life* (RIGHT).

OPPOSITE: Eli Cash escapes from the Tenenbaum house after a tryst with Margot. Although the shot of Eli waving at Royal is supposed to occupy the same physical space as the other exteriors of the house, this bit was actually faked in front of a brownstone on State Street in Boerum Hill, Brooklyn. By bizarre coincidence, the author of this book was living one block away from that location at the time; several shots in the movie were filmed in his neighborhood, and in one of them, his house is plainly visible in the background. Photograph by Laura Wilson.

* George Drakoulias is a record producer and music supervisor who got started as an A&R man for Rick Rubin's Def Jam label, later Def American. The character played by Michael Gambon in *The Life Aquatic with Steve Zissou* is named Oseary Drakoulias, a splice of Drakoulias and Guy Oseary, Madonna's manager, the founder of Maverick Records, and an executive producer on the *Twilight* films. Drakoulias also inspired Billy Bob Thornton's character "Big Bad George Drakoulious" in *Dead Man* and the Drakoulias monster in the 2009 *Star Trek,* and you hear his name in a lyric of the song "Stop That Train" in the B-Boy Bouillabaisse section of the Beastie Boys' album *Paul's Boutique*: "Went from the station to Orange Julius, I brought a hot dog from who? George Drakoulias."

** The Gare d'Orsay, a turn-of-the-century railway station on the left bank of the Seine in Paris, later became the Musée d'Orsay, home to the world's largest collection of Impressionist and post-Impressionist masterworks.

TENENBAUM, M.
BACKGROUND FILE

AGE 12
STARTS SMOKING

ESCAPES SCHOOL
AGE 14

AGE 19
FIRST MARRIAGE

AGE 21
RIVE GAUCHE

PUBLICITY TOUR
AGE 24

PAPUA NEW GUINEA
AGE 25

GYPSY CAB
AGE 26

CROSSTOWN LOCAL
AGE 27

IRVING ISLE FERRY
AGE 30

22 AVE. EXPRESS
AGE 32

OPPOSITE: Still frames from Margot's montage of indiscretions.

ABOVE: A paperback of J. D. Salinger's *Franny and Zooey,* a major influence on Anderson and Owen Wilson's original screenplay for *The Royal Tenenbaums* (2001).

TOP: Anjelica Huston on set. Photograph by Laura Wilson.

Paris, those buildings—you know those wide shots where the buildings are tiny in the background?

Yes!

I love those.

Very deep focus, very, very crisp images, and almost a sense of distortion, you might say, with the edges of the frame bowed.

It's very kind of . . . "expressionistic," I guess is the word.

What are some qualities of Orson Welles as a director, or simply as a storyteller, that you enjoy?

He's not particularly subtle. He likes the big effect, the very dramatic camera move, the very theatrical device. I love that! And then also, he loves actors, and he is an actor himself, and he always created great characters that also tend to be larger than life.

There is a Wellesian sensibility in certain parts of certain films of yours.

Well, that would be great. He's one of my heroes.

Welles, Godard, Hitchcock, Woody Allen, Martin Scorsese—what, if nothing else, do these filmmakers have in common?

They are not simply people behind a camera. You are aware of them. You feel the hand of the storyteller guiding the story when you watch their movies. And sometimes you actually see them, on camera, in the movie.

Roman Polanski is another name you should add to that list. He is also both things.

We haven't seen you, I don't think—you, Wes Anderson on-screen, except in that American Express ad you did many years ago. We see your hands stamping the card in the library book at the start of *The Royal Tenenbaums.* We've seen your draw-ings, your sketches. You're one of the voices narrating Richie's tennis court meltdown in *The Royal Tenenbaums.* You were the voice of Weasel in *Fantastic Mr. Fox,* and you acted out a lot of the characters' motions for the animators.

Well, maybe "acted" is too strong a word. Part of how I would communicate with the animators, and with the director of animation, was to make little videos, but it wasn't meant to be a performance. It was just meant to communicate certain things that the puppets could do. But sometimes a gesture is hard to describe. You have to sort of do it for people. If the gesture is like, "I'll meet you on the other side," I could show them a gesture that means that a bit more easily than if we sat there talking about it until we both figured out that we were talking about the same thing.

Have you ever studied acting?

I was interested in acting when I was a teenager.
And I acted in plays and things like that. But it's
not something I've ever wanted to do as an adult.
I always wanted to write and direct. I'm lucky
enough to be able to get some of these movies
made. I went down this path, and I don't see any
need to diverge from it.

No mid-career change in the works, I suppose.

No!

**The characters in *The Royal Tenenbaums* all wear their
personalities on the outside, I think perhaps to a greater degree
than in any other movie you've directed. You know, Richie is still
wearing the tennis headband.**

Keeps the sweat off.

**And Margot has got that "stay away from me" makeup and the
cigarettes and everything. All these characters, they look like
they could be *New Yorker* cartoons or something.**

Hmm.

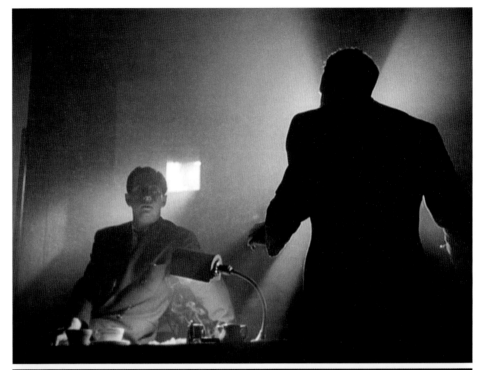

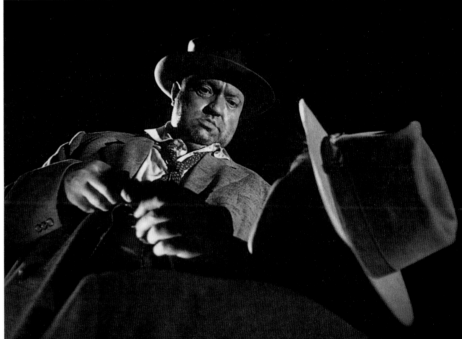

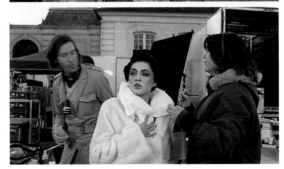

ORSON WELLES, IN DARKNESS AND LIGHT.
OPPOSITE TOP: The reporter receives his assignment in *Citizen Kane* (1941); MIDDLE: Welles as the corrupt cop, Hank Quinlan, in *Touch of Evil* (1958), the director's last film for a Hollywood studio; BOTTOM: Welles as Michael O'Hara in his film of *The Lady from Shanghai* (1946), opposite costar and then-wife Rita Hayworth and their countless reflections. Welles often used mirrors in his compositions, sometimes using multiple reflections to suggest the multiplicity and mystery of our selves. FAR LEFT: Anderson channeling Welles by way of Francois Truffaut in an American Express ad modeled on Truffaut's *Day for Night.* ABOVE: A lobby card featuring Anthony Perkins as Josef K., a bureaucrat hounded for his alleged role in an unspecified crime in Welles's *The Trial* (1962), based on Franz Kafka's novel.

Did you actually draw them beforehand? Did you do any sketches of them? Did your brother, Eric, do anything?

I did have Eric do drawings of the characters at one point, because I wanted to send a drawing to Gene Hackman. I was trying to convince Gene to do the movie, and I had Eric draw this illustration that showed what all the actors would look like, with Gene's character in the middle, and it had a couple of people who were not actually cast in the film. But I sent him Eric's original artwork, which we shouldn't have done. We should have scanned it and sent him a good duplicate. Because later I asked Gene twice if we could borrow that drawing, and I fear I think he threw it in the trash.

Oh my God!

He couldn't find it, anyway.

Oh dear.

Maybe Gene just didn't want to loan it back to us. But anyway, it had some of the wrong cast, so we probably couldn't have used it for whatever our purpose was.

Gene Hackman—it was always your dream for him to play Royal?

It was written for him against his wishes.

I'm gathering he was not an easy person to get.

He was difficult to get.

What were his hesitations? Did he ever tell you?

Yeah: no money. He's been doing movies for a long time, and he didn't want to work sixty days on a movie. I don't know the last time he had done a movie where he had to be there for the whole movie and the money was not good. There was no money. There were too many movie stars, and there was no way to pay. You can't pay a million

Orson Welles powerfully influenced Anderson's conception of what a director does and is; Anderson is far from the first auteur to incorporate aspects of Welles's persona and working methods, as Welles's legend remains so potent that it is virtually impossible for moviemakers not to absorb aspects of his work and life. After a dazzling early career in radio and theater, Welles directed *Citizen Kane* (1941), *The Magnificent Ambersons* (1942), *Touch of Evil* (1958), and *Chimes at Midnight* (1965), among other features. He started in Hollywood so young (at twenty-five!) that he remains the definitive example of a wunderkind director, making up for whatever he lacked early on in life experience with knowledge about theater, literature, radio drama, filmmaking, and other arts. Like certain other directors from Hollywood's first half century—including Erich von Stroheim and Alfred Hitchcock—he refused to be the invisible hand behind the camera and instead

foregrounded the film production process through publicity and numerous acting roles in other people's pictures. All his movies were both freestanding works of art and extensions of his public persona—or as we might call it nowadays, his brand. Anderson evokes many Wellesian signatures, including the use of extreme wide-angle lenses (often placed at a low angle so that ceilings are visible in the shot) and fantastically complex extended tracking shots through geographically tricky locations. One of the famous shots in *Citizen Kane* (the rising-through-the-opera-house maneuver showcased on this page) is echoed in an equally fantastic shot from *The Life Aquatic* (opposite) that tracks laterally across Zissou's boat and runs about the same length. Other directors with a keep-it-going aesthetic include Stanley Kubrick, Carol Reed (who directed Welles in 1949's *The Third Man*), Max Ophüls, and Jacques Demy, whose tracking shots sometimes added woozy slow motion that feels very "Andersonian."

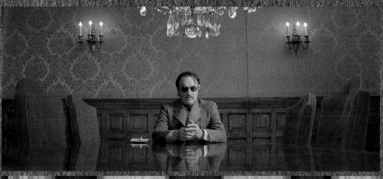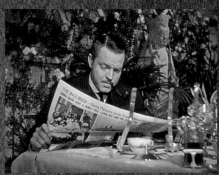

RIGHT: The endless dining room table separating Royal and his children in the prologue evokes the famous montage in *Citizen Kane* that conveys the growing emotional distance between Mr. and Mrs. Kane by showing them at a long table, sitting farther apart as years pass.

OVERLEAF: Wellesian touches abound in *The Royal Tenenbaums*, as they do throughout Anderson's filmography. The "dramatis personae" montage is inspired by the roll calls in 1941's *Citizen Kane* (LEFT-HAND PAGE) and *The Magnificent Ambersons*.

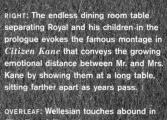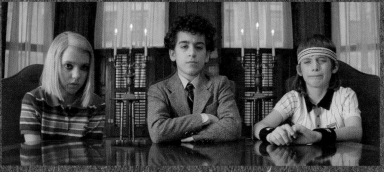

JOSEPH COTTEN
CITIZEN KANE

DOROTHY COMINGORE
CITIZEN KANE

AGNES MOOREHEAD
CITIZEN KANE

RUTH WARRICK
CITIZEN KANE

ERSKINE SANFORD
CITIZEN KANE

EVERETT SLOANE
CITIZEN KANE

PAUL STEWART
CITIZEN KANE

GEORGE COULOURIS
CITIZEN KANE

dollars to each actor if you've got nine movie stars or whatever it is—that's half the budget of the movie. I mean, nobody's going to fund it anymore, so that means it's scale.

Was it actually scale?

Yep.

Wow.

Yep. But eventually, his agent wanted him to do it. He was close to his agent. And he came around, and he did a great job, I thought. I mean, I was just very excited to have him.

In addition to a lifetime of technique, he also is an iconic actor. You talk about you and Owen Wilson kind of worshipping at the altar of sixties and seventies American New Wave—he's one of the guys.

He's one of the guys.

I mean, was that part of the reason why—

No, I don't think so. No. It's just that the part

wanted a legend, but really beyond that, it was just *written* for him.

Literally, or did you realize that after you'd written it?

No, it was written for him, literally. It was during the writing. I told him before. I met with him before. I called his agent and said I wanted to meet Gene because I had this thing I wanted to write for him, and he said, "Well, I'll talk to him, but he won't meet you until you send him the script." And finally he agreed to let me meet him, and it didn't help.

What was the meeting like?

He was very nice. He was very reserved. He said, "I don't like it when people write for me, because you don't know me, and I don't want what you think is me." And I said, "I'm not writing it for what I think is you—I have a character. I'm writing for you to play it." But when it came to him, he didn't want to do it. If we'd gone to him with an offer of anything like what he actually gets paid, then maybe it would have been easier to get him.

BELOW: Anderson directs the initial meeting of "Pappy" Tenenbaum and his two grandkids Ari and Uzi (Grant Rosenmeyer and Jonah Meyerson). Both children's names are Hebrew. Uzi is an Old Testament word meaning "Jehovah is my strength" and the name of an Israeli machine pistol. Ari is short for "Ariel, Son of God." It also happens to be the nickname of the musician Nico's son; she has two songs on the film's soundtrack: "These Days" and "The Fairest of the Seasons." Photograph by Laura Wilson.

OPPOSITE: Eric Chase Anderson's character sketches, and the gathered ensemble (from left to right): Luke Wilson, Gwyneth Paltrow, Gene Hackman, Grant Rosenmeyer, Ben Stiller, Jonah Meyerson, Anjelica Huston, Danny Glover, and Kumar Pallana.

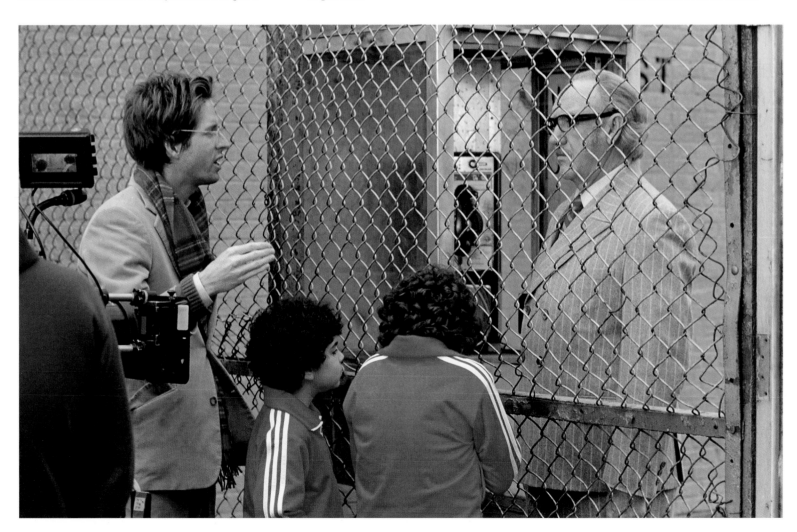

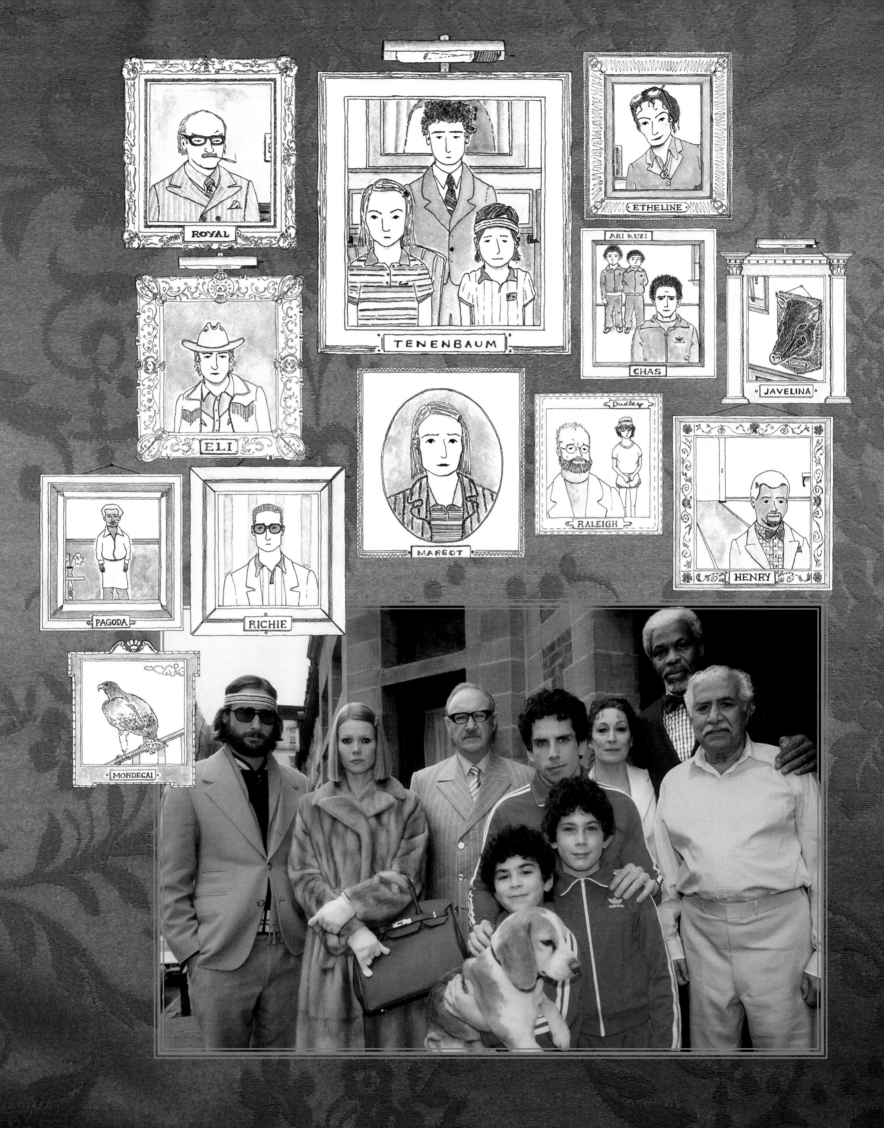

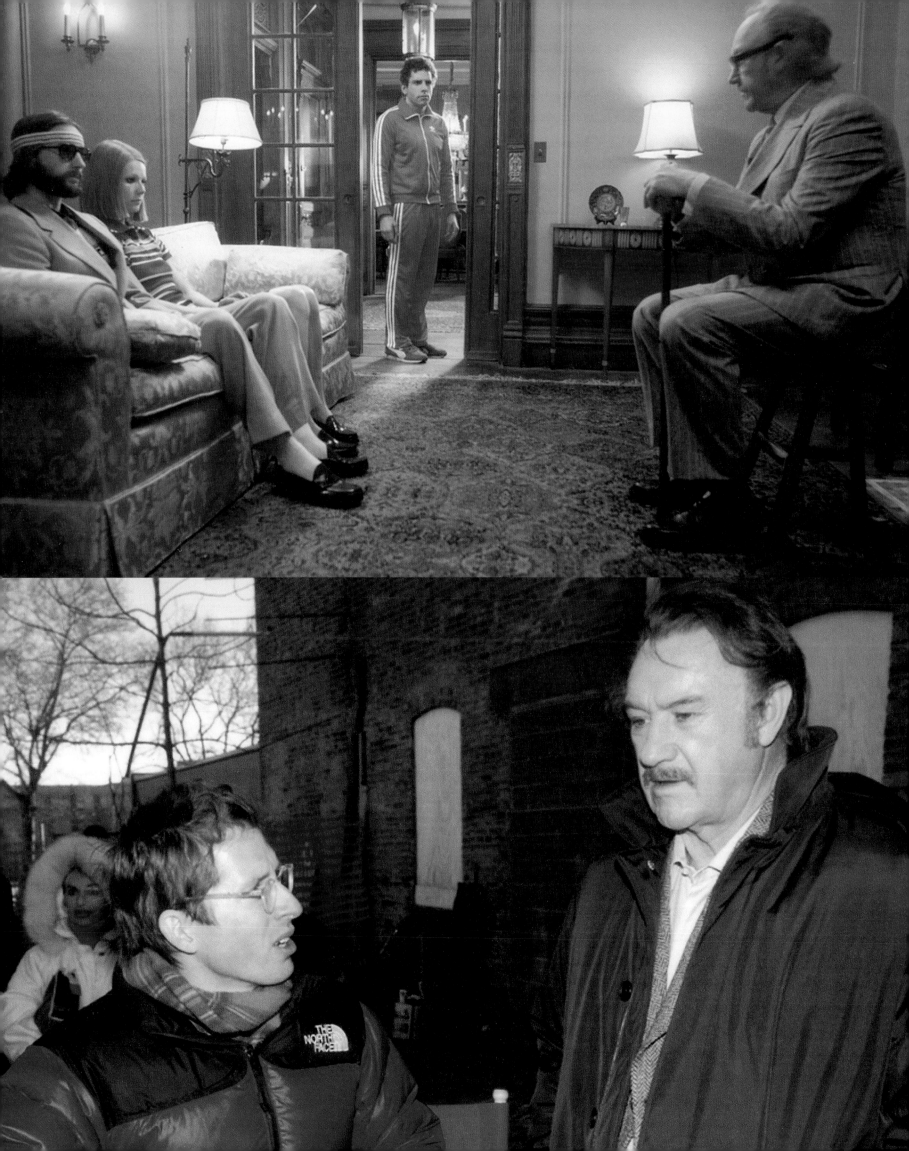

You certainly give the legend his due in the movie. You've got a little nod to *The French Connection* thrown in for good measure.

What do we have? What's our *French Connection* thing? I mean, I thought of *The French Connection* often.

There's the go-kart homage during the "Me and Julio Down by the Schoolyard" montage.

Ah. Yeah, they have dogfights, and there's a lot of *French Connection*–period New York.

And also just the whole sense of Royal Tenenbaum introducing people, introducing the grandchildren, to a less managed way of life, a more dangerous time.

Hmm.

He's bringing the danger back.

Right.

He's a visionary character, this guy, in his way. I mean, he's certainly a strong-willed character.

Right.

And there's no other character in the movie who has that degree of outward-projected force.

Right.

Other characters in the movie are intense, but they're not projecting it outward all the time the way he is.

Right.

You have those types of characters in your movies a lot.

Hmm. There's usually a talker in the middle of it somewhere, trying to get everybody riled up.

OPPOSITE: Royal (Gene Hackman) delivers the "bad news" to his children.

OPPOSITE BELOW: Wes Anderson and Gene Hackman on set.

ABOVE, LEFT AND RIGHT: An homage to the legendary car chase under elevated train tracks in 1971's *The French Connection*, reenacted near Brooklyn's Gowanus Canal with go-karts.

RIGHT: Another shout-out to the *Peanuts* specials—text that writes itself across the screen in time to the rhythms of dialogue (in *The Royal Tenenbaums*, LEFT) or voice-over (1966's *It's the Great Pumpkin, Charlie Brown*, RIGHT).

OVERLEAF, LEFT-HAND PAGE: Annotated still frames from *The Royal Tenenbaums*, identifying key locations. Note that Richie's and Chas's doors are open, but Margot's is closed.

OVERLEAF, RIGHT-HAND PAGE: Irene Gorovaia, Aram Aslanian-Persico, and Amedeo Turturro as the younger incarnations of Margot, Chas, and Richie; Ben Stiller, Jonah Meyerson, Grant Rosenmeyer, Gwyneth Paltrow, and Gene Hackman in the present-day part of the story.

Dear Eli, I'm in the middle of the ocean. I haven't left my

room in four days. I've never been more lonely in my

life, and I think I'm in love with Margot.

DEAR GREAT PUMPKIN, I AM LOOKING FORWARD TO YOUR ARRIVAL ON HALLOWEEN NIGHT.

EVERYONE TELLS ME YOU ARE A FAKE, BUT I BELIEVE IN YOU.

P.S. IF YOU REALLY ARE A FAKE, DON'T TELL ME.

**CHAS' ROOM
(2nd FLOOR)**

**MARGOT'S ROOM
(3rd FLOOR)**

**RICHIE'S ROOM
(ATTIC)**

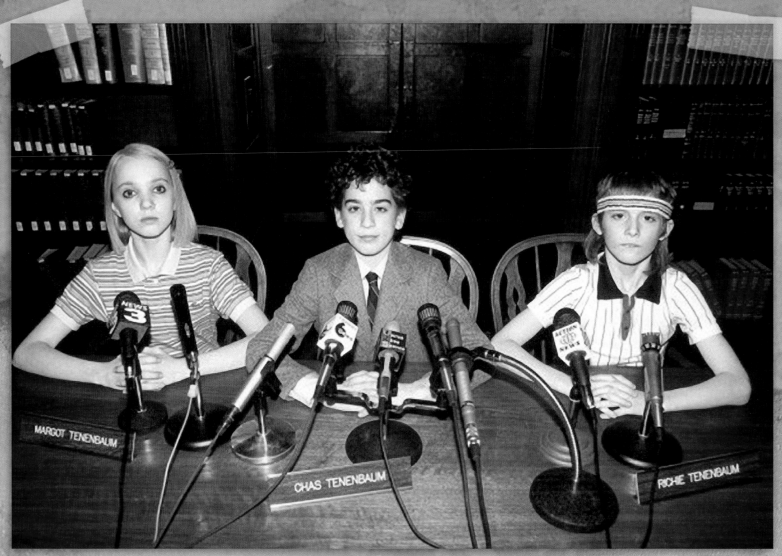

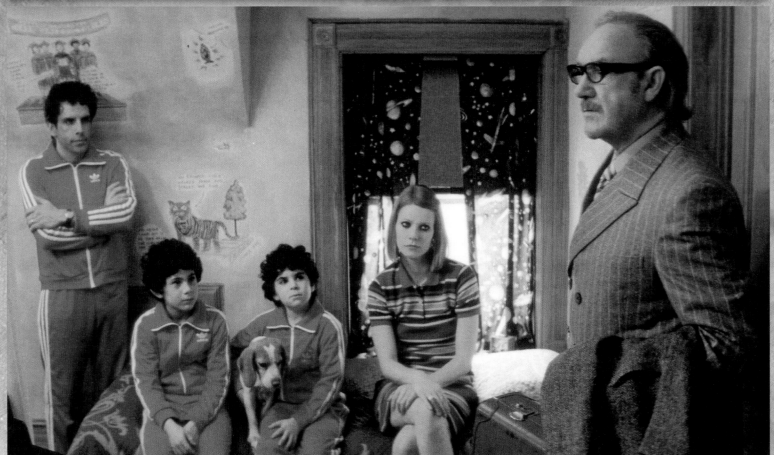

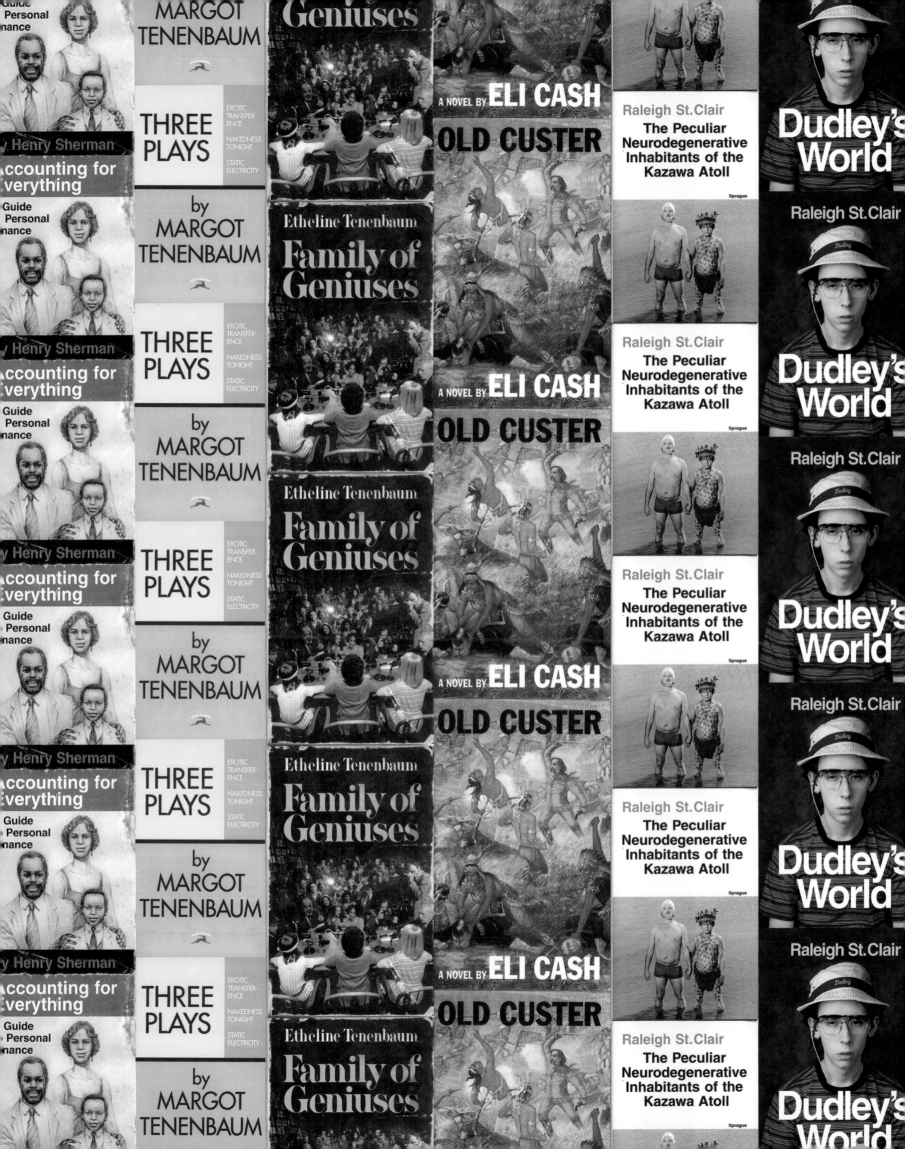

You don't seem to be that type of a person yourself, though.

You know, I do like to get the group together and say, "Let's give it one more try." I do like to have a kind of project going with a company, but that's probably the extent of it.

The annotations on the screen go to a whole new level in this movie.

In this one we've got a lot of them, because we've got all the ones in the flashback, or whatever you call that thing in the beginning.

I would call it a prologue.

It *is* a prologue; I think it's actually called that. In fact, sometimes I think back on how I did certain things and think, "Now, that's odd that I made that decision." Like, you see the actual printed pages of the books, but the chapter titles are superimposed on them; the text and the spot illustration are printed on the page, but then it says "Chapter Two," or whatever. "Prologue"— that's a movie title. Why did I do it that way?

Why did you multiply the book covers? You have book covers and other pieces of art that are multiplied in almost a mosaic pattern.

Well, for those, I know why I did it that way. I saw that in *Two English Girls*, which is another movie that was quite a big influence on *Tenenbaums*. In that film, Truffaut takes copies of the book and fills the frame with them. The thing is, I thought Truffaut just did that because he had twelve copies of this book. We had to physically make each copy, so I could have easily just said that in our case, we can just have the one, but I wanted to do the mosaic thing.

It seems fitting, given the multiplicity of characters and plots— it's almost too much of everything.

Also the other thing you could say is, "Well, if we don't fill it with books, we've got to put something else in there." A book is shaped like *this*, and the frame is shaped like *this*—what else is going to go in there that's not going to take away from this part here? Well, how about the same thing over and over again? That will do it. Yes.

How did Danny Glover come to be cast in *The Royal Tenenbaums*?

PREVIOUS OVERLEAF: The film's publishing, collected in one mosaic. Anderson says the tile-patterned inserts were inspired by François Truffaut's *Two English Girls* (1971). Truffaut is discussed at some length in the chapter on *Moonrise Kingdom*. Trivia note: The shot of Eli Cash is inspired by an image from photographer Richard Avedon's landmark 1985 portrait series *In the American West*. Owen Wilson's mother, Laura Wilson, was Avedon's assistant from 1979–84; she documented the creation of *In the American West* in her 2003 book *Avedon at Work*.

THE FACES OF DANNY GLOVER
OPPOSITE TOP: "Did you just call me
Coltrane?" (frame); BOTTOM LEFT: Frame
of Glover as Roger Murtaugh, the cop
indefinitely on the edge of retirement in
the *Lethal Weapon* movie series;
BOTTOM RIGHT: Charles Burnett's *To
Sleep with Anger* (1990), starring
Glover as the troublemaking Harry.

ABOVE: Henry Sherman (Danny Glover)
and Etheline Tenenbaum (Anjelica
Huston) in the run-up to their first kiss in
The Royal Tenenbaums.

I had particularly loved him in the Charles Burnett film *To Sleep with Anger,* which he's so great in, and also Jonathan Demme's *Beloved.* But he's also great in *Witness.* Do you remember him in that?

I remember him vividly.

You always remember him vividly.

The first thing I remember is the scene where he and the other dirty cop murder that guy in the men's room at the train station, and he's at the sink, and the other guy says, "We gotta get out of here," and he looks at him very coldly and calmly and says, "I'm just washing my hands, man."

He's great! In fact, I think we might quote a scene from him.

From *Witness*? In *The Royal Tenenbaums*?

I think in *The Royal Tenenbaums,* it's not Danny's line, but in that movie I think Danny shoots Harrison Ford in the parking garage, does that sound right?

I think so, yeah.

And Harrison Ford, after he's shot, says, "I know you, asshole!"

That's right!

And Gene Hackman says that in *Tenenbaums:* "I know you, asshole!"

Though Danny Glover is a classically trained actor who's played a lot of diverse roles, he became a star in thrillers, military dramas, and action-adventures. He was one-half of the cop team in the *Lethal Weapon* movies. But in *Tenenbaums* you cast him as a peaceful, somewhat repressed gentleman in a bow tie.

You wouldn't normally think of Danny as an accountant, because he's a very dynamic person. And he has an artist's personality in every way. Yet in *Tenenbaums* he's playing a guy who is the opposite of that, really. But he has a kind of gentle manner, and he's also a very conscientious person. So there is definitely a part of him that relates to this role. The guy he's playing is nowhere near as cool as Danny Glover is in real life. Henry Sherman is awkward, he's clumsy. But nevertheless, he's got—what would you say? There's something of Danny Glover in the role.

There is a gravitas to Danny Glover that comes through even when he's falling into a pit.

Yes.

Gwyneth Paltrow is excellent as Margot, a role that seems to awaken something very deep in her. And it occurred to me that you've got Paltrow, whose mother is Blythe Danner and whose father was the beloved television director Bruce Paltrow; you've got Anjelica Huston, descended from the Huston family; you've got Ben Stiller, son of the performers Jerry Stiller and Anne Meara. And then you've got Luke and Owen Wilson, sons of Laura Wilson, a notable American photographer. That's a lot of anxiety of influence gathered in your main cast.

That's true.

Was that part of the plan, or is that just how it happened?

Well, probably it's part of what draws you to them and makes them seem right for the parts—it all gets woven into it. And also, Royal says, "I'm mick-Catholic, but the children are half-Hebrew," something like that. He has some line like that. They're half-Jewish, half-Irish, is the idea.

Yes.

Well, that's what all these actors sort of are. Stiller and Meara: I think that is Jewish-Irish.

It is.

And the Glass family in J. D. Salinger's stories— that's what they are, too. And it all kind of gelled and took that shape.

How did Anjelica Huston end up in the movie?

I'm a great fan of Anjelica's, but in particular of *The Dead* and *Prizzi's Honor* and *The Grifters*. I think those movies were the ones that made me want to use her. Plus, she'd been in *Crimes and Misdemeanors*, and she was very good in that. I wrote her part for her, too, and I met her in New York and loved her immediately.

You also cast Bill Murray in a role that, in retrospect, *seems* like a Bill Murray part, although no one at the time could have known it would be a Bill Murray part. I think you did it again with Anjelica Huston in three movies. Was there any precedent or bit of information that made you think she'd be right for Etheline?

No. Probably I just *knew*. What we know about her suggests that if there *are* any living people like the characters in *Tenenbaums*, she knows them and she's probably related to them one way or another, you know?

I guess, between having dated Jack Nicholson and having John Huston as her dad. Did she talk to you about that ever during the shoot, about perhaps seeing something in the script that sparked an association with her in her life?

I think it's probably safe to say Anjelica has known every kind of person you can think of. She's covered it.

I was not tremendously shocked to see Owen knock the role of Eli Cash out of the park. It seems like almost a fantastic, cartoon version of the public image of Owen Wilson, and the same for Gwyneth Paltrow as Margot. The real surprise for me was Luke Wilson. Although there was an undercurrent of melancholy to some performances he'd given before, I was completely unprepared for the sheer magnitude of suffering and pain he brought to the part of Richie Tenenbaum. And his face—certain titles of your films make me think of one image, and the image I think of for this film is him looking in the mirror

OPPOSITE: Anderson directs Anjelica Huston. Photographs by Laura Wilson.

ABOVE: Publicity photo of Anjelica Huston (RIGHT) with her father, director John Huston, on the set of *Prizzi's Honor* (1985) with costars Kathleen Turner and Jack Nicholson.

after he shaves, just before he tries to kill himself. That's *The Royal Tenenbaums* to me—that shot. What was it that made you think he would work in this?

I just thought he would. That part was written for Luke, certainly, and there were several things at play. One is that Luke has always had some people who were his followers. When Luke got sent to boarding school, he was saying that no one there liked him, and his father went to visit him, and maybe I won't remember this exactly right, but the thrust of it is that when his father got there, Luke was just being elected one of the prefects or something. When Mr. Wilson got there, what he saw was that Luke was one of the most popular kids in the school, that he was kind of a hero in the school—but Luke just didn't feel that appreciation I guess. He didn't want to be there. He was sad there, and he was homesick, and he didn't want to be there. And that kind of combination, that's very unusual. He's a very charismatic person, and he certainly doesn't wear his heart on his sleeve.

He's walking around like a ghost in this movie. He's like a ghost in his own life, and I know it's an ensemble movie, but if I had to say who the movie is about, I think I would say it's about him.

I always thought of it that way. I mean, Gene does have the showiest character, but Luke's character is the hero of the movie. Here is the ensemble around him, his family. But he is the center. Not Hackman, but Luke. The thing is, Hackman makes things happen in the story. Royal, I guess you'd call him.

Right, he's an irresistible force.

And he does things, as a result of which everything's happening. He's lying and doing the things that are making the next thing happen.

Right. He's committing acts that a person should atone for, and then he's atoning for them.

I like that.

And yet, ultimately, it's Richie who kind of turns the key in the engine, and that's when the family—I wouldn't say they ever quite become healthy, but certainly they're addressing things they haven't before and trying to make amends for things that have gone wrong, and I feel like he's responsible for that.

Does Richie go to Royal or something in the end? In the last part of the story?

Yeah.

He brings him back in, right?

Yeah. I didn't even realize it until a couple of months ago. I watched it again, and I went, "Oh wow, he's kind of like Max Fischer in *Rushmore*. He's bringing everyone together."

Richie brings Royal over to see Eli.

And talks some sense into him.

Right, right. He walks in with him and—

Also, he reaches out to Royal after Royal's been completely cut off from the family.

But do we see him go to him? We only see him with him when they go to Eli, right? Or is there a scene before?

There's a scene where he goes to see him in the hotel, and they're riding in the elevator together.

Yes, and the bird comes back.

Yes.

Yes, you're right.

And there's the moment up on the roof.

He goes to the hotel, and they're riding in the elevator. What are they doing there? He's gone there—I just don't remember.

[MATT LAUGHS]

ABOVE: Promotional still featuring Huston with Martin Landau in Woody Allen's *Crimes and Misdemeanors* (1989).

OPPOSITE: Anderson and Huston on the *Tenenbaums* set. Photograph by Laura Wilson.

OVERLEAF: Mordecai the falcon was actually played by three falcons and a hawk. The falcons were for close-ups in which the child and adult versions of Richie handled the bird; the hawk was for the shot at the end of the prologue where Mordecai flies off the roof of the Tenenbaum home. There's an Internet rumor that Mordecai's feathers changed because the production crew lost one falcon, had to replace it with another, then wrote new dialogue to account for the fact that Mordecai looked different. (Richie: "This bird has much more white feathers on him." Royal: "Oh, the son of a bitch must be molting.") But the director says this is incorrect. The falcon's changed appearance was always in the script, he says, and although they did lose a falcon during shooting, they got it back. The first bird—used in close-ups during the prologue—"flew away, and the person who found him in New Jersey wanted money to return him, but we had a tracking device anyway," Anderson says. "It was just odd good luck that the main bird's sister actually did have more white features. Those were peregrine falcons, and there was another one, too, plus a hawk, which we were authorized to release into the wild—it was rehabilitated from something, and now ready. That's what flies away at the beginning: a hawk. The actor releases a falcon, but then we cut to a hawk." Photograph by Laura Wilson.

I do remember shooting it, but I don't remember what happens. I know they're in the elevator together. He hangs the boar's head back up on the wall, and then he goes to his father—that's what happens. Yes, I remember. "Ruby Tuesday."

That's right.

I've shown I have a rough memory of approximately what might have happened. It was a long time ago, I must say.

I do want to ask about the production design, because this is, I think, a quantum leap over *Rushmore* in terms of the moving parts. I'm assuming you had a shop that was working 24/7, just making stuff.

One thing that helped was that everybody knew what we meant to do. We hired just enough people, and we did it. I worked with Eric, my brother, before we started the movie, and he drew everything for the house. We had everything kind of done, and I gave the work to David Wasco and Sandy Wasco, the production designers, and they knew—they had a lot of information that wasn't just my notes; they had pictures of all these things. Eric did very good pictures.

There's a moment in the opening montage where the narrator's talking about Margot, and we see her click on a light in her little model theater. I laughed at that the last time I saw it, because you're really big on cutting away walls, or on shots that seem to have cutaway walls, even if that's not what you're looking at.

Shots that require cutaway walls, whether you're supposed to notice it or not.

Right, right—that idea that you're Superman, with X-ray vision, and you can see into the building. Did you build a lot of dioramas when you were a kid?

Some, I think, but I used to draw a lot of things in cutaway perspective. I used to draw houses where you could see inside, and boats and things—I've always liked those kinds of views. And *The Life Aquatic* was inspired first by a character—somebody like Jacques Cousteau—but also by an idea about a boat that's been cut in half. I mean, that was the beginning of the movie, those two things.

You've got a lot of shots in all your movies where we seem to be physically moving through walls. In some cases they seem to be sets that were specifically built that way, and in other cases you seem to position the camera in such a way that you're moving through a doorway and it appears that you're passing through a wall, or you're going up or you're going down a level.

I remember that when we did the opening scene of *Bottle Rocket,* in the very beginning when he's in a mental hospital, his bedroom was, in fact, just the end of a long, open room. It wasn't a little bedroom—we just used three walls of a bigger space. One end of a big room. I remember, at the time, thinking that this is a very good system, which is basically to say, "A set. Interesting." And when we did *Rushmore,* we were supposed to do a scene where they were going to have a groundbreaking for the aquarium, and it was supposed to be on this baseball diamond, and we had all

ABOVE: Anderson and Luke Wilson filming the scene in which Richie arrives in port. Photograph by Laura Wilson.

OPPOSITE ABOVE: Luke Wilson shooting the hospital aftermath of Richie's attempted suicide. Photograph by Laura Wilson.

OPPOSITE BELOW: Richie on the roof. Photograph by Laura Wilson.

OVERLEAF: Anderson and Luke Wilson shooting sections of the attempted-suicide sequence. Photographs by Laura Wilson.

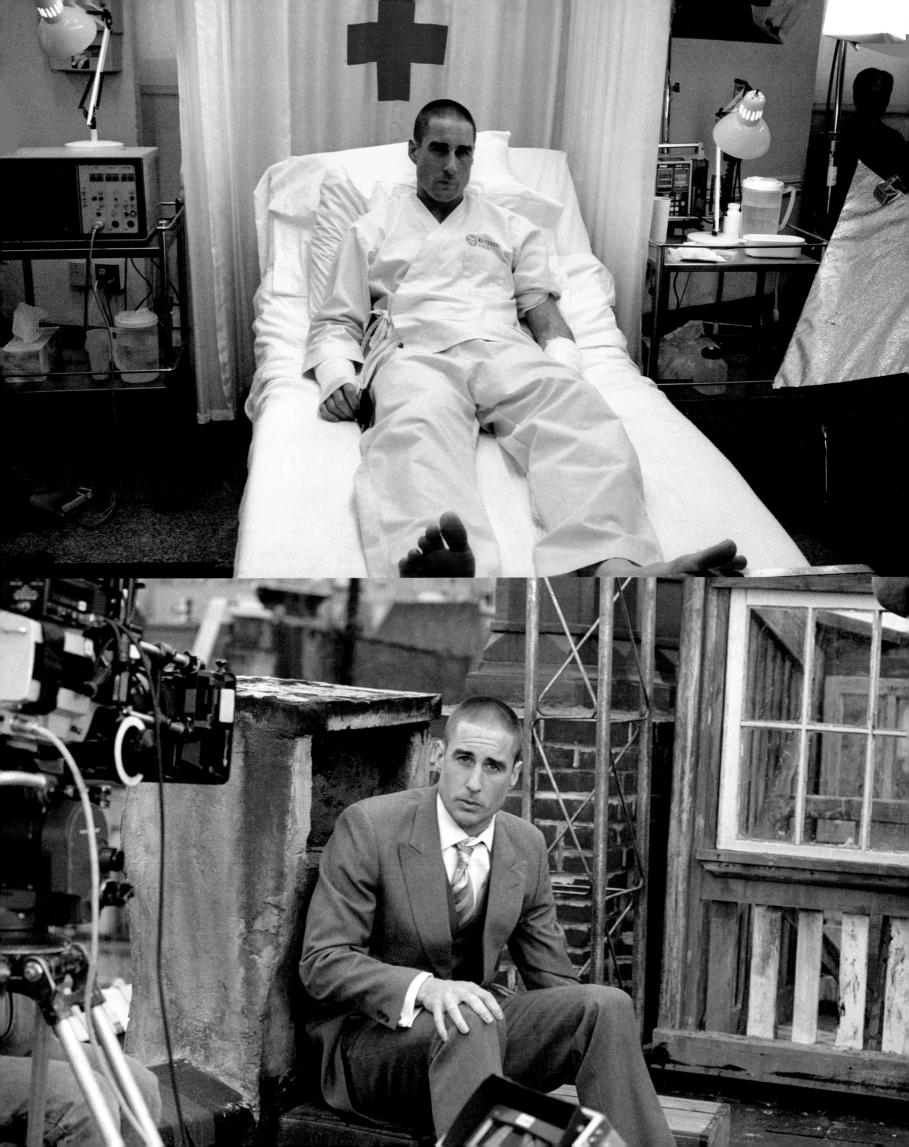

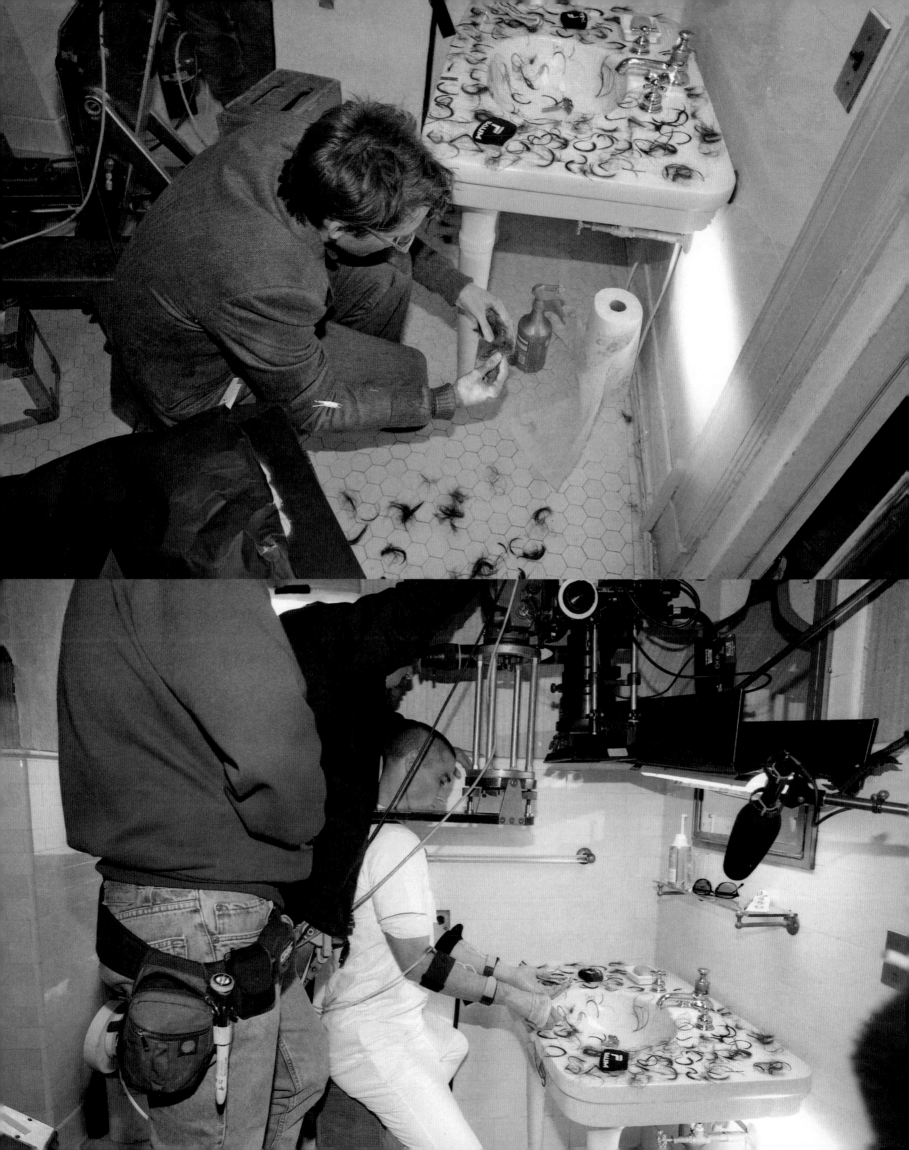

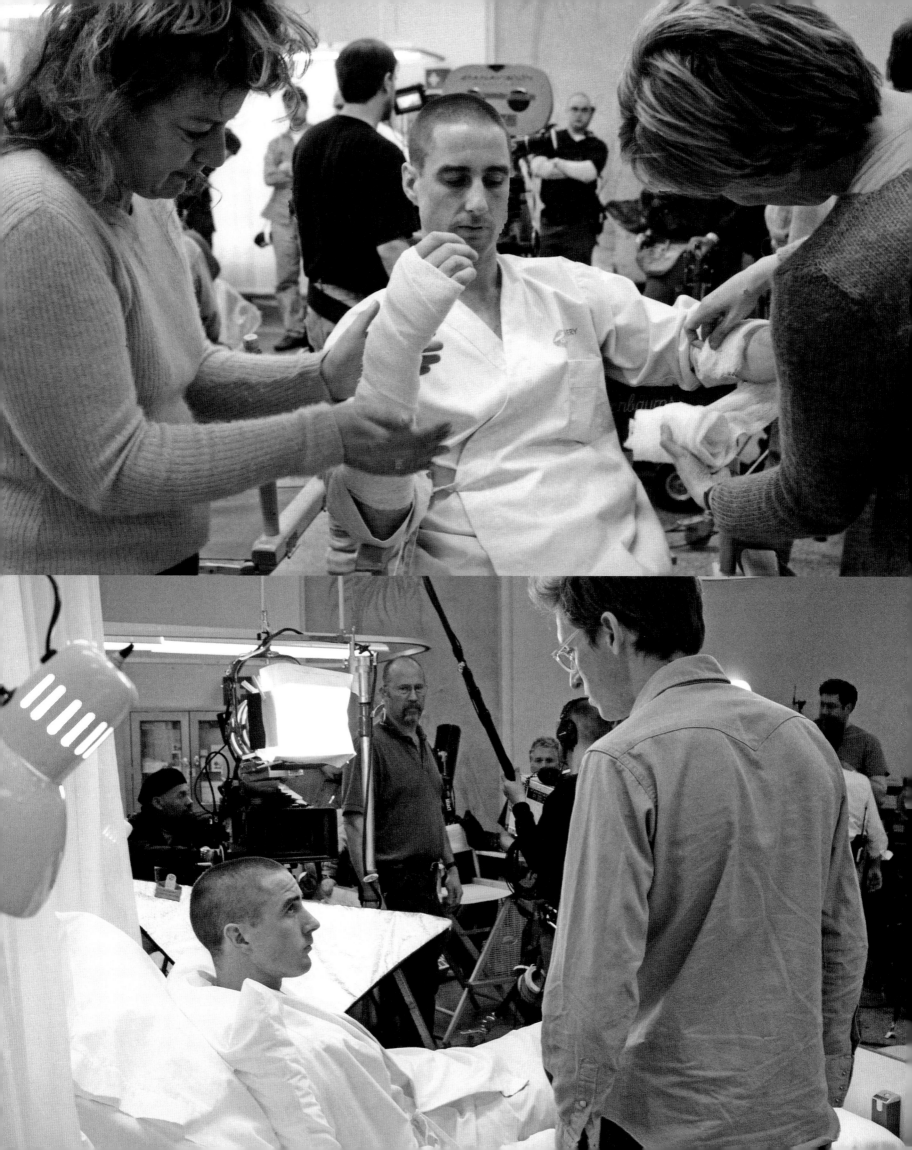

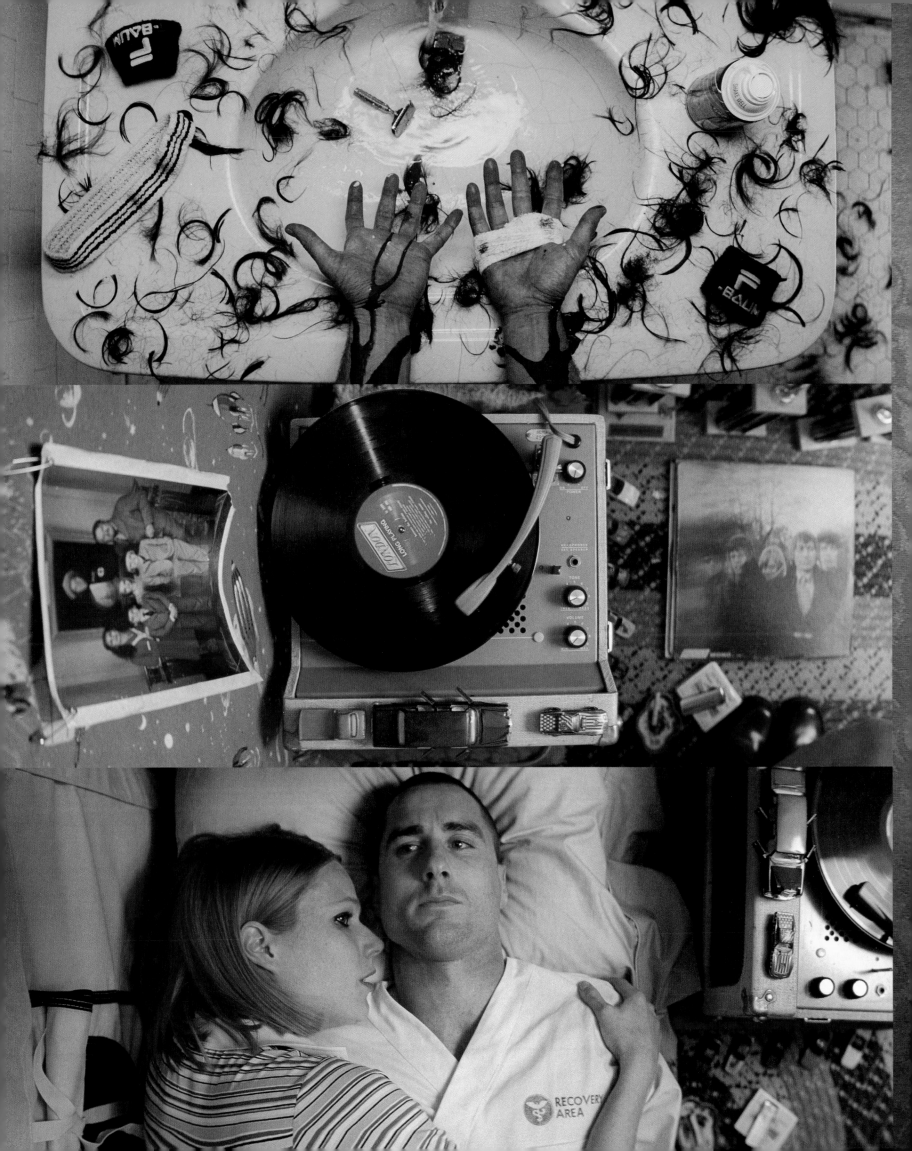

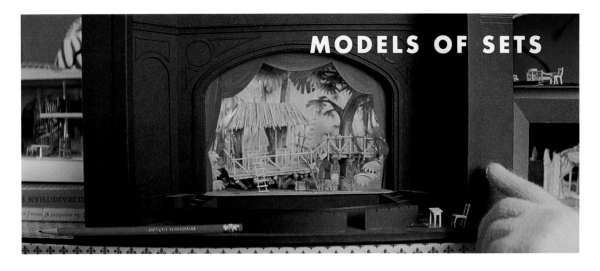

MODELS OF SETS

these things organized—and then it rained the night before, and we arrived, and the place was just mud. The field had ceased to be a baseball field. It was a problem. So I sort of came up with, "Let's not look at the baseball field, then. Let's look at the dugout and the backstop." We shot the whole scene in a line, a scene that was meant to be moving all around the place. "We're going to build a dolly track, and we're going to go here, here, here, here, and here." We did a scene, and I liked how it worked out very much. I've now done variations of that shot twenty-five times and followed the train of thought from getting rained off the baseball diamond—it's this kind of movement that I've always liked in movies.

Lateral.

Lateral, but only because, after this one instant of improvisation, I sort of kept doing it. More and more, I'd say, "I'd like to do this on a train track."

In addition to that shot you mentioned in *Bottle Rocket*, you've got the scene with Miss Cross and Max in *Rushmore*, where they're talking and you're moving across the fish tanks.

Yes, right.

That shot has an element of this in it.

And we weren't rained out.

But you're trying to make it look like the "Superman with X-ray vision" effect.

Hmm. Well, it's through the windows. And aquariums.

And then in *The Royal Tenenbaums*, you've got a lot of those moving-through-walls shots. And I felt like that shot of Margot clicking on the light for that diorama is, or at least has become, in retrospect, almost like a joke about this obsession that you have, you know? It's almost like making it official.

Hmm. Either a joke or just a part of it.

Yes. And then, since we're on this: *The Life Aquatic*. You have the boat chopped in half, and you're crawling all over that thing. But you also have the action sequence when they're rescuing the Bond Company Stooge. There are a lot of those types of shots—long lateral shots where the camera's passing through the architecture. And then I think it reaches its apotheosis in *Darjeeling* with the train. The train—that's my favorite.

The sort of "dream train" shot.

The dream train, yeah, because it's not just violating all the laws of physics—

It's violating all the laws?

Everything, space and time. There's nothing real in that shot. It's completely figurative space.

You're right. It's completely figurative everything. And the thing is, it's meant to be—but to me, the scene is really about "Remember this person?" and "Here's where this one is," and "Don't forget about this one."

Well, there's also sadness in commonality. It's like the idea of death as the great leveler, or the fear of death as the great leveler. That's rarely been expressed so simply as in that shot and the fact that all the train compartments are rich or poor. It's like the line from *Barry Lyndon:* "Rich or poor, they are all equal now." And then you turn to reveal the tiger in the bushes, which is your grim reaper.

Right. A man-eater.

There are a lot of recurring interests in your movies that get gathered together into that one shot.

I always thought when we were doing it that there was no question that we were going to do it, and we were going to do it in *this* particular way, and we needed Natalie Portman here, and we needed Bill Murray here, and whether four thousand, six thousand, or twelve thousand miles away—I don't know how many miles—we had to do it this way, we had to get everybody on this train, and we were going to do it this way. But I did always think, "I have no idea what this is going to—"

Wait a minute. That was on an actual train? I assumed that was a rear projection.

No, that was—

You built this set on an actual train? All the different rooms? And the countryside that we see going by in the background is the actual thing?

Yes, that's the real countryside. It was very exciting to do.

When you turn to reveal the tiger, what is that, the other side of the train?

OPPOSITE, FROM TOP TO BOTTOM: Examples of some of the more striking God's-eye-view shots in *The Royal Tenenbaums:* Richie regarding his slashed wrists; the record player in Richie's tent; Richie and Margot coming to terms with their attraction.

ABOVE: Young Margot lights up a theater set model. This close-up almost feels like a filmmaker's self-deprecating joke on his fondness for cross-section shots that photograph life-size interiors as if they were dollhouses or dioramas.

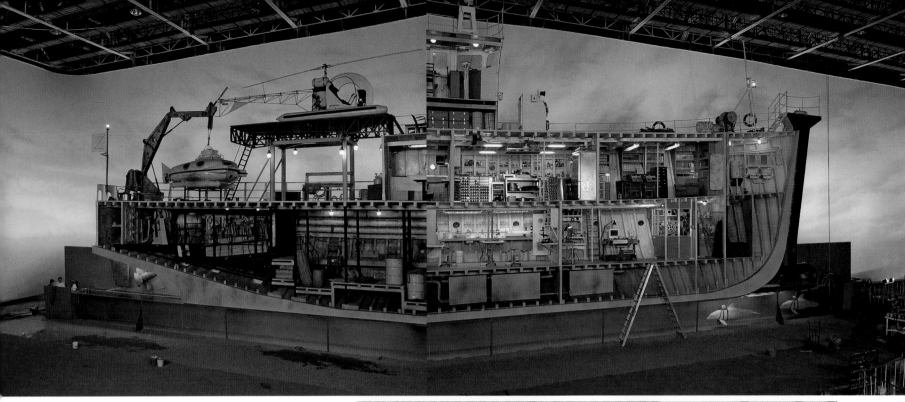

No, it's all one car. We gutted a car, and that is a fake forest that we built on the train, and it is a Jim Henson creature on our train car. The whole thing is one take, and I think because we did it that way, while we were doing it, we did feel this electricity, you know? There's tension in it because it's all real. Fake but real. I mean, that was the idea. The emotion of it, well—there's nothing really happening in the scene, you know? They just kind of sit there, but it was a real thing that was happening. But I did at the time have this feeling like "I don't know."

Well, it's also similar to that great near-ending shot of *I Vitelloni*, where he's leaving the town. But it's almost like an inversion of that shot, where you're seeing the camera passing through the rooms as if we're on the train, but this time it's like you turned it inside out in some way.

It's very beautiful, that *I Vitelloni* one, and there's another one in *The River*. Do you know it?

Yes.

A very similar thing.

Which brings us back around to our conversation about *Bottle Rocket: Rear Window. Rear Window*—what are we looking at? A series of people in these little boxes, and they're like animals in a zoo or creatures in a diorama, a butterfly collection.

Right.

And here you are, you're the viewer, you're looking. You can see through walls. It's kind of beautiful how it dovetails with so many of the concerns in *The Royal Tenenbaums*, chief among which is the sense that the world is looking at the Royal Tenenbaums, at us, that the eyes of the public—whoever that is—are constantly upon us, burdening us with their expectations, you know?

Right. Which we can only manage to disappoint.

THIS PAGE AND OPPOSITE: Examples of elaborate "dollhouse" shots, Wes Anderson–style.

The seeds of this signature shot were planted by accident during the filming of the aquarium groundbreaking scene in *Rushmore* (ABOVE). Anderson refines the technique in the "Let me tell you about my boat" sequence of *The Life Aquatic with Steve Zissou* (TOP). Unit photography from the surreal train compartment sequence of *The Darjeeling Limited*, the first "purely figurative" version of this type of shot; it unites characters in far-flung locations via dream logic (OPPOSITE). For still frame images of the *Darjeeling Limited* "Dream Train" tracking shot, plus discussion of how they were shot, see page 233 in the *Darjeeling* chapter.

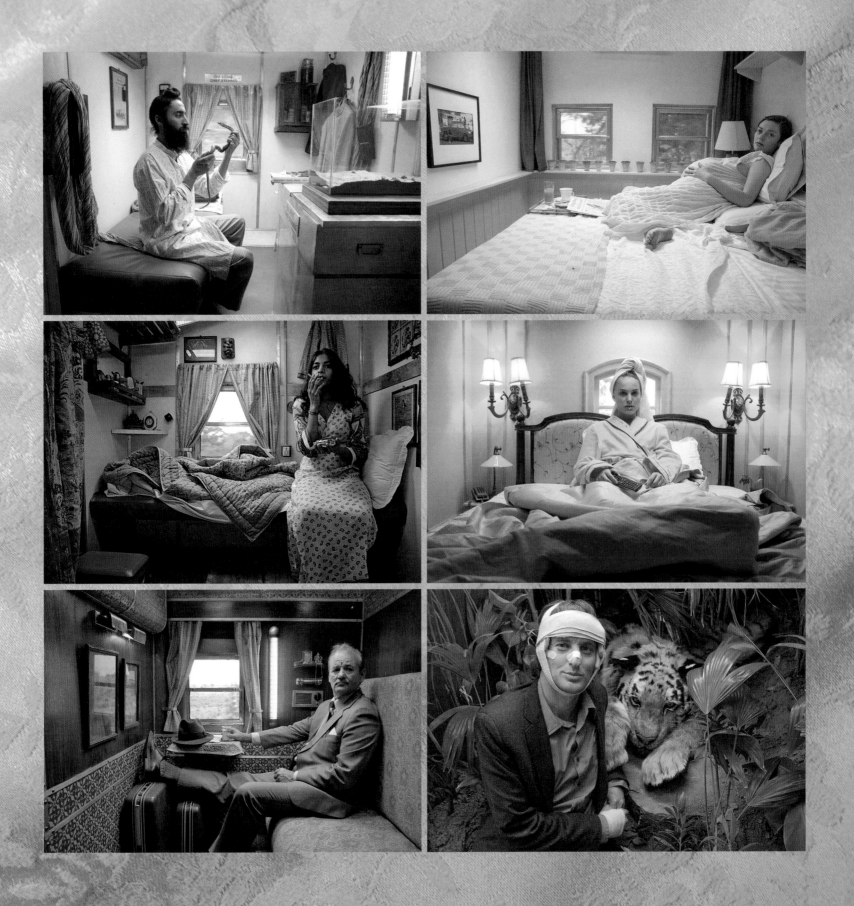

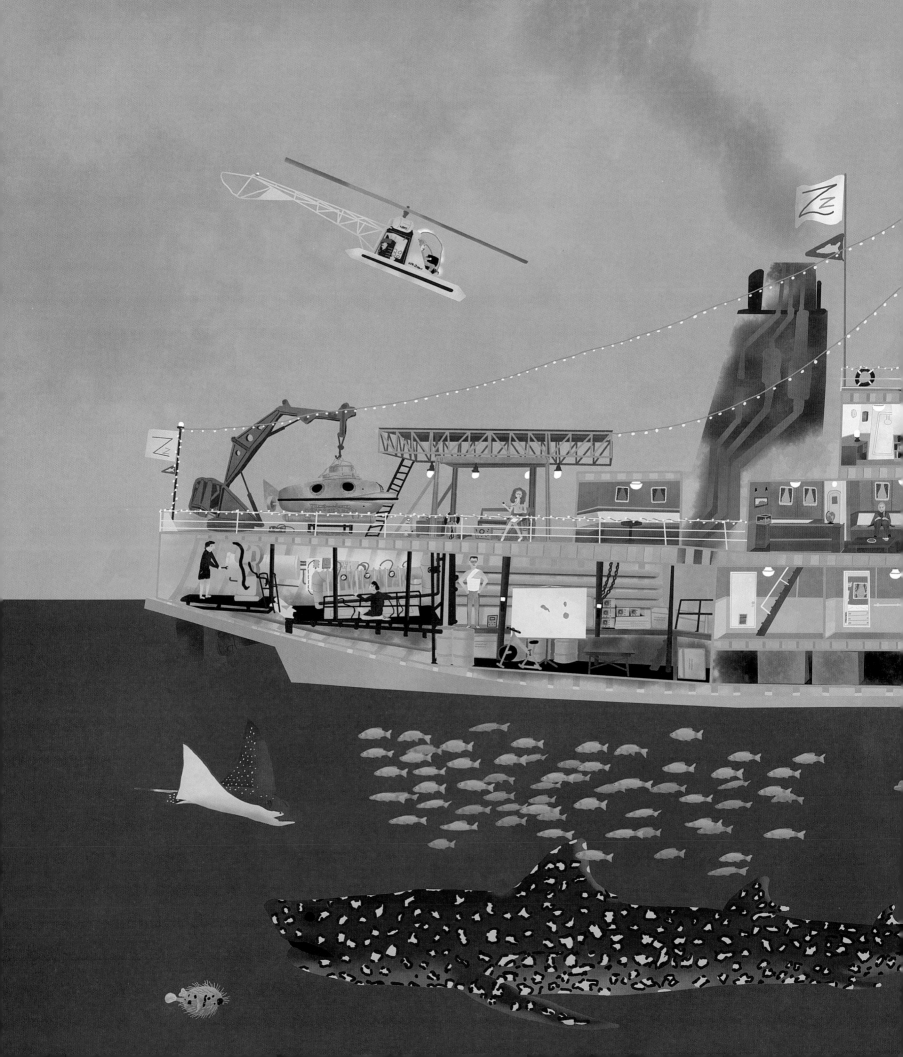

THE LIFE AQUATIC WITH STEVE ZISSOU

The 1,322–Word Essay

"**I**'M GONNA GO on an overnight drunk, and in ten days I'm gonna set out to find the shark that ate my friend and destroy it. Anyone that would care to join me is more than welcome."

With that declaration, the naturalist-director-pothead hero of *The Life Aquatic with Steve Zissou* drags the crew of his research vessel, the *Belafonte,* on a mission to kill the dreaded jaguar shark. It sounds like the plot of a sci-fi thriller, or maybe the umpteenth retelling of *Moby-Dick* or *Jaws*. But while Wes Anderson's fourth film draws on these modes and others, it's defiantly unique. Like its predecessor *The Royal Tenenbaums*, but more so, *The Life Aquatic* anchors its dazzling images and zigzagging detours to basic themes: the lived experience of grief, the futility of revenge, the anxiety of entering middle age and wondering if you'll leave a legacy along with your unfinished business. Cowritten with Noah Baumbach, *The Life Aquatic* is patchwork personal expression on a grand scale. It's as simultaneously old yet new-seeming as Zissou's boat, a refurbished World War II frigate containing a research lab and a movie studio. Dry comedy segues into romance, farce, and deep sorrow. There are lyrical montages and shots of stop-motion sea creatures with made-up names (sugar crab, golden barracuda, crayon pony fish). No wonder the film was a critical and commercial disappointment: It's as immense yet clearly personal as Jacques Tati's *Playtime*, Steven Spielberg's *1941*, Martin Scorsese's *New York, New York,* and Francis Ford Coppola's *One from the Heart*—all box office flops whose reputations grew with time.

Zissou is the nexus of the film's style and themes, a marine biologist and documentary filmmaker who fears he has lost his mojo. He hasn't had a hit in ten years. His rival, Alistair Hennessey (Jeff Goldblum), has stolen his thunder and is probably sleeping with his wife, Eleanor (Anjelica Huston), the business brains

by Matt Zoller Seitz

of Zissou's operation as well as its moral compass. Zissou is vexed by profit-minded backers and a nosy reporter, Jane Winslett-Richardson (Cate Blanchett), who seems to want to praise and bury him at the same time. And he's still in mourning for his beloved friend Esteban (Seymour Cassel). There's a bright spot: the possibility that a young acolyte turned investor, Air Kentucky pilot Ned Plimpton (Anderson's regular collaborator Owen Wilson), might be his illegitimate son. Of all Anderson's charismatic fathers and father figures, Zissou is the most complex and contradictory. He's Jacques Cousteau, Captain Ahab, and Andy Hardy rolled into a spliff and smoked. As Zissou, Bill Murray is exuberant and depressed, hostile and openhearted. It might be his most stylized yet human-scaled performance, rivaled only by his work as the hero of Jim Jarmusch's *Broken Flowers,* another middle-aged stud who suffers an existential crisis when he learns that he might have a son.

Zissou and Ned's maybe father-son relationship is thrown off balance when Zissou falls for the pregnant Jane, then loses her to the man-child Ned. Their awkward love triangle creates a hall of mirrors that obliterates labels and blurs boundaries. Ned was raised by a single mom whom he recently lost to cancer—the same woman Zissou seduced and abandoned decades ago. Jane is a single mother who was knocked up and abandoned by her editor. Zissou lost two seeming father figures, Esteban and his mentor, Lord Mandrake, to death, and is in danger of losing his mate, Eleanor, to divorce. Like *Rushmore*'s Max Fischer and Herman Blume, Zissou and Ned carry themselves like very close brothers as well as father and son, and

their competition for Jane has an aspect of both sibling and Oedipal rivalry. When Jane reads to her unborn child while Ned listens, he's the adult that Jane's baby will one day become, and she's the mom Ned lost.

The Life Aquatic treats all of its characters—including Willem Dafoe's insecure and jealous Klaus and Bud Cort's bond company stooge turned hostage—as if they are real people, intelligent mammals that can mate, suffer, bleed, and die. Imagine a *Peanuts* strip in which Schroeder tries to catch a pop fly, gets hit on the head, and dies in Charlie Brown's arms while Snoopy wails inconsolably, and then the next day Charlie Brown goes to Lucy's psychiatry stand to talk about it, suffers through another of her obtuse monologues, and sighs, "Good grief." That's *The Life Aquatic:* a comic strip that zips from slapstick to tragedy and back like Seu Jorge's fingertips gliding on a fret board. All this, plus a stop-motion fight between horny sugar crabs, and a commando raid that feels like a James Bond set piece directed by Frank Tashlin. This film would be inconceivable if you weren't sitting there watching it.

Like Anderson's second and third features, *The Life Aquatic* was shot in CinemaScope, a superwide format typically used for action movies, science-fiction films, and historical pictures, not comedies. But here, Anderson and cinematographer Robert Yeoman (who shot the director's previous movies) create a glorious oxymoron: a comic epic. The framing is alternately spectacular and intimate, probing the characters' anxious faces in tight close-ups and reducing them to flyspecks in the margins of wide shots. The story is chaotic, but with some exceptions—notably the

jump-cut pirate shoot-out triggered by Zissou's post-traumatic rage against death—the style is orderly. Anderson often plants people and objects dead center in the frame, showcasing them like captured sea life displayed in rectangular tanks. It's as if the film is continually creating a taxonomy of these people, even as it dives into their fathomless interiors.

Here again, Anderson has made a meticulously controlled film about control freaks trying to micromanage their own narratives. Like Max Fischer's and Margot Tenenbaum's plays, Jack Whitman's stories, and Francis Whitman's laminated itineraries, the bracketing documentary sequences have a ludicrous yet haunting quality, like so many supposedly wise tales offered up by people who have no idea what's actually happening to them. *The Life Aquatic* forces Zissou to truly learn a lesson that he falsely believes he already knows. As Zissou tells Eleanor, speaking words that he does not yet recognize as wisdom, "Nobody knows what's going to happen. And then we film it. That's the whole concept." Zissou is constantly trying to turn his life into a neat narrative with a satisfying outcome, but his efforts are as contrived as the cornball voice-overs in his partly staged "documentaries." His mission to destroy the jaguar shark is the ultimate act of hubris: He wants nothing less than to track and kill Death and reassert autonomy over his life.

Zissou's journey takes him out of narcissism and through the stages of grief, ending in acceptance. At the start of the film, he gets drawn into a fistfight at the Santo Loquasto Film Festival when a paparazzo asks a cruel but legitimate question: "How come you're not sitting shiva for your friend Esteban?" When he

returns to the festival, he doesn't even attend the premiere of the movie that he went through hell to complete. The acclaim doesn't matter as much because he's become a different man. Speaking to his worried financial backers at the start of the story, Zissou deadpans that he'll catch the shark but let it live, then adds, "What about my dynamite?" But the second gut punch of Ned's death knocks the rage out of him. Near the end of the story, Zissou, his crewmates, his ex-wife, his patron, and his nemesis pile into a yellow submersible, descend to the ocean floor (bottoming out), and observe the beast through portholes. It's not a battle but a meeting, and it seems to restore everyone's equilibrium, especially Zissou's. They can neither kill Death nor let it live. All they can do is watch it swim up to the sub, snag a fish, and swim away. The grieving hero's catharsis comes not through vengeance, but tears. "I wonder if it remembers me?" he asks.

CLOCKWISE FROM TOP LEFT:
A Jacques Cousteau gallery: Three images comparing light and color quality at various depths (for underwater filming); a *Time* magazine cover story, March 28, 1960; more Cousteau books; (7) the explorer's iconic boat, the *Calypso*, with its logo-emblazoned chopper in the foreground; a photo of Cousteau; a copy of *The Living Sea*, one of many Cousteau books that Wes Anderson adored as a child; a diagram of Cousteau's submersible *Pisces III* that was trapped nearly 1,400 feet underwater while laying a cable in the Atlantic off the coast of Ireland; the vehicle and its crew were rescued after seventy hours; a newspaper article announcing a Cinerama documentary by Cousteau that, alas, never happened.

THE LIFE AQUATIC
WITH STEVE ZISSOU

The 5,213–Word Interview

CLOCKWISE FROM TOP: Anderson examines a scale model of Steve Zissou's equivalent of the *Calypso*, the *Belafonte*; in *Rushmore* (1998), Max Fischer holds up a Cousteau book of personal significance to Rosemary Cross; Cousteau's first Anderson cameo, framed on the wall behind James Caan and Owen Wilson in *Bottle Rocket* (1996).

OVERLEAF: A closer look at the Cousteau photo showcased in *Bottle Rocket, Captain Jacques-Yves Cousteau, New York, October 23, 1956* by Richard Avedon. Owen Wilson and Anderson's three screenwriting collaborations, *Bottle Rocket, Rushmore,* and *The Royal Tenenbaums,* contain Cousteau references, and in Anderson's fourth movie, Wilson's on-screen maybe-dad is, for all intents and purposes, Jacques Cousteau. © The Richard Avedon Foundation.

MATT ZOLLER SEITZ: A boat chopped in half—that was one idea that inspired *The Life Aquatic*. What was the other?

WES ANDERSON: The other was just an idea of doing a film about a Jacques Cousteau–like character.

Let's talk about Jacques Cousteau. The first appearance of Jacques Cousteau in one of your movies is, I believe, in the form of a portrait on the wall in that scene from *Bottle Rocket* where the guys are at a party at Mr. Henry's place.

The Richard Avedon photograph. And then the next appearance by Cousteau is in the form of the book that Max checks out of the library in *Rushmore.*

Is that a book from the actual library at your old school?

No. But it is one of a series of books that he published, a series that the Cousteau Society put together. And they're very good. The graphics are very good; the books are very good.

Were you into Cousteau when you were younger?

We loved him. I mean, he was a star. Did you watch him?

Sure. I didn't own the books, but I watched the TV programs.

He was a giant.

Were you a member of the Cousteau Society?

I don't think I was ever a member of anything. I didn't join anything. I wasn't even a member of the

Star Wars fan club. But Roman Coppola is actually member number one of the Star Wars fan club.

That's impressive.

It is!

What was the appeal of Jacques Cousteau? What was it about him or his work that sparked your imagination?

There was a biography of Cousteau that was published around 1990 or so that gave you a sense of the guy. And there were a couple of articles I read about him—how he traveled, the sort of control with which he traveled—though I don't remember all the details. I started to get this impression of Cousteau not just as an oceanographer and this kind of superhero scientist, but also this *star,* someone who had to organize these operations and deal with funding and ratings and fame and all those things. This biography showed that Cousteau was not one-dimensional. He was partly not a very nice man.

The book showed you the apparatus, the vast machine, behind the image you had of Cousteau. But the film was never actually meant to be *about* Jacques Cousteau. The real man was just a jumping-off point.

It was a jumping-off point. But even though Steve Zissou was an invented character, there is only one guy you can point to as an inspiration for this. So Zissou is an invented version of this guy, of this very singular person. There was also Thor Heyerdahl, and there are other real-life people who inspired aspects of the character. But Cousteau was the main one.

The image of the boat chopped in half—how does Zissou introduce it?

"Let me tell you about my boat."

This is the point where I think the entire film is distilled in one image. You're giving us a cutaway view of this guy's entire life.

Right. And what we get from the boat is that this is a guy who has a lot of enthusiasm for what he's doing, and that what he's doing has a scientific component and an artistic component, but that in general, it's not really very highly functional. And then there's also this promotional aspect that's a part of it all. He just likes to have *all* of this.

Here, again, we have a character who has built a world. He has built himself a world, and he carries this world around with him wherever he goes. It's *his* world.

He can even process his own rushes! On board.

And he's got his own personal dolphins following him around.

They're actually robots, those dolphins in the film.

Zissou not only having this boat in the first place, but proudly taking us on a tour of every part of it—it's a very childlike image of mastery, perhaps more so than in any other one of your movies. I can picture a child drawing furiously on a Big Chief tablet when I watch this movie. And yet it's a very adult movie when it comes to the problems that Zissou has, and that all the major characters have. They're dealing with death and divorce and financial issues.

Right.

And here's Bill Murray in the lead. He was always the guy for this part?

He was always the guy. I think I told him about the idea for this movie during *Rushmore,* as something we might want to do further on down the line.

What did Bill Murray bring to the character that was not there on the page?

He has this melancholy side to his screen personality. There's a lot of sadness that just emanates from him, even though he's so funny. You can't get around it, really. He also has the ability to bring up a kind of brutal aggression if necessary. He's a big guy. You wouldn't want to get into a physical conflict with our imagination's Bill Murray.

I believe it was the year after *The Life Aquatic* that Murray appeared in Jim Jarmusch's *Broken Flowers,* another film in which he plays a guy who has a son he didn't know

CLOCKWISE FROM TOP LEFT: Thor Heyerdahl, the Norwegian ethnographer and adventurer; Cousteau's ship, the *Calypso,* with its observation balloon in the foreground, exploring melting ice floes in Antarctica; the balloon on which Steve Zissou attempts to charm Jane Winslett-Richardson in *The Life Aquatic.*

OPPOSITE: Anderson's rough storyboards for the sequence that takes viewers through every level of the *Belafonte,* with specific instructions to set builders, set decorators, and camera crew.

OVERLEAF: Steve tells us about his boat.

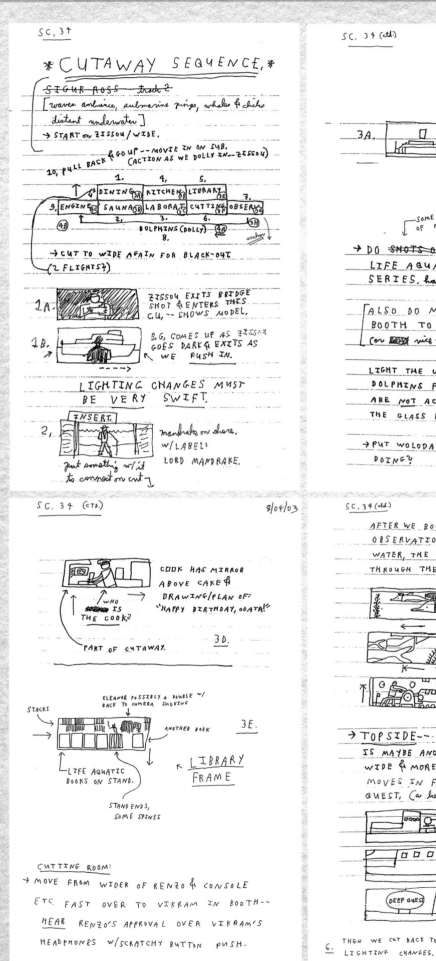

SC. 34

*** CUTAWAY SEQUENCE. ***

~~SIGUR ROSS track 2~~

[waves ambience, submarine pings, whales & clicks distant underwater]

→ START ON ZISSOU / WIDE.

10, PULL BACK & GO UP -- MOVE IN ON SUB. (ACTION AS WE DOLLY IN -- ZISSOU)

1. 4. 5.
DINING KITCHEN LIBRARY
9. ENGINE SAUNA LABORAT CUTTING OBSERV 7.
2. 3. 6.
DOLPHINS (DOLLY)
8.

→ CUT TO WIDE AGAIN FOR BLACK-OUT (2 FLIGHTS?)

1A. ZISSOU EXITS BRIDGE SHOT & ENTERS THIS CU. -- SHOWS MODEL.

1B. B.G. COMES UP AS ZISSOU GOES DARK & EXITS AS WE PUSH IN.

LIGHTING CHANGES MUST BE VERY SWIFT.

2. INSERT. mandrake on shore. w/ LABEL: LORD MANDRAKE.

put something w/ it to connect on cut

SC. 34 (ctd.)

3A. DINING ROOM w/ MANDRAKE @ CENTER

SOME KIND OF MOVE TO

→ DO ~~SHOTS OF~~ OGATA'S CAKE & LIFE AQUATIC COMPANION SERIES. how to show those books?

[ALSO DO MOVE FROM LOOPING BOOTH TO RENZO @ THE BOARD. (or ~~xxx~~ mics -- whse, whichever it is)

LIGHT THE UNDER-THE-SHIP WATER & DOLPHINS FROM BELOW? ANY REFLECTIONS ARE NOT ACCEPTABLE. MUST BE AS IF THE GLASS DOES NOT EXIST.

→ PUT WOLODARSKY IN LAB. WHAT'S HE DOING?

SC. 34 (CTD.) 8/04/03

COOK HAS MIRROR ABOVE CAKE & DRAWING/PLAN OF: "HAPPY BIRTHDAY, OGATA!"

WHO IS THE COOK?

PART OF CUTAWAY. 3D.

STACKS

ELEANOR POSSIBLY A DOUBLE w/ BACK TO CAMERA SMOKING

ANOTHER BOOK 3E.

LIFE AQUATIC BOOKS ON STAND.

← LIBRARY FRAME

STAND ENDS, SOME SPINES

CUTTING ROOM:
→ MOVE FROM WIDER OF RENZO & CONSOLE ETC. FAST OVER TO VIKRAM IN BOOTH -- HEAR RENZO'S APPROVAL OVER VIKRAM'S HEADPHONES w/ SCRATCHY BUTTON PUSH.

SC. 34 (ctd.)

AFTER WE BOOM DOWN FROM OBSERVATION BUBBLE INTO THE WATER, THE 2 DOLPHINS SWIM THROUGH THE FRAME. CUT TO --

4A. ALREADY DOLLYING AT FULL-SPEED w/ THE 2 DOLPHINS.

V.O. BEGINS...

4B. CAMERA STOPS AT RUDDER & DOLPHINS EXIT SHOT.

weird plant

4C. BOOM UP TO ENGINE ROOM WHERE GUY SPRAYS OIL ON GEAR.

→ TOPSIDE -- (SHOT IS MAYBE ANOTHER SHOT THAT STARTS WIDE & MORE TOWARD THE FRONT & MOVES IN FAST TOWARD THE DEEP QUEST, (a key piece of equipment)

5A. FRONT, WIDE.

5B. MIDDLE, MEDIUM.

5C. REAR, CLOSE. DEEP QUEST

6. THEN WE CUT BACK TO THE WIDE SHOT & DO THE LIGHTING CHANGES.

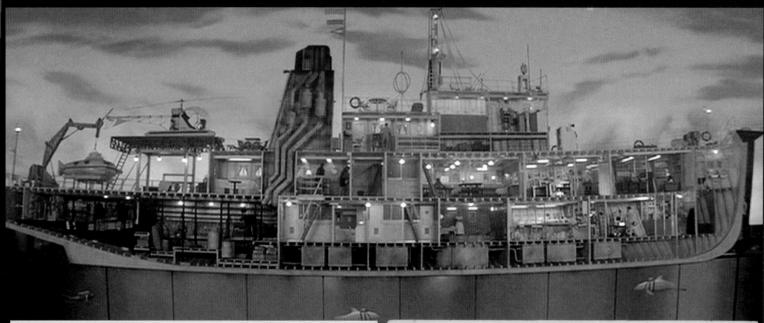

 001 The Life Aquatic with Steve Zissou
Let Me Tell You About My Boat

LOUNGE

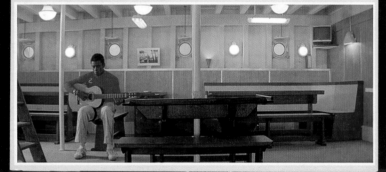

 002 The Life Aquatic with Steve Zissou
Let Me Tell You About My Boat

SAUNA

 003 The Life Aquatic with Steve Zissou
Let Me Tell You About My Boat

LAB

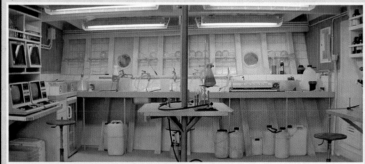

 004 The Life Aquatic with Steve Zissou
Let Me Tell You About My Boat

KITCHEN

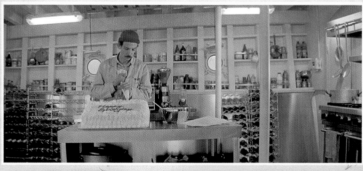

 005 The Life Aquatic with Steve Zissou

LIBRARY

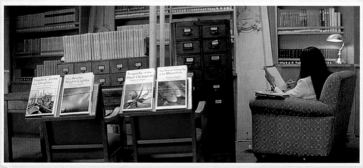

 006 The Life Aquatic with Steve Zissou
Let Me Tell You About My Boat

CUTTING ROOM

 007 The Life Aquatic with Steve Zissou
Let Me Tell You About My Boat

OBSERVATION BUBBLE

008 The Life Aquatic with Steve Zissou
Let Me Tell You About My Boat

TWO ALBINO SCOUTS

009 The Life Aquatic with Steve Zissou
Let Me Tell You About My Boat

ENGINE ROOM

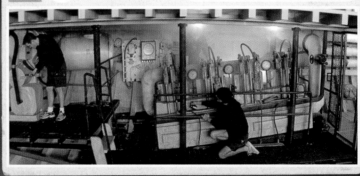

010 The Life Aquatic with Steve Zissou
Let Me Tell You About My Boat

MINI-SUB

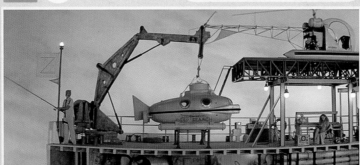

Adventurer Steve Zissou and latest equipment, 1979.

about—maybe. It's weird. There must have been something in the air that made two filmmakers, independent of each other, decide to cast Bill Murray as a guy dealing with this specific issue.

Hmm.

The Life Aquatic is the first Wes Anderson film that moves beyond the United States. In fact, I don't think there are any scenes in this movie that take place in or near the United States.

Nope.

The story begins where, in Rome?

Loquasto.

Loquasto?

Right. But we shot those scenes in Naples. Teatro di San Carlo. It's an opera house in Naples.

That's a huge space. Were those all actual extras in there, or did you have a few dummies thrown in to fill things out?

Real people, but I guess you kind of move them around a certain amount to make it seem like more of them. It's actually not a giant room. It's a very tall space, but not a big space, and the orchestra pit is small.

I get the sense that there's a bit of self-examination, on your part, going on in this movie. It's the first movie you've made that is about a film director. I mean, he has a lot of other things going on besides, but first and foremost he's a filmmaker, and everything else he does is with the goal of being presented to the audience in the form of a Steve Zissou film.

Hmm.

And he's got this ragtag band that he's assembled, people who have been working with him forever. And by that point, you had been working with the same core group of people over the course of several feature films.

Well, the film is certainly from the point of view of a person who does this. I worked with Noah Baumbach on it, and we share some of the same experiences. But Zissou is also, as you were saying earlier, one of these guys who was making movies in the sixties and seventies, and the film is about the stage they reached after a certain point, the things they had to deal with in their own lives.

I didn't mean that it was only about you. That said, I did get the sense that what I was also seeing in *The Life Aquatic* was you using a fictional story to project yourself forward—to imagine what it might be like to have been a filmmaker for thirty years and be worrying about age and irrelevance. One of the things that impressed me about the movie was your ability to put yourself in the headspace of this guy who's probably in his mid-fifties and has a long career behind him but wonders if he has any juice left.

Well, that didn't all have to be imagined by me. I've always had a certain number of friends who were twenty, thirty, forty years older than me. There were several people I was thinking of, their points of view. I don't know what drew me to it, exactly.

Middle-aged failure and disappointment is not a subject that a guy in his early thirties, your age when you directed *The Life Aquatic,* would naturally be attracted to.

Hmm. I guess it's one of those things where I was interested in the character. I felt I knew people like this character. I was related to people like

OPPOSITE: Steve Zissou (Bill Murray) points the way.

LEFT AND RIGHT: A mock-up of Steve's passport; a supposed photo of Zissou circa 1979, showing off his scuba suit and gear; a painting of Zissou hanging on the wall of the Explorers Club.

OVERLEAF: The Santo Loquasto Film Festival, where Zissou debuts parts one and two of his documentary about the *Belafonte*'s encounters with the jaguar shark. In the *Darjeeling Limited* chapter of this book, the director says his experiences at European film festivals while promoting *The Royal Tenenbaums* inspired him to travel more and to shoot *The Life Aquatic* in and around Italy.

OPPOSITE, FROM TOP: Frames from the film-within-a-film that opens *The Life Aquatic with Steve Zissou*: Zissou in his office; "crazy eyes"; Zissou with his late friend Esteban (Seymour Cassel).

ABOVE: Zissou touches an image of Esteban, releasing a small static shock from the TV screen.

BELOW: The hero captured by pirates; a mural from the New Bedford Whaling Museum that evokes imagery from the climax of *Moby-Dick*, Herman Melville's best-known novel and a prominent influence on *The Life Aquatic*'s story.

this character. I admired people like this character. I thought things about him were funny.

But then it kind of grows. And you go on thinking about the character, and the character grows some more, and you realize this is who the character *is*, and he's going to become *that*. The process is often not very clear at the outset. But it eventually found its way to him saying, "Am I ever going to be *good* again?" That wasn't my idea of the character at the beginning. But that's where it arrived.

Zissou is also a character who has been confronted, at the very beginning of the movie, with, to borrow the title of another Jim Jarmusch movie, the limits of control.

Hmm.

He has seen this mythic beast devour his best friend and mentor. And now he's on a mission to kill Death. A good friend of mine, another film critic, said that what he liked most about this movie was that it was a comic retelling of *Moby-Dick*, with a key difference: In the end, the obsessed captain, who's been chasing this beast that took away a part of him, stares the beast in the face and realizes it was nothing personal.

Ah.

Unlike Ahab, Steve Zissou figures this out. It takes him all the way until the end of the story to figure it out, but he figures it out. I feel like that's what's happening in the submersible when he asks, "I wonder if it remembers me?"

Right. Ahab doesn't have a submarine. But if he did, he'd be alone in it, fighting!

Yes. And Zissou doesn't kill the jaguar shark. He doesn't really even confront it. He just wants to look at it.

Theoretically, they filmed it.

Yes, we see the cameraman getting the shot.

Vikram. Yes.

That's one of Zissou's band of merry men. From *Bottle Rocket* onward, we've seen a lot of bands of guys on a mission. And sometimes the mission is a joke, but other times it's an actual mission. In *Bottle Rocket* it's a little bit of both.

Hmm.

And Max Fischer in *Rushmore* is the leader of a band of merry men and women, with the mission of making these plays or building a natatorium or whatever crazy scheme he's dragging everyone along on. And in *The Royal Tenenbaums*, we see an entire constellation of characters who, to greater or lesser degrees, have this sort of personality. And then you really put that type of personality front and center in *The Life Aquatic*. But I get a sense of Steve Zissou being spread too thin. He's got too many irons in the fire, and he's trying to build and control too many things at once. Did you feel that as you were writing it?

Yes.

I feel like he's trying to distract himself from things that may, perhaps, be more urgently important.

I agree. He's spread too thin. And he's not really that interested in his subject. He's more

interested in making a film about something than he is in the thing itself. That's the comic idea of him, to some degree, and it's the sad thing about him. It's his weakness.

No matter what happens, his first thought is, "How is this going to play on film?" or "Can we use this?"

Let's just get something done.

Even moments that are emotionally significant.

I think he's putting equal weight on the making-of scenes, and on anything that could conceivably build this thing out to however long his documentaries are supposed to be. He's after any material that can bring him back to life.

We're talking about the interplay of art and life here. That's a subject that recurs in all your films, with the possible exception of *Bottle Rocket*, arguably.

Hmm.

And Steve is not really living his life, I feel. He's involved in a lot of activities that he believes are his life, but to some degree they're just things he does to keep himself occupied, to keep himself distracted from things he'd rather not think about, such as the decline of his significance as a filmmaker and his abilities as a filmmaker, and even more important, the recent death of his best friend and mentor, Esteban. And with the arrival in his life of this young man who might or might not be his son, Steve is forced to confront the full weight of what that death means to him, the death of a character who was clearly a kind of

THIS PAGE: Director and star.

OPPOSITE, FROM TOP: Anderson on the *Belafonte* while filming the "Life on Mars?" tracking shot; Anderson conferring with Bill Murray between takes.

OVERLEAF, LEFT-HAND PAGE: Preproduction designs for *The Life Aquatic*, some used in the finished film, others purely conceptual.

OVERLEAF, RIGHT-HAND PAGE: A production sketch of the Zissou compound at Pescespada Island (TOP); concept art for Alistair Hennessey's research station (BOTTOM).

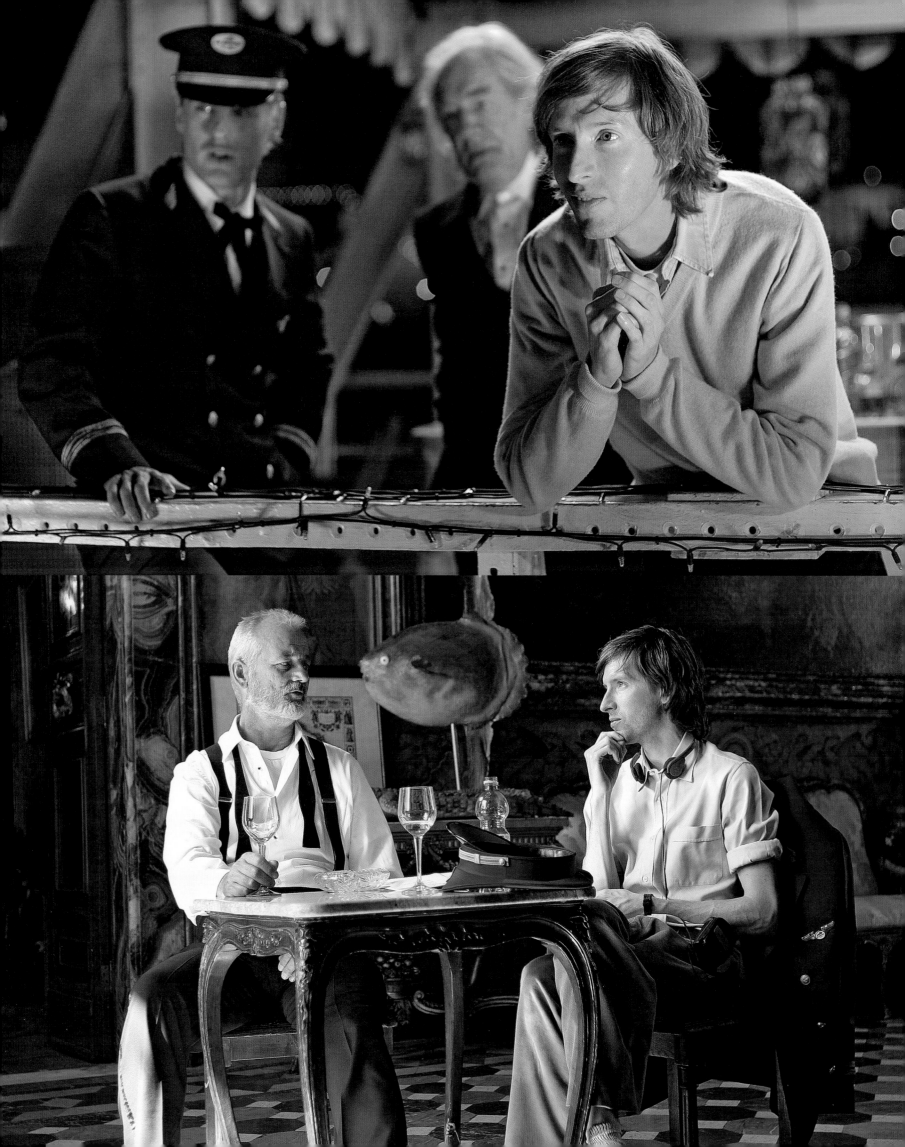

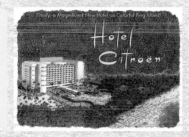

EXPERIMENTAL SEA LABORATORY OPERATION HENNESSEY

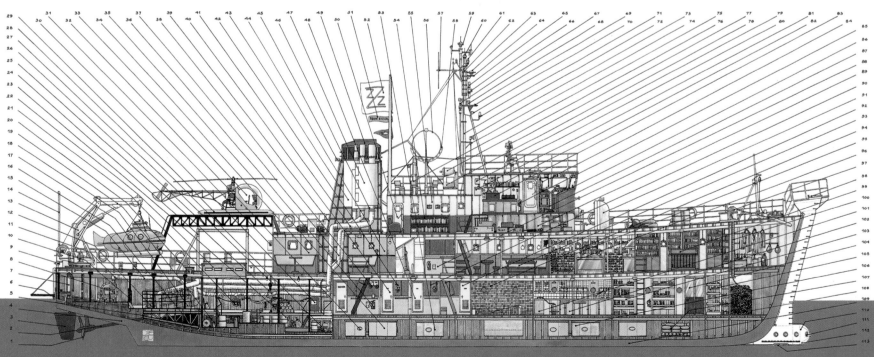

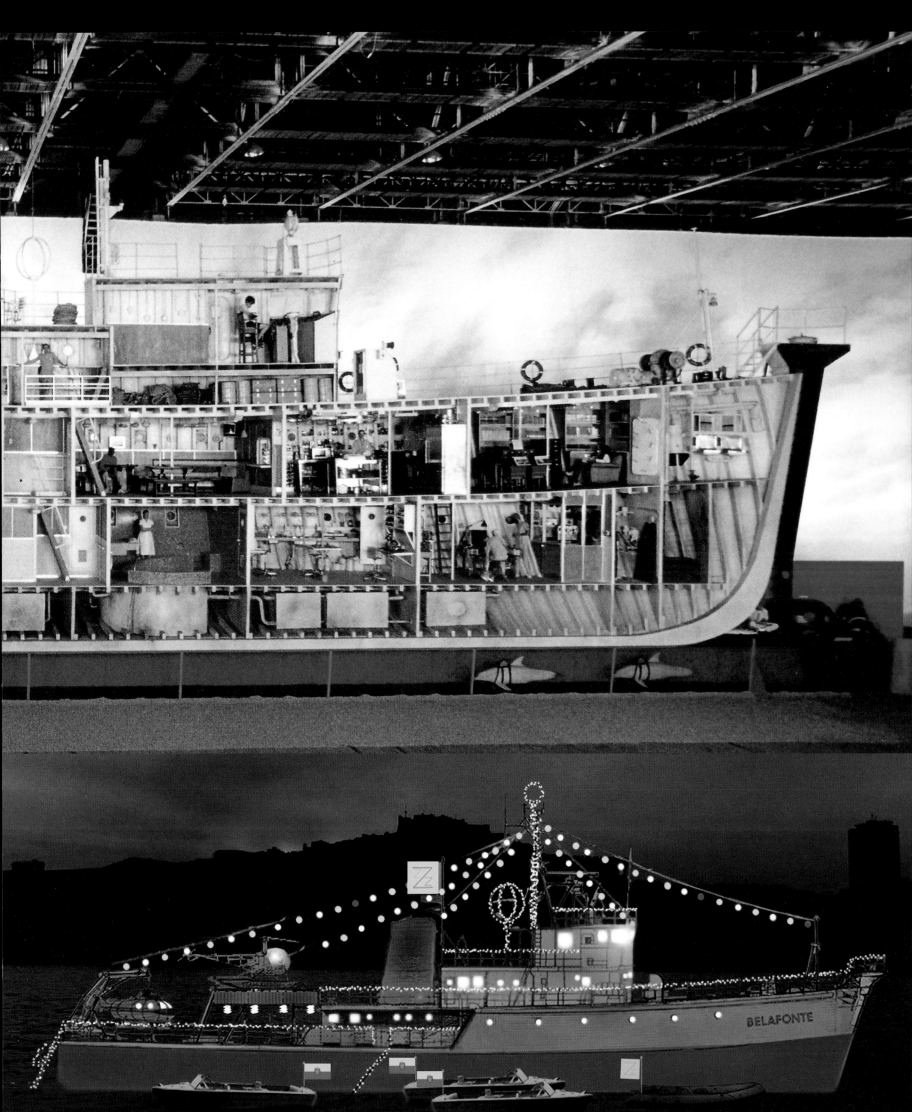

father figure. He is forced to deal with all these things because of the emotions called up by meeting Ned, who represents the continuation of his legacy, the next generation.

There's a symmetry between the scenes at the beginning and end of the film, the scenes at film festivals. Steve is obviously profoundly affected by Esteban's death at the start of the story, but he hasn't fully registered its significance. His friend has just died. He's at this film festival. He probably shouldn't even have gone there. And that question that prompts him to take a swing at that photographer—what does the photographer say? "How come you're not sitting shiva for your friend Esteban?"

Right.

And at the end he is.

Yes, at the end he is.

At the end of *The Life Aquatic*, the premiere of Steve's completed film is going on, and he's not even there to see it. He's sitting outside the theater.

You're right. You know, that "sitting shiva" line is from that book *Naming Names*, by . . . what is the name of the author? Victor—?

Navasky.

Victor Navasky. Right. That's taken from an anecdote in that book. Somebody asked Budd Schulberg, who named names before the Un-American Activities thing, "What are you doing here at the White Horse Tavern when you should be sitting shiva for Herbert Biberman?" who had just died, and whom Schulberg had named. And Schulberg coldcocked him.

The seminal influence of *Star Wars* comes full circle here, because in this film, even more so than in *The Royal Tenenbaums*, you're creating an entire universe. It's a world in which a Jacques Cousteau–type figure can be one of the biggest stars in the world.

Right. He says, "I haven't made a hit documentary in nine years." Well, who has?

And it's also a completely artificial world. Even though you're shooting in real locations some of the time, everything is made to look like a storybook. It's very color-coordinated, and the design details are quite rococo. What did you tell the people working on the movie when they asked you, "What are we doing here, Wes?"

We had all this Cousteau stuff, and we looked at that, because he was the guy and that was the thing. We looked at locations in Italy. We looked at

black-and-white Michelangelo Antonioni movies from the sixties, *L'Avventura* especially. And we looked at black-and-white photos from the sixties.

Photos of what?

Well, Richard Avedon had taken these pictures of these Italian twins in the sixties. And I feel like we looked at photos of Anjelica Huston, fashion photographs of her. I also had this book about the history of fashion photography in the sixties. We were trying to come up with a glamorous approach to oceanography. Steve was a combination of a scientist and Marcello Mastroianni. That was why all this surface stuff was a part of it. I don't know how much of that material really came into the equation at the end, but that was what we looked at.

It does come into play, because in this story, film is at the center of the universe.

Ah.

And granted, that's the only part of the universe we see, the one Zissou is a part of, but as is the case in so many of your movies, that might be a distinction without a difference. In *The Royal Tenenbaums* we get the sense that the entire world cares very deeply about every single thing the Tenenbaums do, and Zissou—

He's caught up in his own thing.

Let's return to the boat chopped in half. How was that constructed?

Well, we found a boat to use as our real boat on the water in South Africa, and there were two of them. They were twin boats. One was in poor repair, and the other was in somewhat poorer repair. They were World War II–era boats, or maybe they were built around 1950, somewhere around there. We bought them both. And one of those boats we stripped to use for our sets, like this chopped-in-half boat. They put the pieces on the other boat, the intact boat, and they sailed it up to Italy. That was a very difficult act, because the boat still didn't work very well. And for some reason, it was stopped as they were passing the Ivory Coast. Maybe they went into port and they weren't allowed to leave, and the whole crew was arrested for some reason. They were held for several days. It was all unclear. Maybe they had to pay somebody off. I don't know what happened.

Then we built the sets from all those parts from the boat that had been dismantled. And so the sets were made of wood, built from the usual

PREVIOUS OVERLEAF, TOP: The boat chopped in half, created from one of two identical steamers purchased for the film, the other of which served as a floating set.

PREVIOUS OVERLEAF, BOTTOM LEFT: A numbered schematic of the ship's rooms and components.

PREVIOUS OVERLEAF, BOTTOM RIGHT: Concept art for how the *Belafonte* might look at night, all lit up for the "Life on Mars?" scene.

ABOVE, LEFT TO RIGHT: Marcello Mastroianni in Federico Fellini's *8½* (1963); a frame from *L'Avventura* (1960).

OPPOSITE, FROM TOP: The *Deep Search* submersible, formerly the *Jacqueline*, named for a woman who apparently got away; a tattoo betraying similar second thoughts ("She didn't really love me," Zissou says simply); monogrammed Team Zissou Adidas footwear.

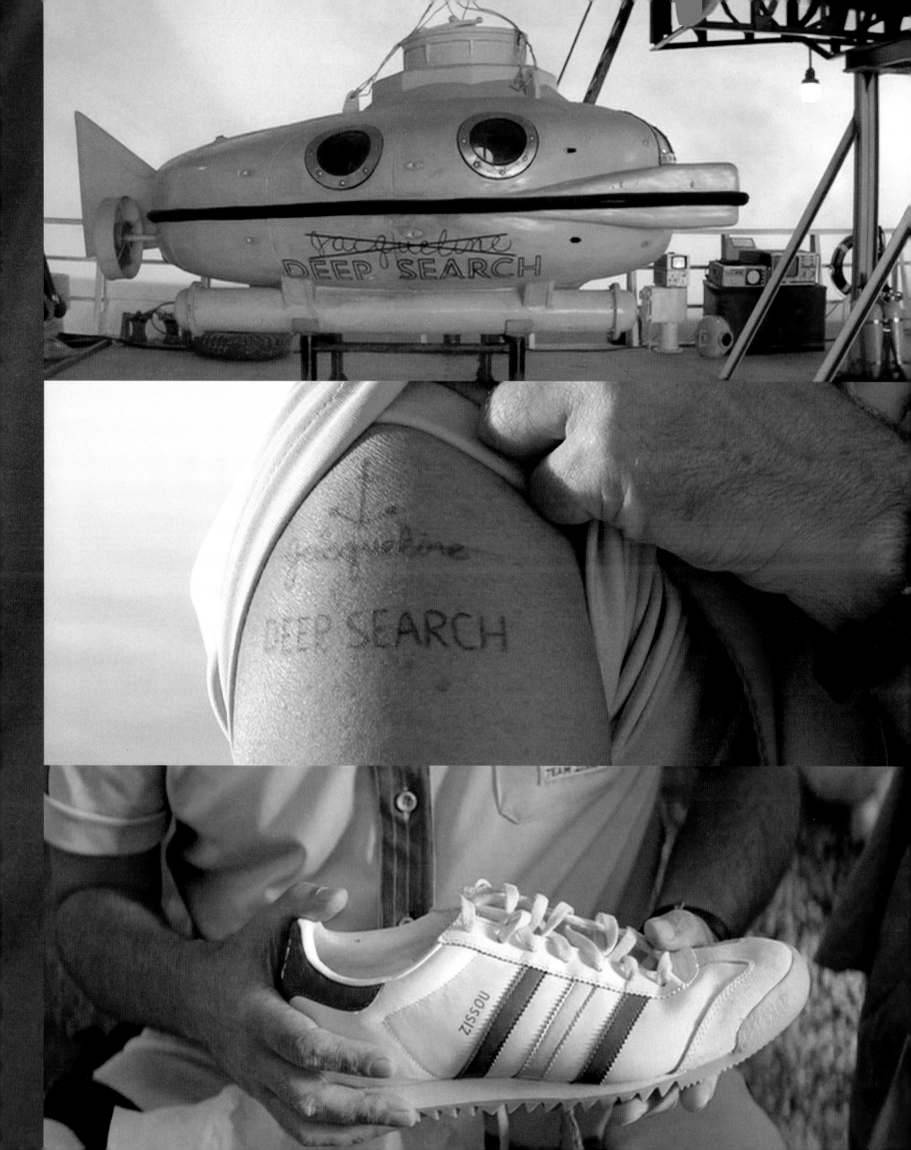

materials sets are made of, plus all the pieces taken from that second boat.

And the camera you used to shoot the chopped-in-half-boat scenes—was that on a crane?

It was on one of those cranes. I don't remember what you call those kinds of cranes.

A Louma crane?

No, we used a Louma for one scene. The Louma is a great big crane that can take you up very high,

and you sit on it. This is a remote-head kind of crane. The crane can go up and down, and it has a telescoping arm that can go in or out.

Who designed the costumes?

Milena Canonero, who also did the costumes for *The Darjeeling Limited*.

What was the idea behind the design of the costumes?

Well, the red caps are from Cousteau. The rest we kind of made up. We wanted them to look like

ABOVE, LEFT TO RIGHT: Vikram Ray (Waris Ahluwalia), Zissou's cameraman; Anderson and costar Owen Wilson between takes on board the *Belafonte*.

BELOW: Preparing to shoot the boat-chopped-in-half sequence.

OPPOSITE: Anderson on a crane.

costumes you'd see on a TV show that would have aired in about 1968.

"In color!"

Exactly. For some reason, I thought Team Zissou's costumes would be made from the same materials as the costumes on the original *Star Trek*. They were polyester.

I bet they were a delight to wear in hot environments.

It's very difficult to work with polyester. It doesn't age very well, either. The colors stay very clean and bright and everything, but when they pick up dirt, it becomes a permanent part of the costume.

Did you decide early on that the sea creatures should be unreal? Artificial?

Hmm . . . It's not that I thought, "Let's make them unrealistic." I thought, "Let's make them up." Once we decided we were going to make them stop-motion and that they would be animated by Henry Selick, that was that. When you're doing stop-motion animals, particularly ones that have characteristics unlike anything that's alive, they're bound to be unrealistic.

But you did have the option to make them plausibly real, in the way that CGI creatures often aspire to be plausibly real.

I guess. You mean like—?

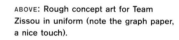
Simulating skin, modeling their movements on real creatures.

Well, there's one that's a sea horse that has all these different colors on it, and Steve holds it up in a little plastic bag, and the animal's colors are not the colors of any sea horse that ever existed. And it's not moving like a sea horse; it's moving like a horse. We made it as realistic as we could make it, given that it had colors unlike that of any living sea horse and it was moving like a horse.

Certainly my thing was not to say, "We're going to go back and touch this dolphin up digitally to make the skin look more like the skin of a real dolphin." It wasn't about trying to make something unrealistic. It was about trying to make something imaginary.

Why did you decide to go with stop-motion, specifically? Where I'm going with this is, the choice seems to be of a piece with a certain philosophy you have about how movies should be made. You chose an old-fashioned, analog method of creating creatures that don't exist.

Right.

And it's not the industry standard at this point.

No, it's not.

You see what I mean.

Yes. But it's not as though I feel like, when I'm watching *Jurassic Park*, "They should have used stop-motion"—although, for all I know, they probably *did* use some stop-motion. They probably used everything that was available. But in *Jurassic Park* the idea is, "There are real dinosaurs in the world." With *The Life Aquatic*, it's a totally different kind of movie. It's not like a movie where the point is to feel something like the wonder we would experience in real life if we were

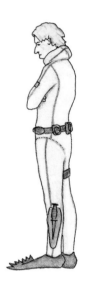

ABOVE: Rough concept art for Team Zissou in uniform (note the graph paper, a nice touch).

BOTTOM, LEFT TO RIGHT: The team as pictured in the finished film; the vibrant hues of Team Zissou were inspired by the crew of the original sixties *Star Trek*.

OPPOSITE, CLOCKWISE FROM TOP LEFT: A stop-motion animation sampler: the Winter Warlock from Rankin-Bass's *Santa Claus Is Comin' to Town* (1970); the abominable snowman from *Rudolph the Red-Nosed Reindeer* (1964); stop-motion master Ray Harryhausen's skeleton warriors from *Jason and the Argonauts* (1963).

encountering real dinosaurs. The sea creatures are there for atmosphere, or as jokes: Some lizard is walking on Bill Murray's hand, and he flicks it off. And in a way, the artificiality of it—which is sort of a by-product of everything else—is, well, I don't want to say "part of the joke," because it's not a joke. It's supposed to be entertaining.

I'm probably not articulating it very well. The answer to "Why stop-motion?" is "Because I love stop-motion." And it's not like I love stop-motion because I think it's this great way to make you think these things are really alive. It's more that I think it's such a *magical* way to make it seem as though these things are really alive. And you can see how the illusion is being created.

You can see the fingerprints on the creations.

Yes. Sometimes literally. You know, Henry said he believes the jaguar shark is the largest stop-motion puppet that's ever been constructed.

How large was it?

About the size of this room. [THE ROOM IS ABOUT THREE METERS LONG.] What's normally considered a big stop-motion puppet is like this. [WES HOLDS HIS HANDS ABOUT THIRTY CENTIMETERS APART.] And sometimes it's as small as that. [WES HOLDS HIS HANDS ABOUT TEN CENTIMETERS APART.]

You must have been a connoisseur of stop-motion from way back, then. You probably watched films featuring animated creatures that Ray Harryhausen and Willis O'Brien worked on.

Well, I loved the mythology-type ones. I loved *Jason and the Argonauts*. I loved *The 7th Voyage of Sinbad*. Fighting skeletons, that kind of thing. And I loved the Brothers Quay. And also those Rankin-Bass Christmas specials.

Rudolph the Red-Nosed Reindeer.

Right. Kris Kringle and so on. Those made a big impression on me. We loved those, I think, because of the technique as much as anything. Watching the way the snow monster's beard moved—there is some special charm to stop-motion.

Putting all the pieces together then, here: A fascination with

Jacques Cousteau. The stop-motion sea creatures. The intricate design of the entire movie. Just looking at it, it's not immediately apparent how you would get from that sort of a concept to the darkness that's at the heart of a lot of this movie. Particularly the ending, which I think is one of the most primal emotional sequences you've ever directed. How do you reconcile those two aspects? Or I guess another way to ask it is, how does a colorful, often very funny film modeled on the life of Jacques Cousteau end up with the hero on the ocean floor, facing a jaguar shark and contemplating the meaning of life and death?

Well, you know, Cousteau's son crashed one of Cousteau's planes and died, and that was one of my original ideas for the movie. And did you ever hear the story that Michael Bay is John Frankenheimer's son?

Yeah. Frankenheimer denied it, at least officially. I don't know for a fact that it's untrue, or that it's true, or that anybody outside those two men's spheres could ever know the truth. But whether it's a fact or not, it's a story that many people believe is true.

Well, they did speak at this Directors Guild dinner, and I was led to believe they spoke about that. My imagination of that conversation was one of the inspirations for that first conversation between Zissou and Ned. There's a lot of Jacques Cousteau in this movie, but there's also an imaginary version of Michael Bay and John Frankenheimer. The pieces came from everywhere, and we mixed them together. That's how you get from this oceanographer and his documentaries to eleven people on the ocean floor confronting a jaguar shark. We made it up. And I remember at a certain point, while Noah and I were working on it, we had to ask, "Well, does it exist, this jaguar shark?" And we decided, "I guess it does. And

scene 194 jaguar shark shot 3
pose test animatic v.2 1/16/04

00:00:00:00 temp. creature design and animation

then, at the end, they go down into the ocean, and they see it." We thought we should have it arrive. And that it was going to stand for everything.

I remember Scott Rudin, one of our producers, kept asking us, "What's the metaphor? What's the metaphor?" And at a certain point, we felt like, "'What's the metaphor?' We don't want to answer that. We just want to embrace it." Because we had a very large symbol that was going to swim into the frame.

Well, it may be a multilayered, multivalent metaphor, but on a basic level, I think when we talk about the jaguar shark, it's pretty clear what we're talking about.

Yes. I liked the way you described it: he's trying to kill Death. But he lets it live.

The Life Aquatic is my personal favorite of your movies. There are other movies you've made that I think are more formally perfect—*Rushmore* and *The Darjeeling Limited*, especially, in terms of every piece being exactly right, and our being able to admire each of those films as a kind of seamless object. And I know there are parts of *The Life Aquatic* that even you, in interviews, have sort of second-guessed, such as the shoot-out on the boat, your big action scene. I remember there was an interview in which you said of that sequence, "John Woo I ain't."

[WES LAUGHS.] Maybe not.

Critics didn't know what to make of it, and audiences generally didn't, either. But it spoke to me quite profoundly on my first viewing, and even more so over the years, because of the character of Zissou and how the movie ends. It's like the Serenity Prayer they say at Alcoholics Anonymous: "God, grant me the serenity to accept the things I cannot change, courage to change the things I can, and wisdom to know the difference."

He's working toward getting to the last part, especially.

This is a guy who has created a world he can control, and who must realize that the world he created is illusory and that his control over it is illusory as well. That's not only an important realization; it might be the ultimate realization.

Yes.

Because that's what the film is building toward. It's about mortality, and discovering his son and realizing how much that means to him.
And here's another thing that just occurred to me: You were talking about your producer repeating the question, "What is the metaphor?" and your being resistant to answering that question. There's a strong element of that resistance to or

shying away from literalism throughout the movie. There are a lot of things that are left unseen, a lot of things that are left undefined, or not fully defined. You don't see the shark attack that kills his partner. You don't know if the creature is real until you see it at the end.

Right.

You at least give the audience that. Then you have the question of whether Ned is actually Steve's son. And correct me if I'm wrong, but you don't ever really answer that, definitely, either.

No, I don't think we do.

Steve *decides* that Ned is his son.

At a certain point, it seems to be confirmed. Then Anjelica gives Cate a piece of information that completely calls it into question again—

And Jane never mentions it to Steve. Or, even if she did, you get the sense that he'd just disregard it, anyway.

Right.

And then you have the central trio of characters: Jane, the pregnant reporter; Ned, the Air Kentucky pilot; and Steve Zissou. Steve is theoretically Ned's father, but they almost behave more like brothers. You have Steve being attracted to Jane, but there's this almost fatherly aspect to his relationship with her. Ned is attracted to Jane as well, and they actually get something physical going on together, but at the same time, there's also a maternal aspect to it for Ned, who recently lost his mother to cancer.

Right.

And Jane is carrying this child inside of her, and in some weird sense, it's as if she's eventually going to give birth to this son that she's already sitting there talking to: Ned.

Hmm.

There's a tremendous amount of subtext, a lot of things bumping around in the margins of the movie.

Everything's kind of linked. And I don't want to add to it.

Is that how you prefer movies to be? Unresolved, or open to interpretation?

I don't know if I prefer *movies* to be any one way. But my way . . . Well, I read about Harold Pinter that when people would ask him about

This page and the opposite page spotlight a sampling of creatures devised by filmmaker-animator Henry Selick for *The Life Aquatic*.

TOP LEFT: Animatics for the climactic jaguar shark encounter on the ocean floor; the lizard that Zissou flicks away during a conversation with Eleanor, placed atop a blue-screen mock-up of what will later be Zissou's hand.

BELOW: Zissou's journal.

OPPOSITE: A gallery of animated sea life.

OVERLEAF: The submersible crew faces Death and lets it live.

the meaning of his plays, his response was, "Here is what they did. Here is what they said. This is what happened." That's your answer. And with this film, but in particular with *The Darjeeling Limited*, we had so much information. For that one, the three of us—Jason, Roman, and I—spent so much time together, traveling and talking about these brothers and playing the roles of these brothers and putting ourselves in their situations, and we created this really expansive tapestry of their lives, their biographies. But we put very, very little of it in the movie. All we ever did was pull things out. We felt the process of taking things out was making it stronger—stronger in the way that we wanted it to be, anyway. That definitely appeals to me, that kind of Hemingway theory of omission.

CLOCKWISE FROM TOP LEFT: Zissou at the end of *The Life Aquatic,* finally sitting shiva for his friend, and other loved ones, too; a continuity Polaroid of Owen Wilson, a.k.a. Ned Plimpton, a.k.a. Kingsley Zissou; a continuity Polaroid of Seymour Cassel as Esteban; Lord Mandrake, Zissou's mentor.

OPPOSITE, ABOVE: Zissou and Jane Winslett-Richardson (Cate Blanchett) on a balloon ride.

OPPOSITE, BELOW: Ned and Jane in the *Belafonte* sauna, which Zissou says was "designed by an engineer from the Chinese space program."

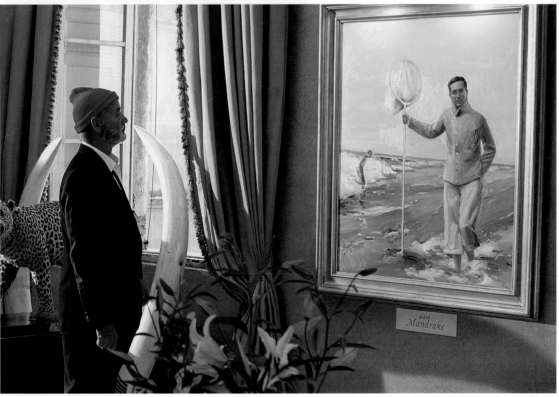

THE DARJEELING LIMITED

The 1,333–Word Essay

WES ANDERSON often tells stories of visionary artist-leaders who try to master every aspect of their lives, only to realize that this goal is impossible and that pursuing it closes them off from enlightenment.

From Dignan in *Bottle Rocket* and Max Fischer in *Rushmore* to the extended family of fallen geniuses in *The Royal Tenenbaums* and burned-out explorer-filmmaker Steve Zissou in *The Life Aquatic,* the director's filmography is filled with characters who learn the hard way that you can't control life; you can only manage your own response to it. There's irony in this theme when you look at the films themselves. Wes Anderson is in command of every line, scene, composition, cut, and music cue. If the color of a character's hat complements a painting deep in the background, or

if the camera swings around from one perfectly centered doorway to match position on another, it's not an accident. Revisions and improvisations happen during shooting, but in Anderson's films there's always an apparent plan, a clearly marked path toward the story's conclusion. Anderson's fifth movie, *The Darjeeling Limited,* puts this desire for control at the center of its story, only to point out how emotionally unhealthy it is. In that sense it might be his most self-critical work, even more so than *The Life Aquatic,* which teased out the same themes and came to a similar conclusion.

Cowritten by Anderson, Roman Coppola, and Jason Schwartzman, *Darjeeling* tells of three brothers who travel by train through India, hoping to reconnect with one another, come to terms with their father's death, and track down their mother, Patricia (Anjelica Huston), who didn't attend the funeral and is now off in a monastery somewhere. The titular vehicle is a specially constructed, fully functioning train, filled with handmade furnishings and props and meticulously painted by local artisans: a studio on wheels. The movie's intricately wrought, storybook version of India

by Matt Zoller Seitz

bears as much relation to that country as the city in *The Royal Tenenbaums* bears to the real New York. It's more a metaphorical space than a geographic one.

From the opening frames of the introductory short film *Hotel Chevalier*—which the director considers the first chapter of this story—you can tell this isn't going to be a mere celebration of filmmaking craft. The control-freak hero of this film within a film is one of the Whitman brothers, Jack (Jason Schwartzman), who has imprisoned himself within a luxurious, hyperclean hotel room. Until its final shot, the short takes place entirely indoors. It's about a man who has withdrawn into a handsome but constrained inner world rather than face the randomness outside. Anderson's fondness for perfectly balanced, rectilinear shots—shots where you could divide the frame into nearly mirrored halves by drawing a line down the middle—has never seemed more oppressive. The director and his cinematographer, Robert Yeoman, often frame Jack very low and off to one side—as if he's an interloper spoiling the image's visual perfection. The appearance of Jack's on-again, off-again girlfriend (Natalie Portman) signals the arrival of chaos in the *Darjeeling* universe. She's his opposite: someone who lives in the moment and who considers pain, signified by the mysterious, undefined bruises on her skin, to be a part of life. Spurred on by love, sex, and surprise, Jack opens the doors of his hotel room and lets the sunlight in. Like the jaguar shark in *The Life Aquatic* and the tiger that appears later in *Darjeeling*, she's an emblem of life's messiness, the uncontrollable certainty of danger and pain. And it's clear from Jack's

intonation in their first phone conversation that he isn't fighting it too hard. She doesn't barge in; she's invited.

After establishing a control freak's anxiety in *Hotel Chevalier, The Darjeeling Limited* amps it into full-blown panic. The film starts with an unnamed character, identified in the credits as the Businessman (Bill Murray), rushing to catch a train and failing. Another of the Whitman brothers, Peter (Adrien Brody), passes him and barely climbs aboard. Peter and his siblings are younger versions of the Businessman—pampered, myopic Americans who rush through life, oblivious to the world around them. The Whitmans could be long-lost cousins of the Tenenbaum clan. Each has his own distinctive style of dress, his own rituals, even his own drug of choice. Jack's *Hotel Chevalier* tics become running gags in *Darjeeling*—particularly his insistence on scoring beautiful moments with recorded music. Francis (Owen Wilson), the bandaged survivor of a motorcycle accident, is a control freak par excellence, the sort of man who orders lunch for others without being asked. He tells his brothers they're on a "spiritual journey," but you can't embark on a spiritual journey without being open to randomness and change, and Francis and his personal assistant have the whole thing scripted on laminated itineraries. Even Peter, outwardly the most easygoing of the trio, exercises his own forms of control. He has appropriated many of his late dad's belongings without asking his brothers' permission, and he has kept the most important event in his own life—the impending birth of his first child—a secret.

Chaos enters the Whitman brothers' universe just as it entered the Hotel Chevalier:

by invitation. Jack's bruised girlfriend pushing him into the light; the train somehow getting lost while on rails; the incident with the snake, which causes the Whitman brothers to be ejected from the train; the brothers' attempt to rescue children who've fallen into a river, only to lose one of them: throughout the story, there's a sense that the universe is testing the Whitmans, shattering their illusions of control and setting them on the path to wisdom, or toward the beginning of wisdom. When they first spot the children on the water, Francis snarls, "Look at these assholes." A few scenes later, Peter is cradling a child's dead body, numbed by horror.

Realistically, though, that day in the village isn't The Day Everything Changed. It's just the point where reality, in all its messy randomness, finally dents the Whitman brothers' psychological armor. It's heartening to see the difference between their disastrous first attempt at a "feather ceremony," in which Francis expresses disappointment that no one followed his script, and the second, in which all three brothers improvise and no one judges the others. But these are just two points on a long road.

Change is possible, but it's going to be a slow process. The pathology we've seen up to now has deep roots in the family's history, a point made clear in the movie's only flashback, in which the brothers are running late to their father's funeral while trying to recover the old man's car from a repair shop. The Whitmans' mania to recover their father's vehicle—one whose repair, symbolically enough, isn't finished, just as Jack's story isn't finished and Francis's wounds aren't healed—reflects the mentality of everyone in the family but the

mom, Patricia. Possessions and gestures are important to everyone, but the Whitmans let them overwhelm their lives. They must let go, as they eventually do with their father's baggage—subtext-as-text verging on parody, like Francis's unhealed wounds. But this gesture is undercut by the film's final scene, which finds the Whitman brothers gathering in another compartment not too different from the one that kicked off their first train journey, and enacting more or less the same ritual. It's a dialectical movie, filled with opposing forces locked in a never-ending battle that will be decided, if at all, in tiny increments. Deep down, the Whitmans need to change, and perhaps they are changing, but it's not an easy process because their lives and habits are on rails. The status quo is deadening but comforting, and it's less work, and vastly less frightening, than looking inward and thinking about how things could be different. The film's final shot sums up *The Darjeeling Limited*. Frame left, nature rushing by, a formless blur. Frame right, a train, metallic, an irresistible object on rails. Chaos and control.

THE DARJEELING LIMITED

The 5,284-Word Interview

OPPOSITE: Owen Wilson, Adrien Brody, and Jason Schwartzman (cowriter of *The Darjeeling Limited*) on location during the marketplace sequence.

ABOVE: A frame from *Hotel Chevalier*, the short-film prologue to the feature. This is a great example of Wes Anderson's use of CinemaScope framing, placing Jack Whitman's bare feet frame right, clutter (indicating internal turmoil as well as bachelor housekeeping) out of focus in the background, and *Stalag 17* (1953) on the TV. The latter is a nifty oblique indicator of Jack's self-imprisonment.

MATT ZOLLER SEITZ: Did you begin working on the story of *The Darjeeling Limited* after *The Life Aquatic*, or before?

WES ANDERSON: Maybe before *The Life Aquatic*. I had this idea about three brothers traveling on a train. But I didn't know where it was going to happen. I envisioned the cast, but it wasn't yet set in India. It was a combination of things.

Around that time, the Film Foundation had just finished their restoration of Jean Renoir's *The River*. Scorsese did a screening, and he invited me to come watch this new print of it. And I walked out of the screening room onto whatever it was—Park Avenue?—and I said, "India. That's where the train ought to be. I want to go *there*." I connected it to Satyajit Ray's films, because I had become an increasingly bigger and bigger fan of his over the years. There was one in particular that I'd seen on Betamax, *Teen Kanya*. Do you know that one?

I haven't seen that one.

It's called *Teen Kanya*, or *Three Daughters* and sometimes *Two Daughters*, depending on which version. It was originally an omnibus of two parts, and then later he added a third part. The original two parts of it are among my favorites of his work. For some reason, they had that in one of the Sound Warehouse video sections in Houston. So the Satyajit Ray films, *The River*, and the Louis

Malle documentaries about India. I was watching all of those, and the next thing I knew, I was there.

And you worked out the story and characters with Jason Schwartzman and Roman Coppola?

Right.

In India?

First in France, and in New York, and then in India. We went to India to write. And we tried to simulate what we had figured out so far, and to learn about the place. We traveled all around and took a long train journey, and a lot of the places we shot were places the three of us had visited.

You were retracing your own journey.

Our own made-up journey.

The Life Aquatic and ***The Darjeeling Limited*** seem to me to have a lot in common, so much so that, in some ways, *The*

Darjeeling Limited seems like a continuation of ideas you explored in *The Life Aquatic*.

Chief among these is the notion of being an American abroad. There are quite a few details in *Darjeeling* that seem unique to that experience, from the opening—and I guess I

should preface this by saying I consider your short film *Hotel Chevalier* to be a part of *The Darjeeling Limited*, and I know many people may not have experienced the two films as part of a whole, but now that they're on the same disc, they can. In the opening scene of *Hotel Chevalier*, Jason Schwartzman's

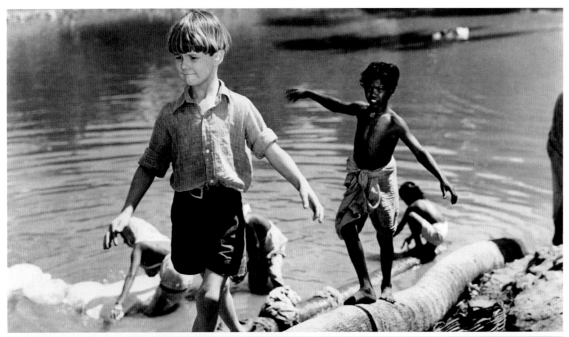

LEFT, ABOVE AND BELOW: Publicity still (ABOVE) and frame (BELOW) from Jean Renoir's *The River*, about an upper-class English family living on the banks of the Ganges (cobras and a harrowing water accident figure prominently).

OPPOSITE TOP: Publicity photo of Bengali director Satyajit Ray, a commercial artist who decided to become a director after seeing Vittorio De Sica's 1948 neorealist classic *Bicycle Thieves* and meeting Jean Renoir. An auteur before the word became commonplace, Ray wrote, directed, and scored his films and often designed their publicity materials as well. His films are distinguished by their meditative pace, attention to details of class and behavior, and deep reserves of empathy. His *Apu Trilogy*—consisting of *Pather Pachali* (1955), *Aparjito* (1956) and *Apu Sansar* (1959)—are considered among the greatest works of world cinema. Akira Kurosawa said of Ray's work, "To have not seen the films of Ray is to have lived in the world without ever having seen the moon and the sun." A portrait of Ray hangs above the Whitman brothers on page 200.

OPPOSITE, LEFT ABOVE AND BELOW: Frames from *Days and Nights in the Forest* (1970).

OPPOSITE, RIGHT ABOVE AND BELOW: Behind-the-scenes publicity stills from *Teen Kanya* (1961), part of the Calcutta trilogy.

character, Jack Whitman, is in the hotel room, and you see his feet sticking out into the frame, and you hear him ordering room service in French very confidently, but not in a way that would fool a Frenchman.

No.

Then in *Darjeeling* proper, there's the fixation on certain details of the brothers' travels, such as their fascination with the savory snacks—the little things you would cling to if you were a stranger in a strange land.

Right.

I assume a lot of this comes from having traveled a lot more in the later part of your life than you had in the beginning.

Certainly it does. And I remember all of us thinking that there are these sorts of talismans the brothers carry—things like a pair of sunglasses or music box or the father's luggage, and these

various objects that a character is placing around the room at a certain point. They affix a meaning to each of those things. Sometimes when you're traveling, you do that. When you're going to be away for a long time, I find you tend to put the things you've decided are your familiar objects around you. That was an idea we definitely wanted to weave into it.

When did you start traveling extensively outside the United States?

Well, more and more when we started working on *The Life Aquatic*. I did a lot of traveling in Europe when *The Royal Tenenbaums* was being released there. I went to the Berlin International Film Festival, and then I ended up in Rome, and I thought that was a place where I wanted to work on the next movie—that maybe *The Life Aquatic* wasn't necessarily meant to be set in one place or another. Then I went out to Cinecittà, and

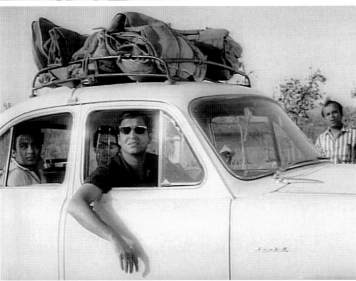

I thought maybe that was the place to do it. I realized we could do it all around there. And starting right around that point, I don't think I've ever spent more than six months of a year in America.

When, from about 2003 onward?

Yes.

Can you describe the experience of traveling abroad at the beginning of that period, as opposed to now, when you're more settled into it?

Well, this doesn't really address then versus now, particularly, but I think there's something about when you're living in places where you don't really speak the language and you don't really understand the language. I'm not very good at learning languages. I'm very slow. My French is very bad, and I've spent a lot of time in France. That's something that isolates you. You kind of wander through. You're sort of an observer. You're at a remove. But what I like is, if I walk down a street in Paris that I haven't been on

before, it's an adventure. Every day that you're abroad, you're discovering something new. When that becomes your routine, it's a strange and interesting way to live.

There is something about language that gives the whole experience a peculiar feeling. I love making progress with a language, and making progress learning about how things are done in a certain place, even if it's only a little progress. I really enjoy going back to a place again and actually having some friends there now, and saying, "Should we go to that place where we went before?" That to me is sometimes more fun than the first visit to a place: getting to know a place, and getting to be known in a place. It's really quite nice to be known, to know people in a place, and to have certain restaurants where you go that are *your* restaurants, places where, even though you don't really speak the same language as the people there, you still have your communication with them, and you're known as this foreigner, so you're different, yet you still have a place in *their* orbit. There's something special about all of that. I didn't experience any of that in my childhood or my youth. It's new for me.

ABOVE: Frame of another God's-eye view: savory snacks and rose petals.

BELOW LEFT: Eleanor Zissou (Anjelica Huston) in a moment of worried repose from *Life Aquatic;* in *The Darjeeling Limited,* her status as an Anglo woman in a monastery in India has faint echoes of Michael Powell and Emeric Pressburger's *Black Narcissus* (1947).

BELOW RIGHT: Bill Murray (the Businessman) thronged in a marketplace.

OPPOSITE ABOVE: Anderson in a compartment of the mobile studio–train devised for *The Darjeeling Limited.*

OPPOSITE BELOW: The Whitman boys, not feeling the brotherly love.

What are the stages of becoming comfortable in a country? How do you know when you have made progress?

It's sometimes challenging to do basic things. I remember when we were doing *The Life Aquatic* and I had to go buy lightbulbs. I managed to get the right lightbulbs. I was able to communicate what I needed to communicate in order to find and buy the right lightbulbs. In America that would not be a particularly rewarding experience. I felt like, wow, that's not what you do when you're a tourist. You don't go buy lightbulbs. If you go buy lightbulbs, it means you're actually sort of living there at that point. That felt like a little step. It was a minor problem, and I solved it, and I didn't use any English to do it, but I didn't use much Italian either.

I don't get the impression that the characters in *Darjeeling* are quite at that level yet. Francis certainly isn't.

I feel like two of the brothers have just been sort of assigned to go to India. They've been told, "Here are your tickets, here's where you need to be, just follow this path and you should end up in this compartment. You'll find me there." I don't think these brothers are exactly the most open-minded to the world.

I remember we had a friend who did a lot of traveling. He traveled all the time, and he kept

OPPOSITE, CLOCKWISE FROM TOP LEFT: Owen Wilson surfs a pachyderm; directing is a balancing act; Wes Anderson, sheepherder. Photographs by Laura Wilson.

ABOVE: Jack Whitman (Jason Schwartzman), not at his most alert; miscellaneous photos from the *Darjeeling* location shoot.

OVERLEAF: A selection of Polaroids taken during the shooting of *The Darjeeling Limited* by Waris Ahluwalia, the jewelry designer and actor who also played the cameraman, Vikram Ray, in *The Life Aquatic*, as well as the chief steward in *Darjeeling*.

SECOND OVERLEAF: Anderson sets up a shot during the marketplace sequence. Photograph by Sylvia Plachy, a former *Village Voice* contributor and Adrien Brody's mom.

these detailed journals which we called "The Musings of a Completely Unfeeling American Abroad." He was always unchanged. He came back with information and experiences, but they never seemed to work their way into his daily communication in any way, or into his worldview. And I think when he was traveling, he had a special confidence. He wouldn't adapt. He was himself, and I think these characters are—each brother's a bit different—but they're sort of, as a group, pressing right through the middle of it, and they're kind of interested. They like the idea of picking up a little of this and a little of that, but they're not really studying it for long. They'll just put it in their suitcase with the rest of their stuff. And it takes a lot to get them to really open their eyes, because they're very fixated on their own problems. They're just very selfish, narcissistic people.

They are. In fact, in some ways the experience of these three brothers in India reminds me of the scene, and I think it's in *National Lampoon's European Vacation*, where they're rushing through the tour of London. "Look! Big Ben, Parliament."

I didn't see it, but I get it.

It's almost like a shopping trip for the brothers in India. And in fact, in one scene it literally is like that, when they go to the bazaar near the Temple of 1,000 Bulls.

Probably one of the most spiritual places in the world, supposedly.

They get out and they look up, and it's interesting that the camera has a God's-eye view at that point. You're looking from the point of view of the temple.

Right, and the action really happens right behind them.

In the marketplace.

Where they try to buy a power adapter.

And some shoes.

Shoes and pepper spray.

Yeah, they regard the monument for all of five seconds, and then they go shopping.

But they go in. After that, they do go in the temple, and they try to pray.

This is another thing that I think proves significant as the movie goes on: Spirituality becomes more important. You would think it would become important after the scene in the village where they see death close up, but I don't think it really starts to sink in until they visit their mom. And even then, only in a small way. I feel like we see the beginnings of the change in these guys but we're not really seeing the change. One of the things I like most about the movie is that it's a highly stylized universe that you've created, but psychologically, it's a very realistic interpretation of how human beings are.

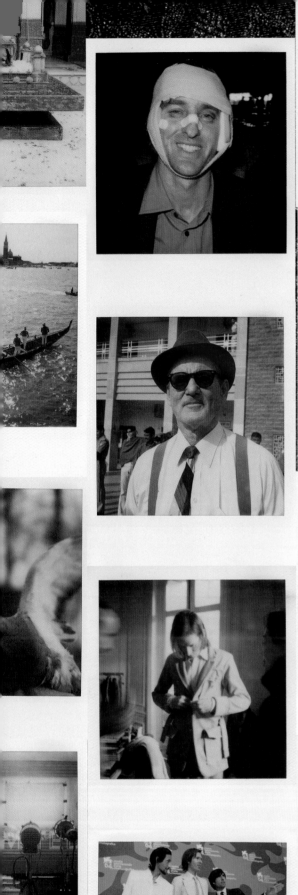
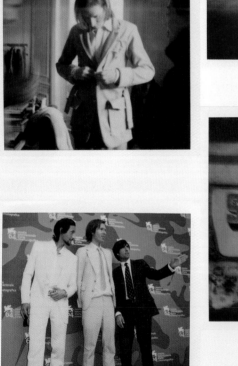

ABONDEND

नी मूर्ति क ला का

Rakana CIRCUS

SHATABDI EXPRESS

LADIES CLUB
ESTD-1928

LIMITED

They go through quite a lot, theoretically. They've had quite a year, and these things have an impact on them. But I don't know if somebody can make a 180-degree turn. I think it's just little, incremental changes. But certainly, there's a moment before they go to their mother when they keep finding different places to simulate rituals, and when they go to the shrine in the airport, I think they're doing what people do when people go into a church: They're saying, "What's happening, and how do I deal with it? And what am I supposed to do next? And can I interpret somehow why I feel this way, and why have I done these things, and what's next? Can I be better?" That's what's happening to them in those moments. They're

still the same people who sprayed each other with mace. But they're trying.

They're trying. One of the best pieces of evidence of their progress is the two feather ceremonies. Francis, as he does in the beginning of the movie, completely dictates the terms of the feather ceremony. He says, "Here is how it's done." And the other two brothers have misunderstood or perhaps not even listened, but who the hell knows if Francis really knows the right way to do the feather ceremony? He may not. Later in the movie, they're doing their own version of the feather ceremony on top of this giant rock near the monastery, and I think that's a very beautiful scene. And that's also, along with the ending of *The Life Aquatic*, one of the most moving scenes in any of your films, to me, because you're seeing that the rules don't matter

ABOVE: Anderson, Jason Schwartzman, and Roman Coppola in front of the Taj Mahal.

BELOW, LEFT TO RIGHT: Jack Whitman's traveling kit; Francis Whitman's medicine.

OPPOSITE ABOVE: Shooting the Businessman's run to the train.

OPPOSITE BELOW: Peter Whitman (Adrien Brody) with his father's baggage.

OVERLEAF: The Whitman brothers. Photograph by Sylvia Plachy.

so much, that the ritual is whatever they are doing. That's what the ritual is. And they're making their own ritual.

And it's up on that rock. It makes me think of the Godard quote you referred to previously, that every movie is a documentary of the actors playing the scene. When we shot that scene—I think we shot it on Christmas Day—there was this place we wanted to use as the location, which is a big rock. It's in this valley, and around this giant rock are many temples. Literally hundreds. It's a place that's just filled with religion, which all of India is, obviously—so many, many different religions and sects of religions and so on. The presence of what you get there, what you get here, in Italy—if

you go for a walk out into a field, you find a little church. Not quite a church; you find a little shrine with a gate on the front. You can go inside, and it's a quarter of the size of this room, and there's an altar, and someone's lit a candle. But in India, there's a much higher density of that. So anyway, when we shot that, on this religious holiday, we only had a tiny group with us. The crew was gone for vacation. We carried the equipment up this mountain, and it was very quiet and private. It was a very good atmosphere for this scene, and I felt like the characters were real.

It's wonderful that it was shot on Christmas Day. I didn't know that. That's a happy accident.

ABOVE: Anderson directs the near-disastrous first meal, wherein Francis Whitman orders for everybody.

LEFT: Frame of the aftermath of the first feather ceremony, during which every Whitman brother does his own thing, disappointing Francis terribly.

OPPOSITE ABOVE: The Whitmans pray, but not too hard.

OPPOSITE BELOW: Peter Whitman and his marketplace spoils.

Well, a happy accident, but also the only way we could actually add this location into the schedule. Usually you say, "OK, what can we do here, what can we do there, and *how* do we do it? We know we want to shoot here, but can we group three things around it?" That place, there was only one thing to do in that place, and it was one scene, and it was a scene that *could* have been done in other places. We could have found another place, but we really wanted to do it there. Well, the way we figured out to do it was we didn't do it within the schedule. We did it during the holiday. We stayed, and we went to this place, this fort that's at the bottom of the place, and we stayed there for Christmas with the few people who wanted to stay, who didn't want to go home to their families. And that was the way we made it work, by saying, "If we shoot it on Christmas, we'll be able to get it."

These movies, *The Life Aquatic* and *The Darjeeling Limited*, seem like they would fit well in a double feature. Of all the things they have in common, key is their similar portrayal of Americans abroad "kind of sort of" being interested in the countries around them, but not really.

And another commonality is the gradual seeping in of a spiritual sensibility, as the characters open up to that. Because they don't have a choice, really. And linked to that is the impact of death and the awareness of mortality. It's dealt with in a slightly more glancing way in *The Darjeeling Limited*, but it's definitely there. There are atom bombs that go off in the two films. Actually, in *Rushmore, The Royal Tenenbaums, The Life Aquatic,* and *Darjeeling,* there are these atom bombs that explode offscreen.

Hmm.

The deaths, the traumas that the three major characters in *Rushmore* have suffered, then the separation in *The Royal Tenenbaums,* the death of Steve's partner in *The Life Aquatic,* and then in *Darjeeling* it's the death of the father. And these are all things that precede the narrative proper in each film, but in many ways they dictate the shape of each film, the concerns of each film.

Darjeeling has this odd structure, when you start the movie, where you wonder who these guys are on this train. And it takes some time. We don't have an opening part that says, "Introducing our characters—here's where they're from, here's what they do, here's where they're going, and we're off." Instead, we just go into a trip—which isn't a terribly unusual situation to discover them

ABOVE LEFT: Francis Whitman finally lets go during the second feather ceremony.

ABOVE RIGHT: A wider view of the Jodhpur marketplace where the Whitman brothers go on a shopping spree.

BELOW: A frame from *The Darjeeling Limited*'s marketplace scene ("Power adapters!"). Not insignificantly, this is a high-angled view looking down on the Whitman brothers' materialist frenzy.

OPPOSITE: Anderson scouting out a hilltop.

OVERLEAF: The Whitman brothers are often pictured three in a frame, side by side, with head-on framing that suggests they are looking at their reflections in a mirror. Sometimes they actually are.

in as they go along—but you don't get that much information up front. And then, after an hour, or an hour and a quarter, we say, "Here's where they were a year ago," and then we show them on the way to a funeral. You know, the scene in the garage—it's an odd thing we flash back to. You kind of think, "If we're going to bother to flash back to a year earlier, let's go to the funeral." Instead, we go back a year earlier to the *way* they *got* to the funeral, but we never get there. We spend the whole time in the garage.

That's important, though. That seems correct, to choose that moment, because first of all, the placement of the flashback feels right to me, because these guys have repressed the full importance of what has happened to them. And so when it pops up in the middle of the movie, it's as if the thing that's repressed has suddenly come to the surface.

Hmm.

Because they're at a funeral just before and after the flashback.

We combine the funerals, I guess. These deaths are just rocking them. They don't know how to deal with it.

There's that, but also, what are they doing in the flashback? They're desperately clinging to the illusion of control and

the—how to put this?—the rituals. They're hung up on the significance of objects and the significance of routines and the way things are done, and that they have to drive their dad's car to this funeral, otherwise it's not right. I get the sense they feel they will have failed if they don't show up at the funeral in that car.

They want to go, they want to be together in their father's car—to drive to the funeral, have it, and get back in the car afterward.

And the car's not finished.

It's not ready yet.

Yeah, well, there's a lot of that.

There's a part missing.

Let's focus on that for a second. The car's not ready yet. The journey that the guys take in *Darjeeling* is already under way when the India portion of the story begins, and it ends before we see the actual conclusion of the journey. Right?

Right.

And then you have Jason's character—

We end on a new train.

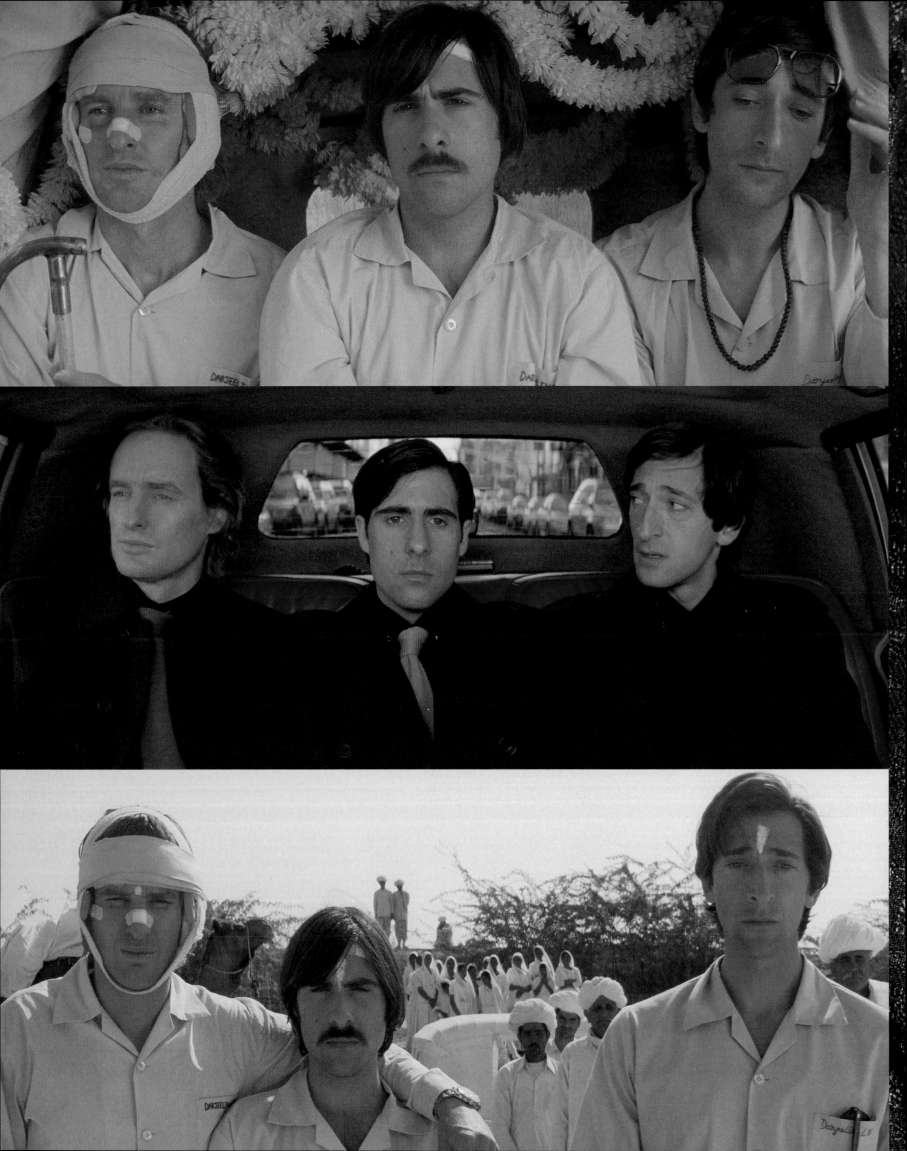

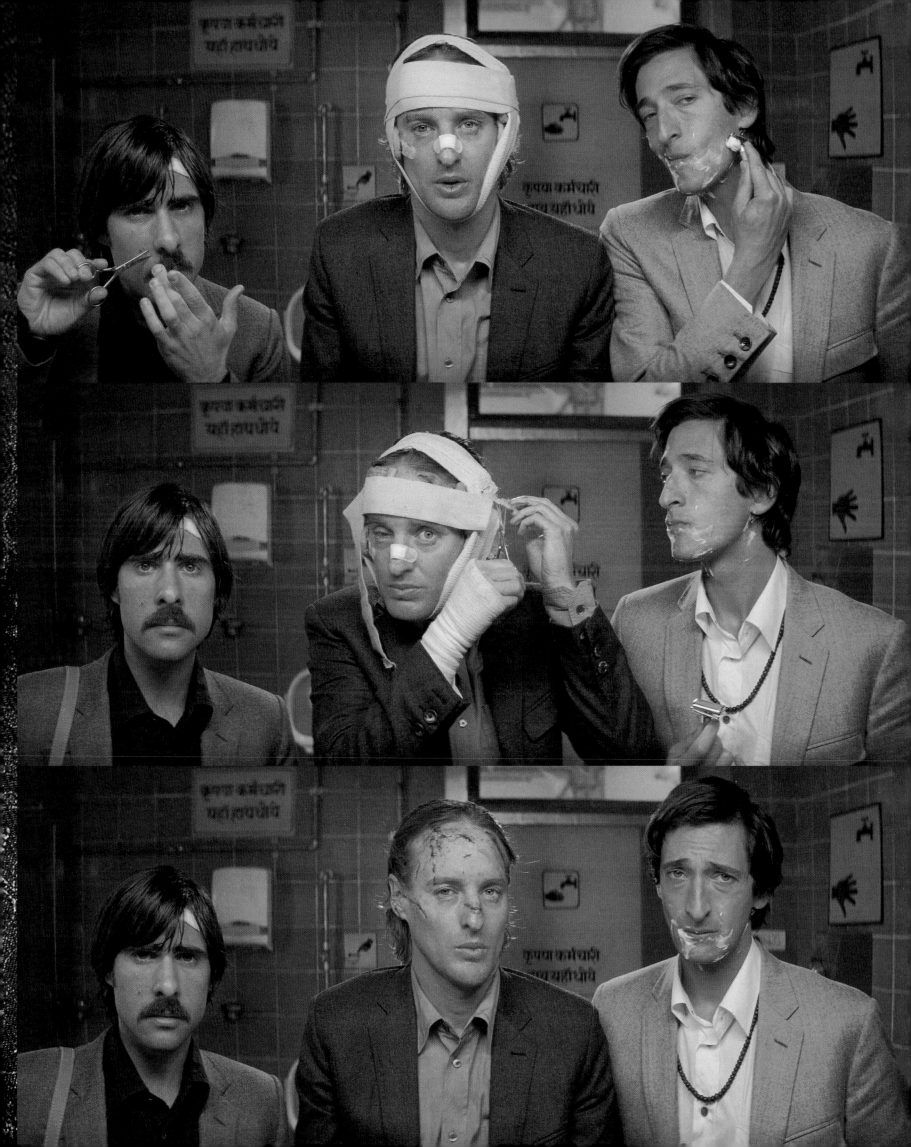

PREVIOUS OVERLEAF: A side view of the "healing" scene in the bathroom.

OPPOSITE: Exquisite detail work done by artisans on the film's train cars.

ABOVE: Owen Wilson high atop a hill overlooking the stalled train, in a *Lawrence of Arabia* pose.

Jason's character, Jack, is writing a story, but he's not done with the story yet.

Right. He wrote the ending, but he hasn't started the beginning yet.

And Francis is in a motorcycle accident, and he's healing, but the healing isn't finished yet.

Right.

There's all this stuff that's in progress in the movie. But we don't see any beginnings or endings.

Yes, you're right.

It's all these middle sections.

That's true. And that's what the flashback is also.

It's a chunk of an important day, but it's not the whole thing.

Right. The one thing that they go through, that they *do* complete, is that they enter into these strangers' lives, for the one time in the whole story that they actually connect to these people, and they go through this experience with them. And that we see from its start to its finish. But everything else is in the middle.

I don't want to reduce anything here, but when a director returns to the same themes again and again, there's usually some

personal reason for it. Is this just personal evolution and an acceptance of mortality? I think everybody is worried about that to some degree, but it doesn't always show up in the movies.

Well, you know . . .

A person could go through their entire career as a filmmaker and never make a movie on those themes.

Right. I think, often, what ends up being important in a movie thematically, or what it ends up being really about, is usually not what you're focusing on. You're focusing on what a certain character is going to say, what this character wants from this other character, how they feel, and how she's going to express what she wants, and what's going to happen, you know? And as with everything else in life or writing or filmmaking, you don't really control what it *means*—my instinct is that I don't want to control it, because it's better if it just comes to life, in whatever way that can happen. And everything else, *everything* feels like it has to be created for one of these movies, so I'd rather have the meanings come out of the life of it, rather than wanting to demonstrate a certain theme, or communicate a certain theory.

This is all very illuminating, because, as I'm sure you're aware, there's a perception of you as being somebody who goes into everything with a very detailed plan. And here, in interview after interview pertaining to your films, you tell me that you really don't have one. You have the script, but in everything else after

OPPOSITE: Some examples of work by local artisans, "a hundred guys painting elephants and things," as Anderson put it.

ABOVE: Owen Wilson and Jason Schwartzman, wrapped.

OVERLEAF: Images from the "Dream Train" sequence.

that, there's a degree of winging it. And I don't mean that you don't know what you're doing at all, or that you deliberately try not to know what you're trying to say.

That's certainly true. My habit is to get the script locked down—I don't like to leave things open in the script. And usually we tend to do what's in the script.

By not leaving things open, you're referring to the plot, the dialogue, things like that? Not the meanings?

Not the meanings. I don't do scenes where it says, "The taxi driver gives him directions." I don't put in, "He talks on the pay phone for a moment and then hangs up." We put in all the words. And I plan the shots. Some of the shots I plan when we're writing the script. And many things you figure out when you get the location. I usually have a vague but clear plan of how to make the movie, but the themes, the meanings? I don't like to field the question at all, even to myself. And also, with *The Darjeeling Limited*, we definitely made it part of our system for producing the movie to accept whatever happened that did not follow our plan—to try not to fight it.

Can you give me an example?

Well, one example is that in order to do a shot, we needed a house—a hut. So we paid these people to build us a hut. And they built us a mud hut with a thatched roof, just like the other ones. But when we came to shoot it, it was painted blue and pink with flowers all over it, and it was not like the other huts. They said, "We made it better." And we said, "All right, well, that's the hut." We didn't say, "No, we meant just like the other ones." It was too late, for one thing. And also, well, that's what they do, you know? The flowers were excellent. Our train was decorated by a hundred guys painting elephants and things—you know, none of the ideas for how the train was decorated came from a real plan. I mean, we had a basic plan, but it modified and changed and evolved—a lot of it was just they *kept painting*.

Are there any examples similar to the anecdote you told about the baseball field in *Rushmore*? Where you had a very distinct idea of what you wanted to do, and then you got on the set and realized, "Wow, I have to do something entirely different now"?

Well, a significant part of the movie is in this little compartment. That we *did* control. It just moved, and we kind of figured out our system for shooting if the train stopped, or if we changed direction. We created a very versatile environment for working on this train. And we had the same compartment built into two different cars—one on one side and one on the other

So that you could do the reverse angle on a different car?

So that we could keep going back and forth. And we could take these things apart completely, and

very, very quickly. We just slid the wall out and folded the thing down.

But when the train stopped and we were shooting outside the train, there was much less control—and there were interesting developments. For instance, we wanted to shoot on this sand dune, so we went to scout it. When we walked up this thing, we found it was very hard to climb, and our feet sank deep into the sand so that when our legs came up, they were covered with these burrs. It was kind of painful. It was a very good dune, but it was going to be very hard to get anything up there. There was no road up there. Everyone would have to walk. And how would we get the camera up there when we could barely get *ourselves* up? Then Jason and I started trudging down, and we looked up and saw that Roman had leaped off the side of the dune and was sort of flying down it like he was skiing or something. When we saw him, we said, "We've definitely got to shoot here. We definitely have to do this, because we have to see them do *that*." And I really like how the scene turned out—they're running down this mountain in a kind of a great way. When it came time to do it, there were camels around, and the camels brought up the equipment, and the scene just sort of unfolded in front of us.

That's not quite the same sort of thing we were just talking about, but—the place, too, can just sort of show you what it wants the scene to be.

So you have this working method where you're extremely certain of the technical details, but you're building those as a safety net so that accidents can happen.

I think that's a pretty good system. For a certain kind of movie, that's what you want. I feel like Robert Altman's whole wonderful system is built in part on the basis of, "OK, let's create the framework for the thing to spontaneously happen. You guys make up what you're going to say, and you guys go write a song and come play it, and bring it all back to me, and I'll stir it together." I don't have that kind of feeling of freedom in my approach. I'd like to! But nevertheless, he's someone I admire so much and I want to imitate to the degree that I can find a way to incorporate it. I mean, to incorporate that approach into my own frankly sort of pretty rigid framework.

What sorts of important details were added by the actors during shooting?

Well, maybe this sounds kind of ridiculous, but to me, they're improvising everything except the words, you know? So the way they're going to do it, the way they're going to move, every gesture is coming out of them and the way they interact with each other. And those guys bring so much of their personalities into it.

Roman and Jason and I went to a Sikh temple with two of our friends very late one night in Delhi. When you go to a Sikh temple, you have to cover your head, but there's usually some kind of can or box of very bright scarves, and you tie

THE DREAM TRAIN

DARJEELING

THE DREAM TRAIN

DARJEELING

THE DREAM TRAIN

DARJEELING

THE DREAM TRAIN

DARJEELING

THE DREAM TRAIN

DARJEELING

THE DREAM TRAIN

DARJEELING

THE DREAM TRAIN

DARJEELING

THE DREAM TRAIN

DARJEELING

Printed in Italy.

HOTEL CHEVALIER

THE DARJEELING LIMITED

OPPOSITE: In a video essay about *The Darjeeling Limited* for the Criterion Collection's DVD release of the film, the author described *Hotel Chevalier* as a sort of scaled-down look at themes explored in more detail in *The Darjeeling Limited*, the short representing the feature in microcosm. (TOP ROW) Exhibit A: The titles of each film as displayed within the story itself. (BOTTOM ROWS) Exhibit B: Both *Hotel Chevalier* and *The Darjeeling Limited* end with nearly identically framed, similarly timed, right-to-left pans that culminate with the title of the movie repeated on-screen in yellow.

BELOW: Artwork by Eric Chase Anderson for the Whitmans' father's custom Louis Vuitton luggage.

them on. Well, everybody does it their own way. And I remember when we got to the set, the costume department had prepared these special tie things, and I was a little upset. "You guys come in, you take the things out of the boxes—and put them on your heads *your* way. You do what *you* do." And they each had some very strange way of doing it. Adrien is looking in his glasses and adjusting everything, and Owen has no idea what it looks like. And their personalities come through in that.

Is every scene shot on the train actually shot on a train?

There's one scene where we wanted to shoot from outside the train, looking in through the windows, because we felt that since we had all these scenes on the train, we wanted to find a way to do each scene differently. So each scene has a different kind of configuration to the set. And one of them is shot from the outside.

And I did want to shoot everything on the train, even though it's a bit insane at the end of the day, because it means you're genuinely limited by the space. There are some times when the camera's got to come over here, and Jason's got to go like this [STRIKES AN AWKWARD POSE.] because the dolly is actually pressed against him, and the dolly grip—Sanjay Sami, who has worked with us ever since—has got his arm against Jason until a certain beat, and then Jason knows the next move, so as soon as the camera moves, he's got to

step here, otherwise he'll be seen, and—it's very crazy. But it's hard to replace the experience of actually going out on the train and being there.

But yes, there is one scene that was shot through the window, where we built a small additional version of the set at our art department, which was actually a little depot. And that was where we rehearsed and blocked out camera moves, because we actually had to practice them to know what equipment was going to fit in the space.

So you had a mock-up of the train that you practiced with?

That compartment. And we actually shot one of the scenes on this mock-up.

Why did you feel it was so important that everything—the interiors, the exteriors—be on the train?

Because I just felt like you'd know whether it was real. Maybe that's not true, but I knew that if we were really on the train, it was not going to feel fake. For the audience or the actors. The actors were going through it, you know. I don't know if Owen and Adrien had gone on overnight trains, but they know what it's like to live on a train now, because they spent a lot of time traveling by train on that movie—they spent a month on the train. Jason, Roman, and I had spent a lot of time traveling in India by train before, but now everybody knows. Everybody who worked on that movie knows what that's like.

FANTASTIC MR. FOX

The 1,194-Word Essay

"I USED TO STEAL birds, but now I'm a newspaperman." So says the title character of *Fantastic Mr. Fox,* a stop-motion cartoon about a family of chicken-stealing foxes and the corporate farmers trying to snuff them out.

This 2009 animated feature was Wes Anderson's most widely acclaimed picture since *Rushmore.* Why? Perhaps because it is overwhelmingly and comfortably a comedy, starring stop-motion animated creatures voiced by the likes of George Clooney, Meryl Streep, Willem Dafoe, Jason Schwartzman, and Michael Gambon. There are no drastic tonal shifts into trauma and grief. It's entertainment, spry and colorful, chock-full of made-up facts (beagles love blueberries; foxes are mildly allergic to linoleum) and extravagantly silly visuals,

including fast burrowing that makes it seem as though the animals are swimming through the earth. It's the sort of film in which animals don "bandit hats" before robbing chicken coops and a fox goes tree shopping with a real estate agent and gripes that there's no pines on the market. As voiced by the perfectly cast Clooney, the hero is a honey-toned, corduroy-suited rock-star rascal—an impresario-leader in the vein of Max Fischer, Royal Tenenbaum, Steve Zissou, Francis Whitman, and Danny Ocean, the suave thief-ringleader played by Clooney in the *Ocean's* films.

But the movie's inconsequential air is as deceptive as Mr. Fox's identity as a newspaperman. *Fantastic Mr. Fox* is an Andersonian primer, rethinking the director's style and themes in terms that everyone, kids included, can understand and enjoy. Liberally adapted by Anderson and Noah Baumbach from Roald Dahl's novel, it's a fable about the tension between responsibility and freedom, and a portrait of families in repose and turmoil. Like *The Royal Tenenbaums* and *The Life Aquatic with Steve Zissou,* it's centered on a charismatic but selfish father figure who cares more

by Matt Zoller Seitz

about his own pleasure than his family's needs, puts them through hell, suffers alongside them, and partly redeems himself.

The film lays out these themes in its opening sequence. Mr. and Mrs. Fox (Streep) are on a chicken run. Mr. Fox smugly points out a trap they avoided and accidentally cages them. Moments later, Mrs. Fox locks Mr. Fox in a psychological cage by revealing that she's pregnant and making him swear he'll give up chicken stealing and be responsible. The story jumps forward to show Mr. and Mrs. Fox years later, with their now adolescent son, Ash. Their burrow seems to be the animal world's version of an efficiency apartment. "You know foxes live in holes for a reason," Mrs. Fox says, the unspoken end of that sentence being: *So we don't get killed and skinned.* "Honey, I am seven fox years old. My father died at seven and a half," says Mr. Fox. "I don't want to live in a hole anymore, and I'm going to do something about it." He goes house hunting—actually, tree hunting—and opportunistically buys a place that gives him a view of Boggis's, Bunce's, and Bean's farms: mother lodes of plump fowl and tasty cider. Under the guise of moving the family toward a brighter future, the sly fox is planning his own regression. "And how can a fox ever be happy without—you'll forgive the expression—a chicken in its teeth?" he asks. It's a rhetorical question.

Mr. Fox's brazen raids infuriate the famers and rouse Mrs. Fox's baloney detector. "If what I think is happening, *is* happening, it better not be," she says. Dahl's black wit bubbles up through the film's sunny surface and fuses with Anderson's flair for the incongruous. As in the book, Mr. Fox gets his tail

shot off by Bean, but the script adds a ghastly embellishment: Bean turns it into a necktie and wears it on a newscast to taunt the hero into confronting him. Boggis's cider cellar is guarded by a rat (Dafoe) who dances like a delinquent from *West Side Story* while twirling a switchblade and purring that Mrs. Fox is still foxy. "Am I being flirted with by a psychotic rat?" she asks, another rhetorical question. The three Bs roar in with earth-moving equipment—blasting the Rolling Stones' "Street Fighting Man" as their personal "Ride of the Valkyries"—and pummel the family hill into a crater.

Anderson's sixth film inspired enthusiastic yet often backhanded praise from critics. They adored its sprightliness, broad humor, clean direction, and buoyant finale. But they also observed, somewhat smugly, that it was only a matter of time before the director made a bona-fide animated film, seeing as how his movies were sort of cartoons, anyway. It's the sort of blinkered modern-day observation that devalues any form of storytelling except whatever's fashionable at that point in time. Right now, what's popular is a bogus "realism," sometimes drab, sometimes frantically busy. That's not Anderson's bag. Despite his fondness for ornate design and detail-packed compositions and music-fueled expressionist interludes, at heart he's a fabulist who works in a borderline-minimalist vein. He gives us enough details to understand the comic essence of a character and no more; he lets a scene go on long enough to communicate salient plot points and no longer; his shots are dynamic, at times arrestingly beautiful, but they don't often move in ways that cry out, "Look what I can do with a camera! Isn't

it amazing?" For the most part, his writing and direction are stripped down, functional, practical: line, line, line, punchline, and we're out; close-up, wide shot, pan right to this, pan down to that. When he does more than you expect, there's usually a reason. His sensibility has more in common with such 1940s filmmakers as Preston Sturges, Howard Hawks, and Michael Powell and Emeric Pressburger than with most of his generational contemporaries. Among its many pleasures, *Mr. Fox* clarifies the essence of Anderson's artistry, boiling his themes and aesthetic down to storybook-simple moments and gestures. There's not a wasted line or moment. It's as tight as *Rushmore*.

Speaking of Anderson's second film, *Mr. Fox* ends on a *Rushmore*-like note of affirmation, with Mr. Fox and his friends boogieing in the promised land to which the hero inadvertently led them: a Boggis, Bunce, and Bean supermarket, accessible via sewer pipe. But the air of total victory is deceptive. Yes, the mammals' nutritional needs are provided for, and they've reimagined their community as a city of tunnels, but out of necessity, because they can't live above-ground anymore. Mr. Fox's tail isn't coming back, either. In the final sequence he's wearing a detachable tail—a haunch-piece, as it were—and trying to put the best possible spin on things. "They say our tree may never grow back, but one day, something will. Yes, these crackles are made of synthetic goose and these giblets come from artificial squab and even these apples look fake—but at least they've got stars on them." Creatures like these, the film suggests, are the bane of our existence and the engines that drive the world forward.

The movie's emotional high point is a near-silent moment: Mr. Fox spotting a wolf on a distant ridge and giving it a solemn salute. After an anxious moment, the wolf returns it, then slinks into the woods. Wild things stick together.

FANTASTIC MR. FOX

The 5,327–Word Interview

OPPOSITE: Mr. and Mrs. Fox in Boggis, Bunce, and Bean's supermarket. In the foreground is a Nikon D3, a high-resolution still-frame digital camera that captures the individual frames that create a persistence-of-vision effect when projected in succession: the essence of all animation, really.

ABOVE: One of Mrs. Fox's landscapes, in oil, with the omnipresent lightning bolt. Artist Turlo Griffin executed all of Mrs. Fox's artwork for the film.

BELOW: A phonograph player miniature/prop.

MATT ZOLLER SEITZ: Did you always want to make an animated film?

WES ANDERSON: No, not really, but I'd been thinking about this one for ten years before we did it.

And you had read Roald Dahl before, as a child?

Yep.

What was it about *Fantastic Mr. Fox*, of all the things he's written, that made you fixate on it?

Just that I liked it. And I wanted to try stop-motion, and to work with animal characters rather than human ones. I wanted fur. I liked the digging, that a lot of the film would be underground in these tunnels. The book was one of my favorites as a child. Plus, it hadn't been adapted yet, and most of them have been.

Here again, this is an entirely analog production. Is there any CGI work in it at all?

Maybe not CGI. We shot it with digital cameras, and there's quite a lot of digital compositing or whatever you call that, but we didn't do a lot of green-screen-type stuff. Often we'd plan things like, "In this shot, the record player's going to be spinning in the corner of the frame." Well, you can do that by having the animator move the record a bit in every frame, plus the characters. Or the animator does three turns of the record, and then just leaves it, and when you put the movie together, you just do a loop of that corner of the frame. You just do a digital thing there, and he's done the record player in fifteen minutes, rather than it adding a minute to each frame, which could add—well, it depends how long the shot is, but it could certainly add hours.

In *The Royal Tenenbaums*, almost all the scenes in the house were shot in that actual house, right?

Right.

And the scenes in *The Life Aquatic* on the boat—you shot them either on the boat on the water or on a replica of the boat in the studio, so it's *that* boat?

LEFT: Roald Dahl, author of *Fantastic Mr. Fox,* among other children's classics that aren't just for children.

BELOW: The cover of the first edition of Dahl's book (TOP), and the cover that appears in the film's opening (BOTTOM).

OPPOSITE, TOP ROW: Prototype for the smallest version of Mr. Fox, used for extremely long shots of the character.

OPPOSITE, CENTER ROW: Annotated script page of the sequence in which Mr. Fox hides by pretending to be a cider jug, with Wes Anderson's drawing of what that should look like.

OPPOSITE, BOTTOM ROW: Clay maquette versions of the cider-jug Mr. Fox, and the final version as it appears in the movie.

OVERLEAF: Concept art of Bean's cider cellar.

Yep, but the interior of the boat was other sets. There was a real boat, and big, chopped-in-half boat set, but most of the scenes were shot on sets with four walls. There's a whole wing of the boat that we built so that we could go down the corridor and into the different rooms, and there was an upstairs part. Each floor of the boat was built. So those were quite traditional movie sets.

But you seem to be quite adamant about trying to have things actually exist when they're going to be photographed by the camera.

Yes.

And there are a lot of ways you could probably construct these things to make them fit easier, and you choose not to do that. Why?

Well, David Fincher, for instance. He's so skilled with the technology. I know there's this one scene in *Zodiac* where there's a street corner with a building—there's no grand visual effect they were trying to accomplish, but in fact, they digitally put in the building because the building had been torn down. And he put in the exact original building—I don't know exactly if they reconstructed it in miniature somewhere and then put it in, or if they took photographs and put it in, or if they made it somehow on their computer. He brought the exact real place back to life.

What appeals to me more are these old-fashioned techniques. Old-fashioned special effects tend to appeal to me, as does the challenge of getting it in the camera. When Truffaut worked with Néstor Almendros, they often would do a fade to black or an iris shot in the camera, which is really like a silent-movie technique. But there's a handmade feeling to it. There's an

imperfection that doesn't really qualify as an imperfection, because it's the real thing. That's just a personal preference.

I'm always aware that your movies are being made by people, and that even goes all the way down to the individual camera moves. Like, it's not a smooth, robotically controlled move when you pan from one character to another. There's a feeling—it's like someone's head is moving. And when you do a zoom, it's an old-fashioned, crank-it kind of zoom. You feel it. It's not mathematically exact.

I don't know the reason, but certainly what's always appealed to me is a more handmade feeling. Or not a handmade *feeling,* just handmade.

And certainly that carries through to *Fantastic Mr. Fox.* You had miniature sets built, right?

You have no choice. The puppets are little.

And they were quite elaborate. Was it forced perspective? How did you do it?

Sometimes we used some forced perspective. We used every different kind of method, I guess. The main Mr. Fox, for instance, was just over a foot high, and most of the sets were in that scale. But often, we would have a set where more than one scale was used: the big Mr. Fox exits, and a smaller Mr. Fox enters in the background. He's supposed to look like he's come in thirty feet away, when in fact he's come in three inches away.

I'm not saying I want people to say, "Oh, they've just changed the scale," but part of what I might enjoy about it is the change in scale. It's not a change in scale that's seamless and that you would never notice. Instead, it's a change in scale that's for fun. The smallest Mr. Fox is made

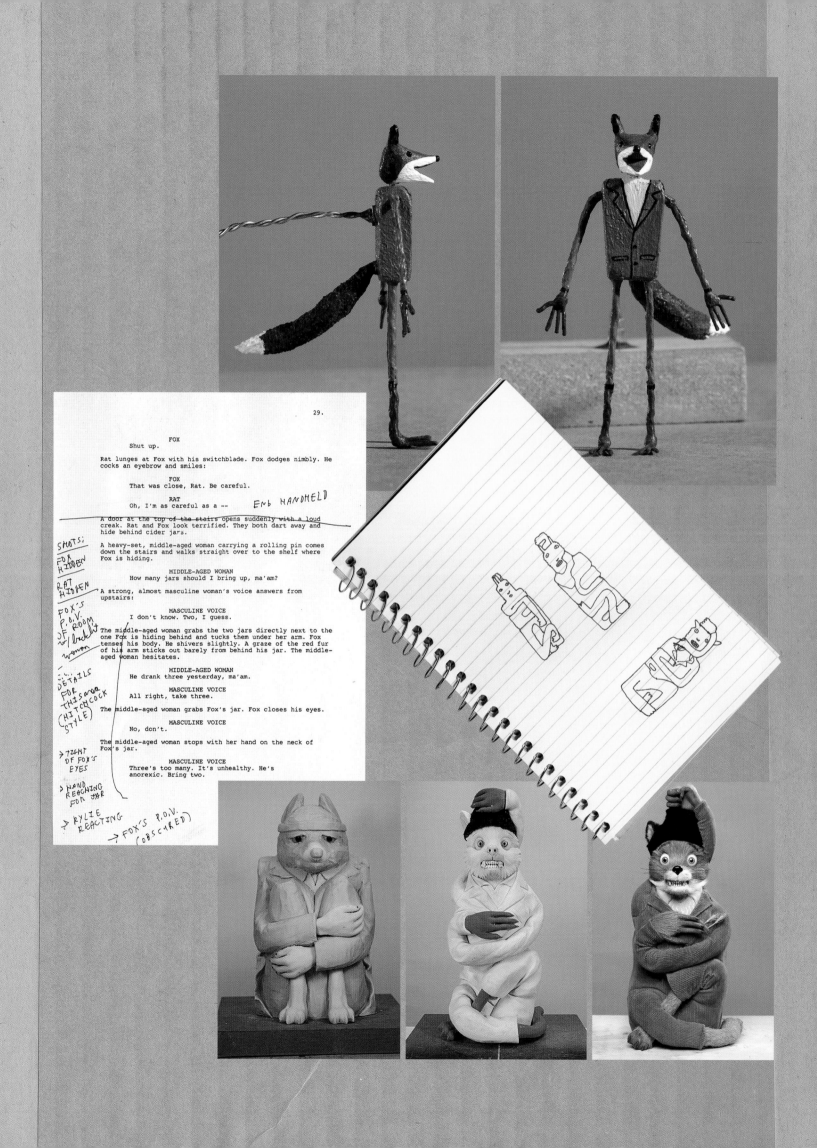

WOLF - APPROVED DESIGN - 16/02/09

E

NOTES:
all black fur not red - paint in silver
refine front leg shape
refine feet
more anatomy in face

roughness is good!

FOX
JULY 26 '06

MRS. FOX
JULY 28 '06

WALK - SONIC

OPPOSITE: The evolution of the wolf that returns Mr. Fox's salute (CLOCKWISE FROM TOP LEFT): Anderson's early storyboards for the scene; Anderson's rough sketches, with annotations; professional renderings of the animal, which at this point looks more wolflike; more advanced renderings of the wolf; photos of the near-finished model, with notes; the finished version.

ABOVE: Eric Chase Anderson's renderings of Mr. and Mrs. Fox.

of silicon, and he's painted, and he doesn't really look like the biggest Mr. Fox at all. If you put them next to each other, you would not say, "This is the same puppet." They look nothing like each other. The smaller one moves differently, and it has no joints. But they're the same character. Unfortunately, I wouldn't use the word *mainstream* to define this instinct, I guess.

Well, certainly not now.

It was certainly meant to be mainstream. We made it as a 20th Century Fox animated Roald Dahl story, but it didn't reach that kind of audience. It was meant to, but at the same time, I just wanted to do what I was excited to do. Maybe Spielberg would not have done the rubber puppets.

Probably not. But that's one of the things that certainly sets it apart from the usual way of doing children's movies now, which is CG. And not just that, but a particular style of CG, the Pixar style. Everybody is doing children's movies in the Pixar style. And on those rare occasions when someone doesn't do it in that style, it really stands out. It almost seems rebellious.

What is one that's not Pixar style?

Oh, I would say *Persepolis*.

But is that CG, or is that hand drawn?

It's hand drawn. I mean, I'm sure they did it on a computer, but it looks like two-dimensional, drawn animation.

By Pixar style, you mean the CG that's meant to evoke a three-dimensional feeling?

Molded and rendered with shadows.

Antz or *Shrek*. But *Shrek* is quite different. *Shrek* doesn't look like a Pixar film. *Shrek* looks like something else to me. *Shrek* is poppier, or something. Pixar's aesthetic is more refined, I think, than *Shrek*.

It is, but I don't see the differences as being quite as extreme as, say, the differences between *Toy Story* and *Fantastic Mr. Fox*. Something like *Despicable Me* or *Toy Story 3* or the *Shrek* films or *Antz*, they're all within a certain school.
　　But your attitude is to try to make it real, even though it's completely fantastical, even in the sense of the sound recording. I heard that if there was a scene that was set at a farmhouse, it was actually recorded at a farmhouse. That seemed, I have to say, a little crazy to me.

Yes, but it wasn't about the quality of the sound. We did it because there would be accidents in the sound. That's what happens when you're on location. You don't have control. When you're in the

FOX FAMILY

studio, you do. We were in the farmhouse because the principal thing we were doing was not getting a recording, it was getting great performances—that's the whole task. And then related to that, it sounds much more *fun* to me for us to go to a farm in New England, all together, and have our cast act out the movie. Another thing is that when you're recording and there's no picture, even on location, you're very free. You're not saying, "Start over. The plane came in the middle." Everything you're recording is interchangeable. The take is not a take; there's just the line readings. The performance may be continuous or you can use anything in any way you want, as long as you can figure out how to deal with the sound of a tractor in the background. In fact, we did some of it on a lake, and there was a boat going by, and we ended up replacing the boat with an airplane. We animated an airplane flying overhead to use the sound of the boat.

Usually, when dialogue is recorded for an animated film, it's line by line, and it's in a studio, and the actors aren't together, and they piece it together like a jigsaw puzzle. The filmmakers put all the lines together in the order they're specified in the script, and then you have your scene. With the way you recorded the sound here, were you able to do that? Or was it not necessary? In other words, could you look at it the way you would if you'd done a live-action film, where you were actually shooting the

actors, and say, "Take four was the best. Let's use the sound from take four?"

You isolated everything. Our system, we split it up, and say we had twenty takes of this sentence, well, we listen to all of those and say, "OK, let's use half of this one and half of this one and the first syllable from the last word of this other one." And then you listen to twenty takes of the next line, and then you start to make a little list, and then you start saying, "I'm always picking number seven, so I'm going to go listen to seven all the way through." And saying, "I like all that, except for the very funny thing that's on take fourteen." And you muddle it together like that, and you tighten it up as much as you can. And now you've got problems, because on take fourteen, there's something different going on. There are birds on take fourteen, and now you figure, "How are we going to add birds here?" And it becomes sort of a collage. That's the way you do it.

So there is, at least, a similarity in the way dialogue is edited.

A lot of the movie was rewritten in this process. A lot of the movie was added—we rewrote maybe half of the movie during the process of making it.

During the process of recording the sound?

OPPOSITE: A preproduction sketch of the Fox family.

CLOCKWISE FROM TOP LEFT: Anderson's storyboard of the insert shot of Mr. Fox's newspaper; a frame of the tree as pictured in the newspaper, which Mr. Fox then lowers to reveal the tree he's about to buy; a frame from Rat's fight with Mr. Fox (electrical zaps!); Anderson's sketch of the same scene.

OVERLEAF: A gallery of miniature furniture, appliances, vehicles, and other items showcased on-screen in *The Fantastic Mr. Fox.*

* This interview was conducted in 2010, two years before the release of *Moonrise Kingdom*, which, while it may not be Anderson's best-reviewed film, is surely in his top three.

No, during the process of animating the movie. Over two years—from the first recording until the movie was finished was at least a year and a half to two years—I added lots of things. I rewrote many things and rerecorded. And so we rerecorded on location a bit, but most of the additional recording we did in studios. If we'd been here in Italy three months earlier, I guarantee we would've recorded something here. I recorded people in closets, I recorded Willem Dafoe in Rome and Meryl Streep in Paris and Michael Gambon in London and George Clooney in California and Jason Schwartzman in New York. The recordings are from all over the map, and they're sort of like documentary recordings.

There was a running joke in reviews of *Fantastic Mr. Fox* that it was only a matter of time until Wes Anderson made an animated film. You probably saw variations of this.

Yes, I did.

What do you think of that? What does it say about the perception of how you work and the idea that the other films were also like cartoons or like animated movies?

The idea would be I'm just so controlling. But also, there's an element of caricature to the characters in the movies I do. Often the way they dress or their very identity is a kind of caricature. There are other people's films that I love that I would say have this quality, but that are nothing like my movies. I find it valid.

It occurred to me recently that Todd Solondz and you have that in common. Perhaps almost nothing else, but that.

Mia Farrow in *Broadway Danny Rose*—you could say that's a caricature, but it's also a wonderful character, and it was one of her best roles.

It is. She's great in it. And it's one of her least expected roles.

Polanski's movies—I could see describing many of the characters as caricatures.

What does a caricature mean to you? Does it mean that one particular trait defines the character?

Not necessarily, but that one or more characteristics are exaggerated, and that the overall effect is not exactly realistic. It's instead something a bit broader. Tati's and Fellini's movies are filled with caricatures. In *Amarcord*, for instance, who isn't? But there's just no reason in the world for that to be a negative in *Amarcord*.

Anyway, I think maybe it partly comes from that.

I think it's also probably visual, too, because you are a world-builder sort of filmmaker. You're constructing an entire universe that surrounds these characters.

In the end, I guess *Fantastic Mr. Fox* must be the best-reviewed movie I've done.* It's not really for me to say why that is.

I have a theory. Would you like to hear it?

Sure.

I think that because it's an animated film, and because it's a children's movie, the stakes were lower for the reviewer. I think critics gave themselves permission not to get hung up on the things they would get hung up on if it were a live-action film. It's a little easier to define what it was that you were doing. There's a box you can fit it into. The way you went about it is unusual by today's standards, but the film itself is maybe the most identifiable film you've ever made, in terms of being an example of a particular kind of movie.

I guess it's just clearer what it's meant to be. I got better reviews because the stakes were low.

And yet it's very consistent with your other movies in the types of things it's concerned about. It's not as heavy in some elements as the preceding three films, but it's got a lot of the things you expect a Wes Anderson movie to be interested in, and one of them is the conflict between a person's creative or professional pursuits and their domestic life. And then there's also the dynamics in a family of very strong-willed, particular types of personalities having to live under the same roof. And

For the home

Have a seat

Travel in style!

Work and play . . .

then there's also an aspect of Steve Zissou, as well as Max Fischer, in Mr. Fox. He's a visionary leader of other characters—his ideas might be good, or they might be bad, but he has this charisma that enables him to lead the team on this mission. Whether or not it's a mission worth going on is an entirely different matter. And the other characters in fact debate among themselves whether or not they should be following this guy.

Well, this definitely falls into that category.

What elements did you add that were distinctively your concerns, that weren't there in the book? I read the book to my son recently, and I noticed a few things.

We didn't approach the book by thinking, "What's missing here?" All we did was make it longer and invent some characters, give them names and identities. But beyond that, it was just incremental. Let's have him find this tree and buy it. Let's start with that, let's go exactly for that—what's that like? Let's say we need a real estate agent. In fact, maybe everybody needs a job. And that's really the way the process happened. Noah and I sort of talked about, well, why don't we make the badger an attorney, and he can advise Mr. Fox on the sale. And it just sort of grew out of that. And so everything that we added, we were thinking of Roald Dahl, but we were making up our own things, so eventually the movie was not exactly Roald Dahl. It was certainly after-Dahl, and he was what we were aspiring to. I think part of the way we tried to keep it true to Dahl was that we decided Mr. Fox sort of *is* Dahl. Let's say he's kind of Roald Dahl, and let's think of him that way. What would Dahl do if he were not writing this, but stealing these chickens? And so that was sort of the way it evolved.

What is your perception of Roald Dahl and his work? Out of all the children's fiction you read as a child, why was he the one you chose when you finally got around to making a "children's film"?

All the things that people usually bring up are basically the explanation. It's that he really did have a knack for seeing from a child's point of view. The details he focuses on and vividly describes are just the ones that might most fully and directly capture a child's attention and inspire a child's imagination.

Or it might just be that his books show a true interest in the things that make children laugh and frighten them. He never particularly held himself back from the extremely scary or disgusting things. He had such a broad imagination and would turn some real-life inspiration into something fabulous. He also had this tremendous facility with inventing characters, and he could just weave a plot that was real. You know, in some ways, theoretically, part of what has prevented him from being thought of on the first order of writers of adult books is that the plots are sometimes like O. Henry stories. They're so often the kinds of stories that tend to be thought of as "genre" because they have such a neat and classic shape. It's a rare ability—you know, somebody like Stephen King; he can do something that few people can do.

But while his reputation persists, Dahl is not persisting. I sense on the part of other parents a bit of hesitancy in exposing kids to Dahl.

Really? In America?

In America. Because there's a whole movement toward making the world of childhood as comfortable, bright, and cheery a place as it can possibly be, and Dahl is the opposite of that.

And they really peg him as that?

Not everyone, but I have had conversations about Dahl and the suitability of reading Dahl to children of a certain age.

OPPOSITE, TOP: Not-quite-final versions of Bunce, Bean, and Boggis, as represented in preproduction art.

OPPOSITE, MIDDLE ROW: Boggis and Bean, posable puppet versions.

OPPOSITE, BOTTOM ROW: Bean, Boggis, and Bunce in the hard hats they don for their Rolling Stones–scored destruction of Casa de Fox.

BELOW: Reference photos of a working chicken farm and sheep ranch in Great Missenden, the village in Misbourne Valley in the Chiltern Hills in Buckinghamshire, England, where Roald Dahl once lived.

OPPOSITE ABOVE: Agnes (Juman Malouf), Ash (Jason Schwartzman), and Kristofferson (Eric Chase Anderson) at the punch bowl.

OPPOSITE BELOW: The feast.

BELOW: Technicians arrange key character puppets for the flint-mine flood sequence. Note the tiny braces that make the characters appear to be "suspended" in the "water." The braces were later digitally erased, and the water composited using the same technology.

And some people say no?

Yeah.

Is it only for very young kids that they'll do it?

Yeah, I think. I read my son most of Dahl when he was five, and he doesn't seem to be particularly disturbed.

And he loved it?

Yeah, he liked it. In fact, I think the scary parts and the disgusting parts were his favorites.

They're meant to be.

Yeah, probably. What's the one? *George's Marvelous Medicine.*

Which one is that? I can't really remember it.

The entire book is about the fear of one's grandmother. And when I read it to him, I made the grandmother's voice just hideous. I was like the Crypt Keeper almost.

You preserved a lot of those Dahl touches—like when Mr. Fox gets his tail shot off.

That's not a touch. It's a plot point.

And I had to laugh when I saw that one of the promotional items related to *Fantastic Mr. Fox* was the fox necktie.

Dahl had his tail get shot off. We made it into a necktie. That might basically describe the collaboration.

You'd never worked with George Clooney up to this point. Was this another case, as it had been with a lot of the lead roles in your films, where you said, "This lead character is Clooney?"

Yep.

What was it about Clooney that made you think that?

Well, I think I just kind of believed he was the guy, you know? There is something very heroic about him. Watching *Michael Clayton*, I thought, that's a real movie-star performance. I just can't imagine anybody you'd root for more. You want him to be the hero when he's at his worst, and he's often at his worst in *Mr. Fox*. And I think he's somebody you'd follow in that situation. And the other thing is his voice. When we started recording him, I

realized how much of it comes from his voice. He has a great voice.

So it was all those things. The simple answer is just that I wanted to work with him.

You have made film after film with this kind of character in it, this sort of man with a plan, starting with Dignan in *Bottle Rocket* with his fifty- or seventy-year plan.

Seventy-five-year plan.

Yeah. And then you've got Max Fischer, and probably two-thirds of the people in *Tenenbaums*, Zissou, Francis in *The Darjeeling Limited*. *The Life Aquatic* and *Darjeeling*, to some degree, seem a critique of that sort of mentality, even as you're celebrating these characters for their humor value. But *Fantastic Mr. Fox* is the most straightforward celebration of it.

Hmm.

Ultimately, it seems to me a celebration of not just that type of personality, but that type of personality represented in the form of a movie star.

Right.

This is the character you like to see in your movies. Scorsese has a certain type of character he likes to put in his movies, and this is your guy.

I guess so.

Why this guy?

I don't know.

As a moviegoer, what do you like about him?

That one's too hard for me to answer. That's too much "the whole thing" for me. I'm probably better talking around it.

Well, OK, let's try that. Who are some of the movie characters and movie stars you've been most attracted to as a moviegoer?

I'll answer that genuinely, which is probably going to have nothing to do with the thing we're talking around. Some of my favorite ones, ones who have made big impressions on me over the years, are Antoine Doinel and that whole cycle of movies. Travis Bickle. I'm trying to think of who from *The Godfather*. Maybe it's De Niro in *The Godfather Part II*.

And I was going to suggest Jimmy Caan in *The Godfather*.

Jimmy Caan. You know, I love Mia Farrow in *Rosemary's Baby*—that's a great performance and a great character. And Marcello Mastroianni in *8½*. Jimmy Stewart in *Rear Window*, that's a favorite. Matt Dillon in *Drugstore Cowboy*. So anyway, that's a few. I don't know. That doesn't lead us in any direction.

APPROVED RAT BADGE DESIGN 21/07/08
Keep stitched border as thin as possible, our focus needs to be on the text.

TOP: Preproduction art of Mr. Fox in a fall state of mind.

ABOVE: The approved, final version of Rat's badge.

OPPOSITE: A Donald Chaffin illustration from the original edition of *Fantastic Mr. Fox* (TOP), a production sketch and painting of Boggis, Bunce, and Bean's destruction of the Fox family home (MIDDLE), and the aftermath as it appears in the finished movie (BOTTOM).

FANTASTIC MR. FOX
——— TAXONOMY ———

Talpa Europea

Cine·Star

FANTASTIC MR. FOX
——— TAXONOMY ———

Oryctolagus Cuniculus

Cine·Star

FANTASTIC MR. FOX
——— TAXONOMY ———

Castor Fiber

Cine·Star

FANTASTIC MR. FOX
——— TAXONOMY ———

Meles Meles

Cine·Star

FANTASTIC MR. FOX
——— TAXONOMY ———

Mustela Nivalis

Cine·Star

FANTASTIC MR. FOX
——— TAXONOMY ———

Microtus Pennsylvanicus

Cine·Star

OPPOSITE: A trademark Anderson annotated sequence, with Mr. Fox whipping his demoralized fellow critters into a fighting mood by saying their Latin names and then having the animals state their abilities.

ABOVE TOP: Ash and Kristofferson in Mrs. Bean's kitchen.

ABOVE BOTTOM: Final approved preproduction photograph of Ash rocking his bandit mask.

Yeah, it probably doesn't, but that's quite a list of movie characters to be fond of. The contrasts and the contradictions there might be a bit instructive, in terms of the question of why "your guy" is "your guy." I don't know. Maybe if we move away from the individual for a moment, and focus instead on family? Because *Fantastic Mr. Fox* is also a continuation of your interest in family, and the different types of characters that make up a family. And then you've got your own brother doing the voice of Kristofferson, acting for you for the first time.

Well, he's had little cameos in some of the other ones.

I mean in a true supporting role.

In *Tenenbaums* he has a line: "Can the boy tell time?" He asks Bill Murray's character that. In *Rushmore* he's an architect who's showing some plans—a baseball field with and without an aquarium, I think. And he's in *The Life Aquatic*, too. He's one of the Air Kentucky pilots at the funeral for Owen's character.

He has a very unique way of talking, so the way his character talks, that's him, that's the way he talks. He was very good. He went well with that puppet.

The movie's also visually consistent with your other films, which on one level should be no surprise, considering that they're all directed by the same person, but the fact that you deliberately refused to take advantage of some of the visual latitude that animation affords strikes me as funny.

Well, except I don't know if I did in fact *refuse* to take advantage of the visual latitude. I never said, "I want to limit what we want to do." In fact, what I said was, "I want to do this other thing."

Well, but you have a very clean style of directing, and there are certain types of shots of yours that are workhorse shots that

you return to again and again, and you tweak them a bit depending on the circumstances.

Hmm.

Like the lateral pans, a lot of 90-degree and 180-degree and 270-degree pans. You've got tilt-ups and tilt-downs, and the tilt-downs always get you in this God's-eye perspective, where you look exactly down.

Well, with this kind of animation, the one thing I found, regarding pans, is that often a set was built for a specific shot, and we often didn't have the sets connected. And I'd plan the pan, and sometimes I didn't know this was the plan far enough in advance, and the sets were already built, so how are we going to pan from one set to another? We're picking up those frames, and then we'll put it together. Well, those pans never looked right. They never felt like pans; they always felt like effects. So, in fact, I took out 75 percent of the pans. In a way, I had less latitude. I couldn't just pan. I couldn't just have a guy walk up a hill.

Right.

But on the other hand, I could have a guy suddenly be replaced by a half-scale, miniature version of himself, which was new. You're not normally given that ability.

But you do have a lot of the signature shots. You do have the pans, you have tilt-ups and tilt-downs, some of those Bill Melendez–style zooms, and you have, again, what I call the "doll-house shots," but they're taken to a whole new level, because you're seeing entire structures cut away, and you're seeing that elaborate ant-farm effect when you're down in the tunnels.

Right.

You're going even further in that direction, in some ways. But, unless I'm failing to remember something, you don't have a whole lot of shots like what one sees in other animated movies, where you're traveling, where you start on the edge of the galaxy and you gradually end up on a bowl of cereal, or where you're passing through walls and partitions and flying all over the place and defying physics. It seems that the rules of physics apply here just like they would in a live-action film.

And also, it's just not in the story, you know? This story is about these animals. We could have had shots that show the farm all the way to his tree, and we see the whole space, or something like that. Instead, we painted a mural. It was really just a matter of someone having to choose "What is this going to be like?" And since that's the case, and since I'm in charge of the movie, we'll choose my way, and that just means the limitation is not in the medium, the limitation is in which way I suggest we do it. I guess I'm just saying I never felt like I was deciding *not* to do certain things in order to keep it a certain way. Instead, I was just doing the things I was most excited to do.

I was thinking more along the lines of style choices, like the fact that you wanted actual animal hair on the animals.

Well, I guess every decision you make like that, somebody's going to feel it's wrong. But when you're doing something in an unusual way, that's part of the routine.

Half the time, when somebody has an issue and is worried about something not working, they might be right, and half the time it's easier. But half the time, the thing everybody thought was going to be no sweat is impossible. And movies are always like that—at least the movies I work on. What you're doing is something you've never quite done before, and when you're doing that, nobody knows what's going to happen, and you learn in the course of time not to get too focused on what people think can't be done. Because usually you can do whatever you want. Instead, you have to encourage those people to

use all their powers, because they're experts. They have so much to bring to you, once you get them to provide it. But that's all part of managing a group. Sometimes it just backfires, but most of the time it's fun.

The aspects you're talking about—the managerial aspects and making it happen—is it a long process getting from what you put on the page or what you see in your head to what you see on the screen?

Sure.

Is that part of the process pleasant for you, or is it something you've just learned to endure with a smile?

I like it.

You really like it?

I like it very much.

Some filmmakers don't.

Some filmmakers don't.

They talk about directing, the actual making of the film, as being the least pleasant part.

No, I like it. It can sometimes be grueling or very stressful—when things aren't going right, you get an ulcer. But it's exciting. And I like working with a group. I like having a company of key people collaborating. And on a movie like this, part of that is there are people who specialize in filmmaking disciplines or techniques I've never worked with. And also people who are making miniature objects, miniature props, and fabricating puppets and all the physical things that are being built. Those are all things that are right up my alley. So it's a lot of fun for me to be working with people who do this kind of thing, and to get to know these people.

ABOVE LEFT: Anderson's hand-drawn reference sketch of Kristofferson teaching Ash and Agnes his trademark meditation techniques, for the film's final sequence.

ABOVE RIGHT: Anderson's hand-drawn storyboard from that same final sequence.

OPPOSITE AND FOLLOWING PAGE: Preproduction sketches and paintings for the underground community that the Foxes and their friends construct at the film's end.

ABOVE TOP: Two frames of Mr. and Mrs. Fox's embrace before a sewer tunnel deluge (evoking, ABOVE BOTTOM, a similar moment between Daniel Day-Lewis and Madeleine Stowe in Michael Mann's *The Last of the Mohicans*, from 1992).

RIGHT: Prototype for the smallest model, used for long shots, of Kylie, the opossum voiced by Wally Wolodarsky.

OVERLEAF: A selection of Anderson's sketches, drawn on whatever paper he had handy, in an array of inks.

Are there any general principles you've learned over the years you've been doing this that result in, if not a better film necessarily, then an experience that is less stressful? Are there any things you've learned about making movies that have made things more sensible, more orderly, more pleasurable?

The thing I've learned is that I enjoy simplifying the set and to have fewer people working. To plan carefully so we can work quickly, but without as big a crew. I don't like people going away to trailers and things like that. I like everybody to just stay together and keep everything as light on its feet as it can be. You know, you can spend a lot of time adjusting people's makeup and pulling on people's clothes and hair, and that's boring.

In the end, that sort of thing isn't as important as people think it is?

Well, if you look at Barbara Stanwyck in some close-up, you do remember that there's something that's been created that's perfect, but in general with movies, and with my kind of movies, what I want is for there to be energy on the set and to keep things alive. So anything that leads to that, I'm for it.

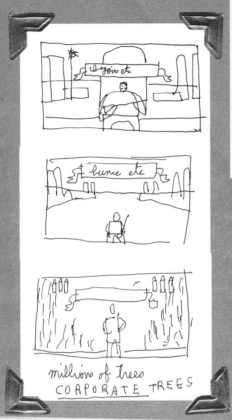

millions of trees
CORPORATE TREES

INTERNATIONAL PATENT #615

Hôtel d'Angleterre
SAINT-GERMAIN-DES-PRÉS

"HE INVENTED THE BEAN-
CHAFFIN TURKEY
EVISCERATOR WHICH
IS NOW THE INDUSTRY
STANDARD."

CHOPS DOWN

BLADES
VIBRA——

CLAMP
OF
SOME
KIND

STABS
UPWARDS

INTERNTNL. PATENT

Hôtel d'Angleterre
SAINT-GERMAIN-DES-PRÉS

44, RUE JACOB - 75006 PARIS
TEL. 01 42 60 34 72 - FAX : 01 42 60 16 93

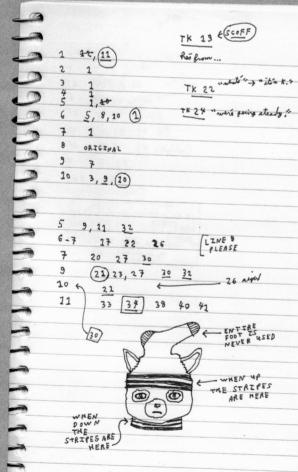

TK 19 & SCOFF

1 (11) hes from...
2 1
3 1 TK 22 "whats" → "it's k.?
4 1
5 1, TK 24 "we're going steady!"
6 5, 8, 10 (1)
7 1
8 ORIGINAL
9 7
10 3, 9, (20)

5 9, 11 32
6-7 17 22 26 LINE 8
7 20 27 30 PLEASE
9 (21) 23, 27 30 32
10 21 ← 26 again
11 33 37 38 40 42

30

ENTIRE
FOOT IS
NEVER USED

WHEN UP
THE STRIPES
ARE HERE

WHEN
DOWN
THE
STRIPES ARE
HERE

RIBBED

ARMS/
SHOULDERS
LIKE
THIS

FINER
HANDS,
LONGER
FINGERS

RIBBED

TROUSER
SHAPE

RAT

TOES A BIT
FINER,
TOO

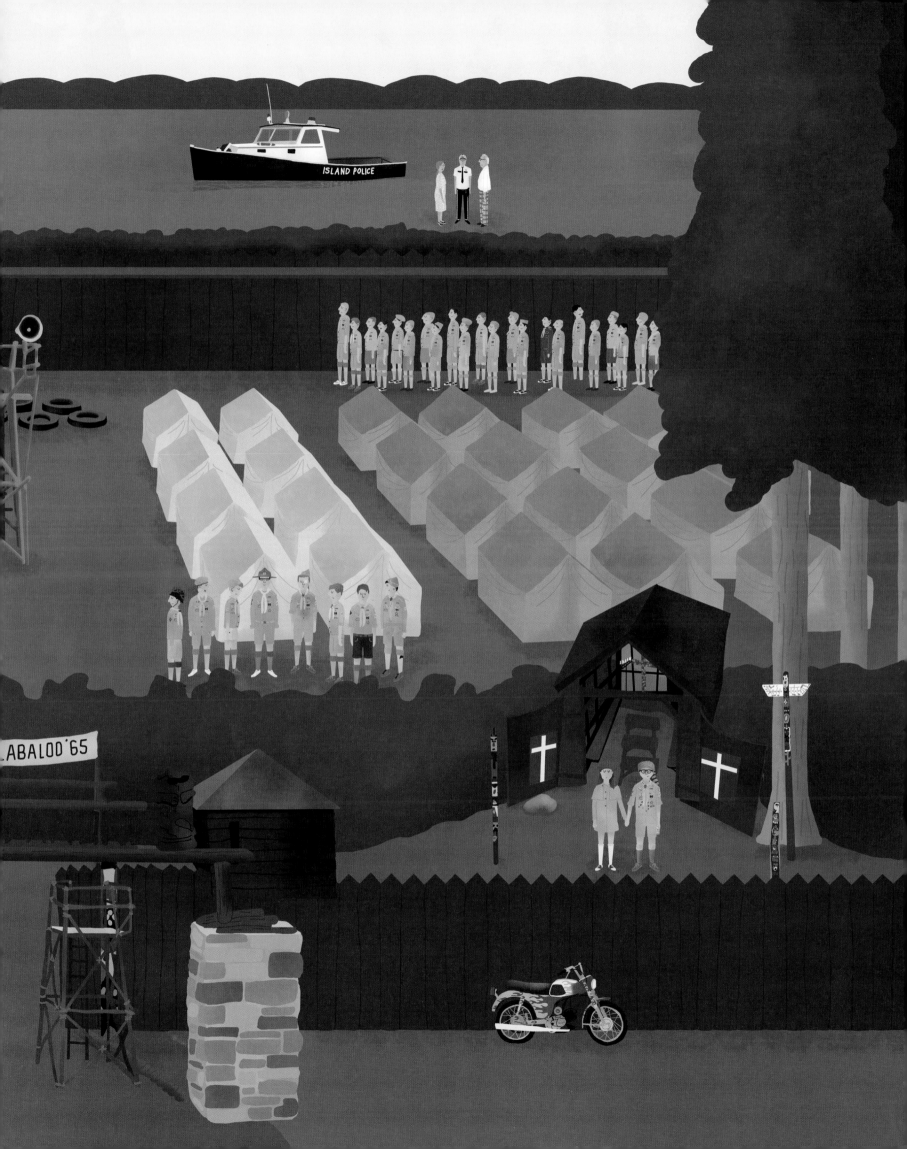

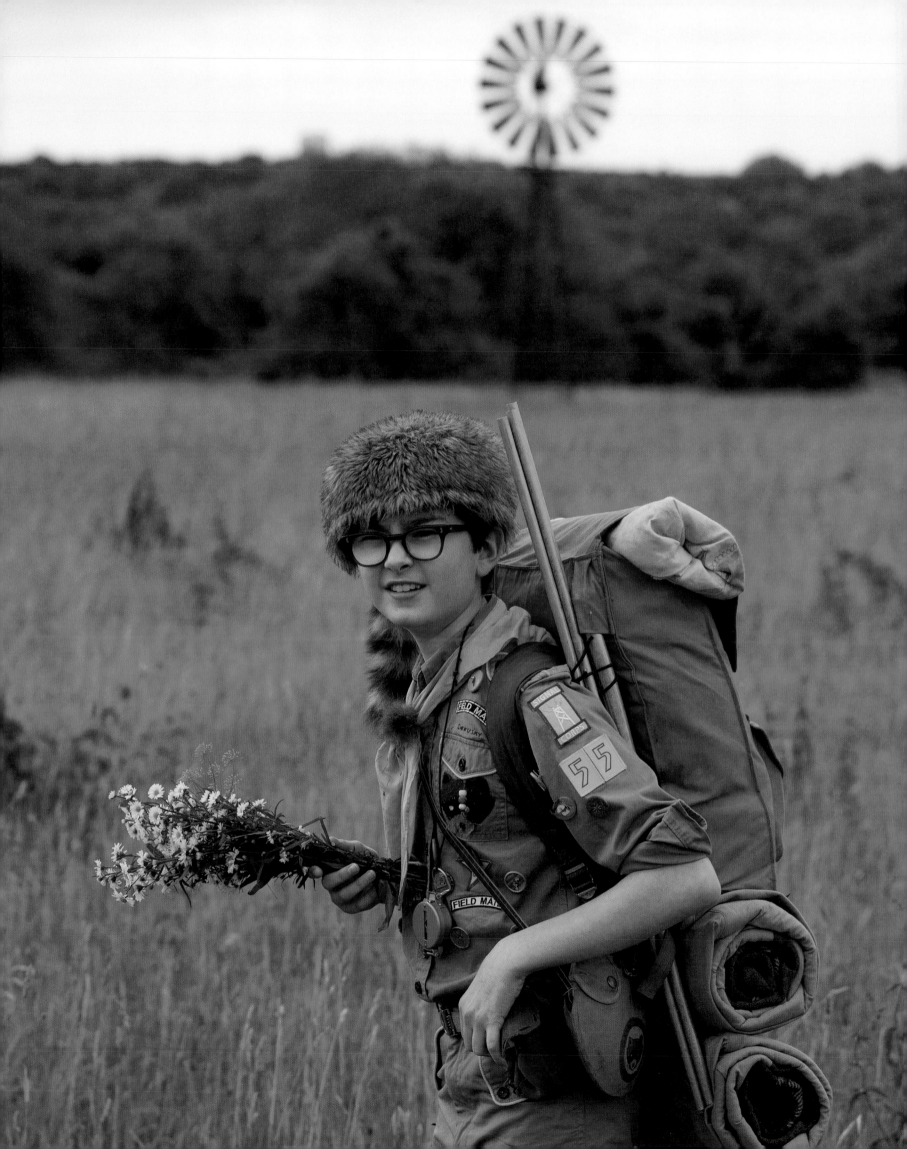

MOONRISE KINGDOM

The 1,200–Word Essay

THE KIDS OF *Moonrise Kingdom*—cowritten by Anderson and Roman Coppola—are lumps of clay, inexpertly trying to mold themselves after years of being shaped by others.

But grown-ups and their institutions are unfinished, too. *Moonrise*'s adults forget that fact until renegade twelve-year-olds—eerily intense Khaki Scout Sam Shakusky (Jared Gilman) and hot-tempered bookworm Suzy Bishop (Kara Hayward)—remind them of it. Wes Anderson's seventh film, a comic romance about troubled middle schoolers who flee adult authority and create a little Eden of their own, boasts the exuberant visuals, clever dialogue, and surprising musical cues that we've grown to expect from the director, plus an unabashedly happy ending. But it would be a mistake to write off *Moonrise Kingdom* as a simpleminded crowd-pleaser. Peek beneath its sprightly lines and absurd slapstick and you'll find a vision of life as melancholy as the darkest parts of *The Royal Tenenbaums* and *The Life Aquatic with Steve Zissou*: Sam and Suzy are surrounded by individuals and organizations that "care" about them without truly hearing or seeing them. The giant storm bearing down on the island is this movie's version of the jaguar shark in *The Life Aquatic* and the tiger in *The Darjeeling Limited*: a metaphor for the chaos and pain threatening all human lives (kids' especially). But it also traces the trail of destruction that Suzy and Sam leave so innocently in their wake. They're the little storm that everyone should have seen coming but didn't. It seems hilariously right that the actual storm would reach a peak of biblical awesomeness just after the runaways tie the knot, and the representatives of adult society (including the pip-squeak Khaki Scout gendarmes) try to bring them to heel. The kids act out in ways that turn their snow-globe town upside down and give it a shake. And what happens? Scandal. Crisis. Social breakdown. Reconciliation. Evolution.

by Matt Zoller Seitz

The adults in charge of Sam and Suzy's lives don't see them as they ought to be seen: as individuals with idiosyncratic personalities and intense desires. No wonder Suzy's parents (Bill Murray and Frances McDormand) and the orphaned Sam's various state-approved parent figures—his foster father (Larry Pine), his de facto guardian Scout Master Ward (Edward Norton), and Social Services (Tilda Swinton)—are dumbfounded when Sam and Suzy vanish. "I admit we knew we'd get in trouble," Sam says. "That part's true. We knew people would be worried, and we still ran away anyway. But something also happened, which we didn't do on purpose. When we first met each other, something happened to us."

What happened to them was a little miracle that most people are lucky to experience in a lifetime: a meeting of true minds that would not brook impediment. As is so often the case in Anderson's movies, the heroes are artists at heart. Their creativity both fuels and is fueled by their anger. Suzy's traits include klepto-bibliomania, storytelling, and binocular voyeurism. "I like stories with magic powers in them," she tells Sam. "Either in kingdoms on Earth or on foreign planets." Sam is a painter—"mostly landscapes but a few nudes," Laura, Suzy's mother, summarizes—and an outdoorsman, with a sense of style. ("That was one of the best campsites I've ever seen," Scout Master Ward admits after the couple is tracked and caught.) The kids' long-distance courtship—laid out in a reading-of-the-letters sequence, one of Anderson's most compact and propulsive bits of direction—makes their predicament clear. The images are hilarious and disturbing: Suzy has an altercation in a classroom and lays another girl out; Sam sleepwalks and sets fires. He's an according-to-Hoyle orphan; Suzy feels like one, because her lawyer parents are so wrapped up in their marital troubles. Walt, Suzy's father, is a slump-shouldered husk of a man, while Laura is all fretful, furtive glances, punctuated by edicts shouted through a bullhorn. Her affair with Bruce Willis's Captain Sharp, the "sad, dumb policeman," is less cause than symptom. Anxiety, fear, and a creeping sense of personal failure afflict nearly every adult in *Moonrise*. The kids have their whole lives ahead of them, but the grown-ups worry that their best years are behind them. "I hope the roof flies off and I get sucked up into space," Walt tells Laura, in a rare, frank bedtime conversation. "You'd be better off without me."

Things only start to turn around after the adults bust up Sam and Suzy's reverie. Captain Sharp, who will eventually become the father figure Sam needs, replies to Sam's "something happened" speech with the film's first piece of useful adult wisdom: "All mankind makes mistakes. It's our job to try to protect you from making the dangerous ones, if we can."

You get the sense that the adult world of New Penzance will step up and become better guardians for Sam and Suzy, but it takes a crisis to force their hands and the wisdom of children to push them down the correct path. Grown-ups perpetuate all their own values, even the bad ones, without thinking, and at times without feeling. The value of independent thought, a sadly too-rare quality, is a key subtheme in *Moonrise*. At first the grown-ups see the couple's disappearance only as a scandal, an embarrassing reminder that they aren't really in charge of anything and were asleep at the

switch when the escape occurred. And during the film's first half, the next generation of New Penzance residents—represented by the kids in Scout Master Ward's Khaki Scout troop—let themselves be treated as bystanders, or worse, proxies for mindless adult authoritarianism. The Scouts arm themselves with lethal instruments during the woodland search, as if the purpose were to destroy rather than merely find Sam and Suzy—an unconscious wish on the part of the grown-ups that has somehow seeped into the boys' consciousness. But these same boys realize their mistake and try to correct it by staging a kidnapping-as-liberation to reunite the lovers. Their improvisation takes Sam and Suzy into the nondenominational tent of Cousin Ben, a self-styled chaplain. "I can't offer you a legally binding union," he tells them. "But the ritual does carry a very important moral weight within yourselves."

The phrase "moral weight" captures the resonance of *Moonrise*. The movie carries itself as a knockabout comedy-romance, a mere diversion, but it lingers in the mind by communicating that the right choice is one based on empathy, attention, and understanding, not mindless fealty to ritual or ostrichlike evasion of unpleasant truths. The relationship between tradition and innovation, the old guard and the new, is ongoing and never fully settled. It can be likened to a negotiation, or better yet, a dance—like the courtship dance (figurative and literal) that Sam and Suzy undertake when they run away. Their ardor is funny because they aren't fully grown yet, but it's powerful because they're doing almost everything else right. Each is headstrong but not averse to bending if it'll make the other person happy.

"I always wished I was an orphan," Suzy tells him. "Most of my favorite characters are. I think your lives are more special."

"I love you, but you don't know what you're talking about," Sam says.

"I love you, too," she replies.

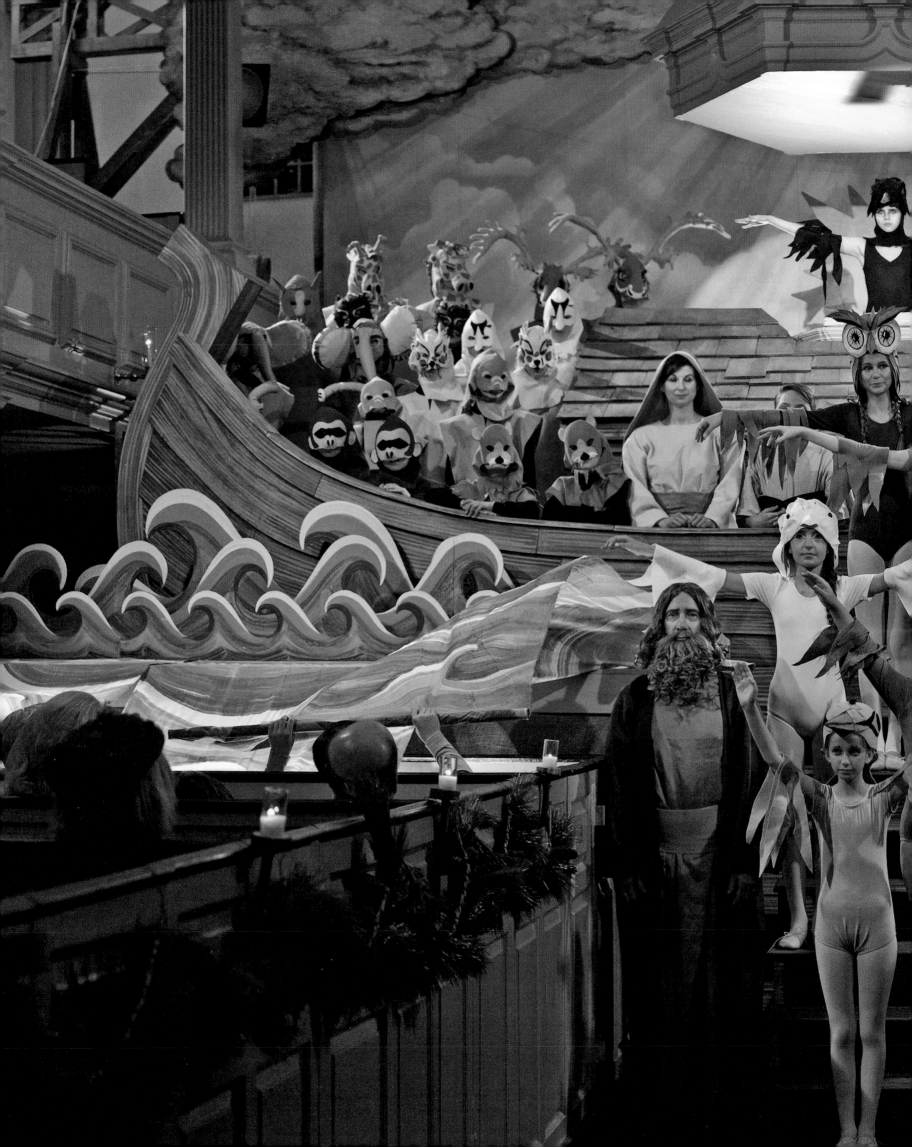

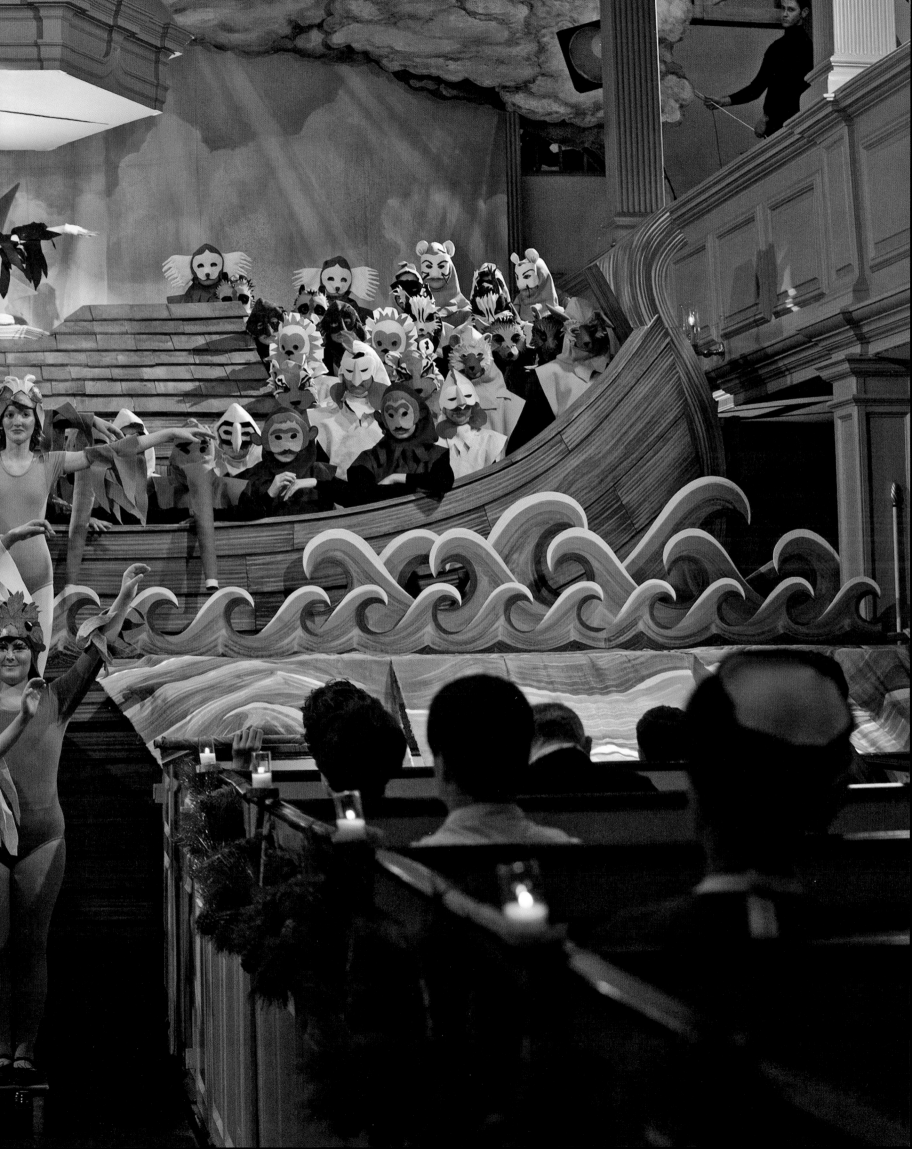

MOONRISE KINGDOM

The 11,104–Word Interview

NEW PENZANCE ISLAND

OPPOSITE: Suzy (Kara Hayward) surveys the island through her binoculars—the possession, apart from her book collection, that most defines her.

ABOVE: A map of the fictional New Penzance Island. Wes Anderson and his cowriter, Roman Coppola, always tried to think about the geography of the world they created, but the map did not become integral to the film's storytelling until postproduction.

MATT ZOLLER SEITZ: *Moonrise Kingdom* is set on an island off the coast of New England in the summer of 1965. Can you give me a sense of where the germ of this idea came from? Is this something you'd been thinking about for a while, or is it recent?

WES ANDERSON: Well, I just was listening to an interview with Tom Stoppard. Charlie Rose asked him what the germ of the idea for one of his plays—or, for the *Coast of Utopia* cycle—was, and he said something like, "I never have a germ. I always have various things on my mind, and they start to intersect with one another. And that's what I like about my work. It's never about one thing in particular. It's always about at least two."

Right.

And you know—I'm paraphrasing, and not really representing him probably to his satisfaction—I sort of feel that way, also.

The Darjeeling Limited. Well, it's in India. I wanted to do a movie about brothers and some of the peculiarities that define brother relationships. And I wanted to do a movie on a train, because I like traveling by train and I like movies set on trains, and the history of movies set on trains, and the idea of movies that take place in one location that is traveling—you know, one location, but it gets to move. And I wanted to make a movie in India. I had all those things in mind, but none of those things sparked the other, and none of them was the beginning. It was sort of, here's all this stuff, and it started to fuse together. It didn't happen all at once, you know?

So that's my preamble. Now I'm trying to answer the question of where *Moonrise Kingdom* comes from. For some years, I've spent time visiting my friends Maya and Wally on this island called Naushon. Wally is in many movies that I've done, and he's had different small roles. In *Fantastic Mr. Fox*, he's Kylie the opossum. They're very old friends who are writers and filmmakers and so on.

Anyway, Maya's family has gone to that island for many years, which is an island that is completely preserved in time—it's not permitted that the place be changed. There are no cars. The houses are all very old. And everything in the houses is very old. It's sort of enforced. There's no place like it. I think there used to be quite a number of places like it. So I wanted to do a movie on an island like that.

Which has nothing to do with my own child-hood experience. I just thought the movie needed to be in the past, because places like that really don't generally exist anymore.

And I wanted to do a movie about a child-hood romance—a very powerful experience of childhood romance. About what it's like to just be blindsided, when you're in fifth grade or sixth grade, by these kinds of feelings. Along the way, I sort of mixed in some interest in "young adult fantasy" writing.

And I thought this girl, maybe, is a big reader, and at a certain point I sort of gave her a suitcase full of all these books. I started writing these little passages and kind of inventing what her books were, and somewhere along the way I started thinking, maybe the movie should be as if it

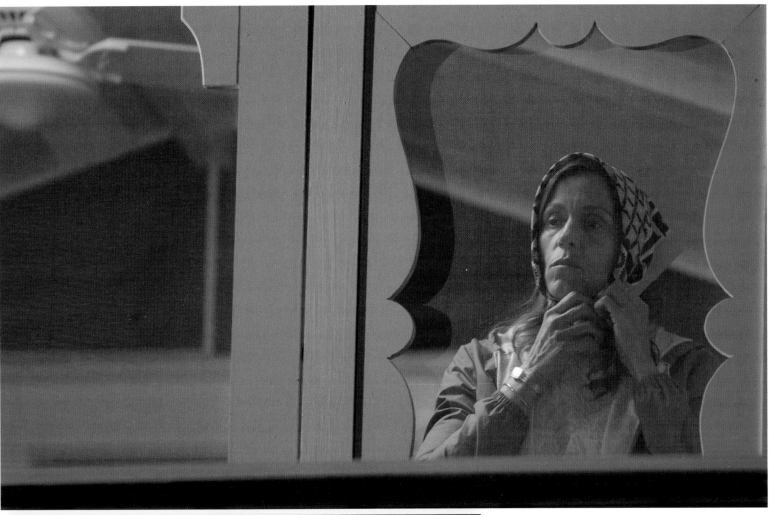

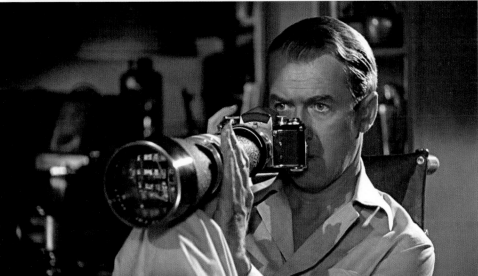

were one of her books, you know? That the movie would not actually be fantasy, but if it could have the point of view of one of her books—that she could open that suitcase and take out *Moonrise Kingdom,* stolen from the library.

That's interesting, because I think one of the first things you see is her looking through those binoculars. It's a recurring image. It does set up the idea that we are seeing through her eyes.

The binocular idea really came from this Satyajit Ray film, *Charulata. The Lonely Wife,* I think, is how they translate it. It's one of the best of all the Ray movies. She is sort of holed up in her house, and she becomes a writer. Anyway, the main character in that film is always looking out the windows with her binoculars, moving from window to window, looking through the blinds.

And there's also, of course, a connection with the whole idea of movies as a form of voyeurism, and *Rear Window* specifically. Which you said in another chapter of this book was the Hitchcock film that kind of got you started on Hitchcock.

Yes. It was also my mother's favorite.

This also ties into these devices that recur in so many of your films. I guess you could call them frames around the story. You've got the curtains in *Rushmore.* You've got *The Royal Tenenbaums* being presented as a book, the fiction that's being written in *The Darjeeling Limited,* the documentary films in *The Life Aquatic,* and of course *Fantastic Mr. Fox,* which you acknowledge from the first frames of the film as being a book. That last touch is kind of a formality, like what an old movie would do. But nevertheless, it fits.

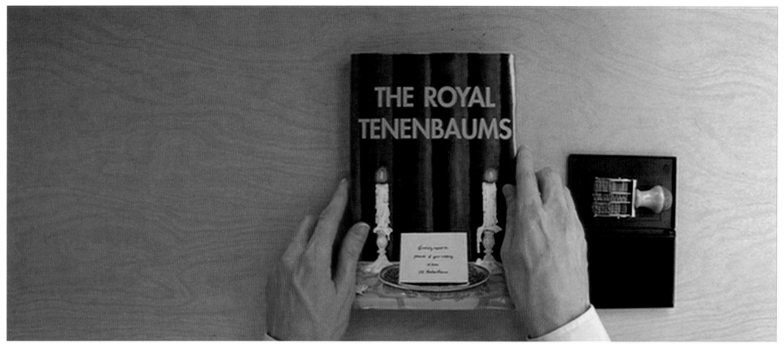

I don't know what it is about that formality that I always enjoy seeing in other peoples' movies.

A lot of people complain that these kinds of devices remind them that they're watching a movie, or that in literature they remind them that they're reading a book.

I don't so much connect to this sort of Brecht idea or response to being distanced. In fact, if you read the Stefan Zweig books, practically every story he tells begins with somebody telling somebody else about it. The first guy meets a guy, and they talk a bit, and he says, "Well, if you like, I'll tell you the story." And then we finally get into it.

That's true. It's a pre-twentieth-century convention as well. It only became, I guess, italicized a little bit more recently. If you look at something like *Frankenstein*, or almost all of Joseph Conrad, there's exactly that kind of a frame around it.

It's just standard Conrad.

Would you qualify this as breaking the fourth wall—this straightforward acknowledgment, active throughout a given film, that you are seeing a story told by a storyteller—or is it something else?

Like our narrator in *Moonrise Kingdom*?

Yeah. He's like the Stage Manager in *Our Town*, almost.

Right. That guy breaks the fourth wall. In this case, I completely associate him with the Stage Manager in *Our Town*. And you know, the Stage Manager must be a very modern idea. It must have been a—maybe shock is too strong a word. But when people saw that play, when it was first performed, it must have been quite striking. No set, and a character who's telling us this sad story and giving us intimations of what's coming. Old Jed Harris who put that one on. Ours is sort of a light comic version of that character. Played by Mr. Bob Balaban.

 I don't have any real experience of *Moonrise Kingdom*. I don't know what somebody's experience of the movie is like. But just as a guy sitting in the editing room for ages, and going through

the process of living with this movie, and having it play a big part in my life for a couple of years, I have this tremendous affection for Bob Balaban walking us through it like that. I hope that somebody seeing it has something like my experience, which is that you want to listen to him.

There's actually a moment in the movie when it becomes kind of outrageous and funny. Isn't there a moment when he actually improves the lighting in a shot? Where he turns on a light in the foreground?

He turns on the lights, period—you can't even see him at first. At the beginning of the shot, he's silhouetted against the sky. Then he comes up to the camera, turns on a light, and speaks directly to the camera. I don't know what tradition to refer to, that moment when he suddenly enters the story—that one point in the movie where he suddenly is talking to the other characters, as if he's just a guy who's walked up out of nowhere. And it's also only the second time you see him. It's one thing if you see the guy a total of five times in the movie, and you've already seen him three times, but then the fourth time he's suddenly joining in. In this case, however, the second time we see him, he suddenly starts talking to everybody else.

ABOVE RIGHT: Mary Shelley's *Franken-stein* and Joseph Conrad's *Heart of Darkness*, two novels that frame their main narratives as stories told to third parties.

ABOVE LEFT: Both *The Royal Tenen-baums* (2001) and *Fantastic Mr. Fox* (2009) are presented as film versions of books. The first book never existed; the second was published in 1970 by Roald Dahl. Portions of *The Life Aquatic* (2004, BELOW) are presented as bits of documentaries directed by the film's hero, explorer-filmmaker Steve Zissou.

OPPOSITE: A gallery of the stolen library books that Suzy takes with her on her journey. These are nonexistent titles created for *Moonrise Kingdom*. Screen-writers Wes Anderson and Roman Coppola wrote the snippets that Suzy reads to other characters.

Choose Any 3... a Fabulous Package of Books for only $1

JED HARRIS
presents
OUR TOWN
A PLAY BY
THORNTON WILDER
with
FRANK CRAVEN

MOROSCO THEATRE

And the audience is like, "Oh, he lives here."

Yeah. So, is he a real person? Or what is he? That part, I don't know. And I don't know what tradition that comes out of, except maybe Buñuel.

I like to picture him walking around the streets of the town, just narrating.

Good!

Let's jump over to our protagonists, Sam and Suzy. You mentioned this idea of a really intense, on-the-cusp-of-adolescence love, and how all-consuming that was. Did you ever experience anything like that in your own life?

Anything like having a crush on somebody like that?

Well, I don't mean, obviously, the axes and arrows and things, but that all-consuming affection. It feels like love at the time; it may just be a crush. But the reason I asked is because I myself experienced that in the sixth and seventh grades. I'm sure a lot of people have. There was an eerie purity and intensity to that experience in this movie that I don't think I've seen represented anywhere else.

That was my experience myself, as a fifth grader. In my case, this girl . . . at Valentine's Day, there were these little white lunch bags stapled onto the walls, with people's names on them, and they'd put the valentines in. Did you have that?

The bags weren't stapled to the walls, but we had the bags with the valentines in them. Boy, what a heart-ripping experience that could be.

I remember she—most people just gave something to everybody. But then there was this one white valentine sack that was just overflowing with stuff. And as this girl took everything out, there was a golden necklace, and there were different gifts, all of them anonymous. No one really having—laid claim to—you know. So . . .

Was that you, Wes?

I didn't give the necklace, no. I didn't give her anything. I didn't announce anything to her. So what sliver of anything that happened there, I had to imagine the rest of it, because it didn't really occur. But for me, the story of *Moonrise Kingdom* is more or less what I was imagining at that age.

Yeah?

Yeah.

It's also striking that these characters are sexual characters, and it's presented very matter-of-factly, and they're living together in this weird facsimile of marriage. It kind of reminded me of the scene in *Badlands* where Kit and Holly build that encampment.

With the tree house.

And also the sequence at the end of *Rebel Without a Cause* where James Dean and Natalie Wood and Sal Mineo create this makeshift nuclear family in that abandoned house.

They set up shop.

ABOVE: A program from the second leg of *Our Town*'s 1938 New York run, at the Morosco Theatre.

BELOW, LEFT TO RIGHT: Publicity still of Bob Balaban with François Truffaut in Steven Spielberg's *Close Encounters of the Third Kind* (1977); Anderson with Balaban on the set of *Moonrise Kingdom*; Balaban's diary of the making of *Close Encounters*, published as a paperback tie-in in 1978 and reissued in 2003 as *Spielberg, Truffaut and Me: An Actor's Diary*.

OPPOSITE AND OVERLEAF: Balaban on location for *Moonrise Kingdom*.

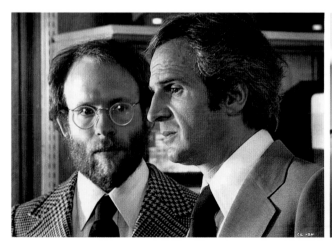

There's the sense that they understand the roles they're enacting, but maybe only in the abstract. There's an element of playacting to it. And yet the intensity of it makes it seem like it's really heartfelt.

Well, you know, our guys actually do go through with the wedding—but you have a sense that it's probably not legally binding! In fact, Jason Schwartzman's character tells us he's not actually licensed, that he has some sort of authority but it won't hold up in the state, the county, or any courtroom in the country. But not only do they take it very seriously, all those kids around them do, too. They kind of join them.

Right. At first it almost seemed as though Max Fischer and Margot Tenenbaum had run off together.

Hmm.

Except that there's a confidence, a kind of absolute sureness, to both of these characters that Max and Margot never really have. There's never any sense of real serious doubt about the purity of their love or their prospects for happiness.

Well, they haven't had time yet for it all to start coming unglued, anyway.

I guess that's a problem, too—once you've turned out a few movies, it's hard not to have people say, "Oh, that one reminds me of this other one you did, and this part came from a different one." But that's the beauty of the first couple of movies. There's nothing to compare it to; it exists unto itself, you know? But yeah, I definitely can see some links with those characters.

Just the sheer industriousness of both of them.

Right.

To be fair, that's more characteristic of your characters in general, than of any specific ones.

Right. And you know, that kid—Jared Gilman—doesn't really look like Jason, but he does end up looking a little bit like Jason's character on-screen. And Kara Hayward doesn't really look like Gwyneth, but she's got makeup, and something about the whole package ends up being reminiscent of the character that Gwyneth plays.

And that moment backstage when Sam points at Suzy and says, "No, what kind of bird are *you*?"

ABOVE: Images from Terrence Malick's *Badlands* (1973), an inspiration for *Moonrise Kingdom*'s romantic runaways plot. LEFT TO RIGHT: Holly (Sissy Spacek) and Kit (Martin Sheen) enjoy each other's company under a tree; Kit and Holly's awkward dance to Mickey and Sylvia's "Love Is Strange"; Holly looks at stereopticon images.

ABOVE, LEFT TO RIGHT: Sissy Spacek's Holly gives herself raccoon eyes in *Badlands*; Kara Hayward's Suzy has raven eyes when Sam meets her in *Moonrise*.

THIS PAGE AND OPPOSITE, BOTTOM LEFT AND RIGHT: Sam and Suzy's epistolary courtship speeds the film's plot along while conveying the filmmakers' love of literary storytelling and the sensuality of words themselves.

OVERLEAF: Sam: "I guess we better try to pretend we're struggling over our decision for a minute before we go back over there and tell him." Suzy: "Maybe he's right. It could be a mistake."

Uh-huh?

They're dressed like animals.

By the time we did that scene, we were near the end of the movie. And this thing always happens with good child actors, once they've sort of settled in and they know their characters and everything—they're the most prepared. We did the scene a number of times. He's playing it to the camera. He's talking to the camera. So is she. I just remember the experience, sitting there in the room with him. He's talking to the camera, and I'm talking to him. He really had command over it.

He did, that's true. And that was one of the things that jumped out at me, that these kids didn't seem like kids.

Well, if you saw the dailies for that scene in particular, you'd see he's kind of locking in the performance. He's kind of saying, "Like this? You want it like this? OK. Let me show you. Hang on,

here I go." He kind of launches into it. It's very exciting to watch kids kind of figure it out and take the control away from you.

These kids are relatively unknown, aren't they? Jared Gilman and Kara Hayward?

Relatively unknown. Well, I mean, they're relatively unknown outside of their seventh-grade classrooms! They never acted in anything before. I mean, neither one of them had ever auditioned for anything before.

That's amazing.

They both got cast on their first auditions.

Wow. So literally, they read and you went, "That's the one"?

More or less. You know, usually when you have this kind of thing going on, you've kind of got, "Well, we've hired everybody on until such and

SAM SHAKUSKY
IN CARE OF:
BILLINGSLEY BOYS' HOME

Suzy Bishop
Summer's End
New Penzance Island

such a date, and if we don't have them, then we have to extend the process." So we still had a little time left. But when I saw Jared, I thought, "Well, this'll be the guy." I immediately showed him to everybody.

And the same thing with Kara. We found her a little bit later. She read the scene in a way where it just seemed like she was making it up. Nobody else seemed like that. They all seemed like they were reciting. And then this girl just did the whole scene and it sounded completely spontaneous to me. That's quite unusual.

How old are they supposed to be? Twelve?

Yep.

And of course, that's the edge of puberty. Some girls are already having their periods by that point. Girls have been known to get pregnant at that age. And yet the movies don't generally acknowledge this. I was shocked, in a good way, to see how matter-of-factly you presented that. Because I remember the thoughts that were going through my head between the ages of ten and twelve, and they were far more explicit than anything I saw represented in movies.

Well, you know, they're not experiencing what was my experience at that age, but they are experiencing what was my fantasy at that age. So they really are in love—they're off on their

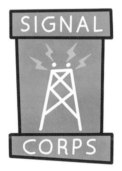

TOP: One of many letters from Sam Shakusky to Suzy Bishop in *Moonrise Kingdom*'s epistolary courtship sequence.

BELOW: Sam and Suzy in the woods.

OPPOSITE: Kara Hayward and Jared Gilman during a break from shooting the chapel scene.

I pictured the architect being an Ewok.

Precisely. But we did build that. That is a real tree
house. We actually had to build the tree from two
trees. We had to attach two tree trunks together
to get the height on it. And the tree house itself
is maybe about half-scale or so. But you know, it's
a big thing up there. When you see the shot, it's a
real tree house.

 At one point, there was a certain amount
of discussion about, "Shouldn't we just make a
miniature?" But we did it for real. Better that way.

I guess you're at the point now where you've worked with cer-
tain core people for so long that you don't have to do a whole
lot of explaining and justification when you make a request like
this. Like, "I want a giant tree house that appears like it's on one
little narrow strand of tree, and I want it to look like it's fifty feet
high." And they're like, "OK, Wes, that'll take us about a week."

Well, the tree house has to be designed—and so
does the tree, in fact! There's a process, but we
have a great production designer named Adam
Stockhausen who I have worked with in various
ways for years. The core people. That's very valu-
able. Our key grip, Sanjay Sami, for example, who
worked on *The Darjeeling Limited*. We had to go to
some strange lengths to get a visa for him to come
work in America. We had Owen and Scott Rudin
and Adrien Brody and Bob Yeoman and Jason and
everybody all petition the immigration depart-
ment and so on, but then we got it. We got Sanjay
Sami legalized for it. And the union said yes, too.

You've got a lot of iconic actors—some longtime veterans of
your films and some more recent additions, like Edward Nor-
ton—in this movie. In the case of the veterans, it seems like you
gave them all sorts of diminished comic versions of the sorts
of roles they often play. Like Bruce Willis. At the end, I thought,
"Is he ever going to turn into the Bruce Willis that we know from
action movies?" And yes, in fact, he does.

feeling, where you have to make a leap into some
sort of magical reality.

Throughout this movie, I thought about a part of our conversa-
tion on *Rushmore*, where we were discussing the "Quick One
While He's Away" montage. You said something to the effect of,
"Well, how does he know how to cut the brake lines?"

Well, like Michael Chapman said to me, "It's a
Godard movie. He cuts the man's brakes!"

In your version of the Boy Scouts, they live out in the field for
months at a time, and they have access to weapons.

They're authorized.

A couple of them are building a tree house that might have
been drawn by Terry Gilliam.

You know, it's a type of tree-house architecture
you would normally only find in remote areas of
Polynesia. You usually need a different kind of
tree to live at that altitude. With coconuts sticking
out of it.

Yes, he kind of does.

But that's true for the newcomers, too. Edward Norton has often played a lot of these kind of really tightly wound, detail-oriented, trapped-in-their-own-heads sorts of guys. Somehow when I see the Khaki Scout hat on him, everything makes sense.

Edward also is a pilot, and he does all kinds of wild river rafting, and he's an outdoorsman, and he's just very confident with all that kind of stuff. And he's a very bright person, just very knowledgeable and intelligent. And Bruce. It was hard for me to picture who else could play that character. I felt like it had to be somebody who was going to be reserved and quiet and kind of defeated, but I wanted him to feel like a real policeman. And most people, if they play quiet and defeated, you might not be convinced by the other part. But with Bruce, the policeman part is just very reliable.

It's like believing that John Wayne could be a cowboy. You've solved the problem the minute you cast that guy.

You can move on to the other details.

Adults behaving like children and children behaving like adults— that comes to the fore again in this movie.

I get that somewhat, but I also feel like I'm just interested in a certain kind of behavior—that I find certain kinds of behavior entertaining. I like the idea of people taking their extreme feelings and acting out on them. So I don't know if I'd really make that much of a distinction between which one's an adult and which one's a child, and what does it mean for this person to do this, this person to do that. I guess I just go on a case-by-case basis.

But you do tend to obliterate boundaries a lot. There's the idea of "What is a family?" In *The Life Aquatic* and *Rushmore*, the relationship between the three lead characters has aspects of romance, but also of a nuclear family unit.

Hmm.

ABOVE: Blueprints for a tree house interior set.

BELOW: Frame of Skotak, Scoutmaster Ward, and Gadge regarding the scouts' nonapproved, nonregulation tree house.

OPPOSITE: The tree house.

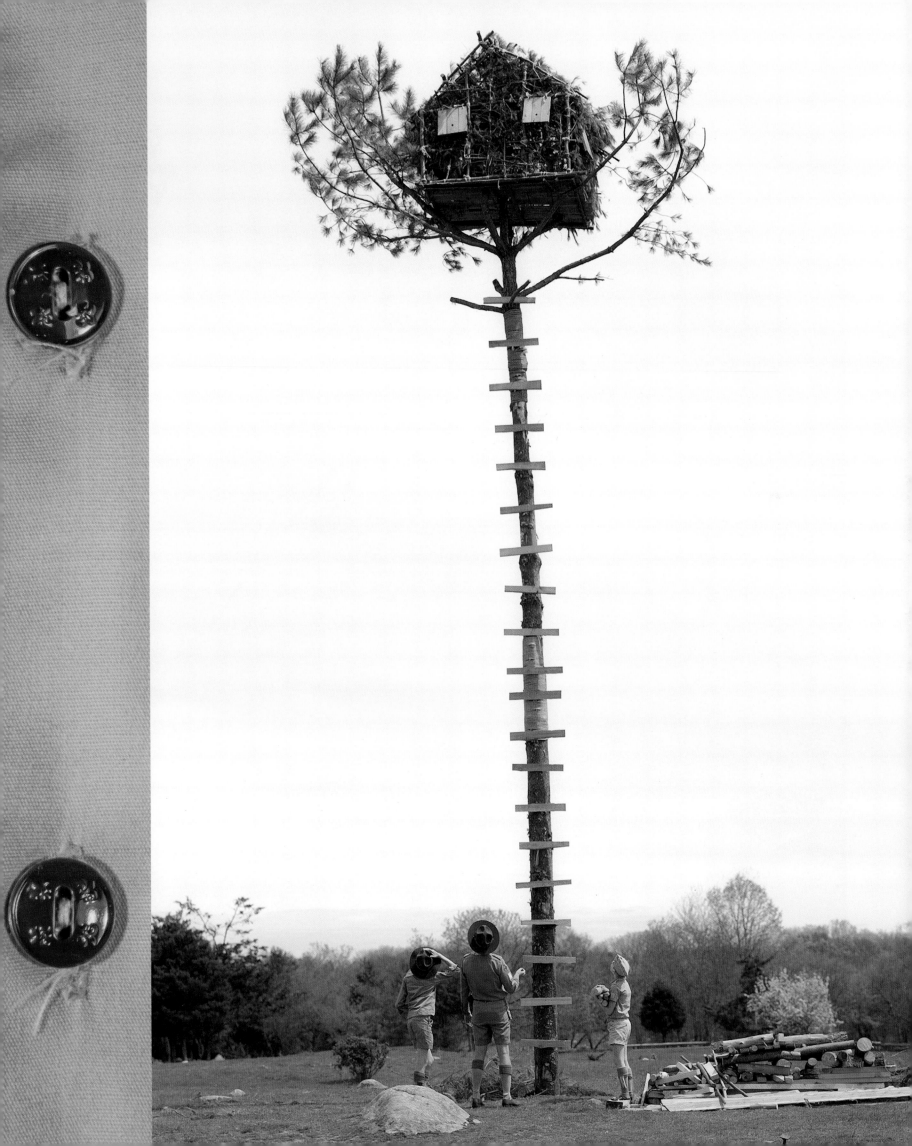

And then geographically you're obliterating boundaries, because everything's taking place in this kind of imaginative alternate universe. The New York in *The Royal Tenenbaums* is not New York, really, and in *The Life Aquatic*, you've got all these made-up animals and place names. I don't think you've made a movie that is set in "reality," exactly.

Right.

In a way, that seems very humanistic, because you see people fighting against these constraints that have been placed upon them psychologically by their families, by their communities, and trying to run away. They literally run away in this movie.

Right. I've more overtly gone into that as I've made more movies. In the first movies I made, we had an invented school, or a couple of invented schools. But we didn't really identify a place. And even in *The Royal Tenenbaums,* we don't identify the place, really. We identify the streets and the areas, but we didn't call the place New York. We didn't call it anything.

The words New York City are never actually spoken, are they?

We don't say New York, but we don't say something else, either. We covered up the Statue of Liberty and, you know, just went from there. But in *The Life Aquatic,* he's on a place called Pescespada Island, which seems like Italy, I guess, and it's more or less Italy. I don't know!

All these things fall under the heading of things you do because they just feel like the things to do?

I think so. For instance, in *The Life Aquatic,* I remember at one point Noah Baumbach and I were trying to figure out, "Where are we now? We seem to be in Southeast Asia somewhere—the South Pacific. The Ping Islands." What are the Ping Islands? We never really quite required ourselves to clarify that.

What, if anything, did you learn from directing an animated film immediately before directing *Moonrise Kingdom*? I ask that because it seemed like you were taking some specific visual chances here that I didn't see in other movies. Like the zoom shots that seemed to go on for miles.

We animated storyboards for anything that had any action, or big sets, or even just long scenes, which I hadn't done before, except for *Mr. Fox.* I did my storyboards as I always do, but then we had them redone by proper storyboard artists like we did with *Mr. Fox,* and we animated them to a soundtrack of me just reading the script, but with the music, and figuring out the timing and all that stuff.

So it was pre-visualized?

Right. And I showed Edward some of the pieces. Edward wanted all of them. He took all of them. He says he used the pre-vis-type information in his performance. Somehow he felt it was helpful to him. But for me, it was very helpful.

Not only did we do that, but for a number of scenes we went and shot them on film without the actual cast, in advance, so I could see what we needed to do.

A lot of that does come out of *Mr. Fox,* then?

Some of it does. Some of it also comes out of doing *The Life Aquatic.* Part of it is, I didn't want to go out with a great big group. I wanted to go out with a tiny group. But if you're going to go out with a tiny group, you've got to make sure you've got the right people and the right equipment. Being prepared is key, because you can't just say, "Let's just pull the dolly off of the truck"; if you come out in a motorboat, you know, there's no truck.

Essentially, you're going camping in the woods, and you need certain types of gear.

You need to know what you need.

In the opening sequence, you go a very long time without a cut, don't you?

There are cuts here and there. The first shot goes on for a bit. That was one of the first images I had in mind for this one, I think. This family sort of wandering around the house while it's raining outside on their island.

OPPOSITE ABOVE: Anderson checks a close-up of Lucas Hedges, the actor who plays Redford. The character is, of course, named for his resemblance to you-know-who.

OPPOSITE BELOW: The *Moonrise Kingdom* crew sets up and executes the film's motorbike wreck.

ABOVE: Edward Norton as Scoutmaster Ward and Bruce Willis as Captain Sharp.

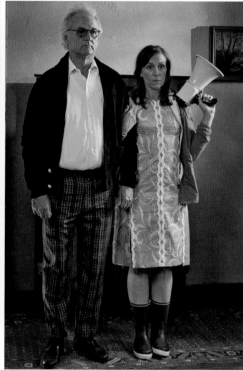

It's also the world that she's going to escape shortly.

Hmm. I also had the idea that maybe the house could have the atmosphere of a rickety old place in some book where the kids go up into the attic and reach through a broken board and find a fragment of a forgotten map and set off on an adventure—that it could have that sort of feeling. We went to a place called Cumberland Island, off the coast of Georgia just above Florida, and we thought about filming there. It's a wonderful place. And there's a house there that I love. But it's a New England story, so it wasn't right.

We looked at another house in the Thousand

Islands, on the border between New York and Canada. There's a place there called Comfort Island. This entire island was for sale, and they had all the pictures on the Internet, so I asked Molly Cooper who works with me to go up there, and our set decorator Kris Moran went up there, too. It's a great, tiny, little island with only one house on it. We thought about shooting there, and what it would be like to do our movie in the Thousand Islands. Then there's another place that I had found on the Internet called Ten Chimneys. This was a house that was owned by the Lunts. It was their house. It's a compound. Then there's another house in Rhode Island near

ABOVE LEFT: Kara Hayward as Suzy, sitting in the Bishop house, interiors for which were constructed inside a defunct Linens 'n Things near Newport, Rhode Island.

ABOVE RIGHT: Bill Murray and Frances McDormand as Walt and Laura Bishop.

BELOW: Suzy and her brothers (FROM LEFT TO RIGHT), Murray, Lionel, and Rudy Bishop (played by Tanner Flood, Jake Ryan, and Wyatt Ralff, respectively).

OPPOSITE: Anderson with Bruce Willis (TOP) and Edward Norton (BOTTOM).

OVERLEAF: Laura and Walt Bishop pictured through the doorways of their adjoining home offices, an example of Anderson's fascination with frames within frames.

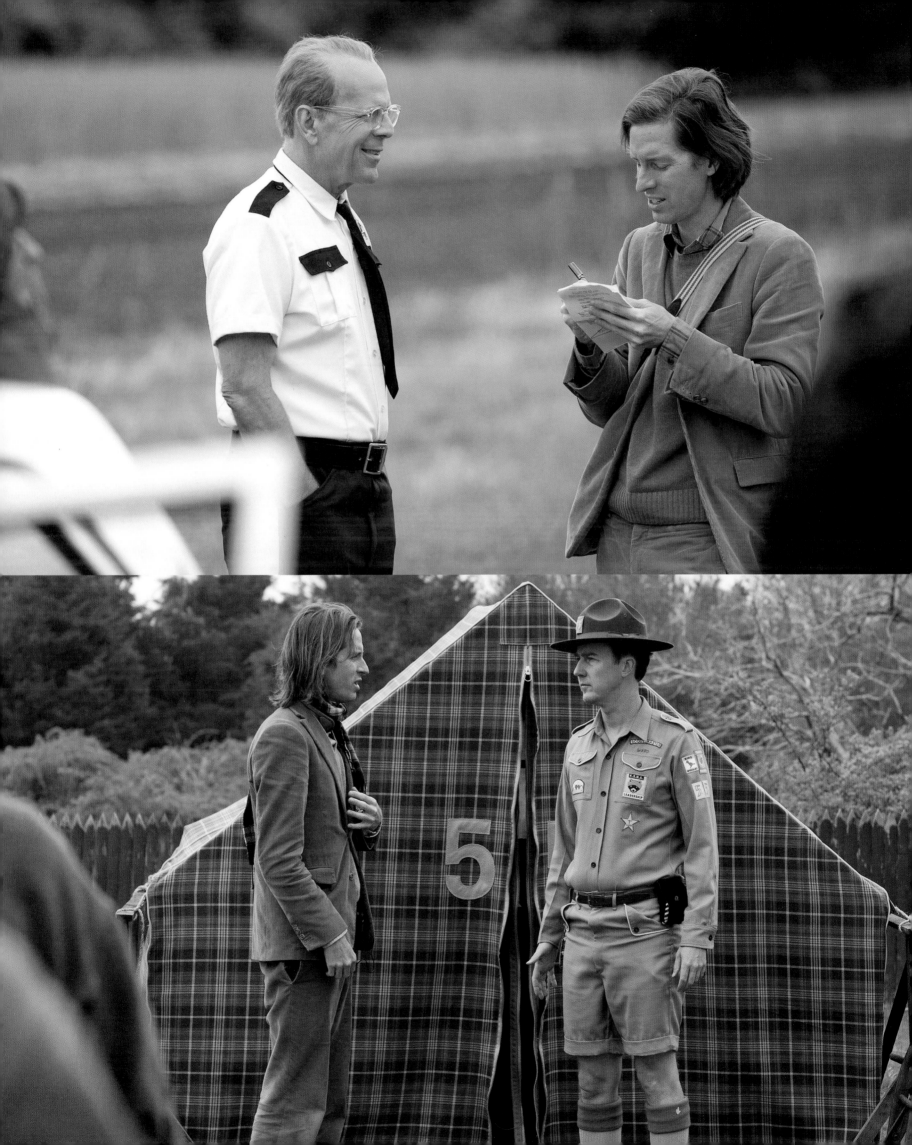

Newport called Clingstone—the whole house is built on a rock in the middle of the bay. We had all these different places to consider.

The house that we actually chose for our exterior was named Conanicut Light. It used to be a lighthouse. In order to do the shots that I had in mind, we had to build a set for the interiors. So we built it all on a former Linens 'n Things near Newport, but we used elements and ideas from all those houses we scouted. We actually rented and borrowed things from the Comfort Island house. We modeled the shingled walls on Clingstone. We re-created a playroom from Cumberland. I don't know exactly if that's answering your question. What's it got to do with how long the shot is? Nothing.

Well, tangentially, maybe it does. There's a sense of geographic connectedness to the way this movie is directed that seems to proceed directly from *Fantastic Mr. Fox,* in the sense that there were times when I felt like I could take out a piece of paper and draw a map of this island.

We put maps of the island in the movie to help you feel like you can find your way around. I showed Scott Rudin an early cut of the movie, and he said, "Are they supposed to be on a different island now? I didn't get that." So we made maps so you know when we've gone to another island, and when we've traveled all the way across the place and so on. In fact, we stop-motion-animated little pins across the maps, which also comes from *Mr. Fox,* I guess.

Doesn't the movie begin and end with a painting?

It begins with a needlepoint of Suzy's house. There's a church called Trinity Church, in Newport, which is where they do the *Noye's Fludde* play, and the end of the movie takes place in that church—one of the oldest churches in the country. A beautiful church. George Washington had his own pew there. I was in the office of the rector, Anne Marie, and I saw that she had a needlepoint of the church on the wall behind her. I thought, "We can use this needlepoint." Which we did.

So then we decided, well, let's just do needlepoints of all our main sets, and we'll put them on the walls of the house. You'd have to watch the film pretty closely to pick up on that. It's a second-viewing type of thing—if anybody actually wants to watch a second time—but in the opening scene, all the main sets of the movie appear on the walls.

We tried to get the same woman who had done the needlepoint of the church to do them all, but she was ninety-six. We ended up having to get them done in the Philippines.

When I visited you in the editing room, there was an overhead shot of the animal masks falling into a water tank. It was an insert shot that was being done in postproduction, and the crew was having trouble getting it right. You were talking on the phone to somebody involved in shooting that insert and saying basically, "You just have to keep dropping this until it falls the right way." Which kind of ties back into some of the things you

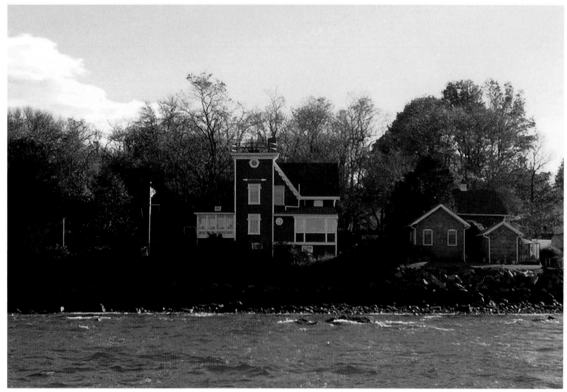

were describing about the production itself and shooting on location, which in turn reminded me of the conversations we had about *Fantastic Mr. Fox* and your insistence on using actual animal hair on the animals. These are all expressive of a very particular, personal sensibility.

In the case of that insert you mention, I think I was having a conversation with someone who was saying, not unreasonably, "I think we should put some wires on it and try to control how it moves. It might be faster to do it that way rather than to keep dropping it." And my feeling was, "Well, it's not going to look right with the wires." If we just keep dropping it, eventually it's going to do the right thing, and it will look right. Because it is right. It's just being dropped.

But yes, I do have a preference for something with a little more homemade feel to it. Plus, the way I write these stories, they tend to be a bit, as we have said, surreal, or at least they take some sort of crazy turn. So the more it can all feel as natural as possible, the less risk there is of those surreal elements taking a whole movie away from our characters and so on.

When you showed me parts of the movie in the editing room, some sequences still had the green screens in, and some of the effects were unfinished. When I saw those scenes in the near-finished film, they were very detailed, dense, lived-in special effects, but they also felt very analog. The flood near the end feels like a flood from a 1960s movie. It doesn't feel like a meticulous, CGI-perfect sort of flood. There's that homemade quality that you talk about.

Yeah. It feels fake as a miniature, rather than fake as a computer. I prefer the miniature. You know, all those old movies—some people can tell it's a miniature, some people don't sense that. I like miniatures in movies. I mean, I actually love miniatures in movies. But when you do a miniature with water, if you're sensitive to that stuff, you can usually kind of tell. Whereas if you do a miniature of a building blowing up, you usually can't tell. There's nothing to give it away.

ABOVE LEFT: Conanicut Island Lighthouse on Conanicut Island, in Rhode Island's Narragansett Bay.

ABOVE RIGHT: Anderson's drawing of the house, and Suzy's stationery.

BELOW: As Anderson explains, the house on the left is on Comfort Island in the Thousand Islands, "which was an inspiration for our house, and we thought of shooting there, and they loaned and rented us paintings and furniture and all kinds of things." The house on the right is the one at Conanicut Light, shown from a different angle.

OPPOSITE: A gallery of needlepoints: Noah's Ark (CENTER), tying into the flashback performance of Benjamin Britten's *Noye's Fludde* and, of course, the climactic flood in the movie; the entrance to Fort Lebanon (TOP LEFT); the post office (BELOW); the Bishop house (BOTTOM); and St. Jack's Church (ABOVE RIGHT).

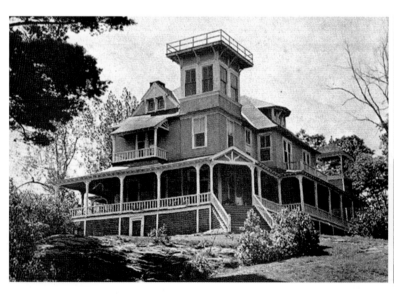

I've always heard water and clouds to be the most difficult things to fake in a miniature.

Clouds, right. Tricky.

Although Spielberg seemed to get a handle on clouds.

What did he make up the clouds with?

Well, he built a cloud tank. He shot all the cloud effects from *Close Encounters of the Third Kind* onward in 70mm, so that the effects shots would be dense when they were composited with the other footage, which was shot in 35mm.

His clouds are underwater clouds in a tank of distilled water, and there's a pneumatic tube that's injecting purple or blue dye into the tank, and they're shooting it in super slow motion to give the clouds an illusion of scale.

It's interesting that when you take a step back, Spielberg's cloud tank seems like it's just several glorified steps up from the kind of filmmaking you probably did with a Super 8mm camera in your backyard as a kid.

Hmm.

"Let's put the camera down low so that we make this toy seem like it's giant."

Right. You know, an unusual number of Spielberg's key exterior scenes I feel were built on stages. I guess not for daytime scenes, but he's done many nighttime scenes—the kind where he adds more stars in the sky. A sort of Spielberg sky. Like you know that curve in the road where everybody is gathered in *Close Encounters,* that

OPPOSITE ABOVE: A special-effects insert frame of CGI lightning silhouetting a weather vane.

OPPOSITE BELOW: A scale model of Trinity Church, found by the production crew in the church hall.

ABOVE: In one of the signature shots in *Close Encounters of the Third Kind*, Jillian (Melinda Dillon) pursues the UFOs that kidnapped her son. The clouds are analog, created by injecting dye into a water tank.

RIGHT ABOVE: Captain Sharp's police car rigged on the stage for a nighttime driving shot.

RIGHT BELOW: A scenic painter paints a dollhouse that the production purchased to use as a model.

hillside? It's a set, I think. But it's a great set. He envisioned a certain landscape. To get that exact landscape, he has to build it.

It's a dream image.

I think that's right.

You can't go around looking for a dream image.

There's no percentage in it.

That ties in with the driving story element in *Close Encounters*, which is the idea of people seeing a shape in their head and then trying to realize it.

Which I always heard was Schrader's contribution—that Paul Schrader had done a draft of the script and that was one of the things he contributed to it.

Yeah. Supposedly the religious overtones were much more overt in that draft, which I guess is no huge shock. Roy Neary's experience that first night was Paul's revelation on the road to Damascus. But *Close Encounters* is also a movie that's very much about the artistic process, and in fact, I would almost say it's a film about filmmaking. What are you doing when you make a movie but trying to build Devils Tower out of some mashed potatoes?

Exactly. And literally the train set.

What's that Orson Welles quote? "This is the biggest electric train set that a boy ever had."

Right.

Let me ask you about some movies that you have cited as being partial influences on *Moonrise Kingdom*, starting with *Melody*.

I didn't know about *Melody* until I started working on the script. I sought it out because it shares similar subject matter. But then I really loved it. It's Alan Parker's first script, I guess.

The heart of the film is a love story between two kids.

That's what drew me to it.

A lot of your movies make it seem as though your heart is in the sixties and seventies. You draw from a lot of eras, and a lot of different film cultures, but that's the impression that I get. Is that accurate?

It sort of happens that way, sometimes. But it's not like my house is filled with nostalgia stuff, you know? I'm more attracted to the rock-and-roll music. That's where it comes from. I mean, there's fifties rock and roll, but the sixties and the seventies—

That's the heyday.

OPPOSITE ABOVE: The crew prepares to shoot close-ups of Edward Norton entering Commander Pierce's tent.

OPPOSITE BELOW: Green screens placed behind sets on location, to be composited with storm effects in postproduction.

ABOVE: Inspirations for *Moonrise Kingdom*: (TOP ROW) Ken Loach's *Black Jack* (1979); and (BOTTOM ROW) *Melody* (1971), written by Alan Parker and directed by Waris Hussein.

BELOW: Suzy on the shore.

That is the heyday. It's not like I deliberately wish to connect myself to that period. I don't.

No, but you seem to have an affinity for it.

Hmm.

In *Melody* you've got a story between a couple of kids—I think they're even younger than the kids in *Moonrise Kingdom*—who at one point just decide that they want to get married.

Right. I think they're the same age. I think they're twelve. *Melody* is also kind of a surreal movie, but it's all done kind of simply. I don't want to say that it has a documentary feeling, but nothing in the atmosphere feels surreal. Just the script itself kind of is.

Another influence you've cited is Ken Loach's *Black Jack*.

Right.

That film is very striking in relation to *Moonrise Kingdom*. If anything, it's more extreme, because it's in period and everything's a lot rougher. You've got the whole plotline about the title character trying to rescue this girl, Belle, who's been consigned to an asylum. Our heroine in *Moonrise Kingdom* is not in an asylum, but I think perhaps she feels as though she is.

Hmm. But also, the boy in *Moonrise Kingdom* is at risk of being committed to an asylum, or something like it.
 I love that movie. I stumbled across *Black Jack* in a video store in London, and practically no one that I talk to has ever heard of it, yet I don't understand why this isn't one of the well-known Ken Loach films. I thought it was a very beautiful movie.

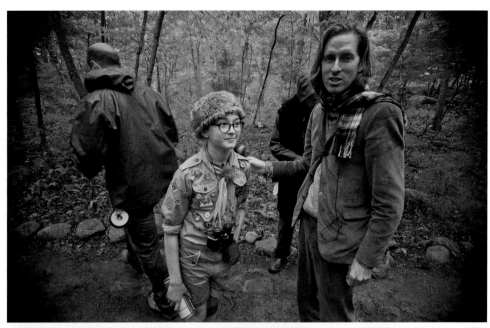

I'm not sure why, either. Maybe it's because Loach, for most of the last two and a half decades, has been known as a "political filmmaker," so we tend to forget the other things he does so well—mainly, observing character. Also, he's great with kids.

Well, *Kes* is much better known than *Black Jack*. *Melody* is interesting, and has a wonderful spirit, and inspired me very much. *Black Jack*, on the other hand, is a great, great film.

Yes. And here we circle around and kill two birds with one stone, because in talking about influences on *Moonrise Kingdom*, I realize that we never had much of a discussion about François Truffaut. Truffaut's *Small Change* echoes throughout *Moonrise* in a lot of ways. Let's talk about *Small Change*, and Truffaut generally.

Melody and *Black Jack* are movies I found as I was working on *Moonrise Kingdom*. *Small Change* is one of the movies that made me want to make a movie about people this age in the first place. In *Moonrise*, Sam and Suzy are the same age as those kids in *Small Change*.
 When I see *Small Change*, even though they're French, I still feel like you can sense that they're just the same as us. I mean you and me specifically. In age. I think these are exactly our contemporaries. So there's something familiar about it.
 But Truffaut in general—the first film of his I saw was *The 400 Blows*. That made a huge, rock band–type impression on me when I saw it. It's one of those films where you say, "Not only did I just enjoy this experience, now I think I would like to model my future on this somehow."

That's an extraordinary statement.

Well, there are a certain number of books and movies that you come in contact with that are the ones you can look to and feel like they are . . . what you were trying to imitate.

How old were you when you saw *The 400 Blows* for the first time?

I think I must have been seventeen or eighteen.

Was it in a theater, or on tape?

I think it was on tape, maybe a Beta tape. I think I saw it before I went to college. But I didn't own it. When I was in college, they had it in the library.

Can you speculate on what it is about that movie that spoke to you so strongly at that particular point when you saw it?

It's hard to describe. It's one thing to see a Godard movie and say, "This is totally different. This guy is doing something crazy. The people break into dance in the middle of a scene," or, "There's something radical happening here." Well, that was my response to *The 400 Blows*, yet it also features a very naturalistic style of storytelling. One striking element is just the visuals—Paris at that time. The

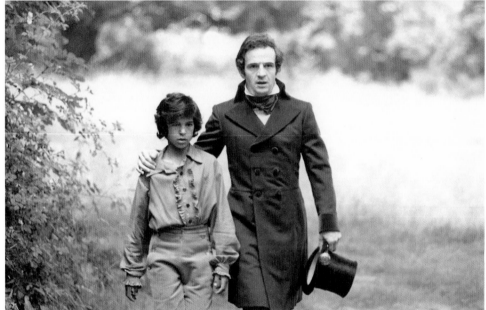

boy he cast, how vividly he portrayed this boy's life—because it was his own, sort of. It's set in his neighborhoods. Something about the combination of all this ends up being a very forceful, very powerful experience.

You do get the feeling when you see that film for the first time that you are hearing a statement from a person.

Right. There's one name that you can put on the whole thing.

There's a line in *Small Change* that made me think of your films: "Children exist in a state of grace." I don't know if that applies exactly to the way that you portray kids, but it felt to me like there was some kind of resonance there. I thought of the line in *Bottle Rocket*, "They'll never catch me, man, 'cause I'm fuckin' innocent."

Hmm.

There is something innocent about almost every character in all of your movies, adults and children alike. Even the characters who seem burnt-out or cynical or who've given up in some way have this core of almost Truffaut-like innocence. I can feel that lineage.

ABOVE: Wes Anderson on location with Jared Gilman.

BELOW: François Truffaut on location with Jean-Pierre Cargol, star of *The Wild Child*.

OPPOSITE LEFT: A French one-sheet for Francois Truffaut's *The 400 Blows* (1959).

OPPOSITE RIGHT: (ABOVE) A still from Truffaut's *The Wild Child*; (BELOW) A one-sheet for *The Wild Child*.

OVERLEAF: Sam and Suzy's campsite, with a centrally placed portable record player.

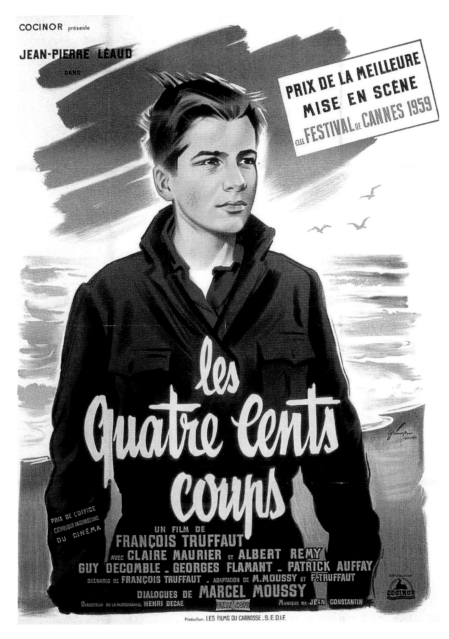

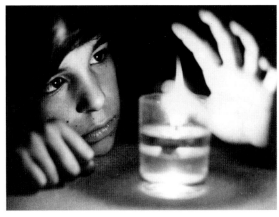

Truffaut's got some quite dark characters along the way. In particular, *The Soft Skin*—the main character in that comes off sort of badly. I love that movie, but he's not a winning hero for an audience.

But yes, with that exception, there aren't a lot of villains, real villains, in Truffaut's films. Even in *Shoot the Piano Player*, the bad guys are very likeable. That's kind of their thing.

There's almost an aura or a halo around a lot of his characters. There's almost a shimmering energy in his films that I can't quite describe.

Renoir is like that, too, you know? *Grand Illusion.* You're hard-pressed to call the characters in that film "enemies." I mean, I guess that's part of the illusion.

That goes back to our earlier discussion about the obliteration of boundaries or limits in your films, or the flagrant disregard of them.

Hmm.

Tell me about the use of music in *Moonrise*. It seemed to me that there were fewer pieces of music, fewer artists represented on the soundtrack. But you used them more

extensively, and the music was woven more deeply into the fabric of the entire film.

That's probably true. A lot of the music in *Moonrise Kingdom* is classical music. It's a different sort of experience from when you go into a pop song in a movie—so often when you go into a pop song, you really feel the needle drop.

"The Young Person's Guide to the Orchestra: Variations and Fugue on a Theme of Henry Purcell." What is the personal significance of that work for you? Why does that play such a prominent role in the film, even to the degree that it seems at times as much a commentary on the action as Bob Balaban's narrator?

Benjamin Britten is a big part of the whole movie. We have lots of Britten, not just "The Young Person's Guide," but also "Noye's Fludde," and some pieces that are arrangements of traditional songs, but then we also have another piece from *A Midsummer Night's Dream,* another opera.

Britten, I love. He wrote a lot of music for children. "The Young Person's Guide to the Orchestra"—it's Leonard Bernstein's recording and arrangement that we use. I imagine that Leonard Bernstein wrote the text that goes with

it. So there's really three composers involved. There's Purcell, whose music Britten took apart and rearranged and made something new out of, and then there's Leonard Bernstein, who's conducting the whole thing, as well as making it into this narrated experience.

"Noye's Fludde" is meant to be performed with amateur groups in a church. That was the purpose—that was the venue it was intended for. It was always meant to be performed by a few professionals, but with a chorus of nonprofessionals and children. It was not meant to be performed in an auditorium, it was meant to be performed in a church. The folk music or traditional arrangements are all things that are for children. I like the idea of these great composers speaking to a young audience. And Leonard Bernstein in particular, that's something that he did for many years—these concerts for young people.

Those recordings are pretty extraordinary, not only for the clarity with which Bernstein expresses his ideas, but also for the mere fact that a man of his cultural magnitude would have been involved in an enterprise such as that.

I guess you do that because you like to teach?

I'm curious about the role of music in your movies. I know from talking to you, and from other interviews with you, that there are sequences in movies that you've made where you've previsualized them as being set to a particular piece of music.

Particular music?

Yeah, a particular song or piece. What is the process of deciding what kind of music you're going to use and how you're going to use it? How much advance planning goes into it? How much of the music that goes into your films, when we're watching them, was decided upon long in advance? And how much of it is simply a response to looking at the footage in editing and going, "Ah, we need a song here"?

Well, it kind of depends on the movie. In *The Royal Tenenbaums,* for instance, I would say probably half of the music was added later. Probably more than half, because there's also original music in it. Whereas in *Moonrise Kingdom,* the only things that came in later were the music that Alexandre Desplat wrote, and the Hank Williams songs. But it varies from movie to movie.

ABOVE: A production still from Benjamin Britten's "Noye's Fludde" being performed at St. Jack's Church.

OPPOSITE: A collection of significant movie music (COUNTERCLOCKWISE FROM BOTTOM LEFT): "Rock Around the Clock," by Bill Haley and the Comets, first used in 1955's *The Blackboard Jungle;* "Be My Baby," by the Phil Spector-produced Ronettes, the opening cut of Martin Scorsese's influential *Mean Streets* (1973); *The Music of Benjamin Britten,* including "Young Person's Guide to the Orchestra"; the musical heart of *Moonrise Kingdom;* George Lucas's 1960s pop-heavy *American Graffiti* (1973), the first major studio release with a "jukebox score" of existing hits; *Pat Garrett and Billy the Kid* (1973), the original score to Sam Pekinpah's boozy revisionist Western, by singer-songwriter Bob Dylan. Anderson wanted to use portions of *Pat Garrett* in *Bottle Rocket* and *Rushmore* but did not have the money to pay for the rights; Mark Mothersbaugh wrote a Dylan-esque facsimile for *The Royal Tenenbaums.*

What directors do you think are the gold standard when it comes to using preexisting music in a movie?

Scorsese, I think, is the filmmaker who made such a huge impression on people with that. *American Graffiti* is a big one. I can't say *American Graffiti* had a huge influence on me, but I love *American Graffiti*. You know, Renoir is someone who used popular music in his films. People listen to music in Renoir movies. There's another movie that made a huge impression on me, another Alan Parker movie: *Shoot the Moon*. There's a scene in *Shoot the Moon* where they play a Rolling Stones record. It's just them sitting there listening to music. And it's a wonderful scene.

Alan Parker is great with music. There's another wonderful scene in *Shoot the Moon* where Diane Keaton's sitting in a bathtub smoking a joint and singing "If I Fell."

That's a great scene. *Apocalypse Now* was filled with pop music. There's one movie where you go from one song to the next through the whole film, and it's almost like someone's playing records for you while you watch the movie as a

separate thing—the music has an amazing, positive effect on the movie, and it's sort of like, when one song ends, he just starts another—which is *Coming Home*.

Hal Ashby. I was just going to bring up *Coming Home*. Ashby was underappreciated for how influentially he used music.

I agree. I don't know any other movie that's quite like *Coming Home*. It's all songs. It's wall-to-wall.

It is wall-to-wall. In fact, it seems that in a lot of Scorsese's films after the late seventies, the arrangement of pop songs is very similar to that. There's something very Ashby-esque about the way he uses music in, say, *Goodfellas* and *Casino* and *Bringing out the Dead*.

You're probably right. But some of the things he does in *Mean Streets* are—those are some of big movie moments. "Be My Baby" and "Jumpin' Jack Flash."

"Rubber Biscuit" in the drunk sequence.

ABOVE: Playboy bunnies entertain horny troops in Francis Ford Coppola's *Apocalypse Now* (1979), a rock-and-roll–driven war epic.

BELOW: (LEFT) Jon Voight and Jane Fonda in Hal Ashby's *Coming Home* (1978), a wall-to-wall-soundtrack movie; (RIGHT) Diane Keaton smokes a joint and sings the Beatles' "If I Fell" in Alan Parker's *Shoot the Moon* (1982).

OPPOSITE: Stills from the *Royal Tenenbaums* sequence in which Margot gets off a Green Line bus to the tune of Nico's "These Days." This was the first scene that Anderson imagined while working out the film's story line.

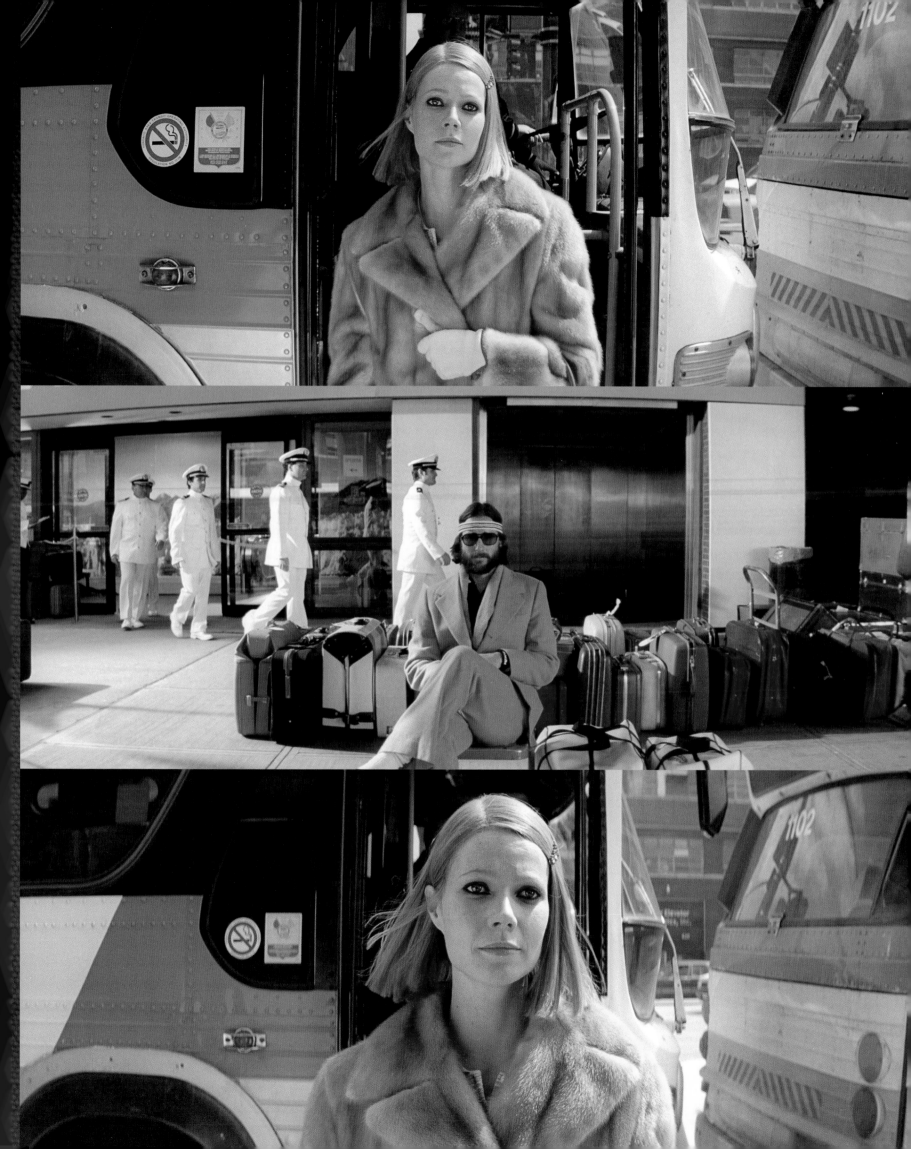

Right, in the drunk sequence. And then it's got the one with the woman dancing.

The scene where Scorsese's got Harvey Keitel up on a platform, the *Madame Bovary*–style moving platform; he's moving toward the stage where the women are dancing.
 Stanley Kubrick and Mike Nichols are two other directors whose use of music had an impact on other filmmakers.

You're right. Certainly *The Graduate*. When did Kubrick start doing that with music?

A little bit in *Lolita*, but in a big way with *Dr. Strangelove*. *Dr. Strangelove* was one of the first movies to use pop music in an editorial way, where the arrangement of the songs gave you additional insight into the characters or the scene. "We'll Meet Again" over the montage of mushroom clouds at the end, for example.

I always heard that *The Blackboard Jungle* was the first movie to use a pop song on its score. That can't be true. In fact, most pop songs probably used to come straight out of musicals, actually. What I'm saying makes no sense.

I think it's the first rock-and-roll song.

It must be the first rock-and-roll song.

It had such an electrifying effect that supposedly, at some of the tougher theaters where it played, the audience went berserk. There were reports of people cutting the seats with switchblades.

Right.

What do all these people have in common in terms of their use of music? There's something more going on in the choosing of the music, and the placing of the music, than simply, "Oh, the hero is sad because he lost his girlfriend. Let's stick a song on here about a guy who's sad because he lost his girlfriend." It's at a higher level.

I guess it's really "How interested in music are these guys?" You can kind of tell.

Yeah, I guess you can.
 We haven't talked about a certain soundtrack selection, Maurice Ravel's "String Quartet in F Major," the second movement of which you use in the cast montage of *The Royal Tenenbaums*. What's the story behind that?

I had bought a recording of it by the Britten Quartet. I haven't thought of that in a long time, but the name of the group was the Britten Quartet, and

years later, I made a movie whose soundtrack was filled with the music of Benjamin Britten. I was interested in French Impressionist music, and I liked the cover, so I bought the CD, and I found this great piece. That was probably before or around the time that we made *Bottle Rocket*. It was a long time ago. I'm sure I bought it in Texas.
 So I listened to that piece a million times, and I had this sequence in my head that was meant to go with it. It was supposed to be in black and white. I kind of related it to an F. Scott Fitzgerald–type New York story. I pictured it being set in the 1960s, though. It was probably a bit like *Good Night and Good Luck*, something like that! It was a Scott Fitzgerald–esque story that was being introduced with this Ravel music. And eventually the movie became color, and the characters began to take shape, and it ended up being very different from what I'd originally pictured.
 But also I remember that I had thought of it for a title sequence. The writing on-screen? Well, I had thought that *The Royal Tenenbaums* would have sort of cursive writing, like *Blue Velvet*. But then we didn't do that for *Tenenbaums*. On *Moonrise Kingdom*, we did use a type kind of like that—one that we made.
 So it all kind of works itself out, I guess.

That particular quartet was actually an influence, in a round-about way, on *The Royal Tenenbaums* itself?

ABOVE: (TOP) Robert De Niro enters a bar in *Mean Streets* to the tune of the Rolling Stones' "Jumpin' Jack Flash." (BOTTOM) Harvey Keitel weaves drunkenly through a party while The Chips' "Rubber Biscuit" blasts on the soundtrack in *Mean Streets*.

OPPOSITE ABOVE: Jared Gilman and Wes Anderson shooting the lightning-strike scene in *Moonrise Kingdom*.

OPPOSITE BELOW: Anderson directs the scene just before Sam and Suzy are married by Cousin Ben.

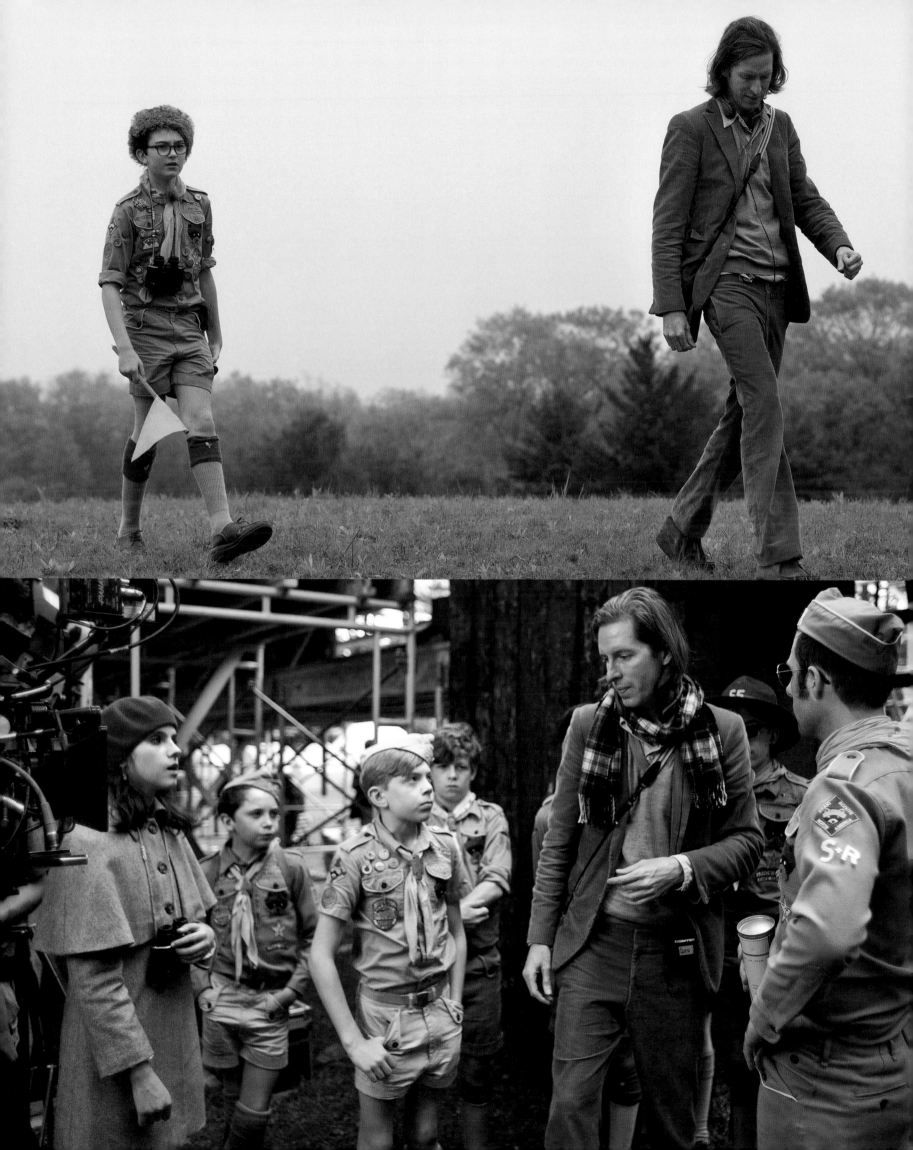

That piece was one of the first ideas I had for the film: Ravel's "String Quartet in F Major," the scene where Margot is coming off the bus, and the tennis court scene where Richie has his meltdown. Those three scenes were the first ideas we had for the movie, many years before we made it.

Do you have a somewhat philosophical attitude about not getting to use the music you wanted? For instance, do you get to the end of the movie—not just in terms of the music, but on the whole—and say, "Now the movie is done. The movie is what it is. And I'm moving on"?

Well, you don't have much choice. Some people will try to touch it up later, with a new version. But I never was particularly drawn to that activity.

You've never had the urge to go back and reedit a movie, or add a scene that you took out that maybe, in hindsight, you have second thoughts about?

Not really. Because then you've got two versions out there. It's not like we're striving toward perfecting the movie. To me, the movie is the movie. It's something that becomes archival. It may have flaws, but we pulled the trigger on it.

It is a natural tendency, though, to obsess over what might have been.

Sure, there's a tendency. But who recommends it?

So for the sake of mental health, it's to be avoided?

I would think!

Let's talk about critics. Earlier on, you talked about discovering the writing of Pauline Kael in college,* and of other critics and film writers as well. Do you learn anything useful from reading criticism of your work? What is your relationship with criticism, as an artist?

It can be nice to read somebody just gushing. That certainly can make you feel, "Oh, boy—I really got through to this person." But often, even in a review where somebody's gushing, you're thinking, "Oh, well, they think I did that on purpose," and you know, maybe if they actually understood how that happened, they wouldn't like it as much. Plus, if you decide to really get into reading reviews, you have to know there's a possibility that you're gonna turn a corner and read a stunningly horrible review that is just gonna be a distraction for you. Really, what you want to do is get on to the next movie, and continue with whatever it is. It would be great if somebody could say to you, "Here is the thing that you always get wrong," and they were right about it, and you could fix that. But I don't think that tends to happen.

You were always a director who people tended to have very strong opinions about, one way or the other. But it seemed like sometime around *The Life Aquatic* and *The Darjeeling Limited*, things took a turn toward the negative. How does that criticism, or any negative criticism, affect you? Would you change your approach on the next movie that you're making based on negative reaction to a previous film?

No, because it would be one thing if you could hand out copies of your work-in-progress to critics, and then you could go back and say, "Ah, you know what? We need to take out at least five minutes of this." But the movie is done, and it's hard to take criticism of your previous work and apply it to the next one.

There is one thing you can absolutely, 100 percent rely on, which is that if you show five different people the same thing, they're all going to have a different complaint or compliment. Each is going to have a different response, and you'd better know what *you're* gonna do, otherwise you're going to get confused.

ABOVE: Britten Quartet's *Ravel String Quartets* album from 1992 contains the first version of "String Quartet in F major" that Anderson ever heard, and that inspired him to imagine the story that later became *The Royal Tenenbaums.*

OPPOSITE ABOVE: Wes Anderson (LEFT) and director of photography Robert Yeoman (THIRD FROM LEFT).

OPPOSITE BELOW: A focus card for *Moonrise Kingdom* specifying that it was shot on Super 16 mm film in 1.85:1, or "flat," format.

** For more on Pauline Kael, see page 41 in the *Bottle Rocket* chapter.

Do you ever feel a disconnect between the world of Wes Anderson, filmmaker, and the world that responds to your films when they finally come out?

Well, I want people to go see my movies, and I want people to like them. I'm very eager to have people like my movies. Some of my films have encouraged people who like them to make drawings and various artworks and things like that. I've gotten lots of pictures from viewers. I love that. What could be more encouraging to me than to see people responding that way?

But how much good can come from putting any time into studying how people are responding to your movies? The best-case scenario is that it makes you feel flattered for a certain period of time, which doesn't really buy you much, in life; and inevitably, it's not going to just be the best-case scenario, so learn to spare yourself that experience, I'd say.

When we were talking about directors recutting and in some cases remaking their own films after first release, you used the word "archival." That made me think of a topic that's been very much in the news in 2012: the future of film.

Do you own any actual 35mm films, or 16mm?

No, the only prints I have are my own movies.

I remember that you had LaserDiscs when I visited you in L.A. twenty years ago.

I still have those LaserDiscs.

All but one of your movies has been shot on film. You are, as we've discussed elsewhere, very committed to analog practices in filmmaking. How do you feel when you look around and see films being projected digitally, films being shot digitally, special effects being done with CGI? Do you just say, "Oh, that's interesting. That's a different way of doing it," or do you think, "Oh, boy. My days are numbered as a maker of this particular kind of film?" Can we even call it a film, after a certain point, if it's not actually shot on film?

We talked in this chapter about miniatures and water.

Yes.

We were saying that there are different ways of doing fake water, right? There's the digital way of doing fake water, which looks fake. And there's the miniature way of doing fake water, which also looks fake. I prefer the miniature. But there's nothing about shooting in a digital format that prevents you from doing the water as a miniature.

When you composite things together—well, if you do it photochemically—it usually degrades the image to a significant degree. So I would never say that the photochemical process of doing dissolves or superimposing things, or doing titles, is automatically preferable to digital. The digital choice is bound to be usually better. And digital projection is better, in my experience, because there are no reel changes, and because the formatting is usually exactly right. As long as the projection is bright and they're using the right equipment, they would more or less nail it every time. Well, whatever way you shot the movie, once it's finished, you'd like the presentation of it to represent your choices accurately. Digital is good for all that stuff.

Why was *Moonrise Kingdom* shot on Super 16mm film?

I wanted to use smaller cameras. I knew we were going to be shooting a lot of scenes in the woods, and I wanted to have a really tiny, kind of documentary-size crew with these kids—to not surround these kids with a big movie crew, and to not get these kids into a rhythm of going into a trailer and then having their makeup touched up. All that kind of stuff.

So we decided to make it more like a documentary. That was part of it.

Also, we found these very little Aaton cameras called A-Minimas where you put your hand under the camera and look down into it from the top. It doesn't go on your shoulder. When you handhold a camera normally, on your shoulder, however light it might be, you're still shooting down at a child. But if you're holding it—

At solar plexus level, I'd imagine—

Right, or anyway at the chest. You're holding the camera like a Rolleiflex. Well, you're right at a twelve-year-old person's eye level.

Is there any sort of film format that you've fantasized about shooting a movie in that you haven't shot in yet?

Yes, there is—1.33:1.

The Academy ratio.

The Academy ratio! Exactly.

The shape of old movies. More squarish. Gus van Sant shot a movie in that ratio, the school-shooting drama *Elephant*.

I didn't realize that was the case.

It was striking to see it in a theater, because the image was so tall. I was so hooked on movies being wide that I'd forgotten they could be just as impressive if they were tall.

My plan is to shoot my next movie at 1.33:1.*** That's why I want to shoot it that way: the tallness. We considered shooting *Tenenbaums* that way, because the house is vertical.

What happens when you can't shoot a motion picture on film anymore?

You know, I've shot some things digitally, commercials and things. *Fantastic Mr. Fox* was not shot on film. *Fantastic Mr. Fox* is digital. And I don't look at *Mr. Fox* and feel like I'm—you know, it's an animated film, so it's a different thing—but I don't look at it and feel like, "This is not a movie." It looks like a movie.

In thinking about my next movie, part of me is like, "Well, can I do this in Panavision? I don't

TOP: Tattoos belonging to Wes Anderson fans Chris Jion (LEFT) and Raishawn Wickwire (RIGHT).

ABOVE: *I Wonder if it Remembers Me?* by Meghan Stratman.

OPPOSITE (CLOCKWISE FROM TOP LEFT): *She's My Rushmore* by Michael Ramstead; *JCW* by Carlos Ramos; *We Are Legion* by Aaron Jasinski; *Blockheads* by Joe Mur; *Belafonte* by Jonas Lofgren; *The Royal Tenenbaums* by Julian Callos; *The Architecture of the House on Archer Avenue* by Danielle Rizzolo.

*** A few months after this conversation, the director shot his eighth feature, *The Grand Budapest Hotel*, in three different aspect ratios: 1.33, 1.85, and 2.35:1. The movie jumps through three time periods; the different aspect ratios tell viewers where they are in the timeline.

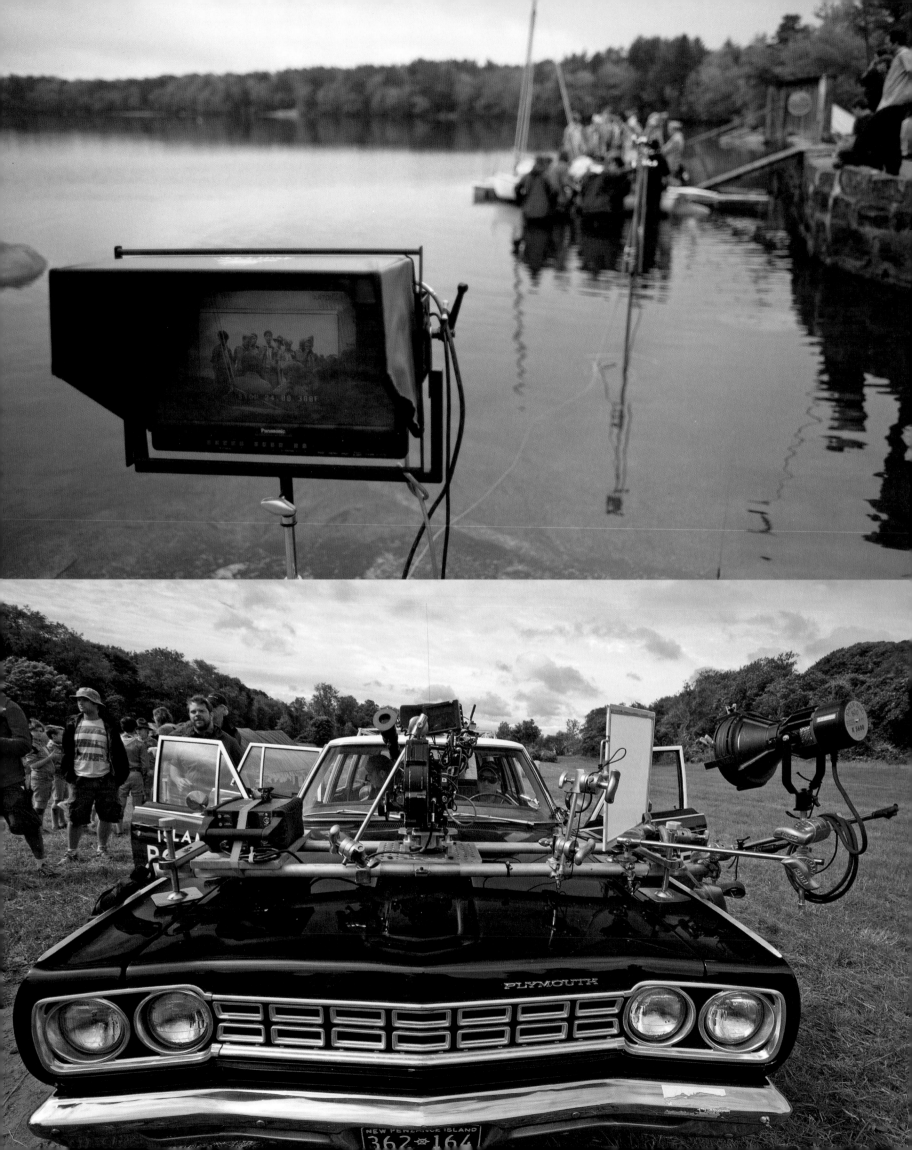

know that I can. I don't know that we're going to be able to process it." But even at the peak of film-making on film, processing the dailies for a movie and just doing the basic required laboratory work that they've always done on movies was always a bit worrisome. Things could go wrong. It's never been a completely reliable process.

So now that we enter into the period when Kodak is not going to be making our film stock and Technicolor is not going to be available to process it, who are we talking about? Before very long, everybody's going to have to do movies on some digital format.

That moment may have already arrived. Somebody sent me a copy of *Filmmaker* magazine, because a friend did an interview with me for it. In the article about each movie, or each director, there's a little box that says, "How They Did It." And it lists the film stock and the cameras, what the editing system is, and all that kind of junk. And other than mine, they all say "HD." There's the same answer for every single movie in the entire magazine. Soon enough, they'll be able to get rid of the box.

Having said that, these changes don't cause me tremendous anxiety. But at the same time, if somebody said, "You've got to start shooting tomorrow—choose," I would say, "Oh, can we please do it with Kodak, Technicolor, and Panavision?"

Do you see theatrical filmgoing as we know it continuing?

I would think so. I mean, this is what they call a "negative fantasy." The record business has totally imploded, but people still make LP records. I don't mean vinyl. People make a record album just the same way they always have, really, at about the same length. You buy it online, but it's sort of the same experience.

So it's really about, how much money can you spend on a movie, and what's all that going to be like? And that is all kind of up in the air. Maybe they'll get it figured out. I don't know that anybody is doing the most wonderful job. But there is still theatrical moviegoing. It's a tradition, and it's an economy. There's no point in expecting the worst.

ABOVE LEFT: The Khaki scouts say good-bye to Sam, Suzy, and Cousin Ben as they sail away; the video "tap" in the foreground helps the filmmakers judge focus and framing for Super 16mm film.

OPPOSITE BELOW: The camera rig for Captain Sharp's car.

ABOVE: Detail of an Aaton camera.

RIGHT: Photo of a Kodak film envelope taped above a trash can in the *Moonrise* production offices, apropos of nothing but symbolism.

OVERLEAF: Sam's painting of the Eden he briefly shared with Suzy.

INDEX

Image Credits

MAX DALTON
Front and back cover illustrations, endpaper illustrations, p. 16, 18, 20, 24, 27

BOTTLE ROCKET
Still photographer: Deanna Newcomb: 2–3, 30, 34–5, 36, 49, 60–2, 67 • Photographs by Laura Wilson: 6–7, 44, 45, 51, 52, 53, 54–5, 58, 63, 65 • Illustrations by Max Dalton: 28–9, 40, 44, 52, 58, 63 • p. 37, left: *The Apple Dumpling Gang* © 1975 Disney • pp. 39, 46: Courtesy of Lucasfilm Ltd. LLC. © 1981–2013 Lucasfilm Ltd. LLC & ™. All rights reserved. Used under authorization. Unauthorized duplication is a violation of applicable law. • p. 50: MURITA CYCLES courtesy and copyright Barry Braverman • "BOTTLE ROCKET" © 1996 Columbia Pictures Industries, Inc. All Rights Reserved. Courtesy of Columbia Pictures.

RUSHMORE
Still photographer: Van Redin: 4–5, 70, 74–5, 77, 79, 84, 85, 93, 100, 152 • Illustrations by Eric Chase Anderson, courtesy the Criterion Collection: 78, 85, 88, 95, 98, 102, 104 • Illustration by Max Dalton: 68–9 • p. 76, bottom left: Hans Holbein the Elder *Presentation of Christ in the Temple* © bpk, Berlin/ Hamburger Kunsthalle, Hamburg, Germany/Elke Walford/Art Resource, NY • p. 76, bottom right: Agnolo Bronzino *Lodovico Capponi* Copyright The Frick Collection • p. 82, bottom middle: *Ed Wood* © 1994 Touchstone Pictures • p. 98, 99, 101: PEANUTS © 2013 Peanuts Worldwide LLC • "RUSHMORE" © 1998 Touchstone Pictures.

THE ROYAL TENENBAUMS
Still photographer: James Hamilton: 108, 112–3, 114, 131–2, 135, 139 • Photographs by Laura Wilson: 115, 116, 118, 121, 123, 130, 140, 143, 144–5, 146–9 • Illustrations by Eric Chase Anderson, courtesy the Criterion Collection: 115, 116, 130, 131, 133, 141, 146, 151–2 • Illustration by Max Dalton: 106–7 • p. 117: Courtesy of Lucasfilm Ltd. LLC. © 1981–2013 Lucasfilm Ltd. LLC & ™. All rights reserved. Used under authorization. Unauthorized duplication is a violation of applicable law. • p. 133: PEANUTS © 2013 Peanuts Worldwide LLC. • "THE ROYAL TENENBAUMS" © 2001 Touchstone Pictures.

THE LIFE AQUATIC WITH STEVE ZISSOU
Still photographer: Philippe Antonello: 8–9, 127, 152, 156, 160–1, 163, 166, 170–3, 175–8, 180-1, 184–6, 190–3, 206 • Drawings and designs for THE LIFE AQUATIC WITH STEVE ZISSOU by Wes Anderson, Maria-Teresa Barbasso, Milena Canonero, Mike Cachuela, Cristina Cecili, Giulia Chiara Crugnola, Sandro Erdolini, Roberta Federico, Mark Friedberg, John Kleber, Sandra Jelmini, Simona Migliotti, Stefano Maria Ortolani, Mark Pollard, Alessandra Querzola, Saverio Sammali, Steve Thomas, Marco Trentini, Eugenio Ulissi, and Greg Winter • Illustrations by Eric Chase Anderson, courtesy the Criterion Collection: 163, 182, 186–8, 192 • Illustration by Max Dalton: 154–5 • p. 162, top row left, middle row middle, third row middle: Cousteau Society • p. 164–5: Photograph by Richard Avedon. © The Richard Avedon Foundation • p. 166, top left: AP Photo/Michel Lipchitz • p. 166, top right: Photograph by N.K. Temnikow • p. 175, bottom right: New Bedford Whaling Museum • p. 186: ™, ® & © 2013 CBS Studios Inc. STAR TREK and related marks are trademarks of CBS Studios Inc. All Rights Reserved. • "THE LIFE AQUATIC" © 2004 Touchstone Pictures.

THE DARJEELING LIMITED
Still photographer: James Hamilton: 10–11, 153, 196, 200–1, 202, 206–7, 214–5, 218–9, 220–1, 226–7, 229 • Photographs by Waris Ahluwalia: 210–1 • Photographs by Alice Bamford: 215, 224–5 • Photographs by Mark Friedberg: 214, 228 • Photographs by Sylvia Plachy: 212–3, 216–7 • Photographs by Laura Wilson: 208 • Photographs by Robert Yeoman: 209, 228 • Illustrations by Eric Chase Anderson, courtesy the Criterion Collection: 203–4, 209, 218, 221, 227, 229, 233 • Illustration by Max Dalton: 194–5 • "THE DARJEELING LIMITED" © 2007 and "HOTEL CHEVALIER" © 2007 Twentieth Century Fox. All Rights Reserved.

FANTASTIC MR. FOX
Still photographer: Ray Lewis: 12–3, 236, 240–3, 245, 252–4, 257, 265 • Drawings and designs for FANTASTIC MR. FOX by Wes Anderson, Chris Appelhans, Christian De Vita, Turlo Griffin, Félicie Haymoz, Huy Vu, and Greg Williams • Illustrations by Max Dalton: 234–5, 249, 250, 251, 255, 257, 262, 265 • p. 244: © Roald Dahl Nominee Limited • "FANTASTIC MR. FOX" © 2009 Twentieth Century Fox Film Corporation, Monarchy Enterprises S.a.r.l. and Regency Entertainment (USA), Inc. All Rights Reserved.

MOONRISE KINGDOM
Still photographer: Niko Tavernise: 14–5, 272, 276–8, 280, 281, 284–7, 289, 290–4, 297–9, 300–5, 308–312, 316, 321, 323, 326–7, 336 • Drawings and designs for MOONRISE KINGDOM by Wes Anderson, Eric Chase Anderson, Paula Bird, Johan Bjurman, David Hyde Costello, Russell De Young, Andrea Dopaso, Eric Helmin, Kevin Hooyman, Sandro Kopp, Asher Liftin, Juman Malouf, Indre McCraw, Kerri McGill, David Moriarty, Mark Pollard, Carl Sprague, Gerald Sullivan, Adam Stockhausen, and Jeremy Woodward • Illustrations by Max Dalton: 270–1, 292, 294, 299, 309, 313, 322 • pp. 324–5: Courtesy of Spoke Art Gallery • "MOONRISE KINGDOM" © 2012 Moonrise LLC.

About the Author

Writer and filmmaker Matt Zoller Seitz is the TV critic for *New York* magazine, the editor-in-chief of RogerEbert.com, a finalist for the Pulitzer Prize in criticism, and the founder of the film blogs *The House Next Door* and *Press Play*. His writing on cinema, TV, and popular culture has appeared in *The New York Times*, *The Star-Ledger*, *New York Press*, and *The London Evening Standard*. Seitz is a pioneering video essayist who has written, narrated, edited, or produced hundreds of hours' worth of short videos about film history and aesthetics, including his five-part *Moving Image Source* series *Wes Anderson: The Substance of Style*, the inspiration for this book. He lives in Brooklyn, New York, with his two children.

About the Illustrator

Max Dalton is a graphic artist living in Buenos Aires, Argentina, by way of Barcelona, Paris, and New York. He has been drawing since he was two or three, and began to take it professionally around the age of thirteen. In the last twenty years he has been illustrating books, newspapers, and magazines from around the world and, most of all, working on personal artistic projects. www. maximdalton.com

EDITOR Eric Klopfer
DESIGN Martin Venezky's Appetite Engineers
PRODUCTION MANAGER True Sims
PERMISSIONS COORDINATOR Monica LoCascio

Cataloging-in-Publication Data has been applied for and may be obtained from the Library of Congress.
ISBN: 978-0-8109-9741-7

Printed and bound in the United States
10 9

Abrams books are available at special discounts when purchased in quantity for premiums and promotions as well as fundraising or educational use. Special editions can also be created to specification. For details, contact specialsales@abramsbooks.com or the address below.

ABRAMS
THE ART OF BOOKS SINCE 1949

115 West 18th Street — New York, NY 10011
www.abramsbooks.com

THE AUTHOR WISHES to thank the following individuals and institutions that helped bring this book to life.

Thank you, Peter McMartin and Deborah Wettstein of Indian Paintbrush; Debbie Olshan, Elizabeth Masterton, and Trinh Dang of Fox; Margarita Diaz and Carey Hanson of Sony; Maxine Hof and Margaret Adamic of Disney; Missy Patrello of St. Mark's; Courtney Burger of St. James; J. W. Rinzler, Carolyn Young, and Chris Holme of Lucasfilm LTD; Marian Cordry and Peter Murray of CBS/Paramount; Barbara Jean Kerney and Kevin Vale of Technicolor; The Richard Avedon Foundation; Susan Arostegy of the Criterion Collection; Lorrie Adamson and Alexis Fajardo of Charles M. Schultz Creative Associates; Mary Velasco of Getty; Matthew Lutts of the Associated Press; Penelope Currier of The Frick Collection; and Monica LoCascio. You all helped immeasurably with materials and clearances, and I am so glad you did.

At ABRAMS, I owe a debt of gratitude to outgoing art director Michelle Ishay-Cohen, and her successor, John Gall; publisher Deborah Aaronson; senior vice president Steve Tager; managing editors Ivy McFadden, Lauren Hougen, and Scott Auerbach; design managers Liam Flanagan, Danny Maloney, and Jules Thomson; Chris Raymond in IT support; Anet Sirna-Bruder and True Sims in production; and CEO Michael Jacobs, for taking a chance on a somewhat peculiar book. I'm also thankful for Samantha Weiner and David Jenkins, who helped with transcription.

Thanks to the many kind and attentive people in Wes Anderson's corner, including publicist Bebe Lerner; Molly Cooper, Edward Bursch, and Rae Murillo; and Cat Cohen and Susan Green of Jim Berkus's office at United Talent Agency. Thanks to the folks in my corner: Peter Miller and the Peter Miller Agency, who negotiated the contract for this book; and my agent Amy Williams of McCormick & Williams.

Thanks to Laura Wilson for your extraordinary photographs, and to Lilly Albritton and Gail Bruno for scanning, cataloging, and shipping them.

Thank you, Ken Harman of Spoke Art Gallery, and all the affiliated artists who contributed work to *The Wes Anderson Collection*—especially Max Dalton, who designed many key exterior and interior images, as well as spot illustrations within several chapters. You're a marvel, Max; I don't so much look at your illustrations as imagine myself living in them.

Thank you, Martin Venezky, for designing this beautiful book, which exceeded my wildest imaginings. Thank you, Michael Chabon, for your introduction, which sets a bar so high that Dignan couldn't pole-vault over it.

Thanks, Ken Cancelosi, for serving as my Riker in Texas and being a great friend for twenty-five years. Thanks, Sarah D. Bunting, for transcription, and for being present. Thanks, Zoller-Dawson-Seitz clan, in particular my dad, Dave Zoller, my creative inspiration. Thanks, Ronnie Dale Wilson, for being such an extraordinarily giving and forgiving person. Thank you, Hannah and James Seitz, my brilliant, headstrong children. Thank you, my dearest Jennifer; how I wish you could have seen this book.

Thanks are also due Aaron Aradillas, Richard Brody, Ali Arikan, Kim Morgan, Odie Henderson, Simon Abrams, Steven Boone, Kevin B. Lee, David Bordwell, and Miriam Bale, my critical sounding boards; David Schwartz, Dennis Lim, Jason Eppink, and Livia Bloom of the Museum of the Moving Image, which published my five-part 2009 video essay *Wes Anderson: The Substance of Style,* the genesis for this book; and Ronald Pogue, for media management.

Thank you, Wes, for being so generous with your time and materials, and for making films rich enough to withstand repeat viewings. Thanks, Juman Malouf; you are utterly charming, and a great host.

Finally, thank you, Eric Klopfer, for not only editing this book, but teaching me a new skill set, and becoming one of my dearest friends in the process. Your humor, taste, and patience were always appreciated, sometimes miraculous. First round's on me for life.

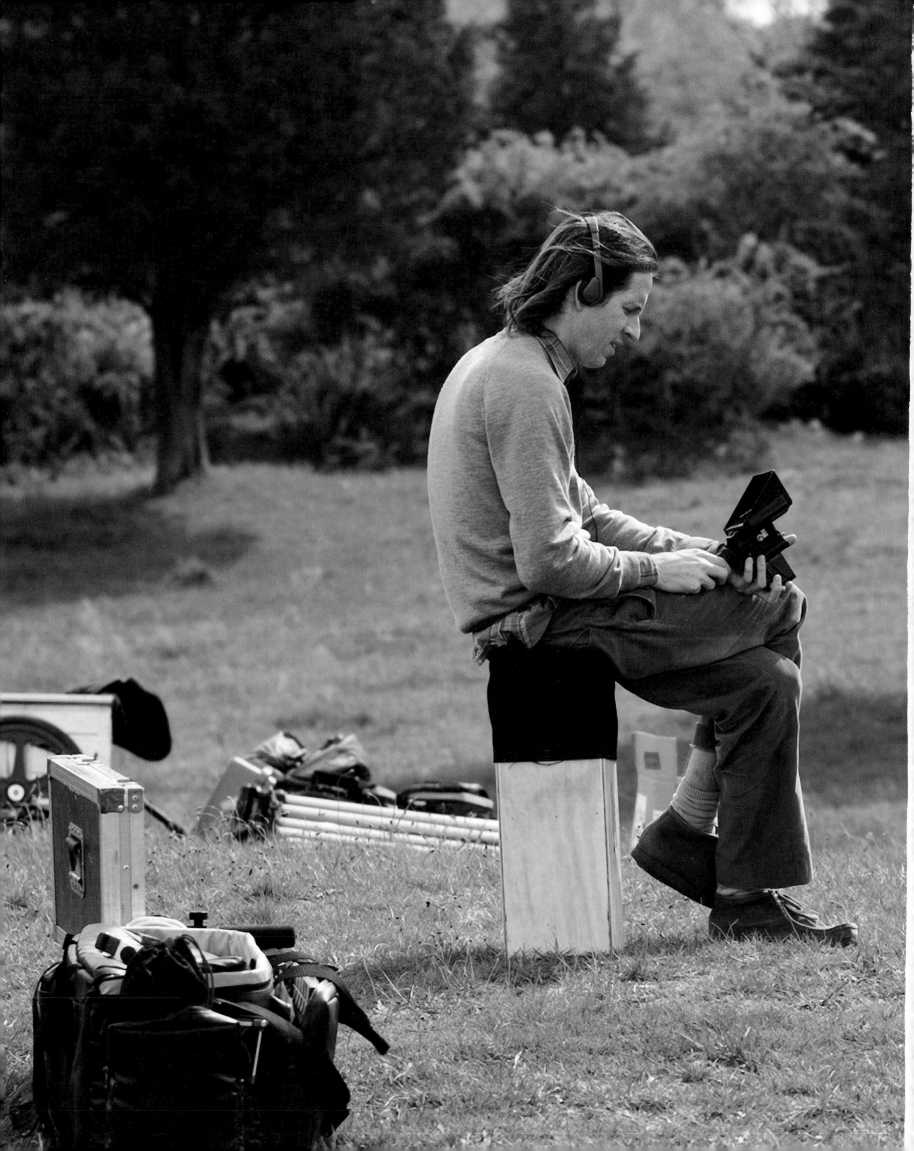